ART NOUVEAU BiNG

PARiS STYLE 1900

BY
GABRIEL P. WEISBERG

ART NOUVEAU BiNG

PARiS STYLE 1900

 HARRY N. ABRAMS, iNC.,
PUBLiSHERS, NEW YORK,
iN ASSOCiATiON WiTH
THE SMiTHSONiAN
iNSTiTUTiON TRAVELiNG
EXHiBiTiON SERViCE

CONTENTS

DEDICATED TO MURIEL RAKUSIN AND THE LATE STANLEY RAKUSIN

FOREWORD

Project Director: Margaret L. Kaplan
Project Coordinator: Nora Beeson
Designer: Bob McKee
Assistant Designer: Julie Duquet

Library of Congress Cataloging-in-Publication
Data

Weisberg, Gabriel P.
 Art Nouveau Bing.

 Bibliography: p.
 Includes index.
 1. Art Nouveau Bing (Firm) 2. Bing,
Siegfried, 1838–1905—Contributions in art
nouveau. 3. Art nouveau—France—Paris.
I. Smithsonian Institution. Traveling Exhibition
Service.
N6847.5.A78W44 1986 709'.44 86–3892
ISBN 0–8109–1486–7
ISBN 0–86528–031–2 (pbk.)

Times Mirror Books

Printed and bound in Japan

Perhaps because it seems so close in time to our own experience, many art lovers feel a special kinship with the turn of the century. We speak of fin-de-siècle artists almost as if we know them, and a large body of scholarly work exists covering nearly every conceivable aspect of late nineteenth-century philosophy, sociology, and art. Given that, it is a rare and remarkable opportunity when one finds something new and unknown about the late 1800s, a privilege we at the Smithsonian Institution Traveling Exhibition Service are pleased to share with everyone who reads this book and visits the exhibition *Art Nouveau Bing: Paris Style 1900*. This presentation documents the work and aspirations of a little-known connoisseur, Siegfried Bing, who, we come to find, is inextricably linked with the dramatic decorative arts movement in France called "art nouveau."

Learning about Bing is something like reading a detective story, for there are very few photographs of the man, and precious little information of his life has been readily available. Dr. Gabriel P. Weisberg, a leading scholar in the field of European decorative arts and nineteenth-century art history, first encountered Bing's name many years ago and, intrigued, began to research scraps of information—critical reviews, sales receipts, legal documents, and business letters scattered in archives throughout Europe—for more details. Gradually Dr. Weisberg, assisted by his wife Yvonne, pieced together the role Bing played in the development of *art nouveau*.

Art Nouveau Bing: Paris Style 1900 is a major contribution to our knowledge of the development of the art of that important period. But more than this, it is also an unparalleled opportunity to experience an exhibition of objects displayed in Bing's shop or produced in his atelier. As a tribute to Bing, this exhibition represents the tangible realization of Dr. Weisberg's commitment to bringing this elusive connoisseur and entrepreneur out of the shadows and into the light of museums and to the attention of the academic community.

The challenge of organizing such a major international exhibition was eagerly accepted by SITES, where a number of people became contributors to realizing the final exhibition. Anne R. Gossett, Assistant Director for Exhibition Development, and Exhibition Assistant Joan MacKeith devoted considerable time, energy, and talent to the organization of this show. Registrars Mary Jane Clark, Fredric Williams, and Gwen Hill attended to the many details involved in transporting these fragile pieces from their European homes to the United States and gathering still other objects from American collections, while James Mahoney, Jr., and his colleagues at the Smithsonian's Office of Exhibits Central designed an exhibition that highlights the unique beauty of each object. Publications Director Andrea Stevens recognized in this subject the potential for collaboration with a major publisher, and we are pleased to publish this book with Harry N. Abrams, Inc., highly regarded for the fine quality of its art books. Editor Nancy Eickel worked closely with Dr.

Weisberg in the preparation of this book, which serves both as a vital document of the exhibition and a valuable tool for future research. To these and the many other staff members at SITES who worked on this project, I express my sincere appreciation and gratitude.

No exhibition can be developed without generous financial support, and we are particularly grateful to Benedict Silverman, Roy I. Warshawsky, Sarah G. Epstein, Arlene and Robert P. Kogod, and Lillian Nassau Palitz, who shared their interest in late nineteenth-century art by making important monetary contributions that enable Bing's achievements to be brought to the attention of a wider public. We are also appreciative of the assistance of the Smithsonian's Office of Membership and Development, particularly that of Diana Duke Duncan.

In organizing and circulating this significant exhibition, we at SITES have been both pleased and encouraged by the enthusiastic support and participation of the museum directors and staffs sharing our tour of *Art Nouveau Bing*: The Virginia Museum of Fine Arts, Richmond, Paul Perrot, director, Frederick R. Brandt, curator, Richard B. Woodward, manager, Office of Art Services; John and Mable Ringling Museum of Art, Sarasota, Florida, Laurence Ruggiero, director, Anthony Janson and Cynthia Duval, curators; The Joslyn Art Museum, Omaha, Nebraska, Henry Flood Robert, Jr., director, Bernard Barryte, curator; and The Cooper-Hewitt Museum, the Smithsonian Institution's National Museum of Design, New York, Lisa M. Taylor, director, David R. McFadden, curator.

It is a special honor for all of us at SITES to have participated in so exciting and fascinating a project as *Art Nouveau Bing: Paris Style 1900*. The period of *art nouveau* is past, but as you read this book and view the exhibition, we hope you will share our pleasure in discovering Siegfried Bing and the art he loved.

<div align="right">

Peggy A. Loar
Director, SITES

</div>

Published on the occasion of an exhibition organized by the Smithsonian Institution Traveling Exhibition Service and shown from September 1986 through September 1987 at:

The Virginia Museum of Fine Arts
Richmond, Virginia

The Joslyn Art Museum
Omaha, Nebraska

John and Mable Ringling Museum of Art
Sarasota, Florida

The Cooper-Hewitt Museum,
the Smithsonian Institution's
National Museum of Design
New York, New York

INTRODUCTION

In France the Industrial Revolution affected almost every level of manufacturing, from factories to cottage industries, and created in its wake a growing, prosperous middle class that could afford—and demanded—improved domestic environments. Homes in mid-nineteenth-century France were all too often dismal with massive, impersonal rooms with walls obscured by artificial trappings. The emerging middle class began to search for something new. They wanted *objets d'art* and exotic items with which to decorate their houses, and the decorative arts field became ripe for innovation in production, technique, and design. This meant historical styles and traditional designs had to be cast aside, but the Academy and the École des Beaux-Arts maintained an official stranglehold on accepted artistic taste. These aesthetic dictators gave little recognition to the so-called "minor" arts, and decorative art objects were rarely found in their official exhibitions. Opportunities for change through established channels remained minimal.

The decorative arts fared slightly better in the huge Paris expositions begun in 1855. There, artists and dealers all over the world could view and test ways to introduce innovative designs to the public. It also gave the French public a chance to see what was going on in both industrial design and the fine arts elsewhere. Despite the popularity of these universal expositions, design reform met intense resistance in France. Many saw the movement's alliance of social and artistic reformers, as well as the influx of foreign influences with each succeeding international art show, as a pernicious threat to the status quo, aided and abetted by such other "unacceptable" elements as Jews, liberals, and the *nouveaux riches*. A stalemate resulted that in the end prevented France from enjoying a florescence of their arts similar to that of other countries. England, where William Morris and John Ruskin advocated a return to skilled workmanship, and America experienced extensive arts-and-crafts movements, while Germany boasted the Jugendstil. It appeared that an enlightened art dealer was needed to bring about a change in France.

By the late nineteenth century an entrepreneur could deal in art as both an investor and a patron. Among these wealthy businessmen were those who thought capitalism could be put to the service of art and, in turn, art could serve society. Most influential in this group were the art dealers themselves, who well knew how to become wealthy through art but were also willing to invest money to promote that art. In their efforts to make the decorative arts enjoyable and useful to more people, some enlightened dealers and connoisseurs encouraged displays in larger museums, international collections to eliminate provincial prejudices, and art-training curricula to give the "decorative arts" equal status and representation with the "fine arts" of painting, architecture, and sculpture. If these could be accomplished, art could then be useful to the ordinary family as well as the rich collector by applying refined design principles to practical items required to furnish any home.

A prototypical example of such a dealer-entrepreneur was the imaginative and dynamic Parisian art patron Siegfried Bing (1838–1905), erroneously called Samuel in art historical research and publications.[1] He bargained his unusual talent for anticipating public taste for art objects into a fortune and then, with almost messianic zeal, used that wealth to better society through art. An admirer of the Japanese aesthetic, Bing began his career as a promoter of Japanese art objects in France. He firmly believed that a new design could be stimulated in Europe simply by applying Japanese aesthetic principles to everyday objects and by adapting the Japanese attitude of making no distinction between the major or minor, fine or applied arts. The fortune Bing accrued through *japonisme*, the French fascination with anything Japanese, was employed to revolutionize the applied arts of France.

From 1895 to 1904 Bing expanded his commercial gallery through workshops to produce harmonious interiors filled with furniture, objects, wall coverings, and appliances all created in a single aesthetic concept. Bing's original heavy reliance on foreign artists, especially English and Belgian, provoked the French establishment into action, for the very act clearly indicated that other countries had outdistanced the French and ended the nation's traditional role as leader of the arts and arbiter of public taste.

Yet this initial response did not ensure the success of Bing's atelier. Despite its considerable achievement and high level of craftsmanship, the French remained adamantly and often rudely critical of the stylistic movement Bing endorsed. Only at the Paris Universal Exposition of 1900, where other nations displayed their advancements in the decorative arts, did Bing's own pavilion, Art Nouveau Bing, meet with some measure of concerted praise. His shop, *L'Art Nouveau*, eventually became identified not only with an innovative style that broke with past design approaches but also with the international decorative arts movement it espoused.

Bing's achievement in the decorative arts, his contribution to the formation of the international *art nouveau* style, his commitment to design reform and the education of the masses, and his uncanny ability to use his resources effectively for the betterment of the nation constitute a little-known story. Documents of the firms he controlled are scattered throughout the world, if indeed they still exist at all, and the objects made by or exhibited at *L'Art Nouveau* have either disappeared or lie forgotten in museums. Even Bing's idea of establishing a worldwide network of decorative arts museums has not met with the success he might have envisioned. Nevertheless, the union of art and industry come together in Siegfried Bing, whose artistic vision surpassed his entrepreneurship and whose innovations await their sympathetic audience.

CHAPTER 1:
BING AND JAPAN

1. *Photo album showing S. Bing and his family*, Private collection.

12 · *Bing and Japan*

The third child in a large family of prosperous merchants, Siegfried Bing (figs. 1, 2) was born in 1838 in Hamburg, Germany. His father Jacob (1798–1868), the second of three sons in a merchant family,[1] was co-owner of Bing Gebrüder, a firm established ten years earlier to import French porcelain and glass to Hamburg.[2] In 1834 Jacob married Friedericke Renner (1811–93), a daughter in another Hamburg trading family; Siegfried was born four years later. Statutes drawn up by Jacob Bing in December 1846 made his father-in-law, Samuel Joseph Renner, an equal partner in Bing Gebrüder. (Renner replaced Jacob's brother Moses Bing, who had gone to Paris to look after a branch of the family business there.[3]) These two ran the business—Renner in Hamburg, Jacob in Paris after around 1850—until Renner died five years later, and Jacob ran the firm as sole owner.

After each graduated from school in Hamburg, Jacob Bing's sons, Siegfried, Michael, and later Auguste, joined the family in Paris and eventually went to work for Bing Gebrüder.[4] In 1854, most likely with capital supplied by the Hamburg branch of the family business, Jacob purchased a small manufactory called Gendarme et Cie. in St. Genou (Indre) to manufacture porcelain objects for the rapidly increasing import-export trade in luxury items.[5] With the purchase of the firm also came a patent for the firing of hard porcelain in a coal-burning kiln, which was extremely efficient for its day and increased production markedly.

In the end, however, the Bings most likely found the ceramic manufactory at St. Genou too expensive to operate. The number of employees gradually declined from an original 500, and in 1863 the manufactory was sold.[6] About that same time, Jacob retired from the family firm of Bing Frères et Cie., and at the age of twenty-five, Siegfried Bing took over the family interests in manufacturing decorative art objects. He soon purchased another porcelain manufactory to provide objects for the family retail outlet on the rue Martel in Paris, a thriving business that sold porcelain and glass to the wealthy. The young businessman associated himself with Jean Baptiste Ernest Leullier, another porcelain manufacturer, in an organization called Leullier fils et Bing. Siegfried served as *chef d'atelier*.[7] Joining the Leullier manufactory with the Bing fortune proved advantageous to both parties: the firm not only increased its output but also won awards for the artistic excellence of its products.[8]

Business flourished at the rue Martel shop as the newly rich middle class of the Second Empire eagerly acquired the latest in household luxuries. In fact, the early success of this retail venture initially convinced the Bings that fortunes could be made in manufacturing porcelain. When Jacob retired, another son, Michael, took over the import-export business and ran the shop in the rue Martel[9] while Siegfried manufactured porcelain with Leullier. Both enterprises prospered by Michael's close association with the Bings of Hamburg and Siegfried's efficient production of porcelain table services, lamps, and some bronzes.[10]

By the mid-1860s the firm of Leullier fils et Bing had manufactories in the Parisian regions of Esternay and Conflans and a display room in the fashionable Faubourg St. Denis. Their popular rococo-style porcelains were subtler in shape than those of other French firms, and a series of decorated table services exhibited at the 1867 universal exposition in Paris won Leullier fils a medal. Happily, such publicity increased their clientele.[11] Siegfried took credit for all this success in a document he submitted in support of his successful petition for permanent residency in France.[12]

On May 3, 1868, Jacob Bing died, and with the acquiescence of Siegfried and Michael, the firm of Bing Gebrüder was liquidated. Both sons were no doubt made rich by the sale of the firm's assets.[13] A few months later, on July 22, Siegfried married Johanna Baer, one of a rich, cultivated, and well-established family in Hamburg that was already related to the Bings. (She was his third cousin.[14]) Siegfried soon moved his new wife to Paris, where they set up house at 31 rue de Dunkerque, close to the offices of Leullier fils. In September of the next year Johanna gave birth to their first child, Jacques.[15]

Political situations in Second Empire France grew more tense as war with Germany became apparently inevitable. Bing had difficulty holding the business together in the face of a financial crisis and an impending war with Prussia, and he

plate 1. Cover from "Le Japon Artistique," April, 1889. Private collection (H. 13¼ x W. 9¾").

soon fled with his family to Brussels, where they remained during the war. (A second child born there did not survive infancy.) In May of 1871 the Bings returned to Paris to a house on the rue de Dunkerque, almost next door to the home they had left the year before.

Back in Paris Siegfried found the Leullier firm in disarray; most of its employees were in the army and the decorative arts business was in decline. With so much of Paris destroyed by the fighting, people were concerned with survival, not luxury. Tragedy also struck the Bing household. Siegfried's brother Michael died in February of 1873, and a third son, named Michael, born to the Bings in May, died two months later.[16] Now the only Bing family businessman remaining in Paris, Siegfried was free to decide what direction his career would take.

Bing first revitalized his porcelain manufactory and then established relations with several major importers. He also started to collect Oriental objects. His personal interest in fine ceramics and his businessman's sense of the decorative arts market almost naturally led him in the direction of the mania for Japanese curios then sweeping France. By 1874 he had already become a prominent enough collector to be invited to join the East Asian Society in Tokyo,[17] and prosperous enough, according to his submitted request for naturalization in 1876, to pay rent on three establishments (two for business and one residential).

It is difficult to say why Bing was initially attracted to the Orient. Although no evidence exists that ties him directly to the artists and craftsmen who utilized Japanese prints or the people who collected them during the 1860s, he did visit Oriental exhibitions sponsored by the Union Centrale, the forerunner of the Musée des Arts Décoratifs in Paris, of which he was a member. Here, artisans displayed ceramics that replaced traditional motifs with designs lifted, often quite directly, from Japanese prints and albums. Bing certainly knew the Paris shops that sold Oriental wares as well. It is easy to imagine him among the throngs of shoppers and collectors who visited the shop of *La Porte Chinoise* to admire the *ukiyo-e* (woodblock) prints, ceramics, and bronzes on view there.[18] Since Bing was certainly not one to ignore an entrepreneurial opportunity, he actively dealt in *japonaiserie* by the 1870s, if not before.[19]

In March of 1876, he sold a collection of Oriental objects at public auction at the Hôtel Drouot.[20] The sale netted him over 11,000 francs, which suggests that he had been collecting for some time and had already developed an eye for buying objects of high resale value. This sale also presents the first record of his public involvement with this market. Before this time, Bing may not have wanted it generally known that he was dealing in Japanese objects. He was, after all, a well-established manufacturer still associated with Leullier fils, and he had an image to maintain. Possibly he entered the field as a sideline, preferring to keep this aspect of

plate 2. Detail of textile reproduced in *"Le Ja-pon Artistique,"* April, 1891.

plate 3. Detail of textile reproduced in *"Le Ja-pon Artistique,"* June, 1888.

his life rather quiet until it developed substantially. Perhaps Leullier did not supply a sufficient outlet for his growing entrepreneurial energies. Although Bing remained affiliated with the firm until 1881,[21] his attentions were directed more and more toward an art business that would combine his interests in Japanese art, his connoisseurial love of beautiful objects, and his business instinct for profit.

The raging mania for Japanese art was reinforced and disseminated by the Paris world's fair of 1878, where Japanese art was well represented. Experts from Japan provided information on artists and the history of a specific place where a particular kind of ceramic or bronze was produced. The huge Japanese pavilion housed examples of both art and industry, revealing to its numerous visitors the complexity of Japanese life and culture.[22] With an eye on the new Japanese market, the French government did everything possible to encourage an enthusiasm for its products, as did the press. When the Japanese pavilion opened, the range of Japanese creativity was fully reported in glowing terms. Critics might have considered Japan an untouched playground whose artists were totally immersed in all aspects of nature, but they extolled the variety of objects displayed and called attention to their importance as models for Western designers. At the same time, businessmen eyed the displays for Japanese objects that would satisfy a Western consumer's exotic preconceptions about Japanese art.

Bing timed the opening of his shop at 19 rue Chauchat to coincide with the Paris Exposition and its Japanese pavilion. Initially he had a partner, Proost Besce, but after the first year only Bing's name appeared on the business logo. He paid the sizable rent of 22,000 francs a year for the shop until he bought it outright in 1892.[23] From the beginning the shop enjoyed great success. As business grew and the size and scope of his stock increased, Bing became more determined to corner the Japanese market, but first he had to establish ties with the Japanese.

Some dealers, such as Madame de Soye and Pierre Bouillette of *La Porte Chinoise*, were content to choose their wares from the diverse art objects regularly shipped to French ports from the East. Others, Philippe and Auguste Sichel, for example, actually lived in Japan for several months at a time to make the business contacts needed to obtain a larger and more varied stock.[24] Yet no one had managed to establish trade relations with the private Japanese collectors of antiquities, whose holdings were still out of the reach of foreigners. This aspect of the Japanese art trade remained untapped, awaiting the right entrepreneur. Bing set his sights on it.

Bing's brother-in-law, Michael Martin Baer (1841–1904), had gone to the Far East in 1870 to serve as acting consul for the German Legation in Tokyo,[25] a post he held for two terms (1870–74, 1877–81). As consul, Baer had ready access to Japanese high society. He was also rich and extremely fond of giving large house parties at his lavish summer residence.[26] In return, he enjoyed rare opportunities to view

3. Photograph of Tadamasa Hayashi, ca. 1900–1904. Private collection, France.

private Japanese collections. As a connoisseur and collector himself, he appreciated what he saw. Soon he began to purchase select items, not only for himself but also for Bing and for other import-export firms such as Ahrens and Company, which claimed offices in Yokohama, Tokyo, and London. Baer was undeniably helpful when Bing himself later went to Japan.

Bing's first trip to the Far East occurred in 1880. He wrote of it:

> In 1880 I could stand it no longer; I left family and business and set my course toward the adventurous shores of the Far East, whose images had

time and again appeared in my dreams. I stayed away for only one year—but what a year! The most perfect things had slipped from control of the richest families, who little by little became impoverished due to the social revolution that had taken place, and it was still not too late to gather in a rich harvest.

So I took off: I traveled throughout China and in a couple of months thoroughly examined the remnants of the capital where, miraculously, the most beautiful things, which the glorious past of the old empire had left to us, were still preserved. Once arrived in Japan I beat the drum in order to procure from one end of this remarkable Island Kingdom to the other all the artifacts that money could possibly buy. I crossed the country in all directions and let it be known everywhere that a wild man had come ashore to buy up everything. That brought forth from underground hiding places treasures of which one never had dreamt before. Well, I bird-dogged the art of this nation of artists down to their most modest products which previously no one had found worth the trouble to stop and consider. The things that were utilized for the most common daily use—toilet articles which women of the lower classes used, combs, hairpins—all seemed to me to be marked by such a special and enchanting character that it provided material for collections, and the time that followed did, in fact, prove that, in this instance, I was not the victim of self-deception. Loaded down with a tremendous booty I embarked again and, after a last reconnaissance of China, went on to India, which I traversed from one end to the other. When I returned home I had the satisfaction of being able to

5. Henry Somm, *Fantaisies Japonaises*, un-
dated, etching. Collection Jaap W. Brouwer.

tell myself that—like a hurricane—I had taken along with me everything
in my path, all that my eyes had considered worth carrying off. Since then
there has been forthcoming the occasional beautiful article, but the signifi-
cant in-gathering had taken place.[27]

An article in the *Tokyo Daily News*, dated July 15, 1880, noted Bing's presence
there.

> M. Bing is a grand French merchant and also a connoisseur of art. He loves
> many kinds of art objects from our country and most especially the works
> of Shibata Zeshin. Since M. Bing wanted to meet him, Kiritsu Kosho
> Gaisha arranged for Bing to attend a party on the day before yesterday,
> that is the 13th, at the villa of Koume.... The German ambassador also
> joined this party.... At this gathering M. Bing informed us that he had
> purchased many works by Korin from Japanese businessmen living in
> France. The elegant quality of these objects was appreciated by connois-
> seurs and all were unexpectedly sold.[28]

Bing apparently did not restrict himself to antiquities but also sought out con-
temporary Japanese artists to buy their work. A market eager for the newest works
by modern Japanese artists already existed among the connoisseurs of Paris.

With Baer nearing retirement, Bing sent for his brother, Auguste Bing, to join
him in Japan to ensure a steady supply of imports for the Paris shop. After an

6. *Cover from "Le Japon Artistique,"* August, 1889. Private collection (H. 13¼ x W. 9¾").

extended journey, Auguste met Bing in Tokyo in July 1881, just before the dealer's return voyage to Europe. Auguste then departed for Shanghai aboard the steamer *Hiroshima Maru,*[29] presumably to escort part of a shipment of goods to Europe. He made a second trip from Japan to Shanghai on the *Tokyo Maru* later that year before returning once more to Paris.[30] Shy and retiring by nature, Auguste was nonetheless a shrewd businessman, and he successfully negotiated a major share of Bing's purchases for his shops and private collection. Certainly without his help, Bing neither could have sustained the flow of high-quality objects he needed nor would his empire have flourished as it did.

When Siegfried Bing returned to Paris at the end of the next year, he reorganized his growing business to accommodate the stock of objects he had purchased in Japan. He opened new outlets, first at 23 rue de Provence,[31] and then at a fashionable location at 13 rue Bleue, which specialized in contemporary works and catered to a wealthy clientele. The spacious shop combined an extensive showroom on the ground floor with opulent rooms used as private parlors for favored clients. Still other rooms served as storage areas where he could hold pieces in anticipation of a better market or reserve them for a particularly distinguished connoisseur.

Popular and scholarly interest in Japanese art and its history was definitely on the rise. In 1883 the noted art critic and collector of Japanese art Louis Gonse organized a gigantic exhibition of Japanese art in Paris to benefit the Union Centrale, a group of art patrons devoted to increasing popular appreciation of the decorative arts. To this end, Gonse wrote a major book, *L'Art Japonais,*[32] to accompany the show, through which he hoped to inspire a serious French interest in the tradition and antiquities of Japan. Rather than obtain objects from the Far East (a risky and expensive endeavor), Gonse relied on the *japonistes* among his circle of acquaintances for loans: the critic and collector Philippe Burty, the porcelain manufacturer Charles Haviland, the art critic Théodore Duret, the collector E. L. Montefiore, the gallery dealer George Petit. Bing lent over 650 objects to the ceramic portion of the exhibition.[33]

A critical and popular success, Gonse's exhibition revealed to the French public the beauty of a whole range of Japanese painting, sculpture, prints, ceramics, and other decorative arts. Reviews of the exhibition stressed the power of the newly discovered art. Newspapers, journals, and scholarly articles all described how Gonse, by placing Japanese art in a historical and aesthetic context, had changed the Western attitude from fad to serious inspiration. The retrospective exhibition examined the origins of minor Japanese arts from the ninth to the nineteenth century and demonstrated the skill of Japanese artisans and artists in combining painting with lacquers or ceramics with metalwork, sculpture, and prints. With the assistance of Tadamasa Hayashi (fig. 3), an emerging promoter of Japanese art in Paris,

Gonse determined provenances of a number of pieces, their specific artists, locales where created, and the particular meaning of an object's theme. The triumphant exhibition and Gonse's book raised questions of aesthetic and historical assessment that forced writers, collectors, and connoisseurs to analyze Japanese art more carefully[34] and to give its study a deserved seriousness. Bing also wrote an essay for the separate exhibition catalogue that explained the traditions of Japanese ceramic art and the techniques utilized, making it one of the first thorough examinations of Japanese ceramics published in the West. The article secured Bing's place as a connoisseur and scholar in the field. His combination of general knowledge of Japanese art history with a collector's appreciation of the intrinsic value of the object provided his readers with the basic information they needed to appreciate Japanese ceramics (figs. 4, 5).

Later in that same year of 1883, Bing organized the first Salon of Japanese Painters sponsored by the Ryuchikai, a Japanese association dedicated to the continuation of the heritage of old Japan that included some Western aristocrats, scholars, and artists. (One of its distinguished members, Ernest Fenollosa, an American philosophy professor teaching in Japan since 1878, particularly deplored the current Japanese craze for Western art.[35]) The Ryuchikai turned to Bing, their Paris agent, to organize this exhibition because his contacts with contemporary Japanese painters who worked in traditional styles made him a likely candidate to bring the exhibition to France. They also asked Bing to write the catalogue's introduction, an honored task which he performed again for the second Salon of Japanese Painters in 1884.[36]

In the meantime Bing's business began to expand into other European countries. Following an exhibition in Amsterdam, the Leiden Museum purchased Oriental objects from Bing,[37] reflecting an interest in Japanese art in Holland ignited by Baron von Siebold earlier in the century. When the National Museum of Ethnology opened its doors in Leiden in 1883, the Dutch merged all of their existing museum collections of Oriental art to form one comprehensive holding. Bing also sold objects to museums in Germany and England. Justus Brinckmann, an old friend and the first director of the Museum für Kunst und Gewerbe in Hamburg, enlarged the museum's Oriental holdings with expensive purchases of sword guards, textiles, and lacquers from Bing's Paris shop.[38] Bing also sold Oriental wares to the Victoria and Albert Museum in London. In a letter to the museum's director dated February 1, 1883, he wrote:

> Yesterday I sent you the photographs of a large bronze which you had seen at the Paris Exposition in 1878.
>
> In time I acquired this piece for which I profess the greatest admiration. Along with the bronze eagle from Mitford's collection—which you al-

ready own—I consider this, in fact, to be the most beautiful bronze ever made by an artist.

Today, because of changes which I am forced to make, I am on the verge of selling it. Consequently, I have thought of you, and my regret will be less if this marvel could find room in your Museum where it would provoke considerable attention.

With regard to the price I shall simply ask the one actually paid (40,000 francs). At the most one would have to add interest at the rate of 5% per year....[39]

The profitable sale of the bronze was enough to finance the remodeling of Bing's Paris gallery. By the time his renovations at 19 rue Chauchat were completed, however, Bing had opened two new shops: one in a rented showroom on the rue Bleue; the other, a small section of a ground floor on the rue de la Paix. He kept the latter shop, located across the hall from his good friends, the master jewelers Paul and Henri Vever, for only a short time.[40] Bing needed extra shops because he catered to two distinct levels of clientele who had opposing tastes and expenses. He dealt in both fine objects of superior quality that he could sell at a high price and ordinary, affordable pieces that appealed to a middle-class consumer with a momentary taste for *japonisme*. The shop on the rue Bleue displayed his contemporary Japanese objects, while the other two stores were devoted to antiques, or at least what Bing thought were antiques. Few connoisseurs had the extensive experience or in-depth knowledge necessary to securely identify genuine Japanese antiques. A distinct possibility existed that a number of these so-called antiques were in reality pieces made in the nineteenth century, in response to the rising Western demand for them or as a way to honor ancient styles in Japan. Whatever the reason, Bing's sponsorship of ancient pieces was not always infallible.

The rue Bleue store later became the headquarters of S. Bing et Cie., a limited partnership formed in the summer of 1884 to create a commercial trading company in contemporary art objects and raw materials from the Far East.[41] In addition to Bing the company had three main managers—Auguste Bing, Daniel Dubuffet, and Henry Ernaux—but as its leading shareholder, Bing maintained firm control. He may have held his own 250 shares in common with Auguste. His brother-in-law, the Tokyo consul Baer, purchased 75 shares, which, together with Bing's and Auguste's shares, would prevent outside stockholders from challenging Bing's practices and policies. For these shares Bing gave the other stockholders, in addition to the rue Bleue shop, the use of his well-established name as a dealer in Japanese art (and presumably other Far Eastern objects) and his large Oriental stock. The statutes of S. Bing et Cie. allowed Bing and Auguste to keep the antiquities business separate from the company. If anyone in the company wanted to secure ancient Japanese art, they could do so by purchasing it through Bing's shop at 19 rue Chau-

9. Vase, Akahada, 18th century. Museum of Decorative Art, Copenhagen (H. 16 x D. 6").

Bing exhibited this vase and the following four pieces in Copenhagen in 1888 and then gave them to the museum.

10. Vase, Shigaraki, 18th century. Museum of Decorative Art, Copenhagen (H. 22½ x D. 4½").

chat. On the other hand, modern works had to be purchased through S. Bing et Cie. In this way S. Bing et Cie. effectively cornered the contemporary Japanese art market, including those objects modern in style or imitating older masters. The formation of the trading company broadened Bing's base of operations by incorporating the import of a wide variety of manufactured goods.

A few months later Bing found himself relatively short of funds and again turned to the director of the Victoria and Albert Museum, who had expressed an interest in securing a Japanese screen. Bing wrote:

> Thank you for your letter which I received yesterday. I hasten to tell you that following a complete stoppage in business—and finding myself in great need of cash—I have to sell the screen anyhow. I was just about to write you when your letter arrived. Hence, I am prepared to make the necessary concessions to see this matter resolved without delay.[42]

He eventually negotiated the sale of this screen, which helped him through the temporary financial crisis. What caused this cash-flow problem is unclear, but the number of dealers entering the market may simply have grown too large. Prices began to plummet as the market became increasingly glutted.

S. Bing et Cie. momentarily retrenched, closing the outlet on the rue de la Paix in 1886 and, in turn, opening offices in Japan. The first office, in Yokohama, was run by Daniel Dubuffet; a second, in Kobe, opened in 1887.[43] Japan was now eager to industrialize, and Bing, equally eager to expand his business, met the demand by importing diverse trade items for the country, including heavy machinery, munitions, dynamite, and gas and oil light fixtures.[44] By handling deals for other French firms through his company, Bing became a major figure in the Far East trade.

To stimulate the market for French goods in Japan, Bing wrote on January 24, 1887, an important letter to the French Minister of Commerce and Industry, asking him to obtain authorization from the Japanese government to hold a large-scale exhibition of French industrial products in Japan after the Paris Exposition of 1889. Bing expressed the hope that a member of S. Bing et Cie. would be sent to Japan to negotiate the agreement. An official of the ministry, Edmond Lockroy, wrote back on March 26 that he had informed the ministry in Tokyo of S. Bing et Cie.'s desire to hold a trade show in Yokohama and other open ports in Japan. He had also notified M. Sienkiewicz (presumably the French government representative in Tokyo) to help Auguste Bing develop the enterprise in Japan.[45] In 1888 S. Bing et Cie. opened new and larger offices in Yokohama and added a number of Japanese to the staff, but it is unclear what became of the exhibition project. Undeniably, however, the firm continued to prosper. It began trading with China and Indochina, and became the general import-export agent for the *Syndicat de l'Industrie Francaise au Japon* as well.

11. Comb, 19th century. Museum of Decorative Art, Copenhagen (H. 2¼ x W. 5″).

12. Figurine, Kiku-jidu—early Kyoto, 19th century. Museum of Decorative Art, Copenhagen (Reproduced in *Tidsskrift for Kunstindustri*, 1888).

13. Vase, Owari, 18th century. Museum of Decorative Art, Copenhagen (H. 8½ x D. 3″).

Bing and Japan · 25

Although the import-export trade in manufactured goods was now the major source of income for S. Bing et Cie., the firm did not abandon the art market. Bing himself continued to deal heavily in Japanese *objets d'art*. In 1888 he also initiated a journal devoted to Japanese art. Called *Le Japon Artistique* (fig. 6 and colorpl. 1), the journal featured articles printed in three language editions (French, English, and German) and used detailed illustrations of works primarily from Bing's own collections (colorpls. 2, 3). The idea for a journal devoted to Japanese art was not original to Bing. His close friend, the art critic and ardent *japoniste* Philippe Burty (1830–90), had already planned such a journal that was to be called *Le Japon Artiste*. For its first issue Burty made etchings of some of his smaller Japanese objects and wrote an introductory text, but either lack of funds or poor health prevented the project from getting off the ground. Bing took over the idea and changed the journal into a full-scale commercial venture to demonstrate that Japanese objects were both beautiful and a good investment.

14. Platter, porcelain, Royal Copenhagen Manufactory. Musée des Arts Décoratifs, Paris (D. 9¾").

Bing sold this platter to the museum in late 1888 for 45 francs.

15. Vase, porcelain, Royal Copenhagen Manufactory. Musée des Arts Décoratifs, Paris (H. 8¾").

The museum purchased this vase in 1888 for 75 francs.

As a new publisher, Bing set out to produce a handsome publication, and that meant colorplates. For these fine reproductions, he called upon the artistic talents of the printmaker Charles Gillot, another avid collector of Japanese art. The resulting journal was an innovation in the commercial art world, since its ultimate purpose was to seduce the nonspecialist, through word and image, into buying Japanese art. It sold for a relatively low price, perhaps because Bing may have subsidized the project as a way to promote his business. In the three years of its existence—Bing abandoned the journal in 1891 when it presumably became too expensive to produce—such *japonistes* as the leading writers Ary Renan, Louis Gonse, the English collector William Anderson, Théodore Duret, and Lucien Falize contributed articles that were sometimes naive and of doubtful scholarship, but at least indicated how eager the broad circle of *japonistes* were to enlist new recruits.

In the first issue of *Le Japon Artistique*, Bing identified Japanese art as an "art nouveau" that would have a lasting impact and seductive influence on European creativity, a comment that proved to be overwhelmingly prophetic. The journal's excellent reproductions provided a host of models for artists and study examples for scholars and students alike. His inclusion of lesser known Japanese painters also provided a more well-rounded view of the country's arts. Later editions of the journal, however, received mixed reviews from critics. George Auriol, a leading printmaker, wrote in *Le Chat Noir* that Bing's deluxe journal was an ingenious idea, its articles important, and its reproductions of bronzes, textiles, furniture, prints,

sword guards, and sculpture of the highest quality.[46] The British *Art Journal* called it a "great success."[47] Yet throughout its three years of existence, *Le Japon Artistique* was more often than not denounced as just another mechanism found by art dealers to inflate the market for Japanese art.

The Japan Weekly Mail, the major English-language publication in Japan that appealed to travelers and businessmen, attacked its scholarship. "*Artistic Japan* bids fair to be more mischievous than serviceable to the cause it espouses. Its letterpress is the work of men who substitute enthusiasm for knowledge. Instead of information we have rhapsodies; instead of research, vapouring."[48] Nor did Bing's own contributions to the journal escape criticism: "Mr. Bing touches only the hem of the garment, and we doubt if the work of weaving the whole is possible for anyone except a Japanese as deeply versed in the social and political history of his country as he is closely in touch with the spirit of art inspiration."[49] (In all fairness, Bing's intention was to appeal to a popular audience, not to publish articles of interest only to specialists.)

This same anonymous critic did manage to slip through some faint praise. He found the journal "pretty," if decidedly commercial. "*Artistic Japan*," he wrote, "though thus far it has not carved for itself a large niche in the temple of literary fame, is certainly helping to disseminate the love of Japanese objects in Europe . . . [and is] awakening fuller appreciation of the beautiful coloured prints for which Western collectors have begun to search with so much avidity." The journal

also helped elevate the *ukiyo-e* print to the domain of serious art, with the "tide of appreciation . . . still rising . . . they have opened their pages to M. Ary Renan, who discourses lengthily and interestingly on Hokusai's *Mangwa,* often indulging in rhapsodies that brother collectors, imbued with the proper spirit, will have no difficulty pardoning." Finally, the reviewer added, "The enthusiasm evoked by these [*ukiyo-e* prints] . . . does not escape the crafty dealer. He has pushed up the prices until a single woodcut by . . . the great masters, a woodcut that might have been bought for ten *sen* as many years ago, now costs twenty times that amount. Nobody complains of that, however; it is natural and proper that the price of Japanese objects of art should ascend as the market for them widens."[50]

One of the artists who drew inspiration from Japanese painting was Vincent van Gogh. In July 1888 Van Gogh wrote his brother Theo about an exhibition Bing had arranged to prove the significance of the reproductions in *Le Japon Artistique* (figs. 7, 8). It is clear from this correspondence that Van Gogh actually worked for Bing by selling prints on commission to fellow artists, a position that gave him ready access to Bing's stock. "The only money I really owe," he wrote to Theo, "is to Bing, in that I still have 90 francs worth of Japanese stuff on commission. But when you think of how many people I have sent straight to Bing's, it is more profitable to him to let that go, and even if I were still on the spot to occupy myself with it, I'd rather increase the stock so as to be able to do more business with it."[51]

Van Gogh mainly sold *ukiyo-e* prints, some of which he first retained for his own use. Japanese prints now seen in the backgrounds of his paintings may well have belonged to Bing. His working for Bing evidently displeased the Van Gogh family, for Theo urged his brother to pay his debt and have nothing further to do with the business. Van Gogh refused. He had no intention of cutting himself off from the largest supply of Japanese objects in Paris. "Thank you very much," he wrote back to Theo, "for your letter and the 100 franc note enclosed. I think now you are right in this idea of settling Bing's bill, and for this reason I am sending you back 50 francs. But I think it would be a big mistake 'to have done with Bing'—ah no, on the contrary, I should not be surprised if [Paul] Gauguin, like myself, wants to have some of those Japanese prints here."

The Dutch artist always encouraged his colleagues to study the *ukiyo-e* images at Bing's shop. This way Van Gogh could "keep in favor . . . with old Bing so that his artist friends would continue to have access to the *ukiyo-e* prints in Bing's storeroom" where "millions of prints [are] piled up there. . . . It gave me a chance to look at a lot of Japanese stuff long and composedly." Van Gogh also profited from the many hours Bing willingly spent educating him to really look at Japanese prints. In any case, Van Gogh continued to bring friends, such as the painters Louis Anquetin and Emile Bernard, to look at Bing's cache of *ukiyo-e* prints. Bing encouraged their inter-

17. Entrance card to the Philippe Burty Japanese Collection Sale, organized by S. Bing in 1891.

est and thereby introduced younger avant-garde painters to the doctrine of a decorative style in painting.

To spread a desire for Japanese objects over the rest of Europe, Bing exhibited his works outside France. He opened a kiosk at the Nordiske Industri Landbrugs of Kunstudstilling in Copenhagen in 1888 where he displayed Japanese ceramics, metalwork, and lacquerware (figs. 9–13).[52] Since he showed these pieces with works by the French designers and ceramists Albert Dammouse, Ernest Chaplet, Charles Haviland, Emile Gallé, and Eugène Rousseau, the strong Japanese influence on the French decorative arts movement could hardly go unnoticed. Bing also hoped that Danish industrial designers would follow the lead of these French artists and use Japanese motifs and glazes in their own ceramics or glassware. Bing and Gröndahl of Copenhagen, whose founder was perhaps another offshoot of the Bing family in Hamburg, were already showing the effects of *japonisme* in their decoration of ceramic services.[53] To demonstrate how this happened Bing showed pieces from the Royal Copenhagen Manufactory (figs. 14, 15) that were later purchased by the Musée des Arts Décoratifs. In Brussels Bing exhibited a collection of prints by Utamaro, Hokusai, Sharaku, and Kiyonaga, which, when reviewed by the press, generated considerable interest among Belgian artists and the general public alike.[54]

In Paris Bing went so far as to make Japanese objects available to technical schools. He provided the Conservatoire des Arts et Métiers with a study collection of ceramics and glassware so young French designers could become familiar with Japanese styles and techniques through specific examples.[55] His philanthropy extended to the Musée des Arts Décoratifs, to which he both sold and donated objects to help them build a comprehensive Oriental collection accessible to French artisans.

By 1890 Bing decided that the time had come for a comprehensive *ukiyo-e* print exhibition that would firmly anchor the genre as a legitimate artistic tradition (colorpl. 4). Japanese artists such as Hokusai and Hiroshige were already popular in France—both Burty and Duret, among others, had written about and collected their works—but other printmakers were still scarcely known. To bolster this facet of the exhibition, prints were borrowed from a few public collections as well as from the private holdings of such prominent *japonistes* as Henri Vever, Edmond de Goncourt, Philippe Burty, Louis Gonse, Roger Marx, and Louis Metman, the director of the Musée des Arts Décoratifs. Bing wrote the catalogue's introduction and contributed most of the objects.[56]

The retrospective exhibition Bing organized at the Ecole Nationale des Beaux-Arts resulted in a lavish display of 725 woodblock prints and 421 illustrated books. Drawn from all periods of the development of *ukiyo-e* art, the sheer number of prints

plate 5. Fukusa, 19th century. Musée des Arts Décoratifs, Paris (H. 30 x W. 27½").

The museum purchased this from Bing in 1899.

exhibited was overwhelming. Bing and his colleagues offered the richest survey of Japanese prints France had ever seen, with masters such as Kiyonobu, Kiyonaga, Toyonobu, Harunobu, Toyokuni, Shunshō, Sharaku, Utamaro, and Hiroshige well represented. In his aim to illustrate the sweep of the *ukiyo-e* tradition, Bing proved that other artists, besides the renowned Hokusai, still needed to be studied, although this master artist remained Bing's favorite Japanese printmaker.

Shortly after this magnificent print exhibition closed, Bing was nominated for the Légion d'Honneur by his friend and colleague on *Le Japon Artistique*, Charles Gillot.[57] An honor rarely bestowed on a naturalized citizen, Bing's receipt of the award indicated that he was recognized as a major tastemaker in France whose exhibitions and publications had greatly furthered the arts of the Far East. At about the same time, an anonymous artist in Rouen humorously depicted Bing dressed in a

plate 6. Section of embroidered silk, 18th century. Musée des Arts Décoratifs, Paris (H. 37¾ x W. 37¾").

This fine silk was obtained at the 1906 sale after Bing's death.

Japanese kimono (fig. 16). This suggests that even outside Paris, when a French thought of things Japanese, Bing came to mind.

Bing's talents in the Japanese art market were again tested when Philippe Burty died in 1890. An art critic in the early 1860s, Burty emerged as the original *japoniste*—he even invented the term—and became the group's most articulate spokesman. His articles on Japanese art, especially those that appeared in the widely circulated *République Française*, were read extensively. Yet he exerted his greatest influence over other connoisseurs, artists, and friends as a collector.

After Burty's death, his wife Euphrosine and his daughter Madeleine Haviland, the wife of the head of the Haviland porcelain and ceramic manufactury in Limoges, asked Bing to sell their extensive collection of Japanese objects and French Impressionist paintings. A close friend and a dealer with authority on Japanese art, Bing was the obvious choice for the job, and he set out to see how high a price

Japanese objects would fetch on the open market (fig. 17). Bing contacted potential buyers, sent them the illustrated sales catalogue, and flattered them by saying he wanted only the best pieces to go to those who would truly appreciate them. In sum, he paved the way for a prime market. The Burty family was not to be disappointed by sale results.

When the Leiden Museum expressed interest in buying objects at the Burty sale, Bing required, as their agent, the unconditional freedom to buy as he liked because he anticipated bids would be high. In fact, a number of pieces from the sale were delivered to Leiden in April 1891, and the museum continued to be one of Bing's regular customers.[58] Bing also saw to it that the Musée des Arts Décoratifs obtained some important objects—sword guards, bronzes, and ceramics—at the auction. Although Burty's collection had been uneven, bidding was active, and the total income generated by the sale demonstrated that collecting Japanese art was no longer limited to a handful of admirers. It had become big business.

In that same year the well-known art dealer Georges Durand-Ruel opened an exhibition of prints by Utamaro and Hiroshige (most came from Bing's stock), which gave Japanese art that prestigious firm's seal of approval. By the end of 1890, even the Louvre acknowledged the legitimacy of Japanese prints, accepting from Bing a hanging scroll (*kakemono*) from the Kano school, a watercolor by Hiroshige, and a fan decorated by Hokusai.[59]

Bing accelerated the number of his Japanese art exhibitions in the 1890s, both organizing shows for his firm and encouraging other collectors to hold exhibitions with the promise of generous loans from his company stock or from his own private collection (figs. 18, 19). He also originated the practice of opening an exhibition at the firm's galleries and then sending it on the road. This innovation of traveling exhibitions of Japanese art as well as touring works by the European decorative designers he sponsored became a staple of Bing's business. All the objects on view were for sale, and collectors, art dealers, and museums could purchase them when the exhibition came to their city, which saved them the trouble of having to go to Paris. In 1893, for example, the Hague Kunstring asked Bing to organize a show of Japanese art for their city, and on August 5 *ukiyo-e* prints, textiles, and other objects arrived from Bing's Parisian stores. After a number of pieces were sold to private collectors, the exhibition traveled to Amsterdam, Rotterdam, and possibly Arnheim. Not incidentally, ceramics produced by local Dutch craftsmen soon displayed the influence Japanese motifs and glazes had had on their work.[60]

The following February Bing journeyed to New York to auction off some of his Chinese and Japanese objects at the American Art Galleries. Traveling as a first-class passenger, Bing listed his occupation as art critic rather than the expected art dealer, although both occupations were in full play during his stay in America.[61]

18. Japanese flower stand, bronze, 18th century. Nordenfjeldske Kunstindustrimuseum, Trondheim (H. 6 x D. 8¾").

Purchased for 750 francs, Bing sold this bronze piece to the museum in 1896.

Despite the fact that Bing had already sponsored at least two auctions in New York—the first at Moore's Art Galleries in 1887,[62] and the second at Bing's offices on Fifth Avenue in 1888[63]—this 1894 exhibition at the American Art Galleries was by far the largest. Under the management of the American Art Association, it lasted for eight days and comprised 1,853 objects. The sale may indeed have been a way for Bing to eliminate a large backlog of stock, for the previous year he had sold S. Bing et Cie., remaining in the firm only as a limited partner.[64]

In addition to this auction, and as part of his entrepreneurial ability to diversify activities, Bing held an exhibition of Japanese prints at the American Art Galleries in March. The catalogue for this exhibition lists 290 individual prints and illustrated books by printmakers from the end of the seventeenth century to the present. Like previous exhibitions, these items were all for sale.[65]

While in New York, Bing was cordially received at the Metropolitan Museum of Art by Samuel P. Avery. (The museum had already made Bing a Life Fellow for his donations to their Oriental Collection; the first of them, a Chinese porcelain, was given in 1882.[66]) Museum officials had earlier corresponded with Bing about his organizing a Japanese art exhibition at the Metropolitan after the Paris Exposition Universelle of 1889, to which Bing replied, "If your Metropolitan Museum of Art could dispose of a room, I would make, with pleasure, a temporary exhibition of the best specimens of this special art, in order to give a complete description from the beginning up to the present time."[67] Since few extensive exhibitions of Japanese art had yet been held in the United States, the museum was agreeable, but space apparently was not available. In 1894, Bing suggested they exhibit his Japanese textiles then on display at the Pennsylvania Academy of Fine Arts in Philadelphia.[68] When the Metropolitan expressed interest in this, the textiles were shipped to New York after the Philadelphia show closed, but the exhibition evidently never took place. The textiles remained in storage for several years until the museum's trustees sought a purchaser for them. With Avery acting as middleman, H. O. Havemeyer, an established collector of Oriental art and one of Bing's customers, bought Bing's textiles for somewhat less than the asking price and then donated the entire collection to the Metropolitan (figs. 20–24).[69]

In April Bing traveled to Boston, where Ernest Fenollosa, his friend and fellow associate of the Ryuchikai and now curator of Oriental art at the Museum of Fine Arts, was arranging a show of Bing's *ukiyo-e* prints.[70] Fenollosa had turned Boston into a major center for Oriental studies. Through numerous publications, public lectures, and exhibitions, he had instilled a lively interest in Oriental art in the museum's benefactors and visitors. His diverse exhibitions included a show dedicated to Hokusai and his school, early nineteenth-century *kakemonos*, sixteenth-century screens, and finally several hundred *ukiyo-e* prints from Bing's stock.

19. Fukusa, 18th century. Musée des Arts Décoratifs, Paris (H. 21 x W. 23¼").

This was also acquired from the Bing sale in 1906.

20. Silk fragment. The Metropolitan Museum of Art, New York, Gift of Mr. and Mrs. H. O. Havemeyer, 1896.

When Bing returned to France later in 1894 he set to work on yet another major show of Japanese objects, this one intended for Dresden. He also finished another article on "The Art of Utamaro" for *The Studio*,[71] a London journal, in which he drew parallels between Utamaro's devotion to the study of elegant women, Western printmakers, and the ancient Greeks. Bing's comparison of the ancients and the Japanese was not original; earlier French *japonistes* had already called attention to the similar harmonies of their compositional designs. Bing's real purpose in writing the article was to attack the views of Edmond de Goncourt, a rival collector of Japanese objects, a firm believer that he had begun the *japonisme* craze in the 1860s, and an anti-Semite with whom Bing had been feuding for years. Goncourt also claimed that he had been the first to appreciate Japanese art, a boast that irritated Bing.

In terms of art criticism, Bing took exception to Goncourt's emphasis on the erotic aspects of Utamaro's art. Rather than blatantly attack his foe's opinions, Bing simply explained Utamaro's prints differently. "And just as Utamaro did not, and never sought to, paint the work-girl in her character of child of the people," he wrote, "so he was never tempted to represent—I am sorry to be at variance on this point with an illustrious writer whom I revere, Edmond de Goncourt—and never did represent, the beautiful frail ones of his country in such a way as to exhibit their

21. *Silk fragment.* The Metropolitan Museum of Art, New York, Gift of Mr. and Mrs. H. O. Havemeyer, 1896.

22. *Silk fragment.* The Metropolitan Museum of Art, New York, Gift of Mr. and Mrs. H. O. Havemeyer, 1896.

23. *Silk fragment.* The Metropolitan Museum of Art, New York, Gift of Mr. and Mrs. H. O. Havemeyer, 1896.

24. *Silk fragment.* The Metropolitan Museum of Art, New York, Gift of Mr. and Mrs. H. O. Havemeyer, 1896.

21.

22.

23.

24.

immodest character." The Japanese artist, he said, created a designed image that had as its "sole aim to combine grace of outline and harmony of brilliant colors."

When Goncourt began to publish a series of articles on Hokusai in the widely read daily *L'Echo de Paris*, Bing launched a direct attack in a note appended to his own "La Vie et l'oeuvre de Hok'sai" in *La Revue Blanche*.[72] The roots of the Bing-Goncourt controversy stem from Bing's Japanese research assistant, Jijima Hanjuro, who was supposed to document details of Hokusai's life for a book Bing was planning to write. Unknown to Bing, Hanjuro published his own book on Hokusai in Japan. When the book found its way back to Europe, the art dealer Tadamasa Hayashi translated it into French, and Goncourt used it in his articles on Hokusai. Bing, feeling upstaged and doublecrossed, more or less accused Goncourt of plagiarism.

In an interview published in *Gil Blas*, Goncourt admitted he had obtained information from Hayashi's translation but said he had been ignorant of the connection between Bing and Jijima Hanjuro.[73] Nevertheless, the series made Goncourt a major Western expert on Hokusai's work. Bing's biography of the artist was less widely read, for the *Revue Blanche* was a comparatively obscure publication. The Hokusai feud had just broken when Bing opened his newly renovated galleries as a showroom where painters and designers could exhibit the latest in "art nouveau." Some critics saw Bing's attack as a simple bid for publicity for his new enterprise. Many sided with Goncourt, primarily because he, more than Bing, was recognized as both a promoter of Japanese art and a major collector, and they felt Bing had shown serious disrespect.

Goncourt died shortly after the argument started, but the scandal cost Bing dearly in his hopes for an "art nouveau." His expertise in Oriental art and his stature as a dealer were well established, but his enterprises devoted to creating a new style of total design in art were blocked. From the outbreak of the Goncourt scandal, his "art nouveau" was either attacked or ignored in the Parisian daily press. Only specialized art journals outside France greeted *art nouveau* with undiminished approval. Although Bing tried to make amends by lending his expertise to the sale of Goncourt's Oriental art collection in 1897, the memory of the episode lingered.[74]

Toward the end of the century, more museums began to collect Japanese art to illustrate a cross-fertilization between East and West in contemporary Western art, and Bing did what he could to encourage the connection (figs. 18–24; colorpls. 5, 6). If a museum purchased glassware by Louis Comfort Tiffany, Bing would try to send them an exhibition of Japanese prints or ceramics.[75] Undoubtedly, Bing hoped this would reinforce in the observer's mind the East-West association so dominant in *art nouveau*.

In October 1897 Bing was asked to prepare an exhibition of Japanese objects for the inauguration of the Kaiser Wilhelm Museum in Krefeld, Germany.[76] Three

years later the museum received the pieces Bing had promised, but they were not altogether to the director's liking. "If I recall correctly we did not only talk of ceramics but you also anticipated providing bronzes and other items (e.g., old sword guards) and a collection of fine textiles, and finally also color prints. As matters stand, the exhibit will be pretty one-sided—rather it will not be a Japanese exhibit. And in regard to the ceramics, I do not deny that there are several fine pieces among them of which we will acquire a few for the museum, but I really would have liked to have something 'exceptional' from you. You know that I am spoiled from my Hamburg days." The director ended by saying that if the exhibit was to go on tour around Germany as planned, Bing would have to "supplement substantially" what he had sent.[77]

Bing's excuses were innumerable. The market was drying up. It was difficult to secure first-rate pieces for sale. The best objects had all been absorbed into private collections. Competition with other dealers was keen, especially with Hayashi, who knew where to find pieces as well as Bing did. Bing himself was no longer willing to send his best works on tour; the damage rate was high and return on the investment often quite low. The harassed dealer finally relented and filled the Krefeld exhibition with pieces from his private collection.

In the last few years of his life Bing increasingly occupied the role of elder statesman, serving on official commissions to strengthen ties with the Far East, acting as

an expert for major Oriental art sales when collectors died or sold off their holdings, and appearing as guest speaker at banquets or meetings. A founding member of the Franco-Japanese Society organized in January 1900, Bing regularly attended meetings with fellow members Louis Gonse, Justus Brinckmann (who came from Hamburg to attend), Henri Rouart, a major collector of Japanese art and Impressionist paintings, the jeweler Henri Vever, Mme. Langweil, a fellow dealer in the Oriental art market, Gaston Migeon, a knowledgeable Oriental curator at the Louvre, and others. He lectured to the group only once, on "Hokusai and His Art" in 1901.[78]

Bing's dedication to the promotion of Japanese art extended to the Exposition Internationale Universelle held in Paris in 1900. The elaborate Japanese pavilion, shaped like a Buddhist temple, displayed both modern works and a range of earlier Japanese art drawn from the imperial treasure as well as from private and temple museum collections that had never before left the country.[79] Hayashi, now a commissioner-general in Japan and the pavilion's chief organizer, asked Bing and other jury members Lasenby Liberty, founder of Liberty of London, Noritatsu Kaware, a ceramicist from Japan, and C. W. Farquhar, director of Doulton and Company in England, to choose objects for the pavilion's section on Japanese ceramics.[80] Bing selected the pottery of Miyagawa Kozan, who received a grand prize for his porcelains.[81]

The elderly connoisseur maintained close ties with the Japanese government, as seen with the Nihon-Gwakei exhibition, sponsored by the Japanese Ministry of the Interior and held in Bing's galleries in the spring of 1901.[82] Although it was meant to reveal the continuity of tradition in modern Japanese painting, the exhibition became an adventurous display of contemporary Japanese art that showed a distinct Western influence on space and composition. Landscapes, animal studies, and sketches of flowers and fruit all forcefully suggested a growing fusion of Oriental and Western concepts. In the words of the critic for *The Studio*, the show demonstrated "a stage between that which is no more and that which is to come."[83] Bing made many other contributions to Oriental exhibitions, including a variety of color prints that were featured in a show on Japanese printmakers similar to the one he had organized twelve years earlier at the Ecole Nationale des Beaux-Arts. (He also wrote an essay, entitled "Le Bois Japonais," for the exhibition catalogue.[84]) He later arranged an exhibition that he called "Three Japanese Masters (Hiroshige, Hokusai, Kuniyoshi)" (fig. 25). His efforts involved providing expertise and promoting the sales of the most prominent collections of the time, such as the Hayashi sales of 1902[85] and the sale of Charles Gillot's collection, Bing's former colleague on *Le Japon Artistique* in the late 1880s.[86]

By 1904, Bing was beginning to realize he could no longer maintain the furious pace of his earlier years. The Gillot sale represented his last major business enter-

28. Japanese objects owned by Louis Bonnier and secured from S. Bing. Private collection, Paris.

prise in Japanese art. Bing also closed his shop on the rue de Provence and transferred his Oriental business to the one on the rue St. Georges, run by his able assistant Marie Nordlinger. Originally a craftsman in Bing's *art nouveau* workshops, Miss Nordlinger often acted as Bing's sales agent. Bing regarded her as a clever and capable protégé, especially since she could work closely with one of Bing's largest clients, Charles L. Freer, an American then building an extensive Oriental art collection.

Bing probably met Freer on his 1894 trip to the United States, although their first recorded contact is dated two years later when Freer asked Bing and Fenollosa for their opinions on three *kakemonos* he was considering buying. In 1897 Freer also bid on objects in the Goncourt sale through Enrique Baer, Bing's nephew and agent in the United States. With Bing's help Freer selected his first piece of Korean pottery and a bowl by Shonsui. This relationship grew as Freer continued to select objects from Bing during the latter years of the dealer's life. While a number of the pieces Freer purchased can be traced to Bing, several have since been judged of low quality.[87] Perhaps Bing experienced a lapse in judgment in first acquiring them. Maybe he was not above selling forgeries or inferior pieces, at least to his American clients. Since Bing also sold Freer an exquisite screen with six folds from Hayashi's collection—Bing "declared [it] was the finest of that school on display in Europe"—discrepancies remain about Bing's later motives in selling Oriental objects.[88]

Dealings with Freer grew complex just when Bing was scaling down his business in Paris. In 1905 Bing sent Marie Nordlinger to the United States to negotiate the sale of his outstanding *ukiyo-e* collection. She visited Freer in Detroit and met with

29. *Stone jar, Satsuma.* Nordenfjeldske
Kunstindustrimuseum, Trondheim
(H. 7 x D. 5½").

The Norwegian museum purchased this from
Bing in Paris.

another collector, Charles Morse, in Evanston, Illinois. Believing Bing would never part with his private holdings, Freer was amazed by this turn of events and suspected that the Parisian dealer was in financial trouble. This may indeed have been the case, or Bing may simply have decided that the time was right to sell. Available *ukiyo-e* prints of excellent quality were becoming increasingly scarce, and Bing's collection, gathered over many years, could have commanded a large sum if sold together. Freer purchased only a few pieces of Rakka pottery, but he bought neither the *ukiyo-e* prints nor the Egyptian antiquities Nordlinger also brought with her.

Marie Nordlinger was still in America helping Freer catalogue his Far and Middle Eastern collection for the opening of his gallery in Washington, D.C. when Bing retired. By the time she returned to Paris with Freer in 1905, Bing's son Marcel was running the Oriental art business, for Bing was clearly ailing. After a brief hospital stay, Bing tried to continue his work in a villa at Vaucresson, outside Paris, working on articles for the *Revue Universelle* for two months and visiting with old friends.[89] Siegfried Bing died in September 1905 at the age of sixty-seven.

Bing's death was widely reported, and a long obituary appeared in the American journal *Brush and Pencil*. It noted:

> The news of the death of Siegfried Bing ... will come as a personal loss to scores of collectors in Europe and this country who owed many of their treasures of Japanese art, and no little of their love of Oriental art, to this indefatigable dealer, who did so much to make known the transcendent qualities of the best porcelains, bronzes, lacquers, and prints of the Far East. ... He was a typical dealer of the old school, the friend and guide of his customers, but while keen enough at a bargain, his chief ambition was to make Oriental art felt as an influence for good upon designers."[90]

The following May Bing's impressive private collection was sold in Paris. The sale of his ceramics, silks, paintings, and prints attracted a staggering number of anxious buyers from all over Europe.[91] A later sale at the Durand-Ruel galleries netted an amazing 356,872 francs, of which 268,574 was turned over to Bing's only surviving heir, his son Marcel.[92]

Siegfried Bing's passing from the Oriental art scene did not signify the end of the Bing family interest in Far Eastern art. Marcel, born on November 13, 1875, and Bing's fourth child, was the logical successor to direct the family empire. A trained jeweler, he shared his father's fervent desire to see European decorative arts attain the same level of fine aesthetic taste and high quality found in Oriental objects. Like his father, he became a capable promoter of Japanese art. He ran the enormous sale of his father's collection with verve, contacting the right clients, including Charles Freer,[93] and setting high prices on the best bronzes, *netsuke*, fabrics, and lacquers. Some of Bing's finest pieces remained with Marcel until his death in 1921.[94]

30. Sword guard (Tsuba). Nordenfjeldske Kunstindustrimuseum, Trondheim (D. 2½").

Japanese works such as this were featured in the 1906 Bing sale.

Continuing the family trade in Japanese art, Marcel maintained his own shop in an elegant townhouse at 10 rue St. Georges. He organized small exhibitions for which the Bing firm was known, published brochures, and dealt in Far Eastern objects of considerable beauty and rarity. A recognized authority on Oriental art, museums were delighted when he donated a work from his collection in memory of his father.[95] He remained an influential dealer, although he did come to favor Chinese art over Japanese. During World War I, at age thirty-nine, Marcel joined the army, but even then he carried on some business from the front lines. In a January 6, 1916, letter to Freer about a possible sale of bronzes, he wrote:

> I am a little late in sending you my best wishes for the New Year, but, as you may believe, we are from time to time pretty busy up here and I really have had no earlier opportunity of doing so: I have had to wait until we were sent back to our restbillets....I have been unable to communicate personally with you about the bronzes and have had to leave it entirely to Mr. Loo (another art dealer). I trust that since the pieces are in your hands, you will enjoy them more and more. Let us hope that the day will come soon when circumstances will allow me to see the old friends of mine in your collection! If I would be in Paris and leading my ordinary life, I believe I would miss them very much.

After the war Marcel agreed to travel to China on an official mission for the French government (fig. 26). Soon after his return, however, he died. (Some of his relatives claimed, without evidence, that he had been poisoned in China.) Bing family interests in Oriental art passed to another dealer, René Haase, who kept the business alive, at a much reduced level, into the early 1940s and the German occupation of Paris. The direct line with the Bings ceased with a final sale of Haase's Oriental art collection in Paris in 1943.[96]

This sad and ignominious end does not diminish the importance of what Siegfried Bing and, to a lesser extent, his son Marcel accomplished. With energy and ambition Bing helped to forge an active international market for all aspects and types of Oriental art objects. In turn, he promoted and sold these pieces to an ever growing audience composed of both museums and connoisseurs, such as Louis Bonnier, the architect who worked for Bing (figs. 27, 28). Numerous Western collections were built upon pieces that Bing originally sold at the height of the *japonisme* craze (figs. 29, 30). Yet aside from his real interest in collecting and endorsing Japanese art, Bing had an ulterior motive. He wanted Japanese art, especially the decorative arts, to influence Western craftsmen to produce new objects for home decoration. Bing combined his vast fortune amassed by dealing in Oriental art with his entrepreneurial acumen and numerous business and art contacts to experiment with a new style of decorative arts that he helped to name: *l'art nouveau*.

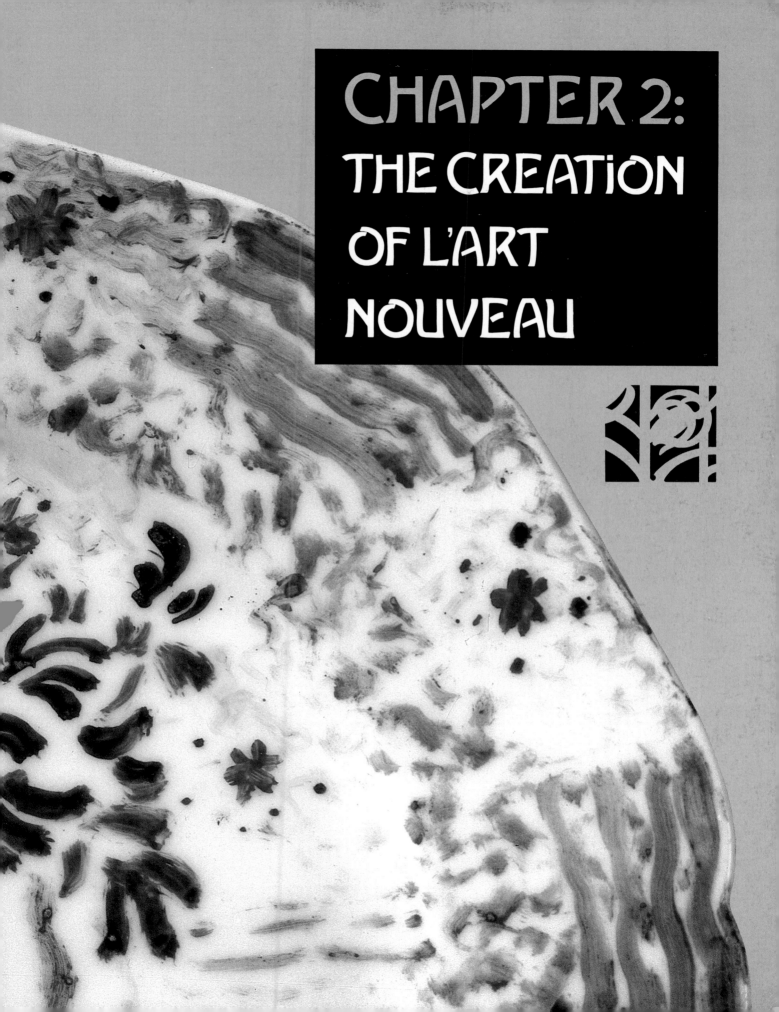

CHAPTER 2: THE CREATION OF L'ART NOUVEAU

31. Louis Comfort Tiffany, *The Garden (Le Jardin)*, stained glass window, 1895. Private collection.

plate 7. Ker Xavier Roussel, *The Garden (Le Jardin)*, cartoon, 1894. Museum of Art, Carnegie Institute, Pittsburgh (H. 47⅝ x W. 36").

By the early 1890s, the idea that homely objects could be beautifully crafted and innovatively designed had already taken a firm hold in Belgium and England. Even in the United States, where tradition had a less tenacious hold, reform movements were afoot. Yet prejudice against the decorative arts as an inferior or "minor" form of artistic endeavor still raged in France. Craftsmen trained in state schools perpetuated official styles, which led to a stultifying historicism in design. Three Paris Expositions—those of 1867, 1878, and 1889—had been planned as showcases for French advancements in industrial design. Instead, when compared with products from other countries, it became increasingly clear that in taste and style French designs no longer measured up. France had to develop a more international outlook if it was going to retain its artistic leadership.

Siegfried Bing was among those determined to see France emerge as a leading nation in the decorative arts. His devotion to and vast experience with Japanese art convinced him that the decorative arts were in no way inferior to the fine arts, and they indeed could be the most appropriate vehicle for unifying all the Western arts

into a cohesive aesthetic force. The revitalizing energy, resources, and industrial vigor the nation needed, however, would have to come from an independent entrepreneur. Bing apparently considered himself the likely person for the task, and he was soon called upon to make that precise effort.

In 1889 Henri Roujon was appointed Directeur des Beaux-Arts, the cultural overseer of French visual arts. Like Bing, Roujon believed that distinctions between the fine and the decorative arts, or minor arts, must first be eliminated. Once the world regarded a ceramics or glass artisan equal to a painter, quality of design would automatically improve. If art and history had learned this lesson earlier in the century, Roujon claimed, French industrial art never would have declined to its present inferior status. With the Directeur des Beaux-Arts now squarely behind the design reform movement, French firms grew eager to lay their hands on designs that would compete in the international market.

The status of the decorative arts re-emerged as a hotly debated issue when France decided to participate in the 1893 World Columbian Exposition in Chicago. Tradi-

32. Louis Comfort Tiffany, *Maternity (Maternité)*, stained glass window after a cartoon by Pierre Bonnard, 1895. Private collection.

tionalists argued that the decorative arts, tainted by commercial considerations that dictated form and production and detracted from aesthetic value, were not "serious" and therefore should not be shown. Design reformers on the committee and organizers preparing the decorative arts section pointed out that in its yearly Paris Salons the Société Nationale des Beaux-Arts had given these minor arts equal ranking with paintings and sculpture, and French decorative design should be similarly exhibited in Chicago. Although conceding that the decorative arts involved investment by manufactories, they maintained that craftsmen still designed works of art of primary importance.[1] While the debate was not clearly resolved by the Columbian Exposition, the decorative arts did receive avid attention at the new Paris Salons throughout the 1890s, indicating the reformers had won.

As with previous international shows, however, the Chicago exposition demonstrated once again that France lagged behind other countries in original industrial design. Innovations in England, particularly the dominant role of the South Kensington Museum, the predecessor of the Victoria and Albert Museum, in promoting the training of craftsmen had raised English standards of design and production far above those of the French. In response, the Union Centrale des Arts Décoratifs, originally organized to give voice to the industrial arts reform movement, held an important conference in May 1894 on the state of French decorative arts. It concluded that without the support of major private industrialists, decorative design and its manufactories would face sure economic disaster. The Union Centrale advocated sending superior examples of decorative design to provincial museums, where they would raise the national level of artistic taste and thus create a market demand for the decorative arts. The first such exhibition, featuring the work of women designers, was planned for the following spring.

Raising the standards of taste of a wider public was discussed at the conference's second session. The Union Centrale decided to found a permanent decorative arts museum with exhibition galleries for burgeoning permanent collections and an associated design school. Like other European countries, France needed a state-supported institution before it could effectively encourage talent and new ideas in the applied arts.

With this design reform effort, Henri Roujon asked Bing to describe his impressions of American industrial arts from his 1894 trip to the United States. In the result, a short book entitled *La Culture artistique en Amérique (Artistic America)*, Bing praised American painting, sculpture, architecture, and the industrial arts, partly to counteract the contempt most Frenchmen held for American creativity.[2] He persuasively argued that the United States had become a progressive nation because its arts were unshackled by imitation and tradition. Bing applauded its museums, and he was particularly impressed by its architects, especially H. H. Richardson (1838–

86), who had created a new formal language. The master silversmith Edward C. Moore (1827–91) and the glassmaker Louis Comfort Tiffany (1848–1933) ranked as his models in the decorative arts. (Both first attracted Bing's attention through their collections of Oriental art, and both became clients of Bing's gallery.[3])

While in New York, dealer/entrepreneur Bing had been naturally fascinated by Tiffany's works of art as well as by the scale and complexity of his production. In *Artistic America*, Bing described Tiffany's studios as "a vast central workshop that would consolidate under one roof an army of craftsmen representing every relevant technique: glassmakers, embroiderers and weavers, casemakers and carvers, gilders, jewelers, cabinet makers—all working to give shape to the carefully planned concepts of a group of directing artists, themselves united by a common current of ideas."[4] Bing decided to use Tiffany as an example to the French of the advanced techniques they could learn from American ingenuity. By concentrating on Tiffany, Bing could simultaneously meet European architects' growing demand for decorative stained glass then being incorporated into entryways and stairwells. He may also have turned to this designer rather than to other Americans involved in stained glass, such as John La Farge, because of the size of his workshop and his willingness to experiment.[5] Before leaving for Europe, Bing discussed with Tiffany the prospects for producing stained glass windows to be designed by young French artists.

Once in France, Bing immediately looked for avant-garde artists of a suitably innovative spirit. He chose the Nabis, young, rebellious painters who demonstrated both a willingness to go against established convention and an interest in working in more than one medium. The Nabis' simple designs, so often suggestive of the flat color zones of Japanese prints, their two-dimensional shapes, and their brilliant colors were all well suited to stained glass, and Bing realized that their work could develop into an altogether new style. In late May 1894 Edouard Vuillard, a member of the Nabis, reported to fellow artist Maurice Denis on a meeting Henri Ibels, the group's leading printmaker, had just attended with Bing about the windows:

> Here is a proposition which comes from Ibels. He has made the acquaintance of Bing, the merchant of curios who would like to present, in France, with the help of artist/decorators, a special type of colored glass where one can achieve all kinds of color, including gradations in the same color while the glass remains transparent. He has, at his home, samples of this type of glass and samples by artists of the country (who are Americans). Ibels has told him about all of us and Bing is waiting to show us samples. He would take it upon himself to have our sketches executed because the fabrication itself is a secret which they will not divulge. Would you like to come to see it? It might interest you. All of us have made an appointment at about 3 PM in my studio. Come, since it should interest you and Bonnard most of all.[6]

By October the meetings were completed and the project underway. Bing al-

34. Exterior view of Bing's "l'Art Nouveau," showing both 22 Rue de Provence and 19 Rue Chauchat, December, 1895. Institut Français d'Architecture, fonds Louis Bonnier.

50 · *The Creation of L'Art Nouveau*

ready had a number of cartoons in hand, but he was forced to cajole Denis, a habitual procrastinator, to turn his in, noting:

> I am going to send to America in the next few days the greatest part of the cartoons for the stained glass windows, and I would be delighted if yours, to which I attribute the greatest importance, could be part of the shipment. You would assist me by sending a note with the date when you could be ready.[7]

Numerous cartoons were then sent to Tiffany for him to select the designs (colorpls. 7–9). Bing may have had his favorites, but he left the final choice to the American designer, who would know which would best translate into glass. By March 1895 stained glass windows based on drawings by eleven artists were in production: *La Cascade* by Albert Besnard, *Moisson fleurie* by Paul Ranson, *Le Jardin* by

35. Entrance to "l'Art Nouveau" at 22 Rue de Provence, December, 1895. Institut Français d'Architecture, fonds Louis Bonnier.

K. X. Roussel, Pierre Bonnard's *Maternité, Iris et roseaux* by P. A. Isaac, H. G. Ibels' *Eté, Marronniers* after a design by Edouard Vuillard, *Paysage* by Maurice Denis, *Papa Chrysanthème* by Henri de Toulouse-Lautrec, Félix Vallotton's *Parisiennes*, and three small windows designed by Paul Sérusier. Except for Besnard and Isaac, all the artists were members of the Nabis. (Besnard was an artist whose work Bing collected, and Isaac, a fabric designer.)

The finished windows arrived in Paris in mid-April in time for the Salon of the Société Nationale des Beaux-Arts on the Champs de Mars (figs. 31, 32).[8] Extremely pleased with the results, Bing looked forward to an enthusiastic reception by critics and public alike. When the show opened, however, reviews were mixed. Some applauded the originality of the effort and the "richness of precious hardstones, jades, and marble."[9] Most found the style too "primitive" and the designs bizarre.

36. Plan of 22 Rue de Provence and 19 Rue Chauchat, central floor, July 3, 1895. Archives de Paris.

Others commented on the artlessness of the compositions and complained that the works' iconography was not based on traditional themes. Clearly the new style challenged established taste.

Yet this window project was only part of Bing's plans for launching a "new art" in France. Since his return from New York, he had been thinking of renovating his gallery (fig. 33) and commissioning works for a planned inaugural exhibition that would unite all the arts under one roof. Bing envisioned a series of rooms that would present a harmonious combination of decorative details, art objects, and paintings all created in the new style. Artists would design complete interiors: furniture, wallpaper, murals, friezes, dishes and ceramics, textiles and fabrics. The stained glass windows would be part of the installation. The Nabis again played a prominent role among the artists Bing selected. He had found them dependable, and they clearly understood the need to keep designs simple. In a letter to Maurice Denis, Bing set forth his concepts of interior decoration for the specific rooms he commissioned. This way, Denis could provide Bing with a totally unified plan for a bedroom, demonstrating how one designer could control not only a room's paintings but also its color, feeling, and all of its decorative details.

> It stands to reason that as soon as you have undertaken the decoration of the walls or a fraction of the walls of a room, everything that goes with it—painting or not—should be conceived, if not executed, by you. I could

never have thought differently. But wouldn't it be high time—from now
on—to start thinking about the decoration which will not be your work? It
is imperative that the execution of these parts progress in concert with
your painting.

Hence, I am asking you, if you can, as of now, to submit to me:

1. the disposition of your panels or sections of a frieze
2. the range of colors
3. your ideas about the rest of the decoration as much as on the relation-
ship between the colors and the materials to be employed and their
disposition.

 You will tell me at the same time if the execution of the entire decora-
tion outside of your fabrics, etc. and paintings must be undertaken by me
following the ideas you will give me or if, in fact, you want to intervene in
this part of the work.[10]

38. *Cross-section of 22 Rue de Provence*, July 3, 1895. Archives de Paris.

39. *Plan of the mezzanine at 22 Rue de Provence*, July 3, 1895. Archives de Paris.

54 · *The Creation of L'Art Nouveau*

40. Plan of the first floor at 22 Rue de Provence, July 3, 1895. Archives de Paris.

Later in the same letter, Bing noted that he had recently traveled to Nancy, where he was attracted to furniture designed by Emile Gallé:

> It is a marquetry work with a flower motif, but much simpler, broader, less mannered and less symbolic than the models to which his exhibitions have accustomed us. Consequently, I have asked him to exhibit this suite of furniture in your room, thinking that it would go well with your type of conception of style and color.
>
> However, I still have an uneasy feeling on that account, and it is that feeling which prompted my last letter. If by chance you were hostile to this scheme it would perhaps still be time to stop it. But I have to tell you that what had prompted my decision was the extreme difficulty in which I found myself due to the complete absence of all acceptable elements among those that had been presented to me and I am afraid that in case the Gallé should not agree with your work, we would be forced to provide another destination than that of a bedroom for your room—something which would no doubt be hardly feasible.
>
> I have forgotten to tell you that the freedom of style which is noticeable in the decoration of the Gallé furniture, of which I am talking to you about, extends also to the contour of the furniture which has much suppleness and simplicity contrary to the Gallé tradition.

Bing then continued to define what he looked for in interior decoration:

> In order that you fully understand my embarrassment relative to the selection of furniture, I must also add that pieces that would show a certain roughness in the style of Bonnard—while eminently artistic as they might

be—would, all things considered, be out of their element in the milieu
which is in formation at the time at *L'Art Nouveau*.

No matter how large my premises seem to be, they are small in propor-
tion to our program and will allow the presentation of one apartment. But
the salons, dining room, etc. imperceptibly assume a certain character of
elegance, for perfect homogeneity should exist in each room. . . . The en-
semble will also have to form a harmonious whole.

One source for Bing's idea to turn his exhibition rooms into a *maison d'art nouveau*
was the Maison d'art in Brussels.[11] Founded by Edmond Picard in 1894, it gave
Belgian artists exhibition space, provided free publicity, pamphlets, and catalogues,
and in general supported struggling young artists. Other inspiration came from the
twenty-eight-year-old German art critic Julius Meier-Graefe. An apparent victim of

43. Japanese stencil from the Louis Bonnier Collection. Private collection.

the current anti-Semitic wave in Western Europe, Meier-Graefe, who had just been dismissed from the German magazine *Pan*, moved to Paris in the spring of 1895.[12] His keen interest in the new style in Germany led him to open a shop in Paris named *La Maison Moderne*.[13] It seems unlikely, as Belgian artist Henry van de Velde later asserted, that it was Meier-Graefe who talked Bing into opening an *art nouveau* gallery because Tiffany had long encouraged Bing to do so. Yet Meier-Graefe did introduce Bing to the new German design concepts called *Jugendstil* and persuaded him to add non-French examples of the new art to his inaugural exhibition.

The building Bing proposed to turn into a center for *art nouveau* included his original townhouse on the rue de Provence, with its circular turret and an interior courtyard that had been glazed over in the 1880s and the smaller building next door

on the rue Chauchat (figs. 34–38). These structures were divided into display rooms and storage spaces, with additional dead storage in the basement. The rooms being designed and decorated by the Nabis and artist Henry van de Velde would have to fit into the existing building structure since eliminating interior walls would have been too costly (figs. 39, 40). Instead, Bing created the impression of newness by adding a glass cupola to the turret, resurfacing the principal facade, and placing ceramic tile around the main entranceway.[14]

For the renovation Bing retained the services of Louis Bonnier (fig. 41), a young architect trained at the Ecole des Beaux-Arts who was experimenting with new building materials, including glass and terra cotta.[15] Bonnier designed the glass cupola and suggested the use of glass to bring additional light into the shop's interior (fig. 42). An avid collector of *ukiyo-e* prints and stencils (figs. 43–45), Bonnier was also one of Bing's clients, no doubt a further reason for choosing him.[16]

To redecorate the building's facade, Bing turned to Frank Brangwyn, an English artist and disciple of William Morris.[17] Brangwyn's drawings for the facade have not fully survived, although an accompanying letter gives an idea of what he had proposed. Bing most of all wanted a pictorial facade, so a notable aspect of the design was its two painted friezes (fig. 34). The rest of the facade would be in tile,[18] but, possibly to save money, Brangwyn suggested that colored plaster could produce the same effect. Other decorative panels were to be placed on the ground floor near the entrance (figs. 46, 47), a mosaic installed over the main doorway, and the upper floors accented by horizontal lines, elaborate moldings around the windows, and tiled pillars.[19] The total effect was more colorful, Brangwyn noted, than it would appear from the drawings.

Apparently unsure of Brangwyn's design, Bing asked Victor Horta, an innovative Belgian architect, to develop an alternative design to what Brangwyn had submitted. In Bing's own critique of Brangwyn's plan, he objected to the complete tiling of the facade and its tremendous expense, proposing instead that the exterior be painted in tones related to the friezes. He also wanted the number of decorative parallel lines reduced to soften the design's overall impact and the doorway widened. (This may have been Bonnier's suggestion since he was then working on translucent glass doors with metal grillwork to provide more natural light [fig. 42].) Bing, thinking he had found a true apostle of modernism in Horta, instructed the architect to "examine the project . . . and to propose any modifications that seemed useful" but keep Brangwyn's friezes and not move any of the existing openings.

Work on the exterior halted in mid-August until Horta submitted his revised drawings a month later (figs. 48, 49). His final revision has disappeared, but six existing preliminary drawings hint at what he proposed. Dramatic linear decorations would have emphasized the building's rectilinear shape, a revolutionary idea

44. Japanese print from the Louis Bonnier Collection. Private collection.

45. Japanese print from the Louis Bonnier Collection. Private collection.

for Paris. A delicate iron framework would have extended over the entire surface of the building like a web or net, but above the first floor it would bend outward from the wall to support an overhanging cornice. Even more tentative designs suggest that Horta played with plant and tendril motifs before opting for the iron colonnettes. In the end, however, Horta's alternative seems to have had negligible effect on Brangwyn's plan (colorpl. 10). The building was reconstructed as Brangwyn originally suggested, but Bing eliminated the extensive ceramic tile for the full facade.

By now only four months were left to complete the showplace by the much delayed opening date of December 26. Bing eventually had to bring Brangwyn to Paris to see that the exterior friezes were properly positioned and colored.[20] Lengths of canvas were stretched along the building's exterior where, without preparatory sketches, Brangwyn developed his scheme of Eastern potters at work and

Orientalized figures talking and playing pipes. When winter weather arrived, Brangwyn turned instead to the allegories of music and dance that were to be placed on panels just inside the entranceway, rendering them in a flat, decorative style only somewhat less stylized than the exterior design (figs. 46, 47).[21]

Although Bing made an effort to consult with other designers, the new galleries were essentially the work of Louis Bonnier, who used glass, metal, and tile to lend an air of modernity to the shop.[22] The main entrance, flanked by plaster sunflowers and large block letters that spelled out *art nouveau*, was set off from the rest of the building by a simple border (fig. 50). Modern streetlights designed by the Englishman W. A. S. Benson stood outside, while placards designed by the Belgian Georges Lemmen announced the permanent exhibition (colorpl. 11). Bonnier also created a second doorway on the rue Chauchat[23] for the Japanese galleries, employing an ornamental design of plants and flowers made from inexpensive metal that could be easily cut and shaped (figs. 51, 52).

The building's decorative effects and modern references, all undeniably unusual for Paris, ranged from a domed skylight to provide interior illumination to horizontal colored bands designed to visually unify the building and make it look longer and broader. String courses broken by metal beams embedded in the cement above the doorway were also radical innovations for their time. Above the exposed beam on the rue Chauchat doorway, a brilliantly lit stained glass window designed by Toulouse-Lautrec guided visitors up the stairs (colorpl. 9). The most Japanese of the Tiffany windows, it appropriately directed the way to the Oriental gallery. Inside, subtle light from the skylight descended to the covered central hallway, giving the impression of unlimited space (fig. 53). Glass walls further diffused the illumination on the various floors. Painted a delicate blue, the interior hall must have been absolutely dazzling when illuminated by both the skylight and the transparent ground-level walls.[24]

Bing retained a traditional eighteenth-century iron grillwork on the walkways of the central hall (fig. 53), but he asked Bonnier to design railings for the turret (fig. 54). The architect created an Oriental effect for the ramp and used stylized plants and flowers for the upper part of the design (fig. 55). He captured one of the leitmotivs of the new style—the cult of nature—in these tendrils and flowers. Beneath the ramp Bing decorated the walls with fabric, while entrances to other rooms were hung with tapestries by P. A. Isaac (fig. 56), a designer whose use of Oriental motifs in tapestries became a hallmark of the new style.[25]

Now a seasoned art dealer and a shrewd businessman, Bing realized that most customers remembered a shop's overall appearance rather than its individual objects. He hit upon the model room as a way to produce such a lasting impression. Permanently installed rooms, located directly off the central hallway and in the

47. Frank Brangwyn, *"Music" panel decoration for the entrance hall at 22 Rue de Provence*, 1895, oil on canvas. William Morris Gallery, London.

48. Victor Horta, *Preliminary sketch for the facade of 22 Rue de Provence*, 1895, drawing on tracing paper. Musée Horta, Brussels.

49. Victor Horta, *Preliminary sketch for the facade of 22 Rue de Provence*, 1895, drawing on tracing paper. Musée Horta, Brussels.

50. Main entranceway and interior glass wall and doorway at 22 Rue de Provence, 1895. Institut Français d'Architecture, fonds Louis Bonnier.

51. *Doorway, 19 Rue Chauchat*, 1895. Institut Français d'Architecture, fonds Louis Bonnier.

52. Louis Bonnier, *Sketch for the doorway at 19 Rue Chauchat*, 1895, watercolor and ink. Institut Français d'Architecture, fonds Louis Bonnier.

plate 11. Georges Lemmen, *Placard for "l'Art Nouveau,"* 1895. Museum für Kunst und Gewerbe, Hamburg (H. 23¼ x W. 30").

53. *Main skylight and upper installation of the First Salon of Art Nouveau*, December, 1895. Institut Français d'Architecture, fonds Louis Bonnier.

circular turret, would reflect Bing's concept of an international but unified interior design for the contemporary, well-appointed home. Traditional distinctions between the arts would be ignored, thus encouraging artists to utilize all media and to think of themselves as creators of living environments. Since the artists Bing commissioned were both well known and young, *art nouveau* came to be regarded as a youth movement, even though it was orchestrated by a middle-aged man.

The original group of model rooms included a bedroom designed by Maurice Denis; a smoking room, dining room, and study by Henry van de Velde; a small waiting room planned by Edouard Vuillard; a salon decorated by Albert Besnard; and a boudoir largely composed of paintings on silk by the English artist Charles Conder. To make visitors aware of the importance interior design had assumed in other countries, Bing's room interiors were intended to provoke a response by creating a deliberate confrontation between styles. When a room became outmoded, Bing either replaced the interior with another he had commissioned or decorated it with pieces he had found in other places. What started as a permanent installation ended as a series of rooms that represented various attempts to solve contemporary design problems, in particular how to create a harmonious interior space from the work of an international range of artists with different levels of craftsmanship.

Things did not always go smoothly for Bing. Denis' bedroom was plagued with

54. *Balustrade designed by Louis Bonnier for the rotunda at 22 Rue de Provence*, 1895. Institut Français d'Architecture, fonds Louis Bonnier.

55. Louis Bonnier, *Sketch for the balustrade at 22 Rue de Provence*, 1895, drawing on tracing paper. Institut Français d'Architecture, fonds Louis Bonnier.

setbacks and snags from the beginning. The artist painted the wall panels himself, while Eugène Pinte produced the room's furniture after Denis' designs. Little remains of this model room, but it was evidently far from an artistic or popular success. Two weeks after the gallery's opening Bing wrote Denis to pick up his furniture; apparently that room was already being dismantled.[26] In Denis' defense, however, Bing had not given him clear instructions. He wanted Denis to use furniture by Gallé that he had purchased in Nancy but probably never fully told him so, since Denis created his own furnishings to harmonize with the bedroom's panels. Bing tried to persuade Denis to incorporate the expensive Gallé pieces into his scheme, but Denis was adamantly against it. Finally Bing had to pay for Denis' furniture out of his own pocket and abandon the Gallé objects, which did not harmonize with Denis' overall design.

After the room was so abruptly dismantled, relations with Denis inevitably soured. When Bing later requested a price for the bedroom panels, the offended Denis eventually quoted an unrealistically high sum to prevent the dealer from making a profit from the sale, even though Bing himself had invested a sizable amount of money in the furniture. Both parties felt betrayed: the painter had failed to grasp the severe financial risks Bing had undertaken on his behalf, while Denis had not allowed the businessman a large enough profit margin. In the end, Bing returned the oil panels he was trying to sell.

56. P. A. Isaac, *Fabric (velvet)*, ca. 1895–1900. Österreichisches Museum für ange-wandte Kunst, Vienna.

This was purchased from Bing in 1901 for 55 francs.

57. Henry van de Velde and Paul Ranson, *Dining room by van de Velde and decorative panels by Paul Ranson designed for "l'Art Nouveau,"* 1895. Private collection (contemporary photograph).

The furniture and panels have not been located; the ceramic plates are decorated by Edouard Vuillard.

The back room, also designed by Henry van de Velde, was furnished with objects similar to those made for "Bloemenwerf," his house in Brussels.

58. *Smoking room*, designed by Henry van de Velde and Georges Lemmen for *"l'Art Nouveau,"* 1895. Private collection (contemporary photograph).

59. *Chairs*, by Henry van de Velde and sold by S. Bing, ca. 1895. Photograph from the *Album de references de l'Art Nouveau (Photo/Album Bing).* Bibliothèque, Musée des Arts Décoratifs, Paris.

57.

58.

59.

62.

Van de Velde's three rooms (figs. 57, 58), produced with assistance from other Belgian and some French designers, posed no such problems. In fact, Van de Velde's plans demonstrated a clear understanding of Bing's concept of a unified interior design drawn from the international market. He may have worked well with Bing because he had more time and certainly more experience in the decorative arts. In turn, Bing may have allowed Van de Velde greater latitude, deferring to Belgium's advancements in interior design. Either way, the dining room, with its wall panels by Paul Ranson, chimney by Theo van Rysselberghe, and furniture by Van de Velde, was the most celebrated of the three.[27] The smoking room had corner cupboards with high wood paneling, stained glass, and wallpaper or tapestry covering every inch of its walls. Judging by an existing photograph, the sitting room (fig. 59), designed with Alexandre Bigot, whose ceramic tile framed the fireplace, contained furniture similar to that in Van de Velde's home near Brussels at Bloemenwerf. The most successful designer represented in this first *art nouveau* salon, Van de Velde and his creations embodied the kind of style Bing hoped would take hold in France. Indeed, one chair became so popular that Bing sold it, as well as Van de Velde's drawer pulls and ceramic tiles (figs. 60, 61), for years after the exhibition.[28] As a final compliment, Bing kept Van de Velde's rooms on display until at least 1897.

In addition to more avant-garde manifestations of the new style, Bing willingly devoted space to conservative trends in *art nouveau*, as seen in the richly colored and

60. *Ceramic tile*, attributed to Henry van de Velde and Alfred William Finch, ca. 1900. Kantonales Gewerbemuseum, Bern.

These tiles were purchased from Bing in 1900 for 10 francs each.

61. *Ceramic tile*, attributed to Henry van de Velde and Alfred William Finch, ca. 1900. Kantonales Gewerbemuseum, Bern.

62. *Circular salon decorated with panels by Albert Besnard for "l'Art Nouveau,"* 1895. Private collection (contemporary photograph).

63. Albert Besnard, *Painted ceiling for the same salon*, 1895. Institut Français d'Architecture, fonds Louis Bonnier.

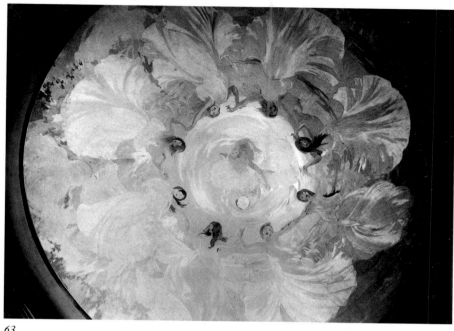

63.

attractive panels for a circular salon designed by Albert Besnard (figs. 62, 63). A second circular salon displayed P. A. Isaac's eleven panels and a frieze in decorated plush that were inspired by Japanese prints and formed by successive acid discolorations.[29] (The same acid process was continued on the frames.) Brangwyn's furniture was installed in the central hallway.[30] Designed in a standard English angular style, the square-shaped tables and chairs employed unadorned wood, straight lines, and strong verticals, with the only curvilinear motifs being in the ornamental handles of the cupboard doors and drawers.

To provide conceptual models for the contemporary home, Bing's room interiors illustrated feasible ways to integrate painting, ceramics (figs. 64–66), sculptures, prints, tapestries, carpets, metalwork, and wall decorations. Prints by artists Louis Legrand and Jean François Raffaelli and pieces by ceramicist Alexandre Bigot and glassmaker Louis Tiffany were unconventionally shown together in roomlike settings rather than typically isolated in cabinets and vitrines.[31] For his opening exhibition, Bing also featured each media separately to demonstrate the renaissance taking place in furniture, stained glass (fig. 67), and ceramics. In addition to Tiffany (figs. 68, 69; colorpls. 12, 13), Bing exhibited glassware by Henri Cros, Emile Gallé, Karl Koepping (fig. 70), and George Morren, as well as some English pieces.[32] René Lalique's opulent jewelry in imaginative, natural forms was included along with Morren's untraditional jewelry designs. Numerous examples of ceramics by Bigot

and the leading Parisian firm of Dalpayrat and Lesbos (colorpl. 14) were selected. He also gave ample space to the stoneware vases Albert Dammouse was producing at Sèvres, although lustreware vases with aquatic designs, created by Clément Massier, and other pieces by Auguste Delaherche and Emile Muller were more appreciated by foreign collectors than the French.

The tapestries Bing showed included designs by several artists, besides the commissioned work of P. A. Isaac.[33] Other rooms displayed screens, rugs, and wall hangings by Morren, Emile Henry, Georges Lemmen, and the Hungarian artist Joseph Rippl-Ronai, a favorite of Bing's who had exhibited at the Salons of the Société Nationale des Beaux-Arts. (Two years later Bing even gave him his own exhibition in the L'Art Nouveau galleries, where his paintings and decorative objects were favorably compared with the Nabis.[34]) Rippl-Ronai and the Scottish design-

er James Pitcairn Knowles were even asked to create the illustrations and bindings for two books, *Les Tombeaux* and *Les Vierges* (fig. 71) by Georges Rodenbach, a leading Symbolist. Although the commissions were for a modest limited edition, this task anticipated the gigantic international book exhibition Bing was to organize the next year.[35]

Bing also placed considerable attention on home lighting fixtures since oil lamps were then being replaced by electric lights. Kerosene lamps and oil fixtures, along with holders for the new electric lights designed by Victor Vallgren and the English firm of W. A. S. Benson, were highlighted. Greatly impressed with all English design, Bing later combined French fabrics with Benson furniture (figs. 72, 73) to confirm his continued admiration for English stylistic innovations.[36]

Exhibition galleries as well displayed examples of wallpaper design, metalwork,

67. Louis Comfort Tiffany, *Stained glass window*, ca. 1894. Musée des Arts Décoratifs, Paris (H. 43½ x W. 27½").

This window was sold by Bing to the Musée des Arts Décoratifs on June 2, 1894, for 450 francs.

plate 12. Louis Comfort Tiffany, *Vase*, ca. 1894. Musée des Arts Décoratifs, Paris (H. 3½ x D. 3½").

Bing sold this to the Musée des Arts Décoratifs.

cartoons for stained glass, and a variety of posters by both American and European artists, proving that lithography had raised the poster to the level of fine art (figs. 74, 75). Works by Will Bradley, Edward Penfield, Robert Swain Gifford, Kenyon Cox, Robert William Chambers, Aubrey Beardsley, Charles Rennie Mackintosh, Margaret MacDonald, Herbert McNair, and others were listed separately, like the prints, in the premier catalogue, yet they were probably shown together. Lithographs by Toulouse-Lautrec appeared next to watercolor landscapes in an interior designed by Van de Velde. *Ukiyo-e* prints hung near furniture designed by Liberty and Benson (figs. 76, 77). Woodcuts by George Auriol (fig. 78), prints by Henri Rivière (colorpl. 15), lithographs by Hermann Paul (colorpl. 16) and Louis Anquetin, ornate book illustrations by Walter Crane, and subtle, luminous etchings by D. Y. Cameron (fig. 79) were also part of the opening salon. The selection of prints seemed rather eclectic, offering trends from Alexandre Lunois (fig. 80) and Eugène Carrière (fig. 81) to Mary Cassatt (fig. 82). Presenting works by well-established artists with contemporary images seemed to stretch the definition of *art nouveau* beyond any reasonable grounds.

The sculpture section was likewise mixed, with works by the famous Auguste Rodin placed next to twelve bronzes by the emerging American artist Paul Way-

68. Louis Comfort Tiffany, *Bottle*, ca. 1896. Musée des Arts Décoratifs, Paris (H. 6″).

This bottle was sold in July, 1896, for 160 francs.

69. Louis Comfort Tiffany, *Gourd*, ca. 1896. Musée des Arts Décoratifs, Paris (H. 6″).

Bing sold this Tiffany piece for 100 francs.

land Bartlett (fig. 83). Stylistically, the sculpture selected extended from Jozef Mendes da Costa of Holland and Constantin Meunier of Belgium to the symbolism of Victor Vallgren (fig. 84), the realism of Alexandre Charpentier (fig. 85), and Henri Cordier's animal scenes. Bing's desire for harmony in furnishings and decor collapsed in the sculpture section perhaps because the pieces were collected too quickly and randomly. Artists also seemed reluctant to send their best works—Rodin in particular proved difficult[37]—and Bing was apparently forced to borrow some objects from private collections.

Most of the paintings Bing exhibited had also been shown before, mainly in the Beaux-Arts Salons and the Salon des Indépendants. Few of the Impressionists were represented, although the foreign painters included, such as Ferdinand Khnopff and Theo van Rysselberghe, were associated with the Symbolists and Neo-Impressionists. Many painters sent in early works, presumably because they had nothing else available. The result, however, was neither new nor innovative. Due to Bing's proud claims to have created an "art nouveau," this collection of paintings drew fire from even the most sympathetic critics once the galleries opened.

An effective public relations operator, Bing easily stayed on good terms with the press, for many journal editors and critics were his personal friends and fellow

collectors of Japanese art. All were invited to the December 26 opening of the renovated *L'Art Nouveau* galleries (fig. 86). Even the invitation itself (fig. 87), printed in black and red, represented the new style. Designed by Georges Lemmen, it had a soon-to-be characteristic curved typeface, which also broke with the traditional block letters of the time.

At the opening, visitors received an exhibition catalogue and, most likely, a program created by Lemmen that set forth Bing's design principles for the works on display (fig. 88). Artists featured in the first Salon de l'Art Nouveau, Bing wrote, were opposed to historicism and historical styles and against pretentious storytelling, the use of mythology in painting, and heavy or ugly shapes in furniture. They wanted to see "life" returned to art. And with this rejuvenation, the unity of all the arts would be represented by the beauty and charm of utilitarian objects.

Despite Bing's efforts to spell out his concepts of an "art nouveau," reaction from the daily press was extremely hostile. Beginning with a front page review in the prestigious newspaper *Le Figaro* on Saturday, December 28, and extending well into the new year, the gallery was continually ridiculed. Few critics gave Bing credit for ingenuity or courage, and most accused him of undermining the established dogma of the art schools. They denied that this was fundamentally new art, for they felt many of the craftsmen were simply imitating each other. An exhibition of so many non-French objects was also a sore point. Why had Bing passed over French artists in favor of designers from other countries? Did this relatively "new" French citizen really think that designs created elsewhere were in advance of what was being produced in Paris?

On January 5 the reviewer for *Le Siècle* was ambivalent,[38] but on January 8 Alfred Pallier, the critic for *La Liberté,* found the decorative arts in Bing's salon decadent and dismissed the exhibition as a misguided commitment to symbolism.[39] Three days later, an article for *La Chronique des Arts* labeled the choice of the name "art nouveau" unfortunate and the level of quality in the exhibition low.[40] Soon thereafter, *Le Journal des Débats* derided the show for its uncomfortable symbolism and found no redeeming virtues in the *art nouveau* supported by a "neurasthenic millionaire."[41]

Arsène Alexandre, a critic for *Le Figaro* and one of Bing's friends, gave vent to a startling animosity, stating that the *art nouveau* gallery had "the smell of the Englishman, of the Jewess or the cunning Belgian."[42] He further remarked that Bing, previously a reasonable man, had suddenly come under the illusion that he could wed the arts in America with those produced in Japan and Montmartre. Opposed to *art nouveau* in general, Alexandre derided the concept of a new style, writing, "art such as it is understood today is a dangerous abstraction because there is no art without good craft, and even the most ingenious or the most capricious imaginations, when expressed by someone ignorant, are but formless stammering." The most damaging

plate 13. Louis Comfort Tiffany, *Vase,* ca. 1897. Musée des Arts Décoratifs, Paris (H. 4″).

In July, 1897, this vase cost 175 francs.

plate 14. Adrien Pierre Dalpayrat, *Vase in the form of fruit,* ca. 1897. Musée des Arts Décoratifs, Paris (H. 8¼ x D. 6½″).

Marcel Bing donated this in October, 1908.

72. *English room interior at "l'Art Nouveau"*
after 1895 (contemporary photograph).

The copper pieces on the buffet and dado are
by W. A. S. Benson, the wall fabric is by Paul
Ranson, the furniture is largely by Benson,
and Frank Brangwyn created the rug.

73. W. A. S. Benson and Alexandre Bigot, *Table*, ca. 1896. Nordenfjeldske Kunstindustri-
museum, Trondheim (H. 28 x W. 23¼ x
16¾").

The table was purchased from Bing in 1896 in
Paris.

part of the review, however, was Alexandre's assessment of the room interiors Bing
had commissioned:

> Let us now enter the Hôtel Art Nouveau. We will see there the confusion
> of lines and colors, the absence of science which creates only novelty. Let
> us move beyond the rampart made of large fragments of broken glass
> which serve as a bewildering background for the sunflowers at the
> door.... The central hall painted in a new coat of blue contains paintings
> and prints arranged on several floors around which there is an authentic
> eighteenth-century wrought-iron banister which flicks an ironic finger at
> all the undigestable architectural forms and furniture.

He thought the French objects neither harmonized with the others nor had
anything new to teach: *"L'art nouveau* tells us that the English are good cabinet-
makers and the Belgians have a better sense of line. We already knew that." The
critic did find something nice to say about Maurice Denis' paintings in the model
bedroom, despite the furniture's ponderous appearance.

With some justification, Alexandre went on to criticize Bing for his choice of
painters, particularly for ignoring such innovators as Odilon Redon, Paul Gauguin,
Paul Cézanne, and Charles de Groux. He accused the dealer of selecting works
simply by the price they would fetch. Besides, Bing had not found unknown artists,
and there was certainly nothing new in showing those who had exhibited before.
Painters Albert Besnard, Jacques Emile Blanche (fig. 89), Edmond Aman-Jean, J. F.

74. Edward Penfield, *Harper's Poster, "July."* Jane Voorhees Zimmerli Art Museum, Rutgers University, New Brunswick, New Jersey (H. 19½ x W. 14¾").

75. William Carqueville, *Poster for Lippincott's, "May,"* 1895. Jane Voorhees Zimmerli Art Museum, Rutgers University, New Brunswick, New Jersey (H. 20½ x W. 14½").

Raffaelli, and Fritz Thaulow had already been included in the Salons, while Camille Pissarro, Armand Guillaumin, Maximilian Luce, Paul Signac, and Henri Edmond Cross had shown at the Salon des Indépendants. Even the foreigners, Alexandre reiterated, were all well known, if not in Paris, at least in their respective countries.

Admittedly, Bing had made some serious omissions, but he was obliged to show only those artists whose works he could sell, which meant eliminating those handled by other dealers. (Durand-Ruel, for example, had cornered the Impressionist market.) Bing was also simply less interested in painting per se. His essential criterion for selecting a painting remained its worth as decoration. Thus painters were judged as designers, not as pictorial artists, and their canvases chosen to harmonize with a room's other decorative details. Critics apparently misunderstood or ignored that crucial point.

Alexandre was not the only one who disliked the model rooms, especially Denis' bedroom. Few critics, even those who were usually receptive to Bing's efforts, had a kind word to say about it. They found it oppressive with melancholy gray colors. It reminded one critic more of a chamber in a mortuary than a livable room.[43] Others

degraded it for being chaotic, the objects inappropriate, and the furniture heavy. Since little remains of this controversial bedroom, it is impossible to judge to what extent these comments were justified, or whether the critics merely failed to grasp Denis' intentions. In light of the troubles it caused Bing and the speed with which he dismantled it after the opening, they likely had some reason for complaint.

Van de Velde's rooms generally faired better, even though one critic found his dining room fit only for someone with gastric problems. Another considered his smoking room suitable for a "neurotic"; more sympathetic critics simply labeled it "derivative." What little comment his study received was unfavorable. (The critics even found the chair that was to become one of Bing's best sellers uncomfortable.) In discussing the furniture, the critic for the English *Art Journal* complained of any "curves without any signification, and designs in draperies and carpets which render without charm the designs of Mr. Walter Crane. As to the stained glass window of M. Lemmen, it is the direct reproduction of the 'granite' glass and the leaden frames ornamenting the bow-windows, as they are now made in London."[44]

Those knowledgeable of contemporary trends in interior design compared Van de Velde's rooms to similar achievements in London and found them wanting. Still largely ignorant of English arts and crafts, the French, and especially the enlightened champion of the decorative arts, Gustave Geffroy, applauded his designs. Writing for *Le Journal* in January 1896, Geffroy felt that in all of Van de Velde's

plate 15. Henri Rivière, *Le Pardon de Sainte-Anne-la-Palud*, from *Paysages Bretons*, 1892, color woodcut. Jane Voorhees Zimmerli Art Museum, Rutgers University, New Brunswick, New Jersey (H. 24 x W. 71¾").

This was exhibited at the first Salon of art nouveau as number 269.

efforts, it was "impossible not to perceive that an equilibrium between all the lines of the furniture and the panels was desired; that a supple gracefulness revealed itself in the frame surrounding a window or a mirror in the shape of an arc; that the copper incrustations carefully placed in the wood form a series of gracious arabesques all around the room."[45]

Oddly enough the effect of the building's exterior decoration was not lost upon the critics. One for *L'Architecture* even liked the cut-metal flowers, although most passed over the facade's unusual details without comment.[46] A few noted the frieze but not the unifying horizontal colored bands. No one mentioned the stenciled abstract designs, most likely conceived by Brangwyn, that Bonnier had placed at various locations on the outside wall, adding another modernistic motif to the facade (fig. 90). Bonnier's exposed structural elements were also ignored.

While not entirely unprepared for the effect his *Maison de l'Art Nouveau* would have on conservative taste, Bing must have been surprised by the ferocity of complaints. The very vehemence of critical attack attracted attention and consequently piqued public interest. Curious visitors streamed through Bing's galleries as if attending a bazaar to ogle the exotic objects and room interiors that were provoking such a furor. (Bing had also gone to great expense to install the new electric lights throughout his galleries, which in itself would have drawn the inquisitive.) Favorable or not, Bing certainly had caused a sensation.

76. *Installation photograph of "l'Art Nouveau" with "Thebes Stool" at the lower left,* undated, *Album de références de l'Art Nouveau* (*Photo/Album Bing*). Bibliothèque, Musée des Arts Décoratifs, Paris.

77. Laget for Liberty and Company, London, *Stool*, mahogany. Nordenfjeldske Kunstindustrimuseum, Trondheim (H. 14 x W. 11").

Known as the Thebes stool, this was first designed in 1884 and purchased from Bing in Paris around 1895.

Yet despite the negative and rather superficial reviews that continued to appear in the press, sympathetic critics truly interested in interior design surfaced. On December 28, *L'Evénement*'s Jules Chancel paraphrased Bing's philosophy and tried to make his intentions clear.[47] Two days later in *Le Temps*, Thiébault-Sisson voiced mixed sentiments. While he agreed with Alexandre that the growing interest in the decorative arts hardly constituted a full-fledged renaissance, he did credit Bing for bringing design innovations before the public through a number of exquisite objects. At the same time, he felt the exhibition had been hastily done, with unfinished efforts placed next to polished ones. Thiébault-Sisson also acknowledged the freedom Bing gave designers in creating their works, a somewhat misplaced compliment in view of the stern control Bing actually wielded over the craftsmen.

Gustave Geffroy later came to Bing's defense in a long article in *Le Journal*.[48] This critic understood Bing's desire to make art relevant to modern life and the home through the collaboration of designer, artisan, and client. He recognized that the exhibition's purpose lay with the room interiors as a whole, not with individual paintings and prints. Elsewhere in his review, Geffroy found Henry van de Velde's dining room gracious and in harmony with the decorative panels by Paul Ranson; Edouard Vuillard's ceramic table service, not mentioned in the premier catalogue, subtle and pleasing (colorpls. 17–19); and even Denis' bedroom acceptable.

The art journals that catered to a more sophisticated audience of tastemakers and connoisseurs than the daily press were also more universally enthusiastic. *La Revue Blanche* published a supportive article on Bing written by Thadée Natanson, with Edmond Cousturier providing an assessment of the furniture.[49] Natanson felt Bing deserved praise for his considerable courage in almost single-handedly developing a new decorative style. By resisting the seductive powers of traditionalism and historical revivalism, he had acted as a catalyst for change and elevated decorative design to the status of an art. Cousturier, beyond repeating the importance of Van de Velde's rooms, noted that Bing had unwisely tried to combine the work of too many designers, with disparaging results. Bing himself later made the same criticism of this first attempt and gave up the idea of turning painters into interior designers.

Reviews of the opening salon published in Scandinavia, Belgium, England, and Germany were considerably less harsh than those written in France. In Scandinavia, little comment was made about individual pieces or questions of style; critics simply reported on the show and mentioned the few participating Scandinavian artists.[50] The Belgians were among the most sympathetic commentators. *L'Art Moderne* rose to Bing's defense, attributing some of the hostility toward *art nouveau* to chauvinism: Bing supported foreign artists, Van de Velde in particular, and the French simply did not like it. The publication considered Bing's exhibition a triumph in its scorn for misguided nationalistic pride and a victory for the avant-garde, stating, "We

78. George Auriol, *Design for a fan*, ca. 1895, woodcut. Jane Voorhees Zimmerli Art Museum, Rutgers University, New Brunswick, New Jersey (H. 13½ x W. 20½").

79. D. Y. Cameron, *Afterglow, Evening on the Findhorn*, etching. Jane Voorhees Zimmerli Art Museum, Rutgers University, New Brunswick, New Jersey (H. 9⅝ x W. 8¼").

plate 16. Hermann Paul, *Salon des Cent*, 1895, color lithographic poster. Ralph and Barbara Voorhees (H. 20½ x W. 16¼").

This was exhibited at the first Salon of art nouveau as number 267.

80. Alexandre Lunois, *Danae*, undated, color lithograph. Jane Voorhees Zimmerli Art Museum, Rutgers University, New Brunswick, New Jersey.

81. Eugène Carrière, *Portrait of Mme. Eugène Carrière*, 1893, lithograph. Jane Voorhees Zimmerli Art Museum, Rutgers University, New Brunswick, New Jersey (H. 22½ x W. 16¾").

have too often waged war against the shabby exclusivism brought about by this type of nationalism. Let us limit ourselves to rejoicing in the renaissance on a new soil, of the good combat of the avant-garde, and let us congratulate M. Bing for having—because of his great valor—provoked the raising of pikes."[51]

An illustrated article in the English *Art Journal* in 1897 discussed fairly Bing's influence on the design movement in Great Britain. Even though the author objected to Bing's insistence on rejecting the past in toto, he made a point that other critics had failed to grasp:

> One does not tend toward a decorative Renaissance in grouping scattered efforts; above all, in giving the public, without arrangement, the individual work of different artists. It must not be forgotten that this exhibition was not destined only for the *dilettante* knowing all the aesthetic ideas, and whose education in artistic things by study or taste had already prepared him to be able to express a personal opinion. No; in this matter, we must keep in mind what we call the mass, who do not make revolutions, but consecrate them, if they are skillfully prepared. This is what [William] Morris, Walter Crane, [Sir Edward] Burne-Jones, Lewis Day and others, have well understood; when they wished to give a new style in England, they united their efforts in a similar, if not uniform, renovation.[52]

German critics, not always well disposed toward the *Jugendstil*, were in general happy to see their fellow countrymen so well represented in France. Bing found his most perceptive reviewer anywhere in his close friend Julius Meier-Graefe, who

82. Mary Cassatt, *Nursing*, 1891, etching and drypoint. Jane Voorhees Zimmerli Art Museum, Rutgers University, New Brunswick, New Jersey (H. 14¾ x W. 9½").

wrote several articles about the exhibition for *Das Atelier*. Meier-Graefe took it as his personal mission to carefully explain what Bing had attempted with the decorative arts. In his first article,[53] Meier-Graefe emphasized that Bing's ideas had been strongly shaped by his thorough understanding of Japanese art. He then defined the predominant role of the contemporary craftsman—"the Renaissance artist [who] holds the tools of the workman just as gladly in his hand as he holds the paint brush"—in this revival of the decorative arts. More importantly, Meier-Graefe stressed how *art nouveau*, by renouncing "the pretension of all the isms," tried to create art for the broadest public and thus return art to the home. As seen with his model rooms, Bing wanted interior environments to be carefully orchestrated milieus rather than cluttered collections of bric-a-brac.

In this detailed review the German critic commented on all aspects of the model rooms—the frieze by Paul Ranson, the Tiffany window after Ranson's cartoon, the porcelain service by Vuillard in the dining room—and demonstrated a full grasp of their design elements. The use of color remained a major principle of the rooms. As Meier-Graefe remarked, "In the corners and at several walls there are large comfortable chairs covered with . . . differently colored material which has again no pattern, dignified and comfortable. . . . The rug: a frieze of one color." He then went on to explain how color could be an important integrating device:

> The right colors on the walls, put together in the right way, give the room, first of all, the convincing peculiarity which is natural at the same time. So the wallpaper acts as the most important part in a modern room. It is the determining factor for all the others in the choice of the whole interior decoration, like rugs, color of the furniture, etc., though it depends itself on color and pattern in the given room and light conditions, and on the purpose of the room. So we have here absolutely artistic laws concerning the use of color, which will be in closest connection with the contemporary style of painting. So the most noble quality of the French painting tradition, which is first of all concerned with color combination, can be of great help to the home.

Meier-Graefe's second article[54] continued this discussion of Bing's salon with several comments that many critics had mistakenly expected to find the new style already fully developed. He pointed out that the collaborating artists Van de Velde, Lemmen, and Rysselberghe had best understood the intricate relationships between artisans. The Belgians had, after all, accomplished the goals of integrated interior design that "perfectly satisfied the requirements of taste and comfort of the spoiled modern person." Later Meier-Graefe analyzed convincingly the interior designs of all the model rooms and explained why certain displays were created in a specific way, which suggested that he had an intimate knowledge of Bing's discussions with various designers. In examining the smoking room and the collection

83. Paul Wayland Bartlett, *Sculpin*, 1895, bronze. Musée d'Orsay, Paris.

This piece, shown in the first Salon of art nouveau as number 303, was reproduced in the *American Magazine of Art* (November, 1925).

84. Victor Vallgren, *Vase*, 1895, bronze. Konsmuseet I, Ateneum, Helsinki.

Also shown in the first Salon of art nouveau, this vase was number 379.

cabinet, located on either side of Van de Velde's room, Meier-Graefe underscored important design principles linked to room usage:

> Both are very different from the first room though the reigning principle is, of course, the same. The smoking room has much more daring; here the eye is supposed to be stimulated after the meal, therefore bolder designs. A frieze by "Lemmen" in strong lines—a decorative, very original motive—stencilled by hand, finishes the walls towards the ceiling. From the floor a heavy mahogany paneling grows up to the frieze; it contains a glass mosaic

85. Alexandre Charpentier, *Mother and Her Child*, ca. 1883, bronze. Private collection, Sweden.

While this example was purchased from Bing by the owner's parents in 1898–99, another example is found in the collections of the Metropolitan Museum of Art, New York.

86. *Invitational letter to attend the opening of the first Salon of art nouveau*, December 18, 1895. Bibliothèque d'Art et d'Archéologie, Paris.

87. Georges Lemmen, *Invitation to the opening of l'Art Nouveau*, 1895, color lithograph. Kunst und Gewerbe Museum, Hamburg (H. 5 x W. 6¾").

88. Georges Lemmen, *Program for l'Art Nouveau*, 1895, color lithograph. Kunst und Gewerbe Museum, Hamburg (H. 9½ x W. 7⅞").

also by "Lemmen" which is recessed from below and spreads architecturally-organically into large boards and charming cabinets in the corners and ends on the only large wall with a huge sofa with a large mirror. In this way all the furniture of this room forms one piece with the paneling.[55]

His discerning eye and practiced interpretive abilities led Meier-Graefe to address one room that almost all other reviewers totally ignored: the Salon Besnard. The lavishness of this room, designed by the French artist Albert Besnard, and all the other rooms Bing had commissioned caused Meier-Graefe to muse on a significant aspect of this type of interior decoration. Created on command, all of the furniture, wall hangings, paintings, and rugs were extremely expensive, making them "available to wealthy people only, who very often do not have a comparable amount of taste as they have money."

Meier-Graefe suggested Bing redefine his audience so his interior decoration could be shared with the less affluent: "Bing seems to understand these ideas. He wanted to start with the most brilliant gun . . . and has already done some work in simpler models; in this way he will much expand the circle of friends of the young enterprise." The German critic tried to correct the one-sided nature of this first Salon of Art Nouveau, but Bing always had difficulty reaching a clientele beyond the wealthy. His objects simply cost too much and were executed on a level of taste and expense that the middle-class in France could not always attain, although Bing did enjoy greater luck with other European countries.

89. Jacques Emile Blanche, *Portrait of Fritz Thaulow and His Family*, oil on canvas, 1895. Musée d'Orsay, Paris.

Number 31 in the first Salon of art nouveau, with the title of *The Painter Thaulow and His Children*, this painting was also shown at the Salon of the Société Nationale des Beaux-Arts earlier in the year.

A third article, on the nuances of individual ceramics and glass objects in the exhibition and their relationship to Japanese models of craftsmanship, completed Meier-Graefe's series.[56] In sum, his reviews became the most detailed and insightful published record of the first Salon of Art Nouveau. These articles may have substantially added to German acceptance of Bing's contributions to interior design, which culminated in the Frenchman's involvement with the Dresden exhibition of 1897.

Several reasons for the severe criticism Bing attracted exist. Unlike similar English and Belgian design reform movements, Bing worked virtually alone. He seems to have made no concerted attempt to organize the Union Centrale to initiate reforms on a national scale. Perhaps he believed that no amount of discussion would help France regain lost ground; maybe he was just in too much of a hurry. Next, his viewers might have been less confused and baffled by his new style if he had first prepared them. An article examining the decorative arts planted in advance might have educated the public and warmed it to the idea of accepting foreign influences, an odd error in judgment on Bing's part, considering his often deft manipulation of the press when promoting Japanese art. Inviting the conservative daily press had certainly been a mistake. Finally, Bing might have simply overestimated his own position as an arbiter of taste.

In December 1896, almost a year after the opening of Bing's gallery, the *Revue des*

plate 17. Edouard Vuillard, *Young Girl with Brown Striped Blouse*, ca. 1895, porcelain. Collection Josefowitz, Lausanne, Switzerland (D. 9¼").

Arts Décoratifs devoted a lengthy article to "Les Expositions de l'Art Nouveau."[57] In it Victor Champier, a supporter of the decorative arts, argued that Alexandre's overly critical article had given others license to reject contemporary art and design outright. Alexandre's attack had so hurt Bing's cause that even the Union Centrale and the preparing commission for the Paris Universal Exposition of 1900 expressed doubts about involving themselves with the dealer. Champier called it a pity that so many had slighted Bing's accomplishments, especially those in building decoration and in showing furniture by foreign artists. Although his exhibition had confused issues in some ways, Bing at least proved that only a private entrepreneurial initiative could produce a new decorative style.

Due to these miscalculations, Bing suffered considerable public criticism and rejection for his noble efforts. Only time would tell whether popular judgment would be reversed. The *Art Journal* summed up the situation when it wrote, "L'Art Nouveau will, perhaps, tend toward a renovation of the decorative style in France, and if, at the present moment, it does not give us an absolutely fresh idea of interesting efforts, in any case we must not refuse it credit for what it can essay in the future."[58]

plate 18. Edouard Vuillard, *Woman Arranging Flowers*, ca. 1895, porcelain. Collection Josefowitz, Lausanne, Switzerland (D. 9¼").

plate 19. Edouard Vuillard, *Woman with Blue Hat*, ca. 1895, porcelain. Collection Josefowitz, Lausanne, Switzerland (D. 9¼").

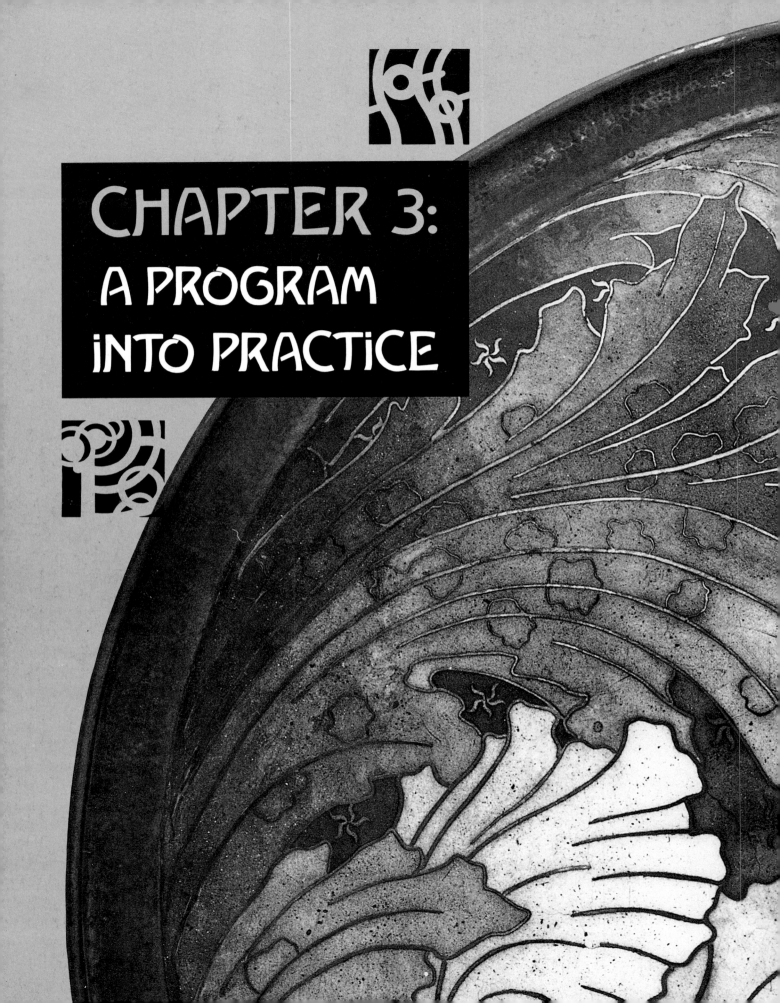

CHAPTER 3:
A PROGRAM INTO PRACTICE

91. Max Laeuger, *Small pitcher*, ca. 1898, enameled stoneware. Musée des Arts Décoratifs, Paris (H. 8¼").

In November, 1898, this work was purchased from Bing for 14 francs.

92. Max Laeuger, *Vase*, ca. 1898, enameled stoneware. Musée des Arts Décoratifs, Paris (H. 8½").

This work was purchased from Bing in November, 1898.

93. Glatigny, *Vase* (designed by M. Lechatelier), ca. 1898, high fired porcelain. Musée des Arts Décoratifs, Paris (H. 7½").

Purchased from Bing in May, 1898, for 20 francs.

In spite of the mixed reviews following the opening Salon of the *Maison de l'Art Nouveau* in 1895, Bing continued to promote the new style in furniture, ceramics (figs. 91–94; colorpl. 20), and glass, especially Continental and English objects. Over the next years he exhibited books, tapestries, carpets, fabrics, and stained glass, and installed an English room interior (fig. 95), which may have replaced Denis' model room.[1] He planned an exhibition of Tiffany favrile pieces in 1897, due to the receptive clientele he found for these extraordinarily rich examples of fused glass.[2] Bing held numerous small exhibitions of Japanese prints, ceramics, or sculpture in his galleries concurrently with works by modern designers and toured Japanese print exhibitions to maintain his high visibility in Oriental art throughout Europe. His avid interest in the new style also led him to publish several articles on developments in modern design. In one of the first, "Wohin Treiben Wir?" (*Dekorative Kunst*, 1897),[3] Bing supported the Pre-Raphaelite craftsmen Walter Crane and especially William Morris, whom he considered the spokesman of new art and the heir of John Ruskin. Illustrated with pieces by Morris and C. R. Ashbee's metalwork,

94. Clément Heaton, *Large circular platter*, ca. 1898, cloisonné on copper. Musée des Arts Décoratifs, Paris (D. 25⅝").

Bing sold the platter in May, 1898, for 250 francs.

the issue contained as well reproductions of the Tiffany windows by Bonnard and Roussel that Bing had commissioned (figs. 31, 32).

Reviews of Bing's *art nouveau* appeared in various Scandinavian journals, and in 1896 Jens Thiis, director of the newly organized Nordenfjeldske Kunstindustrimuseum in Trondheim, Norway, traveled to Paris to purchase these objects of modern design for his museum. A painter himself, Thiis was eager to establish an avantgarde museum in Norway. After visiting Bing's galleries, Thiis wrote the president of his board of directors that he needed more funds to secure the best pieces from the collection, in particular ceramics by Bigot, Dalpayrat, and Carriès, glass by Tiffany (colorpl. 21), and fabrics by William Morris.[4] He later observed of Bing's gallery:

> The idea of such a gallery was new outside of England and constituted a meaningful step in the direction which William Morris had established when he opened his decorative art shop in 1861. But here, with *L'Art Nou-*

95. *Interior of Bing's shop "l'Art Nouveau" with English arts and crafts furniture*, ca. 1896–97 (contemporary photograph).

96. *View of the interior of the old Decorative Art Museum in Trondheim* (contemporary photograph courtesy of Nordenfjeldske Kunstindustrimuseum, Trondheim). Works by Van de Velde, de Feure, Tiffany, Colonna, and Majorelle are visible.

plate 20. Rörstrand, *Vase*, ca. 1898, porcelain. Musée des Arts Décoratifs, Paris (H. 6⅛″).

This vase cost 35 francs in 1898 at Bing's.

plate 21. Louis Comfort Tiffany, *Lamp*, ca. 1900, glass and bronze. Nordenfjeldske Kunstindustrimuseum, Trondheim.

Jens Thiis purchased this at the Exposition Universelle of 1900.

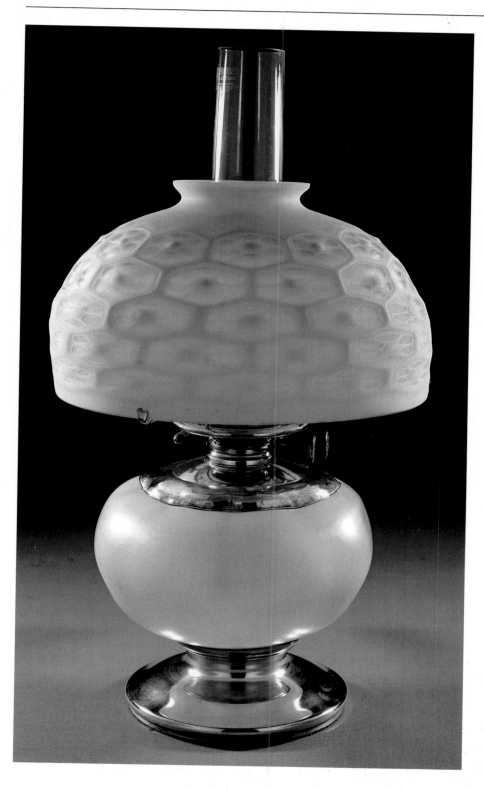

97. Liberty and Company, *Printed cotton*, ca. 1896. Nordenfjeldske Kunstindustrimuseum, Trondheim (H. 31⅛ x L. 37½").

Works in nos. 97, 98, and plates 22–24 were purchased from Bing in 1897.

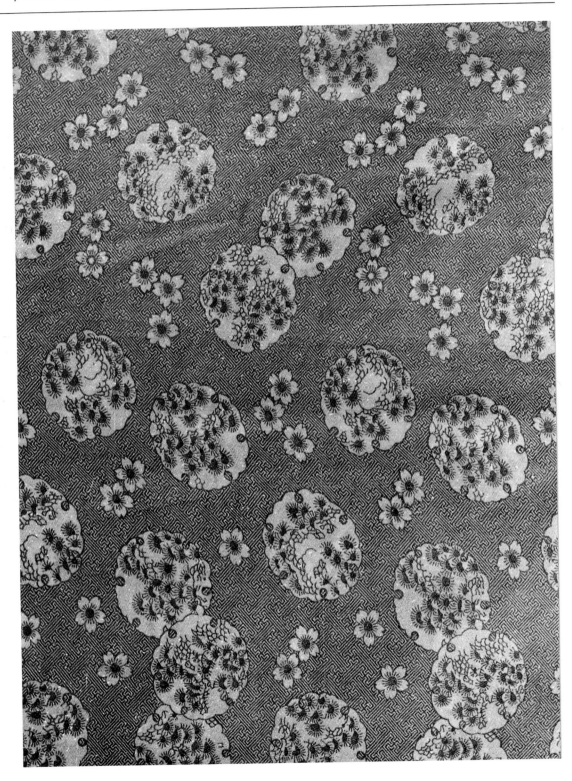

98. William Morris and Company, *Tulip pattern fabric*, 1875, printed cotton. Nordenfjeldske Kunstindustrimuseum, Trondheim (H. 37½ x L. 51½").

99. William Morris and Company, *Rose and trellis pattern fabric*, undated. Nordenfjeldske Kunstindustrimuseum, Trondheim (H. 31½ x L. 37½").

Purchased from Bing in 1897, this and thirteen other fabric samples were bought for 458.16 Norwegian Kroner.

veau, it was not a single man's work or a single direction one got to know. With the choice of the best artists from both sides of the Atlantic, the foundation was placed for the creation of a "new style." Here Frenchmen and Englishmen, Americans and Belgians, Germans, Dutchmen, and Scandinavians met, gathering with a common thought—a modern home filled with modern art....

What gave the exhibit at *L'Art Nouveau* its special significance was the range of interiors that Henry van de Velde had composed and which was the first important accomplishment from him as the ingenious leader of the modern style. But also in many other áreas and overall, the exhibition became convincing proof that what had been established was a "new art" and that it was carried forward by a not insignificant crowd of strong and bold talents that Bing had the honor of gathering.[5]

Thiis' museum was supported by a wealthy magnate eager to encourage the development of the Trondheim collections, so the requested funds soon arrived. As a result of this farsighted purchase, the Trondheim collection (fig. 96) then offered an overview of the range of objects Bing sold, foremost being textiles by William Morris and by Arthur Silver (1853–97) for Liberty and Company, which most strongly showed the influence of the Far East (fig. 97; colorpls. 22, 23). Trondheim bought some of the best-known Morris designs, including the Brer Rabbit patterns (colorpl. 24), created for a children's nursery, the Golden Bough, the Tulip chintz (fig. 98), and the daisy-and-trellis wallpaper (fig. 99).[6] The Norwegian director was particularly impressed by Benson's metalwork, purchasing some of his lamps, a pair of andirons, a warming platter, a teapot, and a jug, all in simple, practical designs (figs. 100–105; colorpl. 25).

Many other English decorative objects entered European houses and collections via Bing's dealership. Although Liberty seems to have sold only a chair through Bing in 1896, this did not keep the dealer from stocking his shop with examples of English arts. During the next years, however, Bing's dependence on the English declined as his own designers, and eventually his workshops, began to turn out goods that met his exceptional standards, but he proceeded to handle works by close associates such as Frank Brangwyn.[7]

In the following years Bing established a continual series of shows focusing on the pictorial arts. The first of these opened as the second Salon of *art nouveau* in February 1896, not long after the gallery began. Its catalogue started its numbering of objects where the first exhibition catalogue left off, as if to indicate that the works on display supplemented the original collection. Several artists were again included, among them K. X. Roussel, Frits Thaulow, and Joseph Rippl-Ronai (fig. 106), but many were new. Prints by Eugène Delâtre (colorpl. 26), ceramics by the Danish artist Herman Kaehler,[8] etchings by the Belgian James Ensor, and a series of woodcuts by Félix Vallotton were featured. Ensor's prints of pastoral landscapes or

plate 22. Liberty and Company (designed by the Silver Studio), *Printed cotton*, ca. 1896. Nordenfjeldske Kunstindustrimuseum, Trondheim (H. 32 x L. 37").

plate 23. Liberty and Company (designed by Arthur Silver), *Printed cotton*, ca. 1896. Nordenfjeldske Kunstindustrimuseum, Trondheim (H. 31¾ x L. 37½").

plate 24. William Morris and Company, *Brer Rabbit pattern*, ca. 1882, fabric. Nordenfjeldske Kunstindustrimuseum, Trondheim (H. 36¼ x L. 55¼").

100. W. A. S. Benson, *Lamp with shade*, ca. 1895, copper, brass, and silk. Nordenfjeldske Kunstindustrimuseum, Trondheim (H. 17½").

Ranging in price from 18 francs to 75 francs, these works by Benson were purchased from Bing in 1896.

101. W. A. S. Benson, *Andirons*, ca. 1895, brass. Nordenfjeldske Kunstindustrimuseum, Trondheim (H. 13¼").

sections of buildings were intimate, sensitive studies of light and atmosphere (fig. 107) that reflected the conservative, almost realist strain of his early imagery, so unlike the intense personal symbolism of his later works. In contrast, Vallotton's more avant-garde, anarchistic woodcuts used a summary treatment that often bordered on abstraction (figs. 108–114). Bing valued Vallotton's work and later asked him to design the catalogue for *L'Art Nouveau*'s exhibition on modern book design (fig. 115), the poster for the gallery's permanent installation (colorpl. 27), and Bing's personal business card (fig. 116).[9]

With the second Salon, the press began to come around to the idea of *art nouveau*. Camille Mauclair in the *Mercure de France* praised Bing for supporting French artists by providing exhibition space free from juries, fees, and other constraints. Although he agreed with Arsène Alexandre's earlier assessment of Bing's first Salon, Mauclair disapproved of the critic's excessive rudeness.[10] Bing's original show may

have had its failings, Mauclair admitted, but its long-range influence would prove to the French that they no longer ranked first in the art world.

Bing next organized a one-man retrospective of bronzes, plasters, paintings, watercolors, pastels, and drawings by the Belgian artist Constantin Meunier.[11] Known to many Parisians, Meunier had exhibited his work in several Salons des Beaux-Arts, being especially well represented in the Salon of 1893.[12] Meunier may have been selected to demonstrate to the French public that even established artists were doing new things, but admittedly in a style more familiar than much of *art nouveau*. Critics and the public alike could easily understand Meunier's traditional imagery and associate his realistic depiction of workers (figs. 117, 118) with the field laborers in Jean François Millet's paintings or the downtrodden poor in Emile Zola's novels. In giving Meunier an exhibition at *L'Art Nouveau*, Bing went far toward placating even the most disaffected critics, for all looked on the show favorably. While a few critics did not appreciate his paintings or pastels, everyone found his sculptures powerful, even comparing them to works by Michelangelo.[13] One reviewer in *La Presse* (February 19, 1896) declared his art a welcome relief from ideal or Symbolist painting. Gustave Geffroy contributed in *Le Journal*:

> He has sought the depths of humanity and visited the darkest regions where obscure forces do not know how to express themselves and where they only begin to stutter. And because he has seen, understood, and represented humble people, he has bestowed on them a language, the beautiful mute language of forms and expressions.... He knows the work of the great naturalists of all time and of all countries. He doesn't take into

account the influence that pedantry has on the past. He admires Greek truthfulness and Roman solidity. He understands the delicate and nervous strength of the Middle Ages. He is like Millet, [Antoine-Louis] Barye, and Rodin; he is of the race of those who know simplified movement, supple musculature, fundamental forms.[14]

Most reviewers acknowledged that Meunier's work was innovative but somehow difficult to define. Perhaps mood, and especially an air of melancholy, served as the unifying thread that tied Meunier to other artists then working in a more schematic style. Meunier's realistic images may not match today's concept of the *art nouveau* tradition, but at the time it helped to establish Bing's identity as a dealer of contemporary art who supported artists of all stylistic affinities.

An exhibition of almost two hundred objects by the printmaker Louis Legrand followed in April.[15] Since the artist was not well known, Bing made every effort to attract visitors with printed invitations designed by Legrand (fig. 119). What few reviews appeared were favorable, particularly one article published in *Le National* which again lauded Bing for his free exhibitions that provided worthwhile artists with valuable exposure.[16] A master technician, Legrand's strong Symbolist inclination sometimes suggested that he had studied Gauguin's prints. Periodically he depicted a topic drawn from biblical sources, but many more images were inspired by the politics, cabarets (fig. 120), and brothels of Paris. Like Edgar Degas, Legrand could capture subtle nuances of character within a particular locale (dancers were a favorite theme), yet he was more of a popularizer and illustrator than an artist of consistently high aesthetic taste.

Bing's next show of close to sixty paintings and drawings by Eugène Carrière, an artist acclaimed at the Salons, opened on April 18, 1896, to little critical enthusi-

plate 25. W. A. S. Benson, *Parafin lamp*, ca. 1895, copper, brass, and glass. Nordenfjeldske Kunstindustrimuseum, Trondheim (H. 25″).

This was purchased from Bing in 1896 for 60 francs.

asm. Critics occasionally deemed Carrière's muted compositions attractive (fig. 81), but an entire hall filled with such works must have been monotonous. Camille Mauclair commented in the *Mercure de France*:

> I do not hide the fact that I fear for the artist in the danger of monotony and affectation. The opacity and gray tone of his paintings are more and more accentuated. They are displeasing and weaken the impression. A few simple phrases written by Carrière for the preface of his catalogue speak well of his intention. But these phrases, of which one or two are touching in their comprehensive sincerity, do not connect well. They clash with ideas which are not made to agree with each other, and this mental confusion is seen in the set purpose of Carrière.[17]

After these mixed reviews, Bing felt he needed more controversial shows to maintain the momentum for *art nouveau* created by his first Salon. If he was going to firmly support the avant-garde, he could no longer fall back on the tried and true Beaux-Arts painters. He searched for both an original and a daring artist. He found Edvard Munch. Hardly an unknown artist when he exhibited at Bing's gallery in May 1896, Munch had been shown at two exhibitions in Hamburg and one in Dresden in the early 1890s,[18] as well as in Copenhagen and Stockholm, where his paintings attracted considerable attention from both connoisseurs and the press. He even sent five canvases to the World Columbian Exposition in 1893, but he was not well known in France until Bing presented his paintings and prints. (The Norwegian artist had emerged as a major lithographer and etcher since he started to make these less expensive and more portable prints two years earlier.) Meier-Graefe also encouraged Munch's printmaking by introducing him to other printers and by publishing his handsome portfolio of eight etchings and drypoints in the summer of 1895. After Meier-Graefe was fired as editor of the journal *Pan*, he brought Munch with him to Paris, where other members of the avant-garde soon admired the artist's accomplishments.

Since November of 1895, when Thadée Natanson, editor of *La Revue Blanche*, favorably reviewed his exhibition in Christiania and published a reproduction of *The Scream*, Munch had enjoyed a following among the intelligentsia. Meier-Graefe then arranged for ten Munch paintings to be in the Salon des Indépendants in April; Bing opened his comprehensive Munch exhibition on May 19.[19] Invitations (fig. 121) announced not only the exhibition of Munch's work but also that "M. Edouard Munch vous prie d'assister à l'ouverture" (Edvard Munch requests that you attend the opening). Coverage by the French critics was nonetheless scanty and reviews negative. Again Camille Mauclair remarked:

> After Constantin Meunier, after Eugène Carrière, Bing has offered his hospitality to Edvard Munch, one of the exhibitors at the Munich secession.

105. W. A. S. Benson, *Platter*, ca. 1895, copper. Nordenfjeldske Kunstindustrimuseum, Trondheim (D. 11½").

This choice was infinitely less fortunate. In spite of the somewhat irritating enthusiasm of [August] Strindberg, Munch seems devoid of any interest. There are paintings in which the draftsmanship is nil, the colors are barbarous, and whose subjects are repulsive because of their ugliness and discordancy. They are adorned with symbolic titles so as to astonish the passers-by; but we have already seen such whims, and Munch would only surprise us if he did not come after twenty others. There are a few portraits which have been deprived of their symbolic content and are simply badly drawn, badly presented, and show ugly colors as so often happens to the paintings of this type of painter. The absence of showy or complicated titles lets us see what one calls in good French, a lack of talent. Some childish etchings are shown next to this sad medley of colors, and despite the illusions of Strindberg—who has already written such extraordinary aphorisms about Gauguin and who seems to know far less about painting than about the theatre—there is nothing there to change our indifference, the good and honest indifference one feels when one approaches art with the ideas of an American Indian. Bing did better when he replaced the paintings of Munch with the book exhibition he had been preparing for a long time.[20]

Despite the fact that Munch's paintings appeared "barbaric" to some and his prints sloppily drawn to others, the show at least introduced Frenchmen to almost all the works that had established Munch's international reputation (figs. 122–126;

106. Joseph Rippl-Ronaï, *Woman Reading,*
ca. 1895, lithograph. Jane Voorhees Zim-
merli Art Museum, Rutgers University, New
Brunswick, New Jersey (H. 7⅝ x W. 5¾").

plate 26. Eugène Delâtre, *Marcel*, 1894, color etching and aquatint. Jane Voorhees Zimmerli Art Museum, Rutgers University, New Brunswick, New Jersey (H. 8½ x W. 11¼").

colorpl. 28). Paintings displayed included *The Kiss*, *The Scream*, and *Madonna*, which were psychologically and structurally among the most advanced works of the time. Among the equally challenging prints were *The Sick Child*, *The Day After*, and *The Death Chamber*, an abstract lithograph from 1896, as well as print versions of several paintings. Some images presented sexually explicit compositions guaranteed to generate discussion. No matter the personal opinion, the exhibition's sixty works gave Parisians, particularly members of the artistic community, a long overdue opportunity to see the whole range of Munch's art (fig. 127).[21]

After the Munch exhibition, Bing turned his attention to a show dedicated to modern book design. The organizing committee, which included Samuel P. Avery,

108. Félix Vallotton, *Self-Portrait (l'Auteur)*, 1891, woodcut. Galerie Paul Vallotton, S.A., Lausanne, Switzerland (H. 5³⁄₁₆ x W. 4³⁄₁₆").

These prints by Vallotton were shown in Bing's second Salon of art nouveau.

109. Félix Vallotton, *Gust of Wind (Le Coup de Vent)*, 1894, woodcut. Galerie Paul Vallotton, S.A., Lausanne, Switzerland (H. 7⅛ x 8³⁄₁₆").

110. Félix Vallotton, *The Burial (l'Enterrement)*, 1891, woodcut. Galerie Paul Vallotton, S.A., Lausanne, Switzerland (H. 10⅛ x W. 13⅞").

111. Félix Vallotton, *The Anarchist (l'Anarchiste)*, 1892, woodcut. Galerie Paul Vallotton, S.A., Lausanne, Switzerland (H. 6¹¹⁄₁₆ x W. 9⅞").

112. Félix Vallotton, *The Charge (La Charge)*, 1893, woodcut. Galerie Paul Vallotton, S.A., Lausanne, Switzerland (H. 7⅞ x W. 10¼").

113. Félix Vallotton, *The Bath (Le Bain)*, 1894, woodcut. Galerie Paul Vallotton, S.A., Lausanne, Switzerland (H. 7⅛ x W. 8⅞").

114. Félix Vallotton, *Swans (Les Cygnes)*, 1892, woodcut. Galerie Paul Vallotton, S.A., Lausanne, Switzerland (H. 5⁵⁄₁₆ x W. 6¹⁵⁄₁₆").

115. Félix Vallotton, *Design for the back of the catalogue for the "Exposition Internationale du Livre Moderne à l' Art Nouveau."* Museum für Kunst und Gewerbe, Hamburg (H. 9¼ x W. 7½").

then president of the Grolier Club in New York and an old correspondent with Bing, Léonce Bénédite, curator of the Luxemburg Museum in Paris, Jules Claretie, a cultivator of contemporary books, Gustave Geffroy, Henri Houssaye, Auguste Lepère, Roger Marx, Julius Meier-Graefe, Gabriel Mourey, and Octave Uzanne, one of the most active promoters of new books and president of the association of contemporary book collectors in Paris, as well as Bing selected over 1,100 entries that represented all aspects of the printed book: ornamentation, bindings, typefaces, styles, and fine paper. Modern type was shown alongside traditional faces; popular books were contrasted with special luxury editions.[22] (The poster's design of a series of owls [fig. 128] and the exhibition catalogue were both created by Félix Vallotton.[23]) Since it immediately followed the Munch exhibition, this show also clearly demonstrated Bing's versatility as a collector and dealer.

In its June 9 review of the book exhibition, *Le Figaro* noted that Paul Gallimard, a member of the advisory committee and a major Parisian publisher, had produced the elegant installation.[24] *L'Art Moderne* in turn reported:

> Now at Bing's, the exhibition of modern books confirms—one pretends— the superiority of the English publishers over all others. This phrase which becomes a cliché annoys even more since it might seem unjust to those who do not admit that a modern renewal of the art of furniture-making bases itself on the geneological tree of past schools, no matter how glorious, but that it must, on the contrary, come out of the direct observation of nature. William Morris remains, it is true, well deserving, but it could be that he indicated the wrong direction.
>
> This point established, it is necessary to say that these books are models of reconstitution and of archaic science. Text, ornaments, tailpieces, en-

116. Félix Vallotton, *Advertisement card for
"l'Art Nouveau,"* ca. 1895, color lithograph.
Museum für Kunst und Gewerbe, Hamburg
(H. 5½ x 3⁹⁄₁₆").

117. Constantin Meunier, *Squatting Miner (Le Mineur accroupi)*, before 1896, bronze.

Included in the Meunier exhibition at *L'Art Nouveau* from February 16 to March 15, 1896, as number 14, this same piece was also shown at the Grafton Gallery exhibition in 1899.

118. Constantin Meunier, *The Return of the Miners (Retour des mineurs)*, before 1899, bronze.

This work appears as an illustration in the Grafton Gallery catalogue.

gravings are well done and give the idea of a book whose elements hold well together. From the presses of Ricketts and Shannon come the pages of the *Book of Ruth* and of the *Legendary Moralities* illustrated by Lucien Pissarro. The unusual character, the clear readable design, constitute real progress on the results achieved by Morris.

On the opposite side of the English vitrine, one will notice the Belgian and French publications. The care given to them cannot be compared with the patience and the conscience of the English, but some books coming from *l'Estampe Originale* are pleasing in spite of their evident faults as attempts worthy of our time.[25]

English book designers received the greatest praise in the extensive foreign press coverage, although works from other countries were hardly ignored. *The Studio* critic elaborated:

22. RUE DE PROVENCE . PARIS

plate 27. Félix Vallotton, *Poster for l'Art Nouveau*, 1895, color lithograph. Museum für Kunst und Gewerbe, Hamburg (H. 24½ x W. 17¾").

It will surely cause no surprise when I say that England holds the foremost place, with the works of William Morris and the Chiswick Press, the publications of Mr. Ricketts and Mr. Lucien Pissarro.... The English section also contains a valuable series of original designs by Walter Crane, Anning Bell, and others.... The printed books in the French section present no special novelty either in typography or illustration. With very few exceptions, [French] publishers seem to have no idea of a decorative scheme for a book, logically conceived, and, so to speak, forming part of the book itself.[26]

Not everyone came off as well as the English. Americans lacked originality and were overly dependent on the English. The Germans were attacked for "heavy, unimaginative ornamentation." Scandinavia and Belgium fared better, for as *The Studio* critic noted, the Belgians "are progressing faster, and on a surer road.... Several of the catalogues of the 'Libre Esthétique' and the 'Salon des XX' also printed books by the firms of Deman ... and the bindings of MM. H. P. Claessen and Van de Velde are very characteristic examples of a genuine and earnest art movement."

French designers were singled out only for their bindings, especially the "remarkable specimens" of MM. E. Carayon, Marius Michel, C. Martin, E. Belville, Meunier, Mercier, and Victor Prouvé. In the staunchly avant-garde *La Revue Blanche*, Edmond Cousturier felt the book exhibition confirmed that the deficiencies in French artistic editions were a "disgrace" due to the designer's inability to break with tradition. Many artists of talent in France, such as Toulouse-Lautrec, Carlos Schwabe, Auguste Lepère, Rippl-Ronai, Henri Rivière, and Vallotton, could easily compete with those of other nations, but too often wealthy bibliophiles and publishers with conservative inclinations dictated taste.[27] Mired in the past, French methods of illustration needed a broader, more democratic outlook, reviewers concluded. This merciless condemnation of native efforts disguised the critics' failure to notice design innovations made under the influence of Octave Uzanne, a member of the exhibition's advisory committee. Vallotton's cover for *Les Rassemblements* (fig. 129), for example, used a wraparound image of a workman carrying a placard through the streets of Paris that cleverly incorporated the book's title, while similar illustrations interspersed throughout the text provided further design continuity.

In organizing this book design exhibition, Bing presented a well-rounded picture of European efforts, which he juxtaposed with related accomplishments from the Far East by showing, for instance, a Japanese novel in the category of books illustrated by hand. The section of books decorated with woodblock prints featured *Les Tombeaux* by Pitcairn-Knowles, one of Bing's publishing ventures, alongside illustrated Japanese books from his private collection. Another of Bing's book enterprises, *Les Vierges*, contained lithographs by Rippl-Ronai, which were then relatively

119. Louis Legrand, *Invitation to the Louis Legrand exhibition*, April, 1896, aquatint. Museum für Kunst und Gewerbe, Hamburg (H. 9⅝ x W. 5½").

120. Louis Legrand, *My Political Opinion ? There it is!...(Mon opinion politique ? La Vlà!...)*, after 1887. Jane Voorhees Zimmerli Art Museum, Rutgers University, New Brunswick, New Jersey.

This image was most likely published in the *Courrier Français*.

121. *Invitation card to the Munch exhibition at "l'Art Nouveau,"* May, 1896. Private collection.

122. Edvard Munch, *Death Chamber (La Mort)*, 1896, lithograph. The Sarah G. and Lionel C. Epstein Collection (H. 15⅛ x W. 21⅝").

Along with the following Munch prints, this work was shown at *l'Art Nouveau* in May, 1896, as Bing no. 43.

M^r EDOUARD MUNCH vous prie d'assister à l'ouverture de son Exposition, qui aura lieu dans les Galeries de l'ART NOUVEAU, 22, rue de Provence, le Mardi 19 Mai, à 2 heures.

Invitation pour deux personnes.

unusual in printed books. Binding designs by Claessen, Michel, Prouvé, Eva Sparre, Antoinette Vallgren (figs. 130, 131), and Van de Velde's cover for Bing's *Artistic America* displayed the greatest range of expression in that some were based on nature and others were abstractions.[28]

Next Bing held an exhibition in August of works by S. Moulijn, a young Dutch graphic artist.[29] Essentially a landscapist with Symbolist overtones, Moulijn had a promising career in the 1880s but apparently could not sustain it. This show generated little interest, and the artist's work eventually disappeared from Bing's stock.

In November Bing again exhibited paintings by Charles Cottet. (Ten of Cottet's works were shown in the first Salon of *art nouveau*.[30]) Cottet had participated in the Société Nationale des Beaux-Arts, was represented in Bing's private collection,[31] and was popular with dealers, especially Georges Petit. Bing placed Cottet's new

123. Edvard Munch, *The Kiss (Le Baiser)*, 1895, etching, drypoint and aquatint. The Sarah G. and Lionel C. Epstein Collection (H. 13⅝ x W. 10⅞″).

Bing no. 31.

124. Edvard Munch, *The Scream (Le Cri)*, 1895, lithograph. The Sarah G. and Lionel C. Epstein Collection (H. 13⅞ x W. 9¹³⁄₁₆″).

Bing no. 42.

Venice series on view (figs. 132–134), plus a few scenes of Brittany that captured light and atmosphere in a late romantic style.[32] The critic for *The Studio* found these twenty-eight works fulfilled expectations,[33] but Henry Ron in *La Plume* was less complimentary.[34]

Except for a show of Alexandre Bigot's pottery in February 1897,[35] Bing set aside organizing exhibitions to prepare for the Dresden International Exhibition in May. For the room interiors he envisioned for Dresden, he decided to bring together two schools of design reform by combining English with Belgian objects. (Only in Brussels had such a hybrid style of furnishings, based in part on English and American innovations, been developed successfully.) Although the English style represented the epitome of taste and choice, Bing felt it was too delicate, while the Belgian style embraced a native Flemish heaviness. Bing knew that the strong nationalistic strains surrounding these international exhibitions would make this a far from popular choice—unless he could somehow synthesize the English and Belgian schools into his own variation of a modern decorative style.

125. Edvard Munch, *The Sick Child (Jeune Malade)*, 1894, drypoint. The Sarah G. and Lionel C. Epstein Collection (H. 14⅛ x W. 10⅝").

Bing no. 19.

126. Edvard Munch, *The Lonely One*, 1896, color mezzotint and drypoint on zinc. The Sarah G. and Lionel C. Epstein Collection (H. 11⅛ x W. 8⅜").

Bing no. 49.

127. *Cover of the "Edouard Munch" exhibition catalogue at "l'Art Nouveau,"* May, 1896. Private collection.

128. Félix Vallotton, *Flyer announcing "Exposition Internationale du Livre Moderne" at "l'Art Nouveau,"* May, 1896. Museum für Kunst und Gewerbe, Hamburg (H. 9¼ x W. 7½").

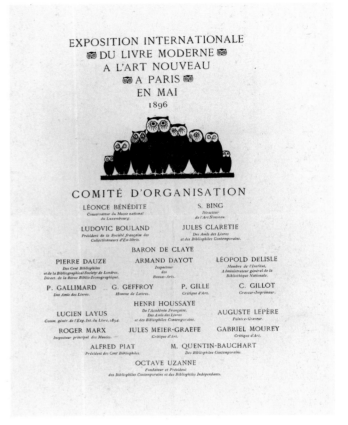

Both Bing and his friend Meier-Graefe, an enthusiastic supporter of the Belgian school, recognized the need to highlight such a style at Dresden, where the sheer number of visitors who saw it might inspire the public to sweep away the past. Meier-Graefe had long paved the way for this general upheaval of popular taste through his journal *Dekorative Kunst* (later called *L'Art Décoratif*).[36] His articles urged readers to think of utilitarian objects as works of art, with chairs and tables as sculptures, and wall surfaces, a room's paper or canvas on which to manipulate a subtle palette. Simplicity of design, harmonious colors, and opulent materials were stressed in all the applied arts. With these elements, a room could become a comfortable, restful environment whose pure shapes and curvilinear lines revealed taste, dignity, and a proper "look"—the hallmarks of the new style.

Bing brought pieces by many of the artists represented by *L'Art Nouveau* to the exhibition in Dresden: glass by Tiffany, Ranson's stained glass window, ceramics by Muller, Bigot, and the firm of Dalpayrat and Lesbos, and rooms by Van de Velde, Isaac, and Besnard.[37] Extensively commented upon in the daily press, these works

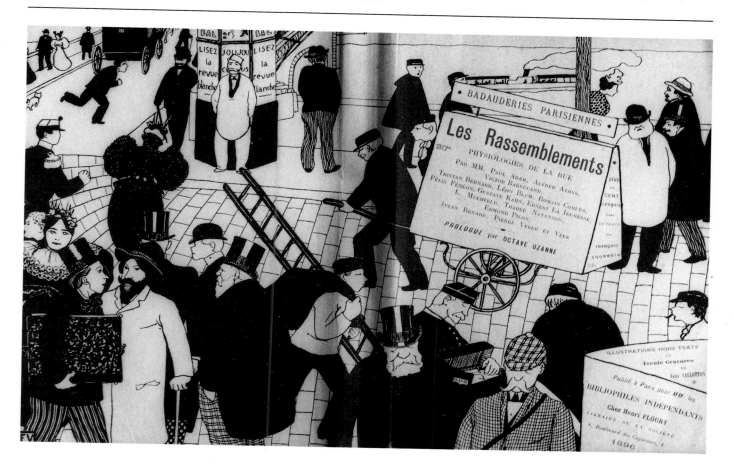

apparently attracted considerable attention to the modern movement in general, and to Bing in particular. Isaac was commended for his small salon, which had received little attention in Paris. Two graceful chairs in Besnard's round room drew special praise as exemplifying Bing's new style. The critic for the *Norddeutsche Allgemeine Zeitung* expressed great enthusiasm for Besnard's round salon in shades of yellow and its eleven paintings by the artist. He did regret that the ceiling, also created by Besnard, had remained in Paris, for its harmonious colors of yellow, lilac, and blue had given the room its finishing touch (fig. 63). Despite all the "bizarre forms" seen at Dresden, this same reviewer found in *L'Art Nouveau* the beginnings of a "new art in the house" where rooms would be stripped of excessive decoration, constructed entirely from pure materials, and furnished with delicately balanced, thoughtfully executed utilitarian forms. He described the model interiors, beginning with Van de Velde's dining-room, as follows:

> The chairs and sofas show only the solid material and the joy of using color. The dining-room, with its paneling and cedarwood, which is high-

130. Eva Mannerheim Sparre, *Bookbinding,*
1895, leather. Photograph courtesy Finnish
National Board of Antiquities, Archives for
Prints and Photographs.

Shown at *l'Art Nouveau* in 1896, this work
was exhibition number 1113 or 1114.

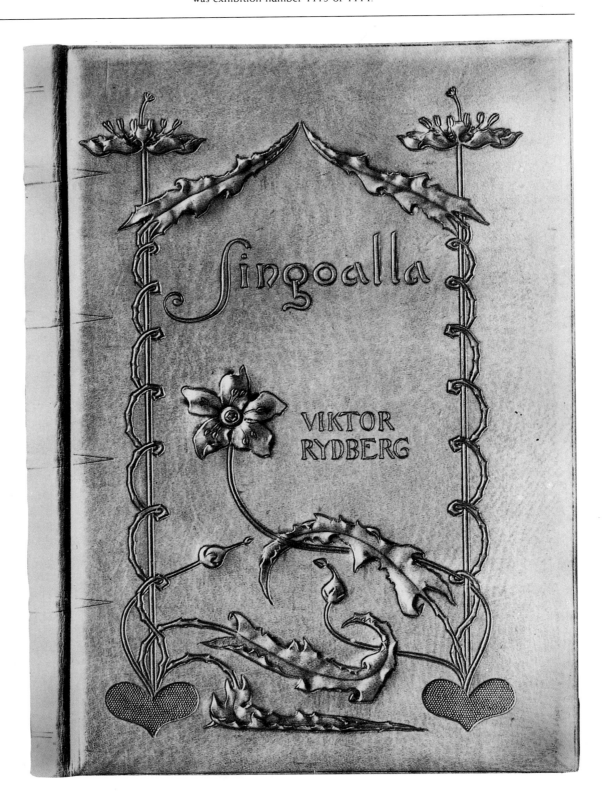

131. Antoinette Vallgren, *Bronze plate for engraving the bookbinding for "Les Yeux Clairs,"* 1894–95. Porvoo Museum.

This binding was exhibition number 121.

lighted by ornaments of copper, features very comfortable chairs and utilitarian cabinets of cedar. The dining-room table forms the center, its polished wooden surface interspersed with pink tiles: the latter are somewhat raised so that hot dishes can be placed on them, and instead of a tablecloth, white damask runners could be placed around this central area. This way of serving might be well suited to French and Belgian households, but our German housewives will object to the lack of tablecloth. The smoking room with its heavy mahogany panels, its beautiful glass mosaics, the huge sofa, and enormous mirror, has an air of comfort reminiscent of a ship's cabin. Each detail, each board, each lock is an original invention and perfectly executed.

The little drawing room, in gray and green tones, with its velvet tapestries that have etched plant ornaments, contains especially dainty chairs and benches....Next comes an antechamber with overhead lighting, which reminds one of a hall in a country home. Very comfortable upholstered benches in the corners and in the middle of the room are covered in a tigerskin-patterned velvet in blue, yellow, and white; the crowning element of the middle sofa is the abundance of fresh, fragrant laburnum which fits beautifully into the color scheme of the room. The mahogany paneling stretches up to the skylight. A huge fireplace covers almost the entire wall. The tiles used for it unfortunately create a somewhat restless feeling; but even here much has been done with brass and paneling of polished wood.

The critic again reminded his readers that this new style of decorating originated not in Paris but in Belgium, where Henry van de Velde maintained an entire staff to build and decorate homes for his clients. Whether castle, villa, or townhouse, the owner was ensured of a well-furnished house. Even if it was not necessarily in his own taste, he could at least be assured that its design was exquisite. The critic continued, "The underlying principle Van de Velde and Bing adhere to is that liveable rooms with solid, useful furnishings can be created that show a refined taste and excellent technique, independent of the worth of the materials from which they are made. Taste should not be correlated with value."[38] Although all these qualities may not have been recognized by the Dresden public who passed through the rooms, the favorable reaction of the press[39] helped to establish Bing's reputation as a tastemaker in Germany.

After the Dresden exhibition, Bing arranged an exhibition of works by the Hungarian artist Joseph Rippl-Ronai, which opened to mixed critical reaction,[40] and then turned his energies to cultivating the *art nouveau* markets in Austria and Germany. He organized a small traveling exhibition of Tiffany's work to meet the growing enthusiasm for these stylish objects on the Continent. Bing had already sold a few Tiffany pieces to the Kunstgewerbemuseum in Berlin in 1895,[41] but he now anticipated a huge market for the American designer's products since the Tiffany glass exhibited in Dresden had caused a tremendous sensation (figs. 135, 136).

The French and English markets for Tiffany's work were already lively, especially after an exhibition Bing had arranged in Paris in the summer of 1897. In August Bing contacted Hofrat de Scala, director of the Österreichisches Museum für angewandte Kunst, with plans for a repeat exhibition in Vienna. He also had in mind similar shows for Berlin, London, and St. Petersburg. Since he had already finalized an exhibition for the museum at Reichenberg, scheduling the Vienna and Berlin shows first would save on freight and other expenses.[42]

The exhibition in Vienna opened in mid-October to overwhelming public response. Private collectors bought objects, while museum directors acquired pieces and begged for exhibitions for their own museums. Ironically, the Österreichisches

Museum almost rejected the objects because Tiffany's prices were higher than what they were prepared to pay. More eager to exhibit his favrile pieces in Vienna than to make a few extra dollars, Tiffany agreed to a 15 per cent discount to conclude the deal.[43] To keep interest in the exhibition high, Bing and de Scala prepared an article on Tiffany glass for the first issue of *Kunst und Kunsthandwerk* (1898) in which Bing claimed that the American craftsman had finally uncovered the lost secrets of stained glass production.[44]

After showing in Vienna, some pieces went to a collector named Fix whose firm manufactured furniture; others were purchased by the Österreichisches Museum,[45] and the rest proceeded to exhibitions in Reichenberg, Brno, and Budapest.[46] Fried-

134. Charles Cottet, *Fishing Boats*, undated, etching. Jane Voorhees Zimmerli Art Museum, Rutgers University, New Brunswick, New Jersey (H. 6 x W. 8¼″).

rich Deneken asked for Tiffany pieces for the Krefeld opening in 1898,[47] but he apparently bought nothing until he purchased a few Tiffany lamps the next year.[48] By then Bing had cornered the market for Tiffany pieces in England and on the continent, although he was now eager to move into other areas of entrepreneurial interest. He was ever sensitive to changes in taste and direction in the decorative arts, and his involvement with the Dresden exhibition and his pursuit of a larger public clientele on the continent suggested that he had set his sights on a higher goal: the creation of a decorative style not by selling the work of others but by sponsoring and controlling his own craftsmen. The two years prior to 1900 were spent implementing these plans.[49]

135. Louis Comfort Tiffany, *Vase*, ca. 1897. Österreichisches Museum für angewandte Kunst, Vienna.

These two Tiffany pieces were purchased from Bing in Paris in 1898. Others were purchased a year later from Bing/London, most likely out of the Grafton Gallery show.

136. Louis Comfort Tiffany, *Goblet*, ca. 1897. Österreichisches Museum für angewandte Kunst, Vienna.

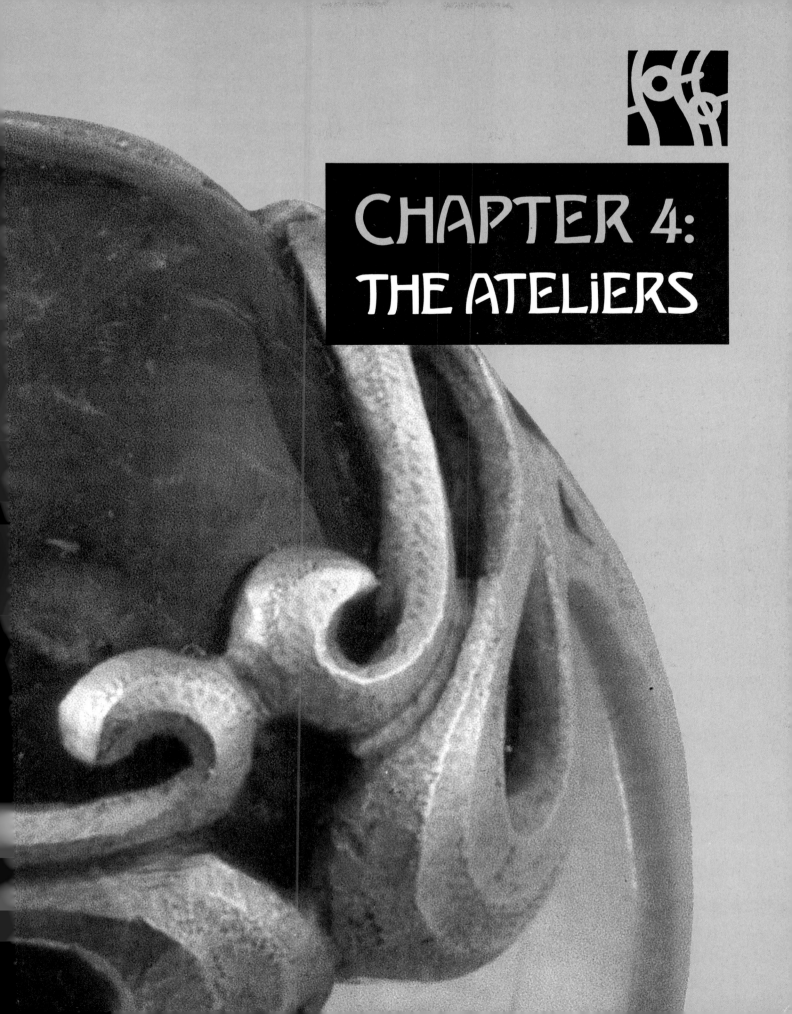

CHAPTER 4:
THE ATELIERS

137. *Interior of jewelry workshop at "l'Art Nouveau,"* ca. 1899–1900, reproduced in *Revue Illustrée*, July 1, 1900, vol. 30, no. 14 (Les Ciseleurs).

138. *Plan of 22 Rue de Provence and 19 Rue Chauchat showing the area to be redesigned,* 1899. Archives de Paris.

139. *Cross section of the Bing ateliers showing the area to be added for the jewelry area,* 1899. Archives de Paris.

140. *Plan of the jewelry ateliers,* 1899. Archives de Paris.

As time went on it became more and more apparent to Bing that the success of his *art nouveau* business, and of *art nouveau* in general, could no longer rest entirely on his acting as an agent for the artists and craftsmen who exhibited in his galleries. If he were ever to achieve the unity and quality of style he sought, he would have to build his own atelier, hire his own craftsmen, and direct them himself in the creation of models and prototypes. He had already begun to produce jewelry and other accessories, such as handbags, at *L'Art Nouveau,* but his quarters were far too small for the plans he now envisaged. In May of 1899 Bing petitioned authorities for permission to enlarge his property at 19 rue Chauchat. The renovation, probably again designed by Louis Bonnier, provided space for the production of jewelry, furniture, carpets, fabrics, tapestries, and ceramics.[1]

Special attention was given to jewelry production, partly because Bing's son Marcel was making his mark in that field, which assured the continuity of the jewelry workshops. Photographs taken in July 1900 show that the *bijoutiers* had ample work space and adequate light from a skylight and a large window (fig. 137). After adding a third story to an area (figs. 138–140) formerly used for storing Oriental objects, Bing gave the space over entirely to the *bijoutiers,* perhaps eight of them, who made not only pendants, rings, and necklaces but also letter stamps,

141. *Interior of the modelling atelier at* "l'Art Nouveau," 1899–1900, reproduced in *Revue Illustrée*, July 1, 1900 (Atelier de Modelage).

142. *Interior of the carpenters atelier*, 1899–1900, reproduced in *Revue Illustrée*, July 1, 1900 (Les Menuisiers).

metal boxes, mounts for ceramics, door locks, handles for furniture, and other luxury items.[2] Designers and cabinet makers occupied the other two floors (figs. 141–145). Such production must have begun by mid-1898 when Bing wrote to Deneken that he had "no more furniture by Van de Velde on hand, because I myself am now involved in the manufacture of furniture that will conform better to our local taste than does the Belgian output." Bing, however, could not yet sell or display the furniture because the pieces were only in the prototype design stage.[3] Besides, before adding to the atelier workshops, work space was limited, making any large-scale production unlikely. Although Bing occasionally contracted out the manufacture of ceramics, textiles, wall coverings, stained glass, and metalwork, all the furniture was produced on his premises.

Bing was an established furniture maker in 1898, even prior to the modernization of his ateliers. That year, the July issue of *Art et Décoration* featured a room for a lavish villa in the northern resort of Deauville embellished with furniture, lamps, wall decorations, and curtains from *L'Art Nouveau*. A buffet advertised in the same journal was also apparently produced in Bing's atelier, since it is found in his book of models preserved in the Musée des Arts Décoratifs in Paris.[4] At about the same time, *Dekorative Kunst* illustrated small objects made in *L'Art Nouveau*'s ateliers (fig. 146), which hint that Bing was already into production before he finalized his plans for enlarging his workshops.

A series of important articles for *Dekorative Kunst* gave further impetus to Bing's intention to institute himself as the major promoter of craft objects in the new style. In his first article, "Wohin Treiben Wir?" ("Where Are We Drifting?"),[5] Bing singled out John Ruskin for the rejuvenation of the decorative arts. Driven by his hatred of industrial blight and ugliness, Ruskin's combative nature, his "power of speech, and his irresistable art of persuasion" had converted many to his point of view, Bing noted. Ruskin had found young, enthusiastic artists to transform his ideas on the arts and crafts into works of art, and his Pre-Raphaelites were Bing's model for interrelating artists and artisans. Bing may have fancied himself another Ruskin, yet he parted company when it came to Ruskin's unbounded admiration for the past. As Bing believed, "This is where they made their mistake."

Another idol was William Morris, "the great reformer of the English House and everything connected with it. Window paintings, fabrics, tapestries, furniture, ceramics, book decoration, all this he embraced with the same artistic love; it was all unified by him to a harmonious entity, pure and simple, artistic, but in all parts strictly corresponding to the kinds of materials used." Morris, too, looked back to an archaic vision that seemed to Bing inappropriate for the end of the nineteenth century. Bing concluded in his first essay that the Ruskin/Morris tradition had in the end led the English arts and crafts movement into stagnation. No doubt this was

143. *Interior of the design atelier*, 1899–1900, reproduced in *Revue Illustrée*, July 1, 1900 (Atelier des Dessins).

144. *Interior of the cabinet-makers atelier*, 1899–1900, reproduced in *Revue Illustrée*, July 1, 1900 (Les Ebenistes).

why Bing severed his ties with English artists and sought his designers and artisans in the United States, Holland, and France.

His second article for *Dekorative Kunst* discussed another source for the decorative arts movement, namely Japanese art, which had freed this tradition in the West. Bing observed that it, too, had its pitfalls:

> After twelve or fifteen years people began to see more clearly. They noticed that a different perspective could be gained from Japanese art principles, if general trends rather than individual examples were followed. People began to understand that the main theme of Japanese art was an eternally young imagination which subjugates itself to nature and knows no higher aim than to look for the most delicate harmonies of the great master.... The main drawback [to this attitude] soon became apparent in the harmful effects it produced: having realized that the charm of Japanese art was based on its closeness to nature, everyone thought they understood its secret, and they began merrily to imitate every conceivable form of nature as faithfully as possible. A curious mistake!

The author wanted Western artists and designers to be inspired by the Japanese, their aesthetic, and their ability to infuse all objects with beauty. Japanese craftsmen, Bing reflected, were able to produce harmoniously composed interiors that created an air of tranquility and calm. He argued:

146. Alfred Daguet, *Copper-repoussé box*, ca. 1899–1900. Photo courtesy Bibliothèque, Musée des Arts Décoratifs, Paris.

147, 148. Edward Colonna, *Designs for a salt bottle and a purse*, executed by "l'Art Nouveau," ca. 1899, reproduced in the catalogue of *Exhibition of l'Art Nouveau-S. Bing, Paris*, Grafton Gallery, London.

The artist's imagination has to be held in check by certain, very definite rules. . . . Here the imitation of physical life is an absurdity, where art in an enclosed space is intended to supply peace for the eye and the nerves. The great mistake of so many artists of our time who want to renew our domestic environment is to misinterpret this inevitable requirement. Instead of striving for the tranquility which is mainly what makes an interior attractive as a refuge from the feverish haste of modern existence, they paint outdoor perspectives on the walls to create an impression that the walls have been opened up to permit a glance at the outdoors.

Bing thought Japanese stylization of motifs could be combined with Western traditions and used in home interiors, thus giving designers a chance to create bold, decorative forms.

Bing's third essay analyzed why the unification of the arts was proving so difficult. For example, artists had lost sight of fundamental principles, such as how the function of each object, no matter how small, determined its structure. Each piece must be designed to perform its function efficiently and still be economically reproduced, an attitude directly counter to the then fashionable notion of art-for-art's-sake. His craftsmen must understand that, above all, simplicity and structure ranked as the two criteria Bing sought in the works that would bear the name *L'Art Nouveau*. Artisans who emphasized literary content or symbolic significance over formalistic concepts were anathema, for Bing demanded "clarity of mind" in each designer.

In early 1898, a young creator, Edward Colonna (1862–1948), presented himself to Bing, who was so taken with his portfolio of designs based on an orchard motif that he hired Colonna on the spot.[6] The talented artist arrived on the scene just as Bing, eager to hire new craftsmen and designers, was expanding his workshop. At first Colonna designed jewelry, mirror frames, and other *objets de luxe,* such as jeweled silver hinges and clasps for purses, Oriental salt containers, and mountings for Tiffany favrile glass, with his typical whiplash curve (figs. 147–149), which, as it happened, was part of Bing's aesthetic program. According to Charles R. Richards, whose history of modern industrial design for the 1929 edition of the *Encyclopedia*

plate 29. Edward Colonna, *Ring*, 1899–1900, gold and emerald. Musée des Arts Décoratifs, Paris (D. ⅞").

Marcel Bing donated these two Colonna pieces to the museum in October, 1908.

plate 30. Edward Colonna, *Scarf clasp*, 1899–1900, gold and pearl. Musée des Arts Décoratifs, Paris (D. 1¼").

Britannica was based in part on a now lost memorandum written by Colonna, "The characteristic curve originated by the Belgian [Van de Velde] was adopted by Bing as the peculiar motive for *l'art nouveau.* . . . Bing crystallized [the different tendencies of modern design] into a style by the adoption of the whiplash curve."[7] Colonna's refined designs varied from the rather heavy furniture Bing produced in his studios,[8] and his tasteful sense of elegance quickly surpassed works by the other *bijoutiers,* including Marcel Bing. His designs and small objects were often singled out for praise by such critics as Gabriel Mourey,[9] although others who failed to understand the deliberate adaptation simply labeled Colonna's works derivative of Belgian motifs.

Reproductions in the periodicals *La Revue Illustrée* and *L'Art Décoratif* indicate that Colonna was at his best when working in an abstract style. Rings, scarf holders, and money holders inset with pearls and gems (fig. 150; colorpls. 29, 30) displayed a graceful linear rhythm that accentuated the structure and dynamism of intertwining lines. Colonna quickly mastered Bing's design language of clear, simple forms with only a trace of historicism. While he might occasionally start with a floral motif, like other craftsmen of the time, Colonna abstracted nature to create the impression of a flower bud or bloom held within a carefully constructed geometric scheme.[10]

Colonna's pieces soon became the backbone of Bing's business, and by the summer of 1898 a number of his works were on display at *L'Art Nouveau.*[11] Keller and Reiner of Berlin, dealers interested in *Jugendstil* and in promoting the modern movement in Germany, bought several of his objects. The next year, Colonna was extensively represented in Bing's exhibition at the Grafton Galleries in London[12] and at

La Libre Esthétique in Brussels. Through Tiffany and Colonna, Bing was determined to convince the English that the arts and crafts movement had gained new life.

While he exhibited his atelier's products in London, Bing tried to locate talented young designers who could take his aesthetic interests in new directions. He discovered Georges de Feure (1868–1943), a young Dutch artist active in France, whose literary and Symbolist paintings were often featured at the Paris Salons. De Feure attracted Bing's attention through his illustrations for Parisian periodicals and his poster designs for such enterprises as the *Paris Almanach* (fig. 151). (He specialized in images of seductive *femmes fatales* dressed in modish gowns and trailing garments that sometimes recalled the kimono-clad women in Japanese prints.) During the 1890s, however, de Feure shifted from painting and printmaking to designing crafts, with his first pieces of decorated furniture and ceramics being shown at the Salon de la Société Nationale des Beaux-Arts in 1894.[13] Now a painter and a craftsman, he was a natural for Bing's atelier. Although he never signed an exclusive contract with Bing, de Feure worked principally for the dealer by 1899 while cultivating his own private clientele.[14] Nonetheless, he soon surpassed Colonna in the sheer variety of objects he created for Bing's workshops.

Another young designer Bing employed at this time was the master furniture maker Eugène Gaillard (1862–1933). Unlike Colonna and de Feure, Gaillard considered himself a specialist only interested in creating furniture that reflected a piece's function and highlighted its material. In their elimination of useless ornamentation, Gaillard's designs tended toward abstraction. The most theoretical of these three craftsmen, Gaillard even published his own ideas of avant-garde furniture design in which he reiterated his hatred of "period styles" and established himself as a staunch advocate of the modern school.[15]

Despite Bing's enlistment of innovative designers and craftsmen, the workshop's output remained small in 1898, and only a few objects entered public collections. When they were in full-scale operation the next year, Bing organized an exhibition of his atelier's products to test critical reaction and public interest. He selected London for this show, believing, perhaps somewhat naively, he could win the British to his ideas. (Bing seemed to have already forgotten the nationalistic chauvinism that plagued his first Salon of *art nouveau* in 1895.) This show at the Grafton Galleries in London (fig. 152) also served as a small dress rehearsal for the Paris Exposition Universelle coming up in 1900.

Organizational problems, however, limited the exhibition to mounts for Tiffany glass and jewelry, with a few objects from Bing's original 1895 Salon. Ranson's window from the earlier set commissioned from the Nabis as well as some favrile pieces by Tiffany and works by the popular sculptor Meunier, included in London, may have already been shown at *L'Art Nouveau*. New works displayed encompassed

a series of stained glass windows designed by Frank Brangwyn and produced by Tiffany, numerous examples of colorful favrile glass, lamps, and a striking collection of jewelry created in Bing's workshops from Colonna's drawings.

The press and public proved indifferent to the Grafton Galleries show. Bing wrote in disgust to Durand-Ruel, who had lent some Impressionist paintings, "I firmly believe that it will still take a long time for most Englishmen to accustom themselves to the new school because I note that their first impression is close to stupefaction."[16] Four months later Bing added, "I regret the failure of the movement to which you have agreed to associate yourself. Great Britain is not yet ripe!"[17] Once again, the critics had refused to give Bing any credit for insight or ingenuity, as the following review attests:

"L'Art Nouveau" in Grafton Street.

How true it is that we must live and learn! Most of us, until a week or two ago, had probably never even heard of Louis C. Tiffany, of New York, and Constantin Meunier, of Brussels. And yet these "two widely differing personalities will forever count among the great geniuses of our epoch." So, at least, Monsieur S. Bing, of Paris, assures us; and, clearly, *he* ought to know, seeing that it is he who has undertaken "to comprehensively reveal their many beauties to the public of Great Britain." In other and more prosaic words he has opened an exhibition of their works at the Grafton Galleries, under the title of "L'Art Nouveau," which is the name, I understand, of a commercial establishment in Paris which "has set itself the task of bringing to light every manifestation within the sphere of Modern Art that exemplifies the needs of contemporary life"—whatever that may mean. M. Bing has also very kindly prefaced his catalogue with short biographies of the two geniuses he seems anxious to exploit. Louis C. Tiffany, it appears, is the son of the New York jeweller of that name, who, at a comparatively early age, paid a visit to certain Byzantine basilicas, which "filled his heart with a transport of emotion never felt before." Small wonder, then, that in such thrilling circumstances "Tiffany dreamed a dream of Art for the Future," or that "in the fossilised remains of our ancient patrimony were revealed to him the primordial principles that live for all time." This only means, in plain English, that young Tiffany proceeded to devote much study and experiment to the study of glass. Some of the results of his labours are to be seen at the Grafton Galleries, and certainly bear witness to a marvellous dexterity in the fabrication, and a great ingenuity in the use, of what he calls "Favrile Glass." But I am not at all sure that he does not in many cases "force the note" rather overmuch with the opaque and opalescent glasses that he produced. I am old-fashioned enough to think that the vitreous substance known as glass should be used as a medium for the filtration of light. To invest the material with a different character, to make it closely resemble highly polished stones of various colours, does not seem to me that supreme achievement of art which M. Bing, of Paris, considers it to be. In fact, this estimable gentleman, in his anxiety to create a Tiffany boom, resorts to the use of panegyric so excessive as to defeat its

plate 31. Louis Comfort Tiffany and Edward Colonna (att.), *Vase with silver mount*, ca. 1900. Museum of Decorative Art, Copenhagen.

own object. One is always inclined to resent having an author or an actor, or a poet, or even an artist in glass, forced down one's throat, and it is quite possible that I might have appraised Mr. Tiffany's efforts more highly had not M. Bing assessed their artistic value at so ridiculous a figure. Some glass windows, also the work of Mr. Tiffany, are exhibited, and they are undoubtedly rich in colour; but these, again, do not, in my opinion, deserve the immoderate praise that the preface to the catalogue bestows upon them.

The other "great genius of our epoch" who has been discovered by Monsieur Bing, of Paris, is Constantin Meunier, a Belgian sculptor, born no less than sixty-eight years ago. It would thus appear that even M. Bing, notwithstanding his critical insight, has taken some time to find him out. M. Meunier has of recent years found most of his models in the workmen of the Belgian "Black Country," and it is amongst them (to quote once more and for the last time the panegyrist of the catalogue) that he "feels his former vocation of sculptor revive within him" as he contemplates "the ever-distorted outlines of those moving statues with chests," and so on. The observation and sentiment of M. Meunier's work may be sincere, but the general result, I am bound to say, is infinitely depressing. For my own part, I found it impossible to take any interest in his "Belgian Puddler at Rest," or his Belgian "Mineur Accroupi." Surely Art may find better work to do than the interpreting of real life in all its sordid, and naked, and disheartening truth. Other things to be seen at the Grafton Galleries just now include a small collection of pictures by French and other foreign masters, a very interesting display of antique Japanese prints, and some specimens of jewellery executed by *L'Art Nouveau*. Nor should the visitor fail to notice that little anteroom which is hung with paintings on silk by Mr. Charles Conder for the decoration of a boudoir. These dainty silk panels possess a curious charm of their own, at once inimitable and indescribable.[18]

In spite of the review's sarcasm, it was at least comprehensive and early enough to attract an audience in mid-July. Other critics, such as Horace Townsend of *The Studio*, were more sympathetic.

Among the many art exhibitions which have been put before Londoners this season the historian of the future . . . will probably find that among those which chiefly claim his attention, not alone for their intrinsic interest but for their influence upon contemporary art, that which Mr. Bing, of Paris, has gathered together at the Grafton Galleries will hold a distinguished place. . . . A walk through the Grafton Galleries, and the mere casual examination of the cases in which the objects are exhibited, fills one first with amazement and eventually with bewilderment.[19]

Overwhelmed by the color and original shapes of Tiffany's glass objects, Townsend felt that the stained glass windows particularly reflected the American's reliance on experimentation and chance, which greatly differed from the way British craftsmen were taught to work. Brangwyn's windows provided an example of what this new standard could inspire.

152. Frank Brangwyn, *Poster for l'Art Nouveau Exhibition at the Grafton Galleries, London*, 1899, lithograph. Museum für Kunst und Gewerbe, Hamburg (H. 30 x W. 19¾").

> Mr. Tiffany's principle is practically to do away entirely with painted glass and to allow the folds of his drapery, the modelling of his figures . . . to be represented entirely by the accidental effects produced in the manufacture of the glass itself, rather than by lines or shadows painted on a sheet of clear and evenly coloured glass. . . . Never has this principle been carried to a greater extent than in the working out of the cartoons of Mr. Brangwyn. . . . Here even the faces are untouched by the painter's brush, and with an ingenuity of selection, which seems almost incredible, have been arrived at by what may be called "Accidentals."

Townsend noted that Tiffany's lamps, glass bowls, and vases with metal mounts designed by Edward Colonna (colorpl. 31) "somehow suggest but in no way [copy] Japanese *shibuchi*. Tin, brass, silver, and gold are run in a sort of pattern which is no pattern, into the bronze groundwork with an alluring effect." When he later addressed Colonna's jewelry (colorpls. 29, 30), Townsend took issue with the critics who had slighted these pieces:

> I must not, however, say good-bye to Mr. Bing's exhibition without calling attention to the small collection of jewellery designed by M. E. Colonna, of Paris, and executed at Mr. Bing's establishment "L'Art Nouveau." It will be seen from the illustrations accompanying this article that M. Colonna is proceeding on absolutely correct lines in his work. He relies on his jewels simply to accentuate the line of his designs, or for a portion of his colour scheme. The interest lies chiefly in the beauty of line and form, and the truly decorative quality of the gold work of the settings, rather than in the pecuniary value and meretricious glitter of the jewels themselves. Admirable use is made of pearls which are of comparatively small value, owing to their being in commercial eyes misshapen and bad in colour. Artistically they are beautiful, and of this M. Colonna has taken full advantage. . . . It must be remembered, too, that this jewellery is entitled to particular consideration, in that it is intended for commercial purposes, and not simply for the cabinet of the art collector.

While the English may not have purchased any of these pieces, several Germans traveled to London specifically to see the show and to buy Bing's objects. Deneken arranged with Marcel Bing to show Tiffany lamps in the Krefeld museum, although Tiffany apparently protested at first on the grounds that the Germans would copy his work.[20] Eventually the Krefeld exhibition of the fall of 1899 did include his lamps. These spectacular works were extensively reviewed and highly praised in Germany,[21] and numerous German museums, including those in Frankfurt and Leipzig, added them to their collections. That August, Bing wrote Deneken that he planned to reopen the Grafton Galleries exhibition in October to display the unsold works, and presumably to take advantage of the enthusiastic reception elsewhere, but little came of the idea. Instead, the elderly Bing directed his attention toward creating a grand display of *art nouveau* for the Exposition Universelle of 1900.

CHAPTER 5:
ART NOUVEAU BING

153. Georges de Feure, *Advertisement card for "l'Art Nouveau Bing,"*—*Installations Modernes*, 1900. Museum für Kunst und Gewerbe, Hamburg (H. 4⅝ x W. 5⅜").

154. *Verso of the card for "l'Art Nouveau Bing"*—*Installations Modernes*, 1900, with location of Bing's pavilion at the 1900 Exposition carefully pinpointed. Museum für Kunst und Gewerbe, Hamburg.

155. Louis Bonnier, *First sketch for "l'Art Nouveau Bing" pavilion at the 1900 World's Fair,* 1900, pen drawing. Institut Français d'Architecture, fonds Louis Bonnier.

This plan was not used, although the design, with two entrances to the building, was similar to what was eventually constructed.

Thirty years of Republican France and the hopes for a new century were celebrated by all nations at the Exposition Universelle Internationale of 1900.[1] Just as the Eiffel Tower had so effectively embodied the mechanical utopia of the 1889 Exposition, the magic of electricity transformed this fair into a wonderland for amusement and escape. France enjoyed a lighter mood, and Parisians delighted in the Exposition's gigantic playground and moving walkways that transported throngs of visitors along the Seine to astounding displays of industrial achievements and the latest creations in the arts. Each nation tried to outdo the next in the imaginative richness of their luxurious exhibitions, while independent entrepreneurs overwhelmed viewers with their own show of wares and interpretations of the "modern style."

Wood, fabric, and ironwork structures erected near the Pont Alexandre represented the new industries spawned by the international decorative arts movement. What had begun as a minimal revitalization had become a major industrial revolution that had successfully attracted an entire generation of young artists into the manufacture of crafts and furnishings. In the future, the homes of the very workers who mass-produced these art objects could conceivably be made comfortable and attractive by the fruits of their own labor.

Along the Esplanade des Invalides, pavilions showing the new decorative style in "home furnishings" from all the major European nations (except England) drew the

156. *Exterior view of "l'Art Nouveau Bing"
with glimpses of the interior areas*, 1900, *Album de références de l'Art Nouveau (Photo/Album Bing)*. Bibliothèque, Musée des Arts Décoratifs, Paris.

157. *Corner view of "l'Art Nouveau Bing,"* 1900, *Album Art Nouveau*. Bibliothèque, Musée des Arts Décoratifs, Paris.

greatest crowds. Josef Olbrich and Josef Hoffmann, two architects of the German Secession movement, each designed rooms. The Hungarians sent rustic furniture and wall ornaments inspired by Russian decorative arts, while the Scandinavians and the Japanese in particular contributed impressive pavilions. Critical response to these exhibitions was, unsurprisingly, little different from the narrow-minded misinterpretations meted out to Bing's avant-garde rooms five years earlier. Despite some enlightened entrepreneurs' attempts to elevate the nation's taste by featuring innovations from other countries, the general French chauvinistic attitude prevailed. The French derided the achievements of the Germans and Austrians, and blamed the Belgians for having started the new decorative style in the first place.[2] Some French critics commented favorably only on the quality of Scandinavian workmanship, yet all agreed that the Japanese alone had reached a pinnacle of refinement and elegance through their careful integration of design and subtle color harmonies.

In turn, French advancements in the decorative arts were depicted in several exhibitions that explored how the modern style could be efficiently mass-produced. (Two leading French department stores, Le Louvre and Le Bon Marché, financed these displays.) The pavilion of the Union Centrale des Arts Décoratifs boasted three rooms constructed to look like a jeweler's shop: one room was constructed so the wood used emulated its natural effect; a second room utilized iron and ceramics to recreate the appearance of station entrances to the subway; and a third exhibited fabrics and textiles. While the installation did feature ways to implement the day's new materials, it lacked the carefully integrated style of decoration that was by then fashionable. Visitors could hardly disguise their disappointment when they compared French exhibitions to the more imaginative displays of other European nations. Public attention turned to the unfinished building by S. Bing et Cie. as the only hope for saving the avant-garde honor of France.

Bing's pavilion, called *Art Nouveau Bing,* did not appear in the official catalogue of the 1900 fair,[3] which suggests that the gallery owner was a late invitee, although Bing did print business cards with a plan of the building location on back (figs. 153, 154). He may have planned at first to limit his exhibition solely to jewelry until he could sufficiently organize his workshops to produce a fully integrated ensemble of objects, which did not happen until late 1899. His display may also have been a last minute addition tacked on after the selection committee realized how much international attention Bing's Parisian-based style of decorative arts was attracting.

In any event Bing, with the preliminary assistance of Louis Bonnier (fig. 155), did not draw up plans for the pavilion and its six rooms or commission his craftsmen to complete the building's exterior decorative panels and its showroom interiors until close to the Exposition's opening on April 14. The pavilion was ultimately designed

by André Louis Arfvidson, a recent architecture graduate who may have been a friend of Marcel Bing or introduced to the elder Bing through Bonnier, now the architectural supervisor for the 1900 Exposition.[4] Architect and craftsmen alike worked under great pressure to open Bing's display before the Exposition Universelle closed on November 12 (figs. 156–158).

Arfvidson, Bing, and their craftsmen carefully coordinated their efforts to avoid errors in room dimensions that would throw off the placement of the floors' ceramic tiles and the stained glass for the skylights. The finished wood and plaster construction provided 200 square meters of exhibition space.[5] For the building's outside panels, Georges de Feure created ornate, flowing designs of female figures that embodied the very essence of the high style Bing sought in his workshops. He posed elegantly dressed ladies in long, trailing gowns at the front of a large house that probably represented Bing's shop at 22 rue de Provence (fig. 156). Whether the figures portrayed the Muses or not, they were readily recognizable as symbols of *art nouveau*.

To assist with all the facets of the pavilion's preparation, Bing hired Léon Jallot as his new *chef d'atelier* to oversee the artists' designs and the products of the craftsmen. (He was a young artist with some experience in furniture design; his early watercolors were naturalistic scenes [fig. 159], while his later studies of interiors stressed constructivist concepts with architectural elements [fig. 160]. His work became more simplified with the Art Deco of the 1920s and 1930s, but even the things he

160. Léon Jallot, *Project for a room interior: combination bookcase and sofa*, ca. 1900–1902, watercolor. Collection Maître Poulain, Paris.

161. Georges de Feure, *Design for a table*, ca. 1900, watercolor. Musée des Arts Décoratifs, Paris (H. 5⅛ x W. 7″).

These eight drawings, created for the craftsmen in Bing's ateliers, were given to the museum by Marcel Bing in 1919. Most of the pieces shown in these watercolors were *not* completed as prototype models. The *Table* appears as number 515 in the *Album de références de l'Art Nouveau* (*Photo/Album Bing*).

162. Georges de Feure, *Buffet*, ca. 1900, watercolor over pencil on tracing paper. Musée des Arts Décoratifs, Paris (H. 9¾ x W. 12").

163. Georges de Feure, *Lady's desk*, ca. 1900, watercolor over pencil. Musée des Arts Décoratifs, Paris (H. 8¼ x W. 11⅝").

164. Ateliers of "l'Art Nouveau," (possibly attributed to Georges de Feure), *Bookcase,* ca. 1900, watercolor over pencil. Musée des Arts Décoratifs, Paris (H. 11¼ x W. 11¼").

165. Edward Colonna, *Bookcase,* ca. 1900, brown ink heightened with white chalk on tracing paper. Musée des Arts Décoratifs, Paris (H. 11⅜ x W. 7⅝"). This piece, similar to number 282 in the *Album de références de l'Art Nouveau* (*Photo/Album Bing*) was identified as "Bibliothèque Victor Hugo." The completed piece was reproduced in *L'Art Décoratif,* January, 1901.

designed for Bing's shop were prototypical examples of furniture's modern direction.) Although Jallot stayed with Bing only a short time, his love of new materials and his ability to mold woods without overelaboration produced furniture designed by de Feure, Colonna, and Gaillard that perfectly meshed with the model room interiors being prepared for the Exposition.

Under Jallot's direction, Bing's atelier operated much like a large-scale factory in that specialists were hired to work out specific details for all pieces and the planned room environments. The workshop's craftsmen were organized into small units with precise functions, such as enlarging the artists' preliminary designs into working studies so the modeling atelier could prepare a maquette of the piece. If the object fit into an overall decor and its plan approved (with Bing having the final say), the piece was actually made. (One dining room chair was built in over a dozen versions before it was judged acceptable.) Only after it was scheduled for production was a furniture design, for example, given to the master cabinet makers, or *ébénistes.* Innumerable small drawings exist for pieces that never progressed beyond the preliminary design stage (figs. 161–167; colorpls. 32, 33), and other plans for

166. Atelier Georges de Feure, *Buffet*, ca. 1900, watercolor over pencil on tracing paper. Musée des Arts Décoratifs, Paris (H. 9¾ x W. 12″).

Although it is similar to those created by de Feure, this drawing may not have been specifically completed for Bing.

167. Georges de Feure (att.), *Dining room*, ca. 1900, ink and gouache. Musée des Arts Décoratifs, Paris (H. 14¾ x W. 19¾″).

168. Georges de Feure, *Studies for chairs*, 1900, watercolor over pencil. Musée des Arts Décoratifs, Paris (H. 7 x W. 13⅛").

These chairs were prototypes for the pieces de Feure created in 1900.

entire room ensembles reveal how pieces could be situated in the model rooms at the Exposition (fig. 168; colorpl. 34).

Between January 1900 and midsummer, Bing, now almost sixty-five years old, pushed his craftsmen to finish the installation at the Exposition Universelle. Everything in the pavilion was originally manufactured, with even the smallest nuance of each object carefully developed and harmonized. The cabinet work was not only technically admirable, but the bronzes, leatherwork, woven silks, embroidered upholstery, floor rugs, and glass windows, all of superior workmanship, were also stylistically consistent throughout the model rooms.

The designers and craftsmen who diligently worked to complete *Art Nouveau Bing* displayed a rare degree of camaraderie. Photographs of the wood sculptors posing in front of the Opera (fig. 169) include an older man, perhaps Bing himself, in the background. Other photos show Bing's craftsmen walking the streets of Paris (figs. 170, 171) in a joyful, even playful, mood.[6] Working toward a common goal of creating perfectly designed and carefully integrated environments, and led by Léon Jallot who is often found in these candid scenes, they apparently forgot daily problems and tensions. If Bing is indeed in these photographs, as he may be in at least two of them, his retiring presence provides not only an idea of how he shied away from publicity but also how he maintained some degree of distance from his employees, even in light of their united efforts.

plate 32. Georges de Feure, *Study for a rug*, 1900, gouache. Musée des Arts Décoratifs, Paris (H. 9⅞ x W. 6").

plate 33. Georges de Feure, *Study for a rug,* 1900, gouache. Musée des Arts Décoratifs, Paris (H. 9⅞ x W. 6″).

Bing played another role at the Exposition Universelle beyond that of exhibitor: he replaced the ill Tadamasa Hayashi as a judge of Japanese potters and porcelain makers.[7] Now an *hors concours* jury member, Bing was allowed his pavilion on the main thoroughfare near the Esplanade des Invalides, but he could neither claim awards nor receive financial aid from the French government. The half-million francs invested in *Art Nouveau Bing* must have come from his own personal fortune, an enormous commitment that reflected the enlightened patron's sincere effort to revive the decorative arts throughout Europe and to prove that France's leading designers could equal those of other countries.

The pavilion itself was small, with each room—dining room, bedroom, sitting room, a woman's boudoir, parlor, and foyer—designed to represent part of a stylish, modern home. When the dining room ensemble (fig. 172) was finally installed and decorated with panels by José María Sert, a then unknown Spanish artist, Gaillard's furniture (figs. 173–175) emerged as a pleasant surprise, at least to one reviewer.[8] Its metal handles and flowing details highlighted Gaillard's fondness for

. *Members of the Bing ateliers clowning in the streets of Paris*, 1900. Private collection.

171. *Members of the Bing ateliers enjoying a moment of relaxation*, 1900. Private collection.

abstract, whiplash lines, the leitmotif of *art nouveau*, as seen on the surface decorations of his large buffet (colorpl. 35). All executed in a lightly tinted walnut, the furniture and its subtle amber color also created a sophisticated mood and impressive visual contrast to Sert's murals, producing a decidedly novel impact: "The eye had been struck, conquered by the splendor before being able to analyze it." One of the most popular objects fabricated by Bing's ateliers were Gaillard's chairs (colorpl. 36), which were later added to the collections of several museums. This same reviewer commented that they "are among the most successful pieces to be seen. The bottom of the chair is connected by a short, curving piece of wood. This is the triumph of line, without which beauty would not exist."

Another reviewer of Bing's results, Jens Thiis, the Norwegian museum director, reported on the dining room cabinet:

[It] consists of a lower and an upper cabinet, of which the lower is the wider, the upper the higher. The upper part is provided with opaque glass doors and rises to an arched crown. On the sides are open shelves. The structure is entirely symmetrical, and none of the sides is curved; to that extent there is nothing extraordinary in the construction of this piece. It is the unconstricted treatment of form and decoration that gives it its peculiarly modern character.

All of the cabinet's lines are supple and flexible.... One cannot find a single sharp edge in the entire piece. Despite the fact that the cabinet's principal lines go in vertical or horizontal directions and are not, as rococo furniture is, made up of strong curves, they never meet at an angle. As the vertical line approaches the horizontal and prepares to join with it, it seems to anticipate it a good while beforehand. The resulting tension begins to tremble and undulate as it gathers energy, it becomes pliable and buoyant, begins to run and collides with the principal line. But the other [line] beside it is also ready; it has given up its meandering course and throws itself, undulating, against the other.

The encounter of the two lines becomes a conflict between two heterogeneous forces which, eventually, meet as in an embrace. With this coming together the ornamenting art is born—an indescribable curving and whirling ornament, which laces and winds itself with almost convulsive energy across the surface of the furniture!

It bears no resemblance to anything: it has nothing floral in it, is completely non-geometric, even less like a flame or a curve, but has a willowy toughness and an eely mobility.

These ornaments are nothing other than an organic expression of mobility impulses in the furniture's interior. The horizontal and vertical principal lines are like opposing chemical elements reacting upon one another—fighting with one another, but ultimately destined to combine into a new unit. The new unit is the bent line, the curve. And just as a chemical process is frequently accompanied by roaring and foaming, so do these lines make their connection with an ornamental roar.

The same principle is found in Van de Velde's art, but with the difference that, while Van de Velde pushes ornament back as much as possible, the organism of this later furniture unfolds itself freely and richly with many mobile lines that at times have an almost dramatic force. Gaillard's lines are much tamer and weaker, because they lavish their forces upon ornamentation. It is his weakness for elements of ornamentation which brings his style so close to the rococo and distances it so far from a constructive type of style such as the Gothic. But if it is rococo, so it is undeniably rococo in a new and original manner.

With all his abundance of carved ornaments, quickly raised, quickly sunk into the furniture's surfaces, and with the abundance of widely branching bronze mountings, which blend in with the carved ornaments and which match the patina-like flow...Gaillard's magnificent furniture

173, 174, 175. Eugène Gaillard, *Interior views of the dining room at "l'Art Nouveau Bing,"* 1900. Nos. 173 and 174 were reproduced in Théodore Lambert's *Meubles et Ameublements de Style Moderne* (Paris, 1904), while no. 175 was reproduced in *Kunst und Dekoration,* 1900.

The inclusion of Benson's metal pieces indicates that Bing was still selling these works in 1900.

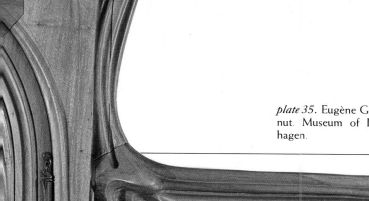

plate 35. Eugène Gaillard, *Buffet*, 1900, walnut. Museum of Decorative Art, Copenhagen.

plate 36. Eugène Gaillard, *Dining room chair*, 1900, walnut and leather. Museum of Decorative Art, Copenhagen (H. 37 x W. 17¾ x D. 16").

Art Nouveau Bing · 179

> does not at all lack constructive logic. It is always from the furniture's joints that the ornament gushes forth; and even if the abundance of ornamentation makes the overall effect rather restless, it does not disturb the principal lines in their function.[9]

The Museum of Decorative Art in Copenhagen eventually purchased the buffet for 7,500 francs.[10]

Both the dining room and the adjoining salon by Edward Colonna were illuminated by stained glass ceilings through which natural light filtered and changed the color of the room below during the day. Similar to Gaillard's dining room, Colonna's graceful salon was a marvel of delicate marquetry that contrasted with the subtle blue and yellow tonalities of the chair coverings and carpets (fig. 176). It was divided into two distinct parts: one area was intended for receiving guests and the other as a music room with a piano and a cabinet for storing sheet music (colorpl. 37). One chair's pierced back suggested a stylized plant (fig. 177); other chairs and a settee, upholstered in a variegated material, were composed of rhythmic curves and gently carved wood in shallow relief. A third grouping, the most widely sold of Colonna's designs, presented more complicated decorations in high relief and elaborate marquetry. Since pieces were sold almost as soon as they appeared, the salon showed several different suites of Colonna furniture over time, but remarkably the room's visual unity never collapsed. The many critics who studied *Art Nouveau Bing*, in fact, remarked on the salon's overall effect, rather than its individual objects. Perhaps only Bing, his craftsmen, and a few exceptionally observant visitors noticed that some works changed from time to time.

Despite the ingenious flexibility of the salon's decoration, Thiis was somewhat less enthusiastic about Colonna's effort:

> Colonna works in a manner similar to Gaillard's, but the dependence of his furniture on Van de Velde is possibly even stronger. Compared with Gaillard, he is simpler, more daring in his form, and less lavish in his ornamentation.
>
> Colonna's salon interior was, however, a still clear testimony to . . . the tendency of this style toward the spirit of the rococo. A look at one of the easy chairs in that room was sufficient to convince one of that. On the whole, as in the rococo style, the chair's form is bent and arched like the form of the body and is intended to enclose the sitter easily and firmly within its upholstered surfaces. Only the furniture's ornamentation is sparser and simpler than the rococo.

The full "S" line of the rococo style is likewise extended and drawn out
to a greater slenderness, approaching a straight line in the legs of the chair
and the table. With the greater slenderness there was also the aim of the
utmost lightness. An exaggeratedly delicate, sickly pale color scheme con-
tributed to the air of effeminate over-refinement of the whole interior.

Yet undeniably the salon's elegant atmosphere and "air of effeminate over-refine-
ment," as well as its rococo-style decor of slender furniture that emphasized the S
curve, forged a link with the past that helped to make the rooms more attractive to
the French.

In an attempt to create something new in Bing's atelier, Georges de Feure de-
signed a second salon even more feminine in effect than Colonna's interior (fig.
178). Gilded furniture and chairs upholstered in embroidered material with a high-
ly stylized plant and tendril motif produced an arresting impression of glitter and
swirls (fig. 179; colorpls. 38, 39). As usual, some critics praised de Feure's efforts,
and others found the furniture uncomfortable. De Feure also contributed a woman's

boudoir (figs. 180, 181), which some thought was more sophisticated in its light furniture made of natural Hungarian ash. One chair with gentle, artful Empire lines was subtly highlighted by floral details embroidered onto the silk covering (colorpl. 40). The immense wardrobe held a double mirror which allowed the user to survey the entire environment while dressing. Rumors circulated that the whole room had been purchased by a Russian princess, but the fate of the boudoir is in fact unknown.[11]

Thiis again gave his opinion, this time of de Feure's environments.

> While Gaillard and Colonna avoided the use of floral forms in their orna-mentation, de Feure cultivated flower ornaments with an effeminate feel-ing for their tenderness. Taken on the whole this accomplished, decadent artist has a fascinating grace of line and a sweetness in his coloring which seems to be inspired by over-refined and capricious women. Next to de Feure, Gaillard's style seems almost plump and Colonna's, daring and sober.
>
> Just as his bathroom harmonized color with its light, so light illumi-nated . . . the American ash of the silver tipped wardrobe cabinet, with pearl-gray feet on the padded furniture, with a couple of simple roses embroidered with pale silk upon the backrest of the chair, and upon the main rest of the chaise; the floor was covered with deep, soft rugs—hya-cinth-blue and flesh-colored rose. It was a masterpiece of suggestive color-ing: one felt the cool morning light; one received the impression of soft, morning apparel, lace and wide sleeves; one imagined the familiar per-fumes from the vanity mixed with the fragrance of the wardrobe made of sweet cedar wood.
>
> And if one stepped from it into de Feure's boudoir one had the same impression of dear, anemic womanliness. The light enters subdued by a large gently colored glass window. The walls are covered with heavy silk on which pale rose branches have been appliqued. The . . . almost trem-bling furniture pierced by an iris motif was clearly first formed in wax by a sensitive artistic hand. Thereafter it was cut in wood and covered with pure gold leaf by a gilder. And the small upholstered areas at the side and the back of the chair and the couch were covered with silk embroidery in faded and tinted colors. The floor cover is like deep moss. The color is a mute light-gray, as only cigarette ash can be, with a sprinkling of light red like fallen rose petals.

Thiis' descriptions help to reconstruct the subtly refined color harmonies Bing's artists created for designs that had been inspired by the arts of Japan filtered through French tradition.

This Norwegian reviewer later commented on de Feure's exterior panels (fig. 156), which took on added significance once he had been through the pavilion:

> On the [exterior] de Feure had painted decorative representations of the new art's muses with piquant taste—modern Parisiennes symbolizing the various technicians of the new decorative art.

plate 37. Edward Colonna, *Music cabinet*, ca. 1899, walnut, cherry, orangewood, and fruitwood. The Dayton Art Institute (H. 62¾ x W. 25 x D. 17").

plate 38 (opposite). Georges de Feure, *Gilded furniture from the sitting room*, 1900. Museum of Decorative Art, Copenhagen.

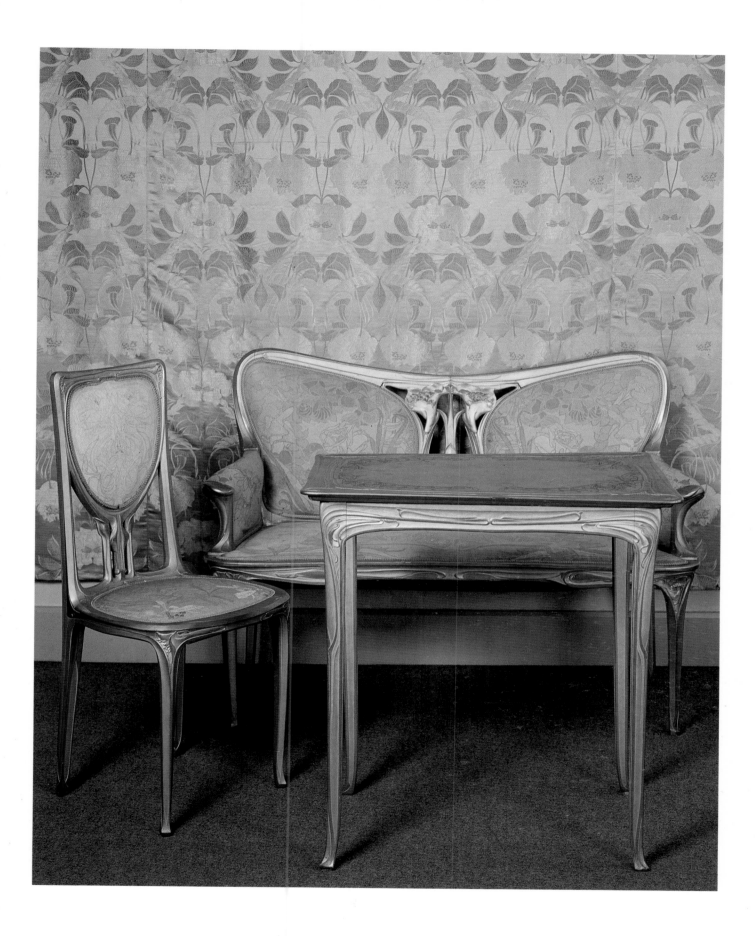

178. Georges de Feure, *Sitting room*, 1900, photograph from *Album de références de l'Art Nouveau (Photo/Album Bing)*. Bibliothèque, Musée des Arts Décoratifs, Paris.

Slim and proper in form, they are dressed in tightly fitting, filmy attire, and over the full coiffures which frame their pale faces billow mighty, fantastically plumed hats. But below the knee falls the modern bell-like skirt and, like a splendid peacock tail, the train sweeps around their little feet, decorated with bizarre embroideries in the "new style."

One of them holds with her little fingers a pitcher with fired glaze and symbolic ceramics on a backgound of ceramic ateliers which stretch their high chimneys toward a dreary sky. Another has modern jewelry around her slim neck; a third, a modern art piece of lace wrapped around her middle. But throughout there is the same composition of exaggerated slenderness and seductive exuberance, which is the charm of de Feure's furniture style. Over all of it shines an anemic beauty and a whiff of over-refined sensuousness, which is the essence of the decadent coloring of his interiors.

Rather than the rising sun of the coming century, this "new art" appears to symbolize the evening twilight of refinement, which has settled over French intellectual life and which, with a worn but still not worn out catchword, calls itself "fin de siècle."

His linking Bing's design to fin-de-siècle decadence illustrated how avant-garde and traditional arts could be intertwined. *Art Nouveau Bing* epitomized the arts and crafts movement carried to the heights of supreme elegance, and Thiis and many others now saw the elderly dealer as the apostle of the style he had christened *art nouveau*.

A bedroom, an entranceway with a large divan conceived by Gaillard, and a connecting passageway with stained glass windows by de Feure (figs. 182–184), as well as tapestries, carpets, stained glass, mirrors, wall coverings, and painted friezes, all of consistently high quality, completed the model rooms. No other display at the Exposition received similar intense scrutiny from art journals or had its objects as seriously appreciated and enthusiastically purchased by foreign visitors as did *Art Nouveau Bing*. Pieces not by Bing's artisans, particularly sculpture and ceramics, were borrowed from his shop at 22 rue de Provence, which was inundated with foreigners eager to take these and other *objets d'art* back to their home countries.

In addition to the workshop pieces that filled his pavilion's six rooms, Bing exhibited a selection of *art nouveau* jewelry (figs. 185, 186; colorpls. 41, 42), ceramics, and mounts for glass.[12] Examples of metalwork included candlesticks designed by Georges de Feure, executed in gilded copper, and decorated with stylized plants in bloom or stems and tendrils (fig. 187). Other metal pieces, such as drawer pulls and locks, were presented as a group, implying that they could be manufactured for any appropriate object.[13] Some of Colonna's metalwork complemented a fireplace or a mirror, while other pieces recalled the exterior panels on Bing's pavilion in their use of the female figure. Colonna and Marcel Bing principally produced the jewelry on view. An abstractly patterned clasp for a cape incorporated Colonna's characteristic use of green enamel and pearls to enrich the work's surface. In turn, Marcel Bing often designed jewelry tied to recognizable shapes, such as a pendant of a woman whose falling hair created an intricate, flowing pattern (colorpl. 43).

The Bing ateliers turned out both luxury objects for a select clientele and pieces that could be mass-produced and marketed for the less affluent customer. Although Bing claimed that his workshops tried to create well-designed, utilitarian objects for the modest consumer, his prices and level of perfection in jewelry, rugs, and wall hangings made it inconceivable that they were intended for any but the rich and sophisticated. A few pieces made in cheap metal and stamped with the mark of the Bing atelier (figs. 188, 189) did display the typical curvilinear pattern of *art nouveau* but were carelessly constructed and far from the imaginative design and exquisite

plate 39. Georges de Feure, *Silk embroidered seat cover*, 1900. Musée des Arts Décoratifs, Paris (H. 21¼ x W. 17").

179. Georges de Feure, *Silk embroidered seat cover*, 1900. Musée des Arts Décoratifs, Paris (H. 17¾ x W. 23⅝").

craftsmanship of Bing's best examples by de Feure or Colonna.[14] Belt buckles and inkwells (figs. 190, 191) may have been among a number of secondary pieces fabricated by Bing's designers to meet the growing demand for *art nouveau* objects. Bing indeed may have nurtured the popular consumption of *art nouveau,* just as he had cultivated French appreciation of Japanese art on both an antiquarian and a popular level.

180. Georges de Feure, *Dressing room*, 1900, photograph from *Album de références de l'Art Nouveau* (*Photo/Album Bing*). Bibliothèque, Musée des Arts Décoratifs, Paris.

Always known as a ceramics enthusiast, Bing was named president of the Foreign Section for the Exposition Internationale Artistique et Industrielle de Céramique of St. Petersburg in 1900.[15] In this role, Bing obtained objects for the exhibition and located ceramicists whose work would interest Russian consumers. Privately, he also used this opportunity to look for a manufactory to produce quality porcelains for his own shop. Little probably came of this search in time for the Paris Exposition, but he eventually selected the firm of Gérard, Dufraisseix and Abbot of Limoges to create pieces from drawings submitted by de Feure and Colonna, with Bing retaining the right of rejection and oversight. Porcelains produced by G.D.A. were obviously ready for market by early 1901, when they were shown at the Salon of the Société Nationale des Beaux-Arts, with Bing acting as patron. They also earned high awards at the first international exhibition of decorative art held in Turin the next year.

One of the most notable of G.D.A.'s productions[16] was Edward Colonna's table service, known as the Canton service (figs. 192, 193), which marked the second time that Bing supported a complete dinner set. (The first, Edouard Vuillard's plates [colorpl. 17–19], had employed motifs from the Nabis.) Colonna's preliminary drawings of the Canton service were sent to Limoges so artisans there could work out their production system. Some experimental pieces were created with gold, pink, and green borders—Bing thought the Canton service would appeal to more

181. Georges de Feure, *Second view of the dressing room*, 1900 (contemporary photograph).

182. Eugène Gaillard, *Bedroom*, 1900, photograph from *Album de références de l'Art Nouveau* (*Photo/Album Bing*). Bibliothèque, Musée des Arts Décoratifs, Paris.

plate 40. Georges de Feure, *Chair*, 1900, American ash. Nordenfjeldske Kunstindustrimuseum, Trondheim (H. 34⅞ x W. 16⅝ x D. 15¾").

plate 41. Marcel Bing, *Pendant*, 1900, gold and mother-of-pearl. Musée des Arts Décoratifs, Paris (H. 2 x W. 1⅜").

customers if it were offered in a variety of different colors—but he gave his final approval only to the light green set. Decorated with a purely abstract intaglio pattern, the Canton service was widely demanded and collected, and even served as Gustav Stickley's tableware in his Craftsmen restaurants in the United States.[17] This proved to Bing's satisfaction that a well-designed table service would sell, although he later had to add a tureen and a large oval platter (fig. 194) for foreign customers, especially Stickley who needed bigger pieces for his restaurants.

Between mid-1900 and a year later, Bing asked de Feure and Colonna to submit a series of designs, which were then manufactured into porcelains in Limoges. Their completed objects, exhibited at the Salons of 1901 and 1902 as well as at the 1902 Turin exhibition, included a large card tray (fig. 195), a container for matches (colorpl. 44), and a number of porcelain vases (fig. 196; colorpls. 45, 46). By 1902 an ink pot and a chocolatière (colorpls. 47, 48) joined the group along with several vases and pitchers.[18] Some pieces, however, were never publicly shown and may simply have been trial works or models Bing found unacceptable (colorpls. 49, 50).

At the Salon of 1901, Georges de Feure's display of works (fig. 197) featured a square vase that flared slightly at the bottom and was decorated with a frieze of petals (fig. 198) whose stems accentuated the porcelain's length. A second porcelain, a small circular container shown at the 1901 Salon (colorpl. 51), appeared in several variations bearing de Feure's mark or that of *Art Nouveau Bing* (the name of his pavilion gradually became associated and intertwined with that of his *L'Art Nouveau* gallery), or both.[19] The 1902 Salon included one of de Feure's most impressive vases, which he called *La Neige* (colorpl. 52). Gustave Kahn described its decoration in his review as "a young woman, elegant and a little elongated, as his aesthetic likes them, dressed in winter garb wandering among the well-drawn violet silhouettes of stylized trees or large flowers, depending on the interpretation."[20] As seen in his earlier objects, de Feure's reliance on delicate colors to depict fashionable Parisian women was very typical of his decorative style. A second vase (fig. 199), shown in 1902 and reproduced in *Art et Décoration*, incorporated a charming motif of flowers and flying birds and became one of Bing's best-selling items. Colonna also exhibited several porcelains at the 1902 Salon. (One work still owned by G.D.A. may have been among them.) Yet unless the artist's mark was on the object's base, critics could not always tell which of Bing's craftsmen had designed a particular work. This confusion of identities helped Bing to make the *art nouveau* style appear unique unto itself, rather than a disparate collection of works by distinctly individual artisans.

With all of his furniture, porcelains, and other finely produced works of art, Bing devoted an overwhelming amount of attention to the details and craftsmanship of the objects that would bear his name. He commissioned high-quality products from the textile firm of Scheurer and Lauth in Thann in Alsace as well as from a glass

plate 42. Edward Colonna, *Sugar spoon*, 1900, vermeil (gilded metal). Musée des Arts Décoratifs, Paris (L. 5¾ x W. 2").

plate 43. Marcel Bing, *Pendant*, 1900, copper and enameled gold. Musée des Arts Décoratifs, Paris.

manufactory in Darmstadt,[21] two companies willing to follow his rigid specifications and accommodate his small quantities and tight deadlines. Bing's relationships with numerous outside firms, an important aspect of his business acumen, provided him with a greater range of goods than he could possibly produce in his own atelier and widened the variety of his manufacturing endeavors.

In spite of his hurried efforts to construct the *Art Nouveau Bing* pavilion and decorate it with the best of the new style, Bing's exhibition opened so late in the run of the 1900 Exposition Universelle that what few reviews did appear served more as retrospective essays summing up his contributions to the decorative arts movement. *Le Figaro* carried no review (Arsène Alexandre was still its critic).[22] The only major review in the daily press was Jules Rais' article in *Le Siècle* on November 13, in which he remarked that numerous artists in several pavilions had adapted the *art nouveau* style. He also had kind words to say about Bing's installations, particularly mentioning "the solid dining room and well-balanced bedroom by Gaillard, the delicate salon by Colonna, and especially the delightfully understated dressing room and boudoir by de Feure," whose work Bing had nourished and disciplined.[23] Otherwise, the French daily press granted Bing little extended comment, probably because *art nouveau* still remained above the head of the average reader, if not the newspaper critic as well.

Although Bing's objects were both too sophisticated and too expensive to attract a mass market, he enjoyed an overwhelming success with the international visitors who sought out his pavilion, wrote about it when they returned home, and purchased his products as fast as they became available. In his article for the Belgian review *L'Art Moderne*, Octave Maus explained:

> It is only last week that Bing has been able to open—or shall we say pull together, since not everything is finished—the lovely pavilion in which he has created a type, at the same time elegant and comfortable, of modern apartment.... The pavilion of l'Art Nouveau is not easy to discover. But once found, one gladly wants to visit it again, because its appearance is enticing and one can see in it, beautifully realized, some lovely pieces of furniture executed in the modern style—neither English nor Belgian—which strive and sometimes manage to combine with today's aesthetic the traditional elegance of French furniture.... For the first time perhaps, the "modern style" is becoming truly luxurious and will resolutely enter fashionable apartments.[24]

Maus interpreted Bing's model rooms as an effort to chart a stylistic path between tradition and other countries' applications of exaggerated floral decorations and overattenuated designs. In comparison, Bing's avant-garde style now appeared more fully under control. His furniture stayed well within the bounds of the estab-

lished principles of French cabinetry, although, aside from a faint suggestion of the eighteenth century, his designers managed to divorce themselves from period styles.

One of the few articles published the moment the pavilion opened in July, Maus' review attracted many of the Exposition's international visitors, including the Japanese, to *Art Nouveau Bing.* Favorable reviews in *L'Art Décoratif,* the new edition of Meier-Graefe's *Dekorative Kunst,* lauded Bing for revitalizing French interior design. In its June issue, an advance review reproduced preliminary drawings for Gaillard's dining room (fig. 200) and de Feure's stained glass windows symbolizing the seasons. Illustrations of rugs and tapestries by de Feure and Colonna indicated that the pavilion would be designed as an actual house with all its decorative accoutrements in place.[25] Rather than view a random display of objects, visitors could see how pieces fit together and, if they wished, purchase a complete decor in the latest fashion.

In August, *L'Art Décoratif* addressed Bing's jewelry display near the pavilion proper, discussing at length works by René Lalique, Edward Colonna, and Marcel Bing. The author, Léon Riotor, felt that this exhibition "brings together an ensemble of pieces in which one could note that they lack some of the diversity which so pleases French taste. But, an effort is made toward a superior taste."[26] Gustave Soulier, an art critic writing a review for the August issue of *Art et Décoration,* praised the furniture of Gaillard and Colonna. Meier-Graefe then featured an article explaining how the Bing workshops had effectively revived the French decorative tradition, as the model rooms aptly proved. This was followed by an article by G. M. Jacques, who, in September's *L'Art Décoratif,* singled out de Feure's work as the epitome of elegance so long lacking in France, adding that only the designer's furniture had been updated. Jacques found the rooms' treatment of wall decoration satisfactory but not really revolutionary, but he later called the wall coverings and stenciled patterns monotonous. The walls were, admittedly, the weakest point of all the Bing rooms, which implied that in producing the other individual objects not enough time and attention had been given to the walls themselves. Generally, however, connoisseurs judged Bing's model rooms a complete success.

Perhaps the most laudatory review was Gabriel Mourey's long, enthusiastic article, "L'Art Nouveau de M. Bing à l'Exposition Universelle," for the *Revue des Arts Décoratifs.*[27]

> Once they have crossed the threshold, a delightful surprise awaits all visitors—whether one is an artist in whom no matter how feebly beats a feeling for beauty—because I am pleased to declare, without being contradicted, that nothing in the foreign or French sections of decorative arts is superior to this exhibition of l'Art Nouveau. Here is the most successful

186. Edward Colonna, *Double coat clasp*, 1900, green enamel and baroque pearl. Musée des Arts Décoratifs, Paris (L. 5⅛").

187. Georges de Feure, *Candelabra*, 1900, silver-plated bronze. Musée des Arts Décoratifs, Paris (H. 10¼ x W. 13⅞").

direction attempted in this area, and one must congratulate in this success, without reservation, not only the initiator of the enterprise—S. Bing—but the artists to whom he has entrusted its realization.

Although the designer of each of the six rooms could be determined by stylistic differences, the rooms together formed a larger, integrated vision, as Mourey noted: "In passing from one room to another, one senses nevertheless a type of unity reigning and also a common tendency manifesting itself, along with a unique will." He commended Bing for avoiding the exaggerations and contortions then evident in some contemporary designs and for achieving instead the elegance of a controlled, balanced style. Mourey later reexamined Bing's contributions to the decorative arts since 1895, recalling the artists he had introduced to France, the originality of *L'Art Nouveau*'s output, and the superior work of his craftsmen.

Mourey's assessment of *Art Nouveau Bing*, which appeared in part in *The Studio*, introduced these model rooms to the English public. His praise for Bing's ability to create "one of the most perfect pieces of combined decorative art work in the whole

Exhibition"[28] made up somewhat for the unenthusiastic reviews of the 1899 Grafton Galleries show, and English journals such as *The Studio* and *The Cabinet Maker and Art Furnisher* soon joined in applause for the artisans in Bing's group.[29]

In Germany, Max Osborn reviewed Bing's pavilion for *Deutsche Kunst und Dekoration* and featured the best photographs then published of the model rooms.[30] Osborn described in detail de Feure's panels with their fashionably dressed women and discussed at length how furniture and wall decorations revealed Bing's ability to select artists of talent. *Die Kunst*'s review, "Der Bing'sche Pavillon L'Art Nouveau auf der Weltausstellung," drew parallels between Belgian innovations and traditional French styles.[31]

Official publications on French art and industry, including Gustave Geffroy's review in *Les Industries artistiques françaises et étrangères à l'Exposition Universelle de 1900*,[32] were also positive in their judgments, as was René Puaux in *Art et Décoration*. "Today Art Nouveau Bing is universally known; at the exhibitions of decorative art it is seen as the official representative of France. It is true that it possesses the rare happiness, the almost exclusive monopoly, of a delicious artist named Georges de Feure, and one cannot disassociate today these two names, and that one should be happy to unite in glory those who are united by a common daily labor and who—one as much as the other—truly merited being recognized by this century so enamored of art and beauty."[33]

The United States was introduced to Bing's shop through an article titled "The Arts and Crafts Movement at Home and Abroad," published in the American journal *Brush and Pencil*:

> Most of the new things in decorative art for the home can be seen at the exhibition of "Art Nouveau," 22 rue de Provence. It is half salesroom and half exhibition room, but wholly artistic and exceedingly interesting. There you find the latest designs in furniture, the newest thing in jewelry and wrought gold, and not only the absolutely new things that are made in the studios attached but you find as well samples of the best decorative domestic art of other countries. For instance, in one large case were specimens of the Rörstrand pottery, which is more beautiful than the Copenhagen ware. There was also a vase from the Grueby pottery, near Boston, really most artistic, the lotus-cup for the central part and leaves terminating in long filaments surrounding it....
>
> There is a Tiffany vase, mounted in silver, gilded, set with coral, and toned to harmonize with the warm color of the glass. The most perfect specimens of favrile glass are selected for mounting, and a design that supplements and completes the special form of the vase is made. The idea is that the mounting should be kept subordinate, and this is especially well carried out in another illustration of a flacon-shaped vase....There is some excellent work in wood at the "Art Nouveau" rooms in the smaller pieces of furniture. Our illustration shows an excellent model for a hat and

188. Anonymous, *Candle holder,* 1900 (aluminum?). Kantonales Gewerbemuseum, Bern.

189. Mark on the candle holder base.

190. Anonymous, *Belt buckle*, ca. 1900, silver. Österreichisches Museum für angewandte Kunst, Vienna.

Purchased from the Bing firm in 1906 for 25 francs, this transaction took place well after the closing of the ateliers.

191. Anonymous, *Ink-pot*, ca. 1900, ceramic with green and blue enamel. Österreichisches Museum für angewandte Kunst, Vienna.

This was purchased from Bing in 1903 for 20 francs.

192. Edward Colonna, *Coffee pot for the Canton service*, 1899–1900, porcelain. Musée des Arts Décoratifs, Paris (H. 9 x D. 2⅝").

Bing's son Marcel donated this to the museum in October, 1908.

plate 44. Georges de Feure, *Match-container*, ca. 1900–1901, porcelain. Collection G.D.A., Limoges.

plate 45. Edward Colonna, *Vase*, ca. 1900–1902, porcelain. Musée des Arts Décoratifs, Paris.

plate 46. Georges de Feure, *Vase*, ca. 1900, porcelain. Musée des Arts Décoratifs, Paris (H. 11 x D. 3¼").

193. Edward Colonna, *Oval platter for the Canton service*, ca. 1899–1900, porcelain. Private collection.

194. Edward Colonna, *Plate for the Canton service*, ca. 1899–1900, porcelain. Private collection.

200 · Art Nouveau Bing

coat rack. It is of walnut, beautifully grained and polished, and with hooks and screws of burnished copper. It is simple, strong, and practical. Our illustration shows a shelf for a dining room, with hooks underneath for cups or jugs, that is exceedingly good in line. It is of carefully chosen oak, finished and well set together, all done, of course, by hand, and very decorative in effect. Another illustration shows an exceedingly pretty tea-table of mahogany. Observe how the design is always adapted to the kind of wood. . . . Some of the most successful designs in the way of jewelry are in belt buckles and pendants. One is by Colonna, of gold, with a heart-shaped opal set in the upper left-hand corner. It is light in effect, and sufficiently solid looking. Another example is a pendant by Bing, made in gold with blue and the swan in white enamel, and is exquisite in workmanship.[34]

Generously illustrated with photographs of Bing's *art nouveau* pieces, the article no doubt enticed American visitors to 22 rue de Provence. The many objects seen in *Brush and Pencil* also reveal that Bing's shop was well stocked in spite of the drain on inventory caused by furnishing the pavilion.

In his comparison of *Art Nouveau Bing* with the Salon de l'Art Nouveau in 1895, the Norwegian Jens Thiis provided the most complete description of the pavilion:

> If, nevertheless, the impression of *Maison Bing* appears to the author of these lines to be less inspiring and less enthralling than the most modest series of interiors with which *L'Art Nouveau* opened five years earlier, it is because Van de Velde is a greater talent than the French artists who have now taken his place and to whom Bing has entrusted this difficult task. Gaillard and Colonna, too, are good and capable artists, even if they can-

not be a match for Van de Velde in artistic originality. And it was one of the exhibit's most pleasant surprises to see with what assurance and elegance the painter de Feure handled himself in the area of furniture composition—he has, undoubtedly, found the right field for his talent.

But while Van de Velde's interiors in the first exhibit of *L'Art Nouveau* were a real breakthrough to complete independence from historic styles, *Maison Bing* signified a compromise between the "new style" and Van de Velde's principles on the one side and the French favorite style, rococo, on the other. The bold freedom with which Van de Velde operates on a foundation of self-acquired insight and logic seems too reckless to French taste. Frenchmen will find security in the circumspect cleverness, supple elegance, and ingratiating tone which distinguishes Colonna's, Gaillard's and especially de Feure's modernism.

Nor can one but admire the nimbleness with which these, Bing's new artists, have understood to combine the new style elements with the thread of a rediscovered tradition. Some of the same charm which used to surround noblemen's radicalism is to be found in their art. The art in *L'Art Nouveau* has, for the most part, a radical character; but it has found its ancestry. It clearly bears rococo's family character, and no heritage can be more advantageous for art in the eyes of a Frenchman.[35]

The success of Bing's pavilion at the 1900 Exposition Universelle established Paris as one of the two centers in France—Nancy was the other—for the creation of a modern style in the applied arts,[36] and made Bing's designers famous. De Feure showed ceramics and Marcel Bing jewelry at subsequent Salons of the Société Nationale des Beaux-Arts.[37] Critics applauded the porcelains Bing introduced in 1901 and again in 1902, and heralded the jewelry designed by Colonna and Marcel Bing as the French contribution to a renaissance in the applied arts.[38]

In analyzing the achievements of French designers represented at the Exposition Universelle, Dr. Henri Cazalis, under the pen name Jean Lahor,[39] concluded that, above all, Bing's *L'Art Nouveau* and Meier-Graefe's *Maison Moderne* challenged the French establishment and forced young designers to create works with considerably more imagination than ever before. Their efforts made it amply clear that an international movement of considerable force and vitality was underway in France. Nevertheless, he reiterated, the French must bear in mind that English and Belgian artists in Bing's original exhibition in 1895 had provided the inspiration for all this activity. The French must seize the moment before they fall behind again.

Valiantly, M. Bing, to whom everyone owes a great deal for this artistic reform, opened his shop; but he had at first borrowed from foreign art, from the Belgians or the Americans, utilizing pieces in his exhibitions that were representative of the new tendencies. We had lost too much at first, the English invasion continued, bringing a little bit of everything—some good and some bad—and what was bad often compromising the cause.

plate 47. Georges de Feure, *Ink-pot*, ca. 1901–1902, porcelain. Collection G.D.A., Limoges.

plate 48. Georges de Feure, *Chocolate-pot*, ca. 1901–1902, porcelain. Musée des Arts Décoratifs, Paris.

plate 49. Georges de Feure, *Vase*, ca. 1901–1902, porcelain. Collection G.D.A., Limoges.

Cazalis continued to say that in jewelry, ceramics, glass, metalwork, and sculpture, Bing had, for the most part, acquitted the French of accusations of poor craftsmanship and inferior design. Even though the French manufactured fewer works than other countries, their objects were of finer quality and taste, and perhaps more expensive. He concluded, "The style in France should be in one word for all products the mark of a special distinction, of a shining superiority that would be inaccessible to others."

According to Cazalis, Bing's philosophic goal of creating a style that would improve the lives of ordinary people meant that art had left the province of the elite. In the future, expositions, museums, applied art schools, and magazines would instill the masses with a more refined taste, while carefully regulated workshops and mechanized production would make the new style available to all. Through Bing, France would become the leader of the design reform movement.

Bing must have felt vindicated by Cazalis' assertion that the Exposition Universelle had confirmed the victory of *art nouveau.* He had recognized that only the challenge of English and Belgian innovations would release French decorative artists from the fetters of tradition. The foreign designs he and Meier-Graefe had brought to Paris had forced the French to move forward, reasserting their superior-

200. Eugène Gaillard, *Drawing for a dining room*. Photograph from *L'Art Décoratif*, June, 1900.

ity in decorative design. His own workshops, largely staffed by French artisans, had helped to create a decorative style that could stand up to the best works produced elsewhere, and his dealings with museum directors and curators throughout Europe had ensured that *art nouveau* would be introduced to ever wider audiences. Yet Bing knew that the next few crucial years would reveal whether or not the new movement would fully take root.

plate 50. Georges de Feure, *Vase,* ca. 1901–1902, porcelain. Collection G.D.A., Limoges.

plate 51. Georges de Feure, *Small bonbonnière,* ca. 1901–1902, porcelain. Musée des Arts Décoratifs, Paris (H. 2¾ x D. 3⅛").

plate 52. Georges de Feure, *Vase called "Snow,"* ca. 1901–1902, porcelain. Photograph courtesy Musée des Arts Décoratifs, Paris (H. 8¼ x D. 5").

CHAPTER 6: THE FULL FLOWERING

plate 53. Louis Comfort Tiffany, *Lamp*, ca. 1900. Museum of Decorative Art, Copenhagen.

In a letter to museum director Pietro Krohn, Bing mentioned that this Tiffany lamp, along with other pieces, had been sent to Copenhagen.

plate 54. Edward Colonna (silver mount) and Auguste Delaherche (stoneware ceramic), *Pitcher*, ca. 1900. Museum of Decorative Art, Copenhagen (H. 2¾ x D. 2").

This piece was purchased from Bing in July, 1900, for 200 francs.

Judging from the attention Bing's shop drew in 1900 as well as over the next few years, *art nouveau* had arrived. In 1902 Bing placed an advertisement in *Art et Décoration* (fig. 201), boasting that the furniture shown in *Art Nouveau Bing* had been purchased by museums all over the world, ranging from the Victoria and Albert in London and the Kaiser Wilhelm Museum in Krefeld to applied and decorative arts museums in Berlin, Kaiserslautern, Leipzig, Hamburg, Mulhouse, Nuremberg, Budapest, Graz, Lemberg, Vienna, Copenhagen, Naples, St. Petersburg, Helsinki, Aarau, Bern, Trondheim, and Tokyo.[1]

The Museum of Decorative Art in Copenhagen, to which Bing had earlier given a handsome collection of Japanese ceramics, lacquerware, metalwork, and textiles (figs. 9–13), bought a number of *art nouveau* objects for its permanent collection (figs. 202–204; colorpls. 53–58).[2] Pietro Krohn, the museum's director and Bing's

202. Eugène Gaillard, *Keys to the buffet,* 1900. Museum of Decorative Art, Copenhagen.

203. *Bill of sale, Art Nouveau,* 1900. Archives, Museum of Decorative Art, Copenhagen.

close friend who had originally worked at the ceramic manufactory of Bing and Gröndhal in Copenhagen,[3] visited *Art Nouveau Bing* in mid-October or November, although, guessing from his relatively large total bill of 14,984.50 francs, he had purchased pieces for the museum throughout the year. Among the objects the Copenhagen museum acquired were a matte glazed Grueby vase with a delicate plant motif across its top (colorpl. 55)—as Grueby's agent in Europe, Bing sold a similar piece to the Victoria and Albert Museum—and selected pieces from Eugène Gaillard's dining room that were reserved in June before the show even opened. Gaillard's polished walnut buffet with frosted glass doors flanked by open shelves and decorated with copper appliqued whiplash curves (colorpl. 35) brought 7,500 francs, a considerable price for the time. Another dining room piece, an embossed leather-backed chair with rivets and uncovered supports in front and along the sides (colorpl. 36), sold for 350 francs. In January 1901 the museum purchased yet another item from the Gaillard dining room: a walnut dado with copper appliqued details (colorpl. 58) costing 725 francs. Krohn may have wanted to reconstruct the entire model room, but no records document his results.

Krohn also bought pieces from de Feure's sitting room and boudoir, including a chaise, chair, table, small carpet, and a tapestry (fig. 204; colorpls. 38, 57;). Covered in an embroidered pattern with two flowers and a stalk at its center, the chaise, which sold for 2,500 francs, was featured in many of Bing's advertisements. The tapestry that might have hung behind it is now in fair condition, and de Feure's stylized abstract floral pattern, so similar to his designs today housed in the Musée des Arts Décoratifs in Paris (fig. 205), is still visible. Bing used a brocade in a corresponding design on the walls of the original installation (fig. 206). The Danish museum purchased a large amount of this wall brocade, again possibly for the model room's reinstallation in Copenhagen.

Although de Feure's boudoir was decorated with small carpets, which the critic Mourey described as "silken," Krohn bought mohair or wool ones with abstract floral designs (colorpl. 57) for 500 francs. Another purchase was a hanging gilded *étagère* (colorpl. 56) that was not displayed in Bing's pavilion but included instead in an album of furniture Bing produced through his shop, where it was identified as the "étagère Copenhague."[4] This suggests that the piece was either made especially for Krohn or he obtained a unique example. Krohn also invested in a stoneware cream jug created by Delaherche and mounted in silver after Colonna's designs, a rare Tiffany lamp (colorpl. 53), and possibly a series of mountings and furnishings by Georges de Feure (fig. 207).

Jens Thiis, director of the Nordenfjeldske Kunstindustrimuseum, was similarly enthusiastic about *Art Nouveau Bing.* (Based on his direct observations, his report in the museum's 1901 yearbook remains the most thorough evaluation of Bing's model

plate 55. Grueby and Company, *Vase*, ca. 1900, earthenware. Museum of Decorative Art, Copenhagen (H. 11¼ x D. 5¼").

Secured from Bing in April, 1900, this ceramic cost 189 francs.

plate 56. Georges de Feure, *Hanging "étagère,"* 1900, gilded wood. Museum of Decorative Art, Copenhagen.

This was purchased from Bing for 1,500 francs.

204. Georges de Feure, *Wall covering*, 1900, silk. Museum of Decorative Art, Copenhagen.

This large work, purchased in November, 1900, cost 320.50 francs.

205. Georges de Feure, *Sample of wall covering*, 1900, silk. Musée des Arts Décoratifs, Paris.

206. Georges de Feure, *View of sitting room with fireplace*, 1900, reproduced in Théodore Lambert, *Meubles et Ameublements de Style Moderne*, Paris, 1904.

plate 57. Georges de Feure, *Rug,* 1900, mohair. Museum of Decorative Art, Copenhagen (L. 76 x W. 47½").

Purchased from Bing in November, 1900, for 500 francs, this work was reproduced in "Le Tapis moderne," *Art et Décoration,* 1903.

plate 58. Eugène Gaillard, *Dado for the dining room,* 1900, walnut. Museum of Decorative Art, Copenhagen (H. 39 x L. 76¼ x D. ¾").

The price of 425 francs included several of de Feure's handles for furniture.

rooms.) Like Krohn, Thiis purchased pieces for his museum in Trondheim, but he had less money to spend. Instead of selecting a number of pieces from one room or trying to recreate an entire installation, Thiis settled for smaller but equally typical examples of *art nouveau* furniture, metalwork, and glassware. After he left the Exposition, Bing sent him a notice for shipping a chair from the woman's dressing room (fig. 208), for which he owed 280 francs. He also selected a table and glassware by Colonna for 500 francs (figs. 209–211), a Tiffany lamp (colorpl. 21), and iron furniture handles and lock plates for doors (figs. 212–217) that reflected the Norwegian predilection for metalwork. Thiis hoped these works of art would inspire local craftsmen to incorporate new motifs into traditional patterns, an idea the Decorative Arts Society of Trondheim must have shared, for they controlled the funds for some of these museum purchases.

In 1900, Ernst Nordstrom, director of the newly formed Finnish Decorative Arts Society and part of the official Finnish delegation to the Exposition Universelle, also traveled to Paris. Despite Finland's own innovative pavilion, Nordstrom was allotted 2,000 marks to spend on objects of modern French design for the decorative arts museum in Helsinki. He acquired works by the leading ceramicist Taxile

207.

208.

Doat, ceramics by Delaherche, glass by Gallé, and Antoinette Vallgren's bookbindings. At *Art Nouveau Bing* he purchased two chairs for 638 marks, one from Edward Colonna's salon, the other from Eugène Gaillard's dining room (fig. 218).[5]

The popular success of the Finnish Pavilion in 1900, and the Finns' eagerness to compete with French designers and painters, led one of their most accomplished painters, Albert Edelfelt, to organize in the fall of 1901 an exhibition of both French avant-garde and conservative artists.[6] Paintings by Charles-Emile Auguste Carolus-Duran and Pascal Adolphe Jean Dagnan-Bouveret appeared next to prints by Jacques Villon and Charles Maurin. Decorative art objects included cigarette boxes, ceramics, pendants, brooches, and tiepins designed by Marcel Bing.[7] Georges de Feure was well represented by his vases, plates, fans, cup and saucer sets, candlesticks, and a candelabrum. Almost all of these pieces bear the name *L'Art Nouveau* on their base, indicating that they were made in association with Bing's atelier.

Jewelry and ceramics, among other works from *Art Nouveau Bing*, were known to command substantial prices. As discussed in the illustrated Finnish journal *Ateneum*

209.

(1901), one necklace cost 550 francs and a de Feure vase could fetch as much as 150 francs.[8] These high prices tended to define Bing's market for such luxury items as Gaillard's dining room table (fig. 219) and a complete set of his chairs, which were purchased by the affluent young couple, Mr. and Mrs. Knut Andersson of Sweden (fig. 220). They had traveled to Paris on their honeymoon in 1898 and discovered Bing's shop, *L'Art Nouveau*, where they purchased a ceramic vase by Clément Massier (fig. 221) and *Mother and Her Child*, a bronze plaque by Alexandre Charpentier (fig. 85). (Both pieces figured prominently in Bing's first Salon of *art nouveau*.[9]) The Anderssons may have returned to Paris for the 1900 Exposition, or they may have seen Gaillard's works on a previous visit. Perhaps they simply ordered a dining room ensemble from *L'Art Nouveau* and left the details to Bing. Either way, the table and chairs cost the astounding amount of 4,000 francs. Bing presumably attracted other wealthy clients in Sweden, for the Anderssons could hardly have been alone in their admiration of *art nouveau*, considering the important status Bing's objects had by then acquired in Scandinavia.

207. Georges de Feure, *Handles for furniture*, 1900, gilded metal. Museum of Decorative Art, Copenhagen.

208. Letter sent to Trondheim by S. Bing to Director Jens Thiis, October, 1900. Archives, Nordenfjeldske Kunstindustrimuseum, Trondheim.

209. Edward Colonna, *Table*, ca. 1899, polished purple wood. Nordenfjeldske Kunstindustrimuseum, Trondheim.

The Trondheim museum bought this and the next seven works from Bing between July and October, 1900.

210. Edward Colonna (att.), *Glass*, ca. 1900, tinted glass. Nordenfjeldske Kunstindustrimuseum, Trondheim (H. 4⅝ x D. 2¾″).

211. Edward Colonna (att.), *Wine carafe*, ca. 1900, tinted glass. Nordenfjeldske Kunstindustrimuseum, Trondheim (H. 10⅝ x D. 2¾″).

210.

211.

212. Edward Colonna, *Mount for furniture*, ca. 1899–1900, bronze. Nordenfjeldske Kunstindustrimuseum, Trondheim (L. 3").

213. Edward Colonna, *Mount for furniture*, ca. 1899–1900, bronze. Nordenfjeldske Kunstindustrimuseum, Trondheim (L. 2¾").

214. Edward Colonna, *Mount for furniture*, ca. 1899–1900, bronze. Nordenfjeldske Kunstindustrimuseum, Trondheim (L. 4½").

215. Anonymous, *Mount for furniture*, ca. 1900, brass. Nordenfjeldske Kunstindustrimuseum, Trondheim (L. 5").

216. Selmersheim, *Handle*, ca. 1900, brass. Nordenfjeldske Kunstindustrimuseum, Trondheim (L. 4⅛").

212.

213.

214.

215.

216.

217. Henry van de Velde, *Handle*, ca. 1900, brass. Nordenfjeldske Kunstindustrimuseum, Trondheim (L. 11⅞").

This was purchased from Bing in February, 1901.

In Germany, however, Bing's family and business ties with dealers and collectors there made it comparatively easy to generate a market for *art nouveau* works. International expositions of applied arts, such as the Dresden show of 1897, and Meier-Graefe's support also helped. His friend and fellow *japoniste* Justus Brinckmann,[10] director of the Kunst und Gewerbe Museum in Hamburg, facilitated and sponsored Bing's contacts with other museums, particularly those with directors he had trained. In turn, Brinckmann visited the Paris Exposition with almost 100,000 marks to spend and the authority to select whatever he wanted, perhaps intending to form the most outstanding collection of contemporary applied arts anywhere.[11] He bought from *Art Nouveau Bing* a vitrine, stand, table, and chair from Colonna's salon (colorpls. 59–61), one of Gaillard's major buffets (colorpl. 62) and a chair from his dining room ensemble, a Dalpayrat ceramic with mounts by Marcel Bing (colorpl. 63), and other smaller objects. The museum's bulletin published news of the Bing acquisitions to announce that the Kunst und Gewerbe Museum had become a significant collector of the new style.

Friedrich Deneken, director of the Kaiser Wilhelm Museum in Krefeld and another of Bing's many business associates, was also eager to acquire examples of *art nouveau* for his institution. Since Krefeld was an industrial city that produced crafts and tapestries, local museum exhibitions and collections naturally tended to reflect these new directions in the decorative arts. For one of the Krefeld museum's first exhibitions in 1897, Deneken, who was exceptionally knowledgeable of *Jugendstil* and other arts and crafts movements throughout Europe, chose to display *art nouveau* ceramics by Bigot, Dalpayrat, Dammouse, Delaherche, and the firm of Bing and Gröndhal.[12] Unlike other German museum directors, however, Deneken showed a preference for works by Georges de Feure, such as those on view in Bing's pavilion, and he purchased strap hinges and other de Feure-designed metalwork pieces for the museum, which arrived in Krefeld on November 29, 1900. Draperies in Deneken's own home may well have come from the Paris workshop.[13]

The Krefeld Museum soon acquired numerous objects from Bing's shop, including ceramics by Dalpayrat and Dammouse (colorpls. 64–67), glass vases and lampshades by Tiffany, and a clothes hook and other metalwork designed by Colonna.[14] Following Brinckmann's advice, Deneken also purchased three pieces of furniture from Colonna's salon: a mahogany table, a popular item Bing produced in different versions, for 450 francs; a mahogany chair that originally displayed an abstract flower design (fig. 222) for 250 francs; and an armchair for 312.50 francs. (De Feure's pieces, among other works owned by the museum, were apparently destroyed during World War II.)

Deneken's involvement with *art nouveau* reached to Georges de Feure himself, who worked on the catalogue for a Japanese art exhibition that the Krefeld museum

arranged to tour Germany. Apparently "an unsettled type," de Feure managed to send only two drawings to Deneken before the stated deadline.[15] The exhibition presumably went on as scheduled, since other museums expressed an interest in the show and another edition of the catalogue was prepared. Nevertheless, Bing also avoided using de Feure any further, for, as he wrote to Deneken, "After all the chances I have given him to gain experience and further his talents in the making of small objects, and after my sensational production of items according to his design, after all that, success has so swollen his head that it is difficult to deal with him. In any event, he has chanced upon some capitalist with whose help he is about to establish his own workshop (for however long this may last)."[16] In spite of this skepticism, de Feure's work caused considerable excitement at Bing's 1903 exhibition at *L'Art Nouveau* (fig. 223), but the Kaiser Wilhelm Museum seems to have stopped purchasing *art nouveau* objects from Bing by then.

Bing's sales to other German museums at this time may well have been as extensive as those to Hamburg and Krefeld, but records for the Kaiserslautern museum, which may have purchased a few objects, and the Kunsthandwerk Museum in Leipzig, which may have bought furniture from the model rooms at the Exposition, were destroyed during World War II. Records of Bing pieces in permanent museum collections or displayed in museum exhibitions, such as the international art show in Dresden in 1901,[17] have been found, but subsequent acquisitions cannot be traced. The Museum für Kunsthandwerk in Frankfurt-am-Main bought six silk-and-

velvet designs by Colonna and de Feure at the Exposition Universelle, along with a chair from the Gaillard dining room and a vase by Dalpayrat with mounts by Marcel Bing,[18] while the Staatliche Kunstgewerbemuseum in Berlin secured pieces of furniture as well as works by Tiffany, Emile Gallé, and Clément Heaton from Bing's pavilion.[19] Several exquisite Rookwood ceramics (colorpls. 68–70) were purchased by the Nuremberg museum in 1901, which suggests that Bing served as the European agent for this American firm even after the Paris Exposition. He also sold the museum a de Feure tapestry and a spoon and fork (colorpl. 71) from a dessert service.[20]

New museums, in addition to more established art institutions, sought out examples of innovative decorative styles for their growing collections. When the Kantonales Gewerbemuseum opened in Aarau, near Zurich, in 1895, it developed exhibitions of both regional and international contemporary applied arts that would serve as models for local craftsmen in this center of the Swiss furniture industry.[21] The museum definitely purchased furniture from *Art Nouveau Bing*, although which ones remains unknown. Already a home for the rich, Switzerland undoubtedly provided Bing with a number of private clients for his *art nouveau* objects as well.

Like the heads of several other European museums, the director of the new Kantonales Gewerbemuseum in Bern journeyed to the Paris Exposition. In his report published in the museum's yearbook, the director briefly commented on Bing's installation, from which he purchased furniture, glassware, metalwork, leather pieces, and glazed tiles.[22] The furniture has since disappeared and the museum's original collection dispersed, but of the few Bing works that still exist, the most unusual is a lightweight aluminum candle holder that could be one of the few surviving mass-produced objects Bing marketed (figs. 188, 189). Bearing the inscription "L'Art Nouveau, 22 rue de Provence" on its base, the piece may have been part of de Feure's *cabinet de toilette* at the 1900 exposition (fig. 224).[23] Other pieces the Bern museum acquired ranged from a number of furniture handles by Colonna and ceramic tiles (figs. 60, 61), roughly 7¾ inches square that sold for ten francs each and coincided with designs by Henry van de Velde to a copper tea service (colorpl. 72) that could have been created by Alfred Daguet, an artisan in Bing's atelier.[24] Their group of tooled leather pieces with floral or animal motifs resembled works by Paul Pierre Jouve.[25]

A client with more complete documentation of its transactions with Bing was the Österreichisches Museum für angewandte Kunst in Vienna. Throughout the 1890s Bing had sent his exhibitions to its first director, his friend Hofrat de Scala, and had sold the museum a series of impressive Tiffany glass objects (figs. 135, 136) and a few textiles. In September 1899, the museum purchased for 125 francs each two

Colonna rugs (figs. 225, 226) possibly made in Germany.[26] Two years later it bought a sample of de Feure's printed silk (fig. 227) and an extremely elegant velours, most likely created by P. A. Isaac (fig. 56).[27] Museum representatives at the Exposition Universelle sent a small table by Edward Colonna (fig. 228) back to Vienna, which was placed on display as a model for student craftsmen to copy in the museum school (fig. 229). The city museum of Graz, another Austrian institution that collected Bing's works of art, bought a Colonna table, a Gaillard chair, and another chair possibly by de Feure.[28]

Later in 1900, Bing took an active role in developing exhibitions for an international exposition held in St. Petersburg, and he no doubt hoped to obtain wealthy clients in Russia, although no evidence remains that he sold anything there. Bing most likely visited Russia, since he was well informed about Russian craftsmanship

plate 60. Edward Colonna, *Plant stand*, 1900, pear-tree wood. Museum für Kunst und Gewerbe, Hamburg (H. 46⅛ x W. 14¼").

plate 61. Edward Colonna, *Round table*, 1900, fruitwood, veined-wood, and rosewood. Museum für Kunst und Gewerbe, Hamburg (H. 27⅝ x D. 24⅞").

The museum in Hamburg acquired these pieces in 1900.

222. Edward Colonna, *Arm-chair*, 1900, mahogany. Kaiser Wilhelm Museum, Krefeld.

and decorative style. The Moravska Galerie in Brno, Czechoslovakia, however, bought several pieces from *L'Art Nouveau* in 1901, including a buffet by Eugène Gaillard (fig. 230), a Tiffany favrile vase (fig. 231), and a copper-plated vase by Rookwood and Company (fig. 232).[29] Similarly, the Museum of Decorative Arts in Budapest purchased a group of pieces by Colonna and de Feure (fig. 233) as well as an unusual *portemanteau* by Gaillard with a rich surface pattern of curvilinear lines that suitably epitomized the *art nouveau* style (fig. 234).[30]

Even though numerous Japanese visitors attended the Exposition Universelle, and Bing had enjoyed a long and fruitful association with that country and its arts, Japanese interest in *art nouveau* was apparently limited. A museum in Tokyo did acquire some pieces of furniture,[31] perhaps for a collection of Western art or to show Japanese craftsmen what their Western counterparts were producing. Yet considering their decorative aesthetic and dedication to fine craftsmanship, the Japanese may not have been overly impressed with European designers' creations. Despite a period of Westernization in Japan, no records indicate that rich Japanese customers purchased *art nouveau* objects either, but Bing's pavilion certainly did not go unnoticed. Asai Chu, one of the most famous painters of modern Japan, toured *Art Nouveau Bing* on July 12, 1900, and published his account of his visit the next January:[32]

> I would like to report briefly on what I saw there. A certain M. Bing is a famous dealer in curios and a designer, who is in fact one of a number who collected old Japanese paintings and vases and introduced the taste for these objects into European countries. The other day I visited him twice and saw his things. All sorts of Japanese objects were shown me, including a surprising collection of vases. There was a mountain of hanging paintings, nishiki-e, albums. . . . His connoisseurship is incontestable and excels ours. When Mr. Fukuchi, who accompanied me, showed him many prints, I was delighted to see him identify each old painting and select all the best ones. As a designer, he employs many designers and craftsmen in his shop and produces there many pieces of metalwork, pottery, glass, and other objects. These manufactories are all situated at his shop, the main part of which is used as a gallery. Here there is an enormous number of objects; Bing is recognized as the director of this atelier. We were told that the only thing produced elsewhere is the textiles. What an enviable life! It must be pleasant to earn money in such an interesting way. One style in evidence in all this work we have identified as the "line prolonged encircling" style. It is true that his style smacks a little of bad taste, but it is new, it is surprising, and it is welcomed by contemporary people. Though he is quite erudite and prudent, there are many that speak badly of Bing because he is a Jew and good at making money.

As hinted in this article, the Japanese were somewhat skeptical of the inherent good taste of Bing's new style. Given the Japanese love of tradition and care for

223. Georges de Feure, *Entrance-card to the de Feure exhibition*, 1903 (contemporary photograph).

making objects, they may not have understood how any creation, old or new, could be divorced from tradition. Asai and other Japanese connoisseurs remained cautious and aloof, commenting only on *art nouveau*'s surprising elements but displaying little enthusiasm for it.

Despite the cool reaction of the English to his exhibition at the Grafton Galleries in 1899 and to the jewelry designed by Edward Colonna, Bing had not completely given up on the British market. Always a good customer, the Victoria and Albert Museum[33] purchased twenty-four objects from Bing for 3,833 francs, including ceramics from the Swedish firm of Rörstrand and Company, works from the Grueby, Rookwood (figs. 235, 236), and Tiffany firms in America as well as from Bing protégés Alexandre Bigot, Colonna, and Alexandre Charpentier (figs. 237, 238). English collectors may have purchased furniture by German designers such as Otto Eckmann, but they bought only one piece, a table by Colonna, from *Art Nouveau Bing*. While they may still have preferred the English school to the new style, customers in Great Britain definitely remained loyal to the more traditional designs generated by the Grueby or Rookwood firms. Since Bing continued to serve as the European agent for these American manufactories, the English at least admired him for his promotion of other firms. Nonetheless, Bing's *art nouveau* objects never sold well in England, which may be why he ceased pursuing British markets and relied instead on those on the Continent.

Oddly enough, French public reaction to Bing's pavilion at the Exposition remains the most difficult to judge. Daily newspapers were consistently silent, while art journals, almost all of which were controlled by Bing's colleagues and friends, wrote glowing reviews. Bing actually may not have sold many objects to the French. Given the large inventory he disposed in 1904 when he closed *L'Art Nouveau*, sales in France probably were not as brisk as he would have liked. A few villas in Deauville and an occasional home along the north coast were decorated with works by Colonna, but no extravagant French client ordered an entire ensemble of furniture or a completely decorated room like those shown at the fair.

One French institution with an extensive assortment of objects from *Art Nouveau Bing* was the Musée des Arts Décoratifs, whose collection grew from donations made primarily by Marcel Bing after the Paris Exposition. Among the works the museum did obtain within the Bings' lifetimes were a ceramic tigerware creamer designed by Bigot with silver mounts by Colonna (fig. 149), purchased in 1899 for 175 francs, a small Tiffany vase, a series of porcelain plates created by Colonna and de Feure (figs. 239, 240), and pieces of Colonna's Canton service. After an exhibition at the Salon of the Société Nationale des Beaux-Arts in 1902, the museum secured a number of pieces produced by G.D.A. in Limoges (fig. 241; colorpl. 73).[34] None of these purchases proves, however, that Bing's model rooms exerted a lasting

influence on the curators of the Musée des Art Décoratifs, who may have limited their acquisitions to ceramics and glass because they felt they were competing with the Musée National de Céramique in Sèvres and the Musée Adrien Dubouché in Limoges. On the other hand, the curators' failure to collect even major pieces of furniture until 1902—they bought de Feure's vitrine from that year's Salon—may have indicated that the *art nouveau* aesthetic was simply too radical for official museum taste.

All in all, the French were uncommitted to Bing's *art nouveau*, for it developed from Belgian innovations rather than French decorative traditions. Japanese and English collectors remained indifferent. Despite American design contributions, the United States understood little of European *art nouveau*. It seemed that Bing's

plate 63. Marcel Bing (silver mount) and Adrien Dalpayrat (stoneware), *Vase*, ca. 1900. Museum für Kunst und Gewerbe, Hamburg.

plate 64. Adrien Dalpayrat, *Vase*, 1897, stoneware. Kaiser Wilhelm Museum, Krefeld.

These vases were purchased between 1898 and 1900.

plate 65. Adrien Dalpayrat, *Vase*, ca. 1897, porcelain. Kaiser Wilhelm Museum, Krefeld.

plate 66. Albert Dammouse, *Vase*, 1897, stoneware, Kaiser Wilhelm Museum, Krefeld.

plate 63.

plate 64.

plate 65.

plate 66.

creative works sold best in countries that emphasized new design and used his pieces as teaching models, and thus only in Germany, the Austrian Empire, and Scandinavia did the new style take root. Somewhat surprisingly, it was the central European countries that lauded Bing as the foremost promoter of a new decorative style.

In the whirl of activities surrounding the Exposition Universelle, Bing maintained his interest in both Japanese art and new trends in European painting and sculpture. He organized a small exhibition of works, mainly portraits, by Marie Bermond, a friend of Auguste Rodin and Emile Bourdelle, in March 1902. Her landscapes and still lifes, similar to the dreamy Symbolist images of Eugène Carrière, gave the exhibition a pleasant atmosphere. *La Revue Blanche* found the works had "some delicate nuances, some fading smiles, some hair-dos which fluff upward

224. Georges de Feure, *Dressing-room*, 1900. Photograph from Théodore Lambert, *Meubles et Ameublements de Style Moderne*, Paris, 1904.

225. Edward Colonna, *Rug*, ca. 1899, wool. Österreichisches Museum für angewandte Kunst, Vienna.

These two rugs were purchased from Bing in September, 1899, for 125 francs.

226. Edward Colonna, *Rug*, ca. 1899, wool. Österreichisches Museum für angewandte Kunst, Vienna.

or fall down."[35] Women artists were then in vogue and often participated in the Salons of the Société Nationale des Beaux-Arts—Bermond first exhibited there in 1893—so this noncontroversial exhibition was guaranteed to make Bing popular with the powerful Parisian feminists who were campaigning for equal status with male artists.

Paintings by the little-known German artist Félix Borchardt were displayed the next month.[36] While Borchardt's paintings followed the Neo-Impressionist techniques of Georges Seurat and Paul Signac, they also presented Parisians with a non-French version of these artistic styles. Landscapes of regions in Germany and pastel portraits of elegant women and children completed the exhibition, which was briefly reviewed in *The Studio* and *La Revue Blanche*.[37] Sponsoring this show further indicated Bing's decision to direct his business away from objects and focus again

plate 67. Alexandre Bigot, *Vase*, 1895, stoneware. Kaiser Wilhelm Museum, Krefeld.

plate 68. Rookwood Pottery, *Vase* (designed by Rose Fechheimer), 1899, faience. Gewerbemuseum der L.G.A. Bayern, Nuremberg (H. 8¾ x D. 4¾″).

Such Rookwood vases were selected from Bing's stock in January, 1901.

plate 69. Rookwood Pottery, *Vase* (designed by Anna Marie Valentien), 1899, faience. Gewerbemuseum der L.G.A. Bayern, Nuremberg (H. 10¾ x D. 9⅛″).

plate 70. Rookwood Pottery, *Vase* (designed by Kataro Shirayamadani), 1897, faience. Gewerbemuseum der L.G.A. Bayern, Nuremberg (H. 11½ x D. 7⅛″).

plate 67.

plate 68.

plate 69.

plate 70.

plate 71. Georges de Feure, *Dessert fork and spoon*, ca. 1901, silver. Gewerbemuseum der L.G.A. Bayern, Nuremberg (L. 7½").

Purchased from Bing in 1901, this work was reproduced in *Deutsche Kunst und Dekoration* and in *L'Art Décoratif*.

plate 72. Alfred Daguet, (att.) *Tea service*, ca. 1900, copper. Kantonales Gewerbemuseum, Bern.

on contemporary painters. Certainly Meier-Graefe, in his shop *Maison Moderne*, was likewise shifting from the applied arts toward Impressionist paintings.

A special exhibition devoted to Japanese foliage, especially dwarf trees, opened in May 1902.[38] In June Bing held two shows, one of works by Paul Signac, the other of sculptures by Meta Warrick. Signac's 123 pictures offered a representative sampling of his oils, pastels, and watercolors, and Arsène Alexandre's introductory essay evaluated Signac's contribution by comparing his *oeuvre* to that of his contemporaries Maximilian Luce, Camille Pissarro, Henri Cross, and Charles Angrand. *La Revue Blanche* regarded the Signac show significant for providing visual evidence of the artist's written theories. The review later praised Signac's clarity of touch from which "dryness is completely absent in the canvases Bing exhibited; all witness a happy meeting of elements which orchestrate themselves, support each other, and are unified, strong, firm pages."[39]

Exhibiting Meta Warrick's sculptures was a more daring enterprise for Bing. A black American artist working in Paris, Warrick had developed her own artistic style while studying in France's leading academic ateliers. Auguste Rodin, greatly impressed by her understanding of sculptural form, allowed Warrick to work in his studio, where she produced a number of symbolic works that critics labeled strong

plate 71.

plate 72.

227. Georges de Feure, *Fabric sample*, ca. 1900, silk. Österreichisches Museum für angewandte Kunst, Vienna.

228. Edward Colonna, *Round table top*, 1900, inlaid wood. Österreichisches Museum für angewandte Kunst, Vienna.

Similar to one exhibited at the *Art Nouveau Bing* and to one in the Kunst und Gewerbe Museum in Hamburg, this table was secured from Bing in 1901 for 1,000 francs.

229. *Copy of Colonna table*, ca. 1901–1902, inlaid wood. Österreichisches Museum für angewandte Kunst, Vienna.

230. Eugène Gaillard, *Buffet*, 1900, walnut. Moravian Gallery, Brno, Czechoslovakia.

At the same time this piece was purchased by the Mährisches Gewerbemuseum in Brno, now the Moravian Gallery, the museum purchased the following two examples. A buffet similar to this one is found in Hamburg.

228.

229.

230.

231. Louis Comfort Tiffany, *Vase*, ca. 1900, favrile glass. Moravian Gallery, Brno.

232. Rookwood Pottery, *Vase* (designed by John D. Wareham), electro-deposit copper overlay. Moravian Gallery, Brno.

233. Georges de Feure, *Mounts for furniture*, 1900, molded silver-gilded copper. Iparmüvészeti Múzeum (Musée des Arts Décoratifs), Budapest.

Made for the furniture in his model dressing room, de Feure's mounts cost 724.13 crowns.

231.

232.

233.

236.

234. Eugène Gaillard, *Coat-rail*, 1900, walnut. Iparmüvészeti Múzeum (Musée des Arts Décoratifs), Budapest.

235. Rookwood Pottery, *Vase* (*Narcissus*) (designed by Harriet E. Wilcox), ca. 1900, earthenware. Victoria and Albert Museum, London.

These two vases, priced at 250 and 175 francs respectively, were purchased from Bing in 1900.

236. Rookwood Pottery, *Vase* (*Brown Poppies*) (designed by Josephine Zettel), ca. 1900, earthenware. Victoria and Albert Museum, London.

237. Alexandre Charpentier, *Plaque*, ca. 1897, bronze. Victoria and Albert Museum, London.

and anguished in their concentration on the "horrible."[40] Soon after her exhibition at *L'Art Nouveau*, however, Warrick was recognized as one of America's leading women sculptors. Bing even purchased two of her works, *The Bouquet* and *Dancing Girl*, for his private collection. Almost all of Warrick's early pieces have disappeared, many of them destroyed in a fire, but her Paris success gave her the encouragement she needed to pursue a career in the United States. This exhibition, added to the Bermond show, likewise made Bing something of a champion of women's rights and of young unknown artists who deserved the opportunity to publicly display their work.

In November Bing exhibited works by the Belgian artists William Degouve de Nuncques and J. Massin.[41] Although they were essentially Symbolists, Bing displayed their scenes of Majorca, in which each painter captured the brilliant light and rich colors of the Spanish countryside. Exotic landscapes were again featured in a show of fifty watercolors by Adolphe Dervaux that opened in January 1903.[42] *La Revue Blanche*'s brief review linked Dervaux's efforts with those of other contemporary landscape painters who applied intense pigments to their canvases with almost brutal brushstrokes. Such dazzling coloration and primitive patterning represented one of the many stylistic tendencies that eventually came to counter *art nouveau*. This general movement toward Expressionism was hardly new to Bing—he had, after all, shown Munch's works in 1896—but more importantly, these exhibitions proved that Bing remained open to experimentation even in his advancing years, clearly one of his more remarkable attributes.

Attracted by these different exhibitions, so many new visitors daily entered Bing's gallery on 22 rue de Provence that he decided to sponsor a show of works by one of his own designers. Clearly the only one whose *oeuvre* could sustain a large-

238. Alexandre Charpentier, *Plaque*, ca. 1897, bronze. Victoria and Albert Museum, London.

scale retrospective was Georges de Feure, who created numerous watercolors, paintings, and drawings in addition to stunning art objects (figs. 242, 243; colorpls. 74–77). Long recognized at international exhibitions, de Feure had received the Legion of Honor in 1901,[43] and his works were widely appreciated by collectors and patrons. Regrettably, all this adulation had made de Feure rather difficult, but Bing was forced to tolerate his foibles, for no other designer in his workshop, including the artisans Gaillard and Colonna, produced such an astounding range of creative work as did this artist. Together, Bing and de Feure carefully organized this exhibition of ceramics, tapestries, paintings, posters, watercolors, and drawings. The post-opening celebration at the Restaurant Konss even took place in an *art nouveau* room that de Feure had decorated. Critics were also invited to the official opening on March 30 to ensure that the show would receive full press coverage, which it did. Publications in Holland as well as France granted the exhibition extra attention because it had only recently become public knowledge that de Feure, born Van Sluyters, was Dutch by birth, although Bing confided that it was "hidden under a layer of French varnish."

One Dutch critic described the varied works of his newfound countryman this way:

> Bing's Art Nouveau hotel is nowadays almost a de Feure museum. One can see here all kinds of furnishings: cabinets, chairs, glass cases...lamps, clocks, metal work, ceramics, porcelains, objects of luxury and of daily use. Moreover, during the first three weeks of April there is a special exhibition of de Feure's paintings, drawings, watercolors, pastels and lithographs. Even though de Feure has a feeling for atmosphere and moods, he looks in the first place for color and line. He is a good observer and his landscape drawings, quick chalk studies, give evidence of that. He is touched by the

plate 73. Georges de Feure, *Ice bucket*, ca. 1902, porcelain. Musée des Arts Décoratifs, Paris (H. 7⅞ x D. 5⅛").

This porcelain, most likely shown at the Salon of the Société Nationale des Beaux-Arts in 1902 (number 88/16), was eventually purchased for 75 francs.

harmony of nature, by the sad grandeur of a rainy sky over a field with ricks of wheat, by the silence or the quiet of the countryside. But he rather uses his own imagination, and paints and draws according to his fantasy in long, lingering lines. The lady in *Sur la montagne* with her long colorful train blowing around the rock is just as foreign to her environment as the Parisienne in the Dutch-looking *Gust of Wind*. More integrated are his scenes of the race track, where the female figures fit in better, notwithstanding the sharp contours and bright colors and the overall decorative aspect. But de Feure is at his best when he can isolate his women and can decorate and ornament them without regard for the environment. Then he can be as decorative as he wishes and harmonize his tones as in *Harmonie Grise*.

In contrast to these female figures are his large landscapes brushed on with a freedom that comes close to set-painting. The colors drip down from the tree trunks, red and blue glows in the dark earth, the summer is full of green and the fall is in bronze-brown and gold. Here he smears on the paint, mixing and overpainting and preserving only the main lines.

The paintings are mostly richly framed and many of the frames may have been designed by de Feure himself.[44]

Considered a well-rounded artist, de Feure in his semi-Symbolist studies of women approached a personal mysticism that was partially based on his lingering interest in the literature and poetry of such writers as Charles Baudelaire and Georges Rodenbach.[45] His women in long, flowing gowns posed in barren surroundings (colorpl. 75) evoked the mysterious mood French and Dutch poets sought. In comparing his somewhat less Symbolist landscapes (fig. 243) to stage sets, however, the Dutch reviewer may have been referring to de Feure's experience as a designer of stage backdrops and theatrical costumes.[46] The reviewer for *Het Neiuws van de Dag* continued this discussion of de Feure's exhibition:

In *L'Art Nouveau Bing*, Georges de Feure exhibits oils, drawings, watercolors, pastels, a series of lithographs and many of his best *objets d'art*.

De Feure (Van Sluyters) is a many-sided artist who, whatever form of material he uses to realize his vision, first finds the decorative aspect of that form or material. He is a master of the charming line, even in those bizarre and mystical scenes that one finds in his earlier works and of which some lithographs in the exhibit are an example.

With these lines of charm, he represents, in as many ways as he wishes, the Parisienne, *cet être de charme et d'élégance* in such a way that she is always Parisienne and de Feure, and yet never the same. To each subject, to each figure, he gives its own color in a rich variety of hues, so that each of his women whether *Charmeuse* or *Féline*, *Petite Fée sous bois* or *La Dame en Noire* appears to us in an individual, harmonic combination of a few colors in many hues.

For his latest works, among which are a few masterly paintings, de Feure looked for his subjects outside, especially in the Forest of Fontainebleau, near *Bois-le-roi*. He has achieved powerful effects by creating vistas, along-

239. Georges de Feure, *Plate*, ca. 1900–1902, porcelain. Musée des Arts Décoratifs, Paris (D. 8⅝").

René Haase donated this piece in July, 1906.

240. Edward Colonna, *Plate*, ca. 1900–1902, porcelain. Musée des Arts Décoratifs, Paris (D. 8⅝").

The museum bought this in 1902 for 15 francs.

side heavy tree trunks and massive rocks, or a clearing in the wood. . . . He has beautifully suggested the grandeur of the woods, in which we see an unlimited depth between the trees, in which light and dark are contrasted with each other. . . . De Feure is a peculiar artist, Frenchman in his art, Dutchman in his heart.[47]

Close to the time of the de Feure opening, Friedrich Deneken asked Bing if he knew of any suitable Dutch artists for a museum exhibition he was organizing in Krefeld. Bing relayed the news of de Feure's recently revealed Dutch origins and, if interested, promised Deneken "pictures, prints, porcelains and other aspects of his applied art" when his own show closed.[48] Always a fan of de Feure's art, Deneken was definitely enthusiastic, but the offer came too late: "We are virtually on the doorsteps of our Dutch exhibit [and] I cannot make room for them. If these items are available in late summer or next winter I would like to exhibit them very much. It did interest me to learn that de Feure is Dutch; his style, however, is reminiscent neither of the Javanese of his fellow artists in The Hague nor of the simple, heavy manner of the Amsterdam artists."[49]

While temporarily confined to France, public awareness of de Feure's exhibition increased due to several positive critical reviews. In May's issue of *Art et Décoration*, Gabriel Mourey greatly admired the richness of de Feure's imagination and its ties to Baudelaire's writings, while an article in *L'Art Décoratif* celebrated the artist's uncanny ability to create a variety of works that revealed *art nouveau*'s diverse applications.[50] Toward the end of 1903, *Deutsche Kunst und Dekoration* carried the most comprehensive and extensively illustrated essay on the exhibition.[51] These articles consistently singled out de Feure as one of the most creative artists of his generation (colorpl. 78) and credited Bing for discovering and encouraging his talent.

During this long period of artistic exploration, Bing maintained his personal interest in art criticism by regularly contributing articles on both the business and aesthetic sides of art. His report on *La Culture Artistique en Amérique*, which was serialized for broader distribution in France, earned him considerable esteem in the United States, primarily because in it Bing praised American art in general and American innovations in the applied arts in particular.[52] This and other articles were also widely disseminated throughout Europe and increased Bing's reputation as one of the main theoreticians of the period. On the other hand, when Bing's workshop emerged as a major international center for avant-garde applied art designs, other critics and writers conveniently associated the decorative arts movement he espoused with the name of his gallery, *L'Art Nouveau*, and Bing thus became identified as the force behind a decorative style that spread across the Continent.

This debate over design reform in France came to involve architecture as well as the decorative arts.[53] Critics for *La Construction Moderne* demanded a new architectur-

241. Georges de Feure, *Pitcher*, ca. 1900–1902, porcelain. Musée des Arts Décoratifs, Paris (H. 6⅛ x D. 3⅝").

Also included in the 1902 Salon (number 88/17), this pitcher cost 40 francs.

al style, lamenting that teaching methods in French architecture schools were outmoded and backward when compared to those of other countries[54] or when set against the decorative art reforms seen in works by Pierre Selmersheim, Charles Plumet, Hector Guimard, and the school of Nancy.[55] Whether reform advocates insisted on alterations or conservatives urged caution, Europe was undeniably in the throes of change. All areas of creativity were being reexamined[56] with the advent of new colors for home decoration, new shapes in furniture, new building materials, and a new formal language. Throughout these heated discussions, the words "art nouveau" constantly reappeared, and it became increasingly clear to all concerned, including Bing, that its definitive meaning and style had to be determined.

Isolated from these debates on the Continent, America's version of *art nouveau* took hold relatively late. In 1902 the editors of *The Architectural Record* asked Bing to discuss this design reform movement for their interested but poorly informed American readers. In the periodical's August issue,[57] Bing complained about those who thought the term "art nouveau" referred to a style "founded on aesthetics altogether invented—or fallen from the moon." When he renovated his shop in 1895, he added, he "did not aspire in any way to the honor of becoming a generic term." Other dealers had copied him, used his name, and designed their own line of *art nouveau* furniture for popular consumption. Bing went on to defend his right to create an "establishment" where young spirits could show the "modernness of their tendencies," even when some people believed that a general revival of all the arts was scarcely needed. On this point Bing himself claimed to see little demand for changes in painting, although he had exhibited in his gallery new painting styles comparable to the applied arts. By 1902 Bing may either have decided that this effort had failed or concluded that alternatives were required only in the area of "art applied to decoration." Another idea Bing modified over time stemmed from his earlier staunch belief that any use of past styles was at best stultifying. Now he felt that the past should neither be imitated nor entirely dismissed. Discarding the past had been a "mad idea," Bing asserted, for everything "produced by your predecessors is an example to us, not assuredly for its form to be servilely copied, but in order that the spirit which animated the authors should give us inspiration."

The Architectural Record article also revealed how Bing considered his role in the larger design reform movement had evolved from middleman pushing for change to tastemaker and promoter of the new style. "In the beginning I confined myself to the role of intermediary—of standard bearer in the service of the good cause. Soon, however, the disillusion came." Discouraged by the erratic display of styles in his shop, Bing took a different position, for the new movement "was in great danger. The only way to save it from total collapse was to endeavor to make it follow a fixed direction, carefully marked out." As a result, Bing produced pieces made under his

plate 75. Georges de Feure, *Ladies on the
Beach (Elégantes sur la Plage)*, ca. 1900,
gouache. Bury Street Gallery, London.

own supervision to better control the *art nouveau* aesthetic and thus create works
that could serve as paradigms of fine craftsmanship and sophisticated taste.

> There was only one way in which these theories could be put into prac-
> tice—namely, by having the articles made under my personal direction,
> and securing the assistance of such artists as seemed best disposed to carry
> out my ideas. The thousand ill-assorted things that I had collected togeth-
> er in a haphazard way gave place, little by little, to articles produced in my
> own workshops.[58]

plate 76. Georges de Feure, *Clock*, ca. 1903, porcelain. Collection G.D.A., Limoges (H. 9¼ x W. 8 x D. 5").

plate 77. Georges de Feure, *Vase*, ca. 1903, porcelain. Collection G.D.A., Limoges (H. 8½ x D. 4").

plate 78. Georges de Feure, *Stained glass window*, ca. 1901–1902. Virginia Museum of Fine Arts, Gift of Sidney and Frances Lewis.

Reproduced in the catalogue *Oeuvres de Georges de Feure à l'Art Nouveau Bing*, the window was also published in color in *Deutsche Kunst und Dekoration*.

plate 77.

plate 78.

242. *Cover of the catalogue of the Georges de Feure exhibition at "l'Art Nouveau Bing,"* March–April, 1903 (contemporary photograph).

Bing's brief, informative article tremendously impressed a circle of designers, artisans, and architects in the United States. Almost immediately after its appearance, Gustav Stickley, himself a master designer of mission-style furniture, used his magazine, *The Craftsman,* to examine larger aesthetic issues. Two articles—one by A. D. F. Hamlin on the movement's significance and value, the other by Jean Schopfer on the critics of *art nouveau*—introduced their American audience to the major protagonists of the new style.[59] In the third part of the debate, written by Bing and simply titled "L'Art Nouveau," he elaborated his ideas and presented his most forceful denunciation yet of the radically exaggerated elements that had become associated with *art nouveau*. Illustrated with objects produced by his atelier, this article more thoroughly examined why the names of Bing and *art nouveau* had become so closely linked.

Attempting to dilute the notion that *art nouveau* opposed historical traditions, Bing tried to explain various aspects of the new style, beginning with its primary principle—"liberation." Artisans should be free to create unrestrained by conventions. Next, he addressed the practical applications of *art nouveau*, while taking critics to task for not helping the public understand artistic developments, attacking newspapers that ignored both exhibitions and individual objects, and criticizing journals that merely provided photographic documentation of works. Bing added:

> But among those who assumed the somewhat grave responsibility of instructing the public regarding the artistic phenomena of each day, among those even who declared with emphasis that there should no longer be an aristocratic art, and that all artistic manifestations: painting, sculpture or the products of the industrial arts, had equal rank, no one assumed the duty of making a serious study of this subject, that is, no one in position to speak with authority. *L'Art Nouveau,* it is true, if it be considered as a whole, has no cohesive principle.[60]

Bing went on to cite the early difficulties he encountered in breathing renewed life into the decorative arts, for good design was in short supply, and the women who abandoned their leisure pursuits to work with leather and copper were "almost touching in their artistic poverty." Manufacturers, capitalizing on the idea that almost anything could be called *art nouveau*, produced extremely eccentric objects, to say the least. In trying to identify the design principles behind these purely ornamental lines and floral elements, Bing recalled the role that English and Belgian designers, especially Gustave Serrurier-Bovy and Henry van de Velde, had played:

> [Van de Velde] executed in 1895 for the establishment of L'Art Nouveau, Paris, a series of interiors, which he followed by other works exhibited at Dresden in 1897, and which not only constituted in Europe the first important examples (ensembles) of modern decorative art, but have since

243. Georges de Feure, *Landscape (Red Rocks at St. Raphael)*, undated, gouache and watercolor. Photo courtesy of The Museum of Modern Art, New York.

remained the most perfect types of species. This species was the development of the line—the decorative line shown in its full and single power.

It was Van de Velde, Bing claimed, who challenged French designers to follow suit or be left behind.

Finally, Bing confessed that stylistic advancements in Germany and Austria proved to him that French artists had to throw off the influence of foreign "impediments" if they were ever to create anything original. International exhibitions, such as the one in Dresden in 1897, taught him that "the influence of France will never again dominate the world so completely as in former times. As communication between the different nations becomes easy and constant, as frontiers grow nearer, and the exchange of ideas multiplies, one may imagine each separate people as fearing lest the formidable leveling wind that is now passing over the world" overtake them. Artistic innovations, stimulated by new ideas in local crafts and Bing's own objects, were occurring in Holland, Denmark, Sweden, Norway, and Russia, providing reason enough to assume that France would continually be challenged in the decorative arts. Even America, with its own "special destiny," was surpassing France. Bing's acute sense of these continual changes in design reform emerged in the business modifications he instituted after his exhibition in Turin in 1902.

CHAPTER 7:
BING'S LEGACY

244. L. Cappiello, *S. Bing in the sales room at a Japanese art auction in Paris*, ca. 1903–1904. Private collection.

It is possible that Cappiello drew this image of Bing at the Gillot sale, since the dealer appears quite elderly.

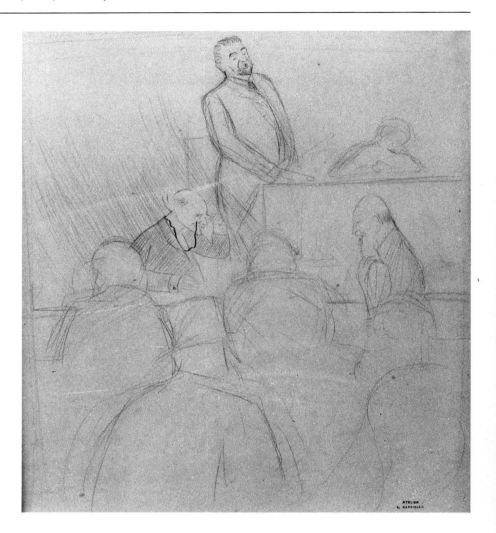

After the Paris Exposition Universelle in 1900, the idea grew that a truly world-wide fair dedicated solely to the applied arts was needed. Machines, entertainments, and "historic styles" that might distract visitors from appreciating the contemporary products of design reform movements would be rigorously excluded.[1] The First International Exhibition of Modern Decorative Art, held in Turin, Italy, in 1902, became the result.

In a number of respects, the Turin exhibition differed greatly from the Paris show. More European countries were represented by the best work of their avant-garde designers. From Scotland, the furniture and room interiors created by Charles Rennie Mackintosh, his wife Margaret, and other members of "the Four" were particularly appreciated. The Belgian artists Victor Horta and Gustave Serrurier-Bovy[2]

and their fellow designers from Austria and Germany were also exceptionally well represented, confirming that French artisans were no longer unopposed.

Unlike the Exposition two years earlier, where many nations failed to exhibit major works by their most innovative designers, the new style was evident everywhere at Turin. Unified room interiors that carefully integrated furniture to emphasize three-dimensional space over two-dimensional decoration dominated the exhibition. Unfortunately, the French, not overly adept at such installations, were reluctant to abandon their time-honored tradition of displaying each piece of furniture as if it were a masterpiece in itself.[3] Bing had tried to conform to this tightly coordinated decorative scheme where objects and furniture visually extended into space, but as critics noticed with his 1900 pavilion, he never really solved the problem of how to enliven the walls the way Van de Velde and the German designers did.

Critics who visited the Turin exhibition searched for designers who were challenging tradition and creating new vistas in design. A red dining room inlaid with glass by the German architect Peter Behrens made a lasting impression,[4] but it was the interiors and crafts in the Scottish section that held the distinction of being the least understood by the public and the most appreciated by connoisseurs. According to one critic, "Those who are head above all exhibitors are Mr. and Mrs. Mackintosh. They have composed with their furniture panels, their embroidery, their lamps, a pretty room ... which is the most charming thing at the International Exposition. The general public will not, cannot even, understand it." Their refined

plate 79. Georges de Feure, *Cytisus*, ca. 1899–1900, reinforced silk. Musée des Arts Décoratifs, Paris (H. 64¼ x W. 50⅜").

Purchased from Majorelle in 1906.

plate 80. Georges de Feure, *Plate*, ca. 1901–1904, porcelain. The Metropolitan Museum of Art, New York, Edward C. Moore, Jr., Gift Fund, 1926 (D. 8½").

The Metropolitan purchased the plate from René Haase in 1926 for $10.

rooms, designed as complete ensembles with subtle color harmonies of white, silver, rose, and occasional additions of purple, were Symbolist environments of coolness and simplicity that breathed "sentiment and finesse."

Although Henry van de Velde did not participate, Belgian talent was well represented by Victor Horta, whose two rooms, complemented by photographs of his other works, illustrated the breadth and originality of his accomplishments. (To many critics at Turin, however, Horta excelled as an architect, not as a master of interior decoration.) Reactions to the Dutch, Italian, and American sections were equally enthusiastic, with the only disappointment being the French contribution, which had been controlled by Auguste Rodin and Albert Besnard, artists of major ability but hardly judges of new decorative design.[5] Their selections unwittingly reinforced the common opinion that after their triumph in 1900, French designers had not moved forward as rapidly as they should have.

> France, on the contrary, although in the field of the New Art she can show some very remarkable artists and can boast of successes of the first order, is far from exciting the curiosity of the intelligent visitors at our International Exhibition. The reason is that she has sent things already known, and her exposition has evidently been improvised. We have Lalique, Charpentier, Bigot, Rodin, Marjorelle, de Feure, Colonna, Sauvage, but these artists have given their help indirectly, through the medium of two well-known Paris establishments, "L'Art Nouveau Bing," and "La Maison Moderne" (J. Meier-Graefe). There is also an independent section, but it is not over-interesting.[6]

Evidently, French organizers and selection committees had come to rely too heavily on Bing and Meier-Graefe to bolster the French section of this international exposition, but regrettably neither dealer had sent many new works to Turin. Perhaps somewhat surprisingly, individual French designers still won major awards, including Georges de Feure, who received one of six diplomas of honor for the varied and imaginative design of his newest furniture. Both Marcel Bing and Edward Colonna were awarded silver medals, and Bing himself, along with Meier-Graefe, was voted a diploma of merit.[7]

Despite these official awards, Bing recognized that the French *art nouveau* he promoted, with its elegant objects, gilded surfaces, and ever curving lines, was already beginning to appear dated. New decorative trends favored functional interiors with more restrained linear rhythms, like those by the Scottish and German designers. Ever observant of such developments, Bing also began to replace on the objects he advertised for sale the curvilinear patterns and ornate vegetal decorations—the very hallmarks of *art nouveau*—with simpler, straighter lines.[8] Yet the elderly Bing, no longer viewed by critics as the controversial leader of the design reform movement, may have started to think about retiring as well.

247. Georges de Feure, *Fan*, ca. 1900–1901,
silk and ivory. The Metropolitan Museum of
Art, New York, Edward C. Moore, Jr., Gift
Fund, 1926.

256 · *Bing's Legacy*

The next year (1903) Friedrich Deneken initiated plans for a horticultural exhibition in Düsseldorf,[9] for which Bing had promised to provide "a number of mounted glass or clay vessels with which I (or rather my son) have been occupied in recent times. Our porcelains with color under the glaze may also play a part in it."[10] Such correspondence implied that Marcel was assuming a more prominent role beyond *bijoutier* in the firm. By January 1904, when Deneken asked to have some of his friends shown around *Art Nouveau Bing*, Marcel clearly ran the workshops. Undeniably a talented craftsman, he was scarcely an organizer and an entrepreneur like his father.

Ever since the Turin exhibition, Bing and Meier-Graefe had both experienced drops in demand and diminishing returns. Tastes were changing, the decorative arts trade had deserted France for other European markets, and business simply declined. Bing slowly admitted that it was time to close the now unprofitable workshops and abandon *art nouveau*. Perhaps his health was failing, although he was working on the sale of Charles Gillot's collection and still retained his business dealings in Japanese art (fig. 244). He was neither bankrupt nor even in debt. Most

248. Georges de Feure, *Rug*, ca. 1902, wool. Musée des Arts Décoratifs, Paris. De Feure's rug was reproduced in an article by O. Gerdeil in *l'Art Décoratif* (January, 1902) and in *Innen-Dekoration* (1902).

249. Frank Brangwyn, *Rug*, ca. 1898, wool. Musée des Arts Décoratifs, Paris (L. 73 x W. 37½").

A variation of this rug is found in an 1898 article by Georges Lemmen in *Dekorative Kunst*.

likely he had chosen to slowly withdraw from the trade arena by having others, that is, Marcel running the workshops and Marie Nordlinger selling Japanese objects, act on his behalf. What he kept for himself, such as cataloguing a collection or writing an essay for a publication, he did at home. For whatever reason, by March 1904 he could write to Deneken that "all my young people have left already."[11]

Both Bing and Meier-Graefe officially closed their respective shops within a month of each other,[12] which dealt the Paris decorative arts market a severe setback. Almost immediately, Bing began to return unsold objects he held on con-

plate 81. Edward Colonna, *Card case*, ca. 1898–99, Moroccan leather, gilt silver, silk lining. Musée des Arts Décoratifs, Paris (L. 4¾ x W. 2¾").

Several of these works were part of Marcel Bing's large donation to the museum in 1908.

250. Alexandra Thaulow, *Book-jacket*, ca. 1902, leather. Musée des Arts Décoratifs, Paris (L. 6⅜ x W. 4½").

plate 82. Georges de Feure, *Cup and saucer*, ca. 1901–1904, porcelain. The Metropolitan Museum of Art, New York. Cup (H. 1¼ x D. 3⅜"), saucer (D. 5½").

signment from non-French firms, including his entire stock of Tiffany's works. Although he initially kept his showroom open on the rue de Provence, it was only a matter of time before it, too, closed.

The simultaneous closings of *Art Nouveau Bing* and *La Maison Moderne* wielded a crippling blow to *art nouveau* and devastated the artistic community of Paris. Judging from a letter from Georges de Feure to Tadamasa Hayashi, few, if any, of the designers and craftsmen working for Bing had any inkling that he was about to close. Caught unprepared, de Feure appealed to Hayashi to buy some of his objects, for "I [find] myself in a bit of a financial bind."[13]

Bing may well have kept his decision to close a secret, hoping some kind of last minute reprieve would salvage his decorative arts trade. (He had definitely invested too much time and money to abandon it without a struggle.) His final act may

plate 82.

251. Paul Pierre Jouve, *Desk blotter* (executed by Ribe-Roy), ca. 1900–1905, leather. Musée des Arts Décoratifs, Paris (L. 17⅜ x W. 12⅛").

indeed have been somewhat dictated by the loss of his leading designers. In 1903 Edward Colonna left *Art Nouveau Bing* to move to Canada and pursue an independent career as an interior designer since he was almost certainly assured substantial commissions there.[14] At about the same time Eugène Gaillard broke away to establish his own firm and design furniture for his patrons. De Feure's earlier one-person exhibition may also have sown discord in Bing's atelier. Despite his incomparable

252. Georges de Feure, *Portefolio* (executed by Ribe-Roy), ca. 1902–1903, Moroccan leather. Musée des Arts Décoratifs, Paris (L. 8⅜ x W. 5⅞″).

Other examples of this style were reproduced in *Deutsche Kunst und Dekoration* in 1903.

talent and imaginative creations, de Feure had a difficult personality, and the other designers undoubtedly resented Bing's favoritism of an unpopular colleague.

Even though his staff was dwindling, Bing still advertised his shop in the 1904 trade periodicals.[15] In June, however, he sold the property at 22 rue de Provence and moved the Japanese trade to 10 rue St. Georges, where his son Marcel lived. By the next month the new owners of the *Art Nouveau Bing* shop, Majorelle Frères of

plate 83. Alexandre Bigot and Edward Colonna, *Pitcher,* by Bigot dated 1895, by Colonna, ca. 1898–1899, glazed stoneware with gilt silver mounts. Musée des Arts Décoratifs, Paris.

254. Adrien Delovincourt, *Bonbonnière*, ca. 1900–1902, porcelain. Musée des Arts Décoratifs, Paris (H. 4 x D. 4⅝").

Nancy, another major *art nouveau* firm, had eliminated all the building's external decorations (fig. 245), including the doors and windows, and renovated its interior (fig. 246). To make matters worse, Majorelle Frères sold objects produced by the Nancy school that were presumably decorated in the florid style Bing detested. A few museum directors, among them Friedrich Deneken,[16] conducted some business with the new firm (colorpl. 79), but their ties were soon severed.

Space at Bing's new headquarters on the rue St. Georges was so limited that few things manufactured in his workshops could be kept there. Furniture by Colonna, de Feure, and Gaillard, which would soon be stylistically outdated anyway, had to be sold. The only viable solution became a liquidation sale,[17] held at the Hôtel Drouot on December 19 and 20, 1904, almost nine years to the day after *L'Art Nouveau* opened. Although a few notices appeared in the *Journal des Arts* prior to the sale, the Paris newspapers in general did not report on it, before or afterward, and apparently no statement was released to the press.[18] Similarly, the sales catalogue itself was extremely modest, as if Bing considered the closing of *Art Nouveau Bing* not only a sad moment but also a personal failure and a tragic defeat for the reform of applied arts in France.

The substantial number of items offered at the sale represented a considerable portion of Bing's inventory, which hints that *L'Art Nouveau* and later *Art Nouveau Bing* may not have been as successful in selling objects as they appeared. (Admittedly, many of these works could have been floor models and samples to show perspective clients.) Major pieces of furniture designed by Colonna, de Feure, Gaillard, Hirtz, and Adrien Delovincourt were featured in Bing's sale, along with innumerable *objets d'art*—metalwork, ceramics, clocks, leather pieces, jewelry, tapestries, and rugs[19]—all of which sold well and netted the sizable, though not sensational, sum of 30,971 francs. Most objects went to buyers who had patronized Bing's shop or were close family friends. Some were purchased by the wealthy Duchesne and Carnot families and have since disappeared into private French collections. Others failed to reach their reserve and were not sold. Bing's family deliberately withheld a few choice examples of *art nouveau* (fig. 247; colorpls. 80, 81),[20] which remained with Marcel Bing and his successor, René Haase, until the early 1920s, when they were sold at auction or inherited by other family members through Marcel's will.[21] Over the years a number of small pieces were also donated to the Musée des Arts Décoratifs, which eventually formed one of the most outstanding collections of *Art Nouveau Bing* anywhere (figs. 248–260; colorpls. 82, 83).

After the sale, Siegfried Bing continued with his other interests, until he fell ill in 1905 and died in the small village of Vaucresson on the outskirts of Paris. His obituaries all mentioned his significant place in the world of Japanese art, but few, like the *Art Journal*,[22] commented on his role in the decorative arts:

255. Georges de Feure, *Comb*, ca. 1900, horn. Musée des Arts Décoratifs, Paris (H. 3 x W. 4").

256. Georges de Feure, *Small Tea-pot*, ca. 1900–1901, porcelain. Musée des Arts Décoratifs, Paris (H. 4⅝ x D. 2⅝").

257. Edward Colonna, *Vase*, ca. 1900–1901, porcelain. Musée des Arts Décoratifs, Paris (H. 4⅛ x D. 5⅞").

M. Bing, who died recently in Paris, was one of the most widely known figures in the "Art Nouveau" movement. His influence served to attract many talented young artists in the late eighties and early nineties. . . . It would be obviously unfair to make M. Bing responsible for all the squirms and wriggles and blobs since perpetrated under the "Art Nouveau" mantle.

Some obituaries mentioned that Bing's hopes for the revitalization of the decorative arts had not been met,[23] while others completely overlooked his involvement with the applied arts.[24] Ironically, in the eyes of his contemporaries, Bing's successful promotion of Japanese art ultimately dominated his devotion to *art nouveau* and his crusade to reform French decorative arts.

After Bing's death, his son Marcel and his associates neither maintained the dealer's commitment to Japanese art nor pursued his love of quality design with the same passion and verve. Although Marcel stayed active in both trade and design, he lacked his father's driving ambition, and under his direction the family business gradually abandoned Japanese art.

Today, without a clear record of the Japanese objects he sold to museums and collectors throughout his long career,[25] it is difficult to evaluate Bing's position as a connoisseur of Oriental works of art and his reliability as a dealer. Indeed, he was hardly infallible, for he occasionally sold imitations or fakes, and he could not always resist the temptation to make money on worthless knickknacks. Yet in the overall view, Bing used *japonisme* to encourage French designers, craftsmen, and consumers to seek quality and innovation in all the arts, "fine" and "decorative"

258. Georges de Feure, *Sugar bowl*, ca. 1900–1901, porcelain. Musée des Arts Décoratifs, Paris (H. 5⅜ x D. 4").

259. Georges de Feure, *Small vase*, ca. 1900–1901, porcelain. Musée des Arts Décoratifs, Paris (H. 2¾ x D. 1¼").

alike. At the same time, however, he stressed that imitation was not art. Europeans must be inspired by Japanese motifs, techniques, and achievements if they were to truly emulate Far Eastern art, but they were blocked from fully grasping Japanese art because they could not detach it from its origins.

In turn, it is a more complex task to assess his influence on French popular taste. Initially, to draw the attention of a potential audience sated with exhibitions, Bing labored to create innovations in the production and display of the works he sold at *L'Art Nouveau*. He often courted controversy with art critics, reviewers, and the press in general. By the time of the Exposition Universelle of 1900, however, he no longer had to rely on shocking avant-garde designs to attract recognition. He modified his earlier decorative style and muted obvious foreign influences in favor of a more traditional French preference of elegance. His insistence that every object in a room play its part in the interior's visual harmony brought him early acclaim from the public outside France. Yet despite this popularity, only a rich and sophisticated clientele could truly afford and appreciate his version of an *art nouveau*. Whatever he might say about improving domestic design for every family, Bing's decors were still far beyond the purse of the ordinary man. His best customers remained museums, which through their public exhibitions could assist Bing in his endeavor to elevate public taste.

260. Georges de Feure, *Chair*, ca. 1900–1901, walnut and ribbed velvet. Musée des Arts Décoratifs, Paris (H. 34⅝ x W. 16").

Raymond Koechlin donated this in 1907.

The clue, then, to Bing's achievement must be associated with the profession of *artiste/decorateurs* that he inspired. For years all sides of the design reform movement issue had been hotly debated, with little visible progress. Bing, with his courage and tenacity, dared to make a move by establishing his own atelier. Most importantly, this breakthrough demonstrated to European museums, art schools, and manufactories that the revival of the applied arts only required originality and determination. His results proved that the applied arts in France could be the best in the world, that industrial methods and artistic creativity could be wedded to produce refined works of art, and that designers, decorators, and artisans should be regarded as the professionals they actually were.

Siegfried Bing's name disappeared into the shadows of history until its resurrection accompanied a renewed interest in *art nouveau* in the 1960s. Even though this "new art" could well have been created almost anywhere, there is some justice and comfort in knowing that the decorative style has become identified with the French name it acquired through *Art Nouveau Bing*. Bing's strong commitment to carefully unified interiors and his continued belief that the East and the West shared many aesthetic concepts placed him among the most significant design activists at the turn of the century. Only now, when *art nouveau* is judged more kindly, is the pioneering work of Bing and his artisans assessed with greater objectivity and appreciated for what it was—a true revolution.

NOTES

INTRODUCTION

1. Much confusion surrounds Bing's first name. Is it Siegfried or, as listed in twentieth-century art history texts, Samuel?

 Problems about Bing's first name emerged immediately after his death on September 5, 1905, when an obituary notice in the *Revue Universelle* (October 15, 1905) called him Samuel. Camille Mauclair's article in the *Revue Bleue* in 1909 also referred to Bing as Samuel. Even the American art historian Robert Koch, who published the first study of Bing in the *Gazette des Beaux-Arts* in 1959, called him Samuel, claiming that S. Tschudi Madsen incorrectly gave S. Bing's name as Siegfried in his 1956 publication, *Sources of Art Nouveau*.

 During his lifetime Bing was invariably referred to as S. Bing, which is how he signed all of his own published writings. Later notices on Bing's career or on *art nouveau* in general also called him simply S. Bing, at least into the early decades of the twentieth century when much art historical research was based on wrong information and unverified facts. Later research was heavily influenced by Koch's 1959 article.

 A few articles published soon after Bing's death did provide his rightful first name. (See "The Passing of Siegfried Bing" in the November 1905 issue of *Brush and Pencil*, and Gabriel Mourey's chapter on Siegfried Bing in his book *Essai sur l'art décoratif français moderne*, Paris, 1921.) The only primary evidence for calling him Samuel was a death notice published in the *Revue Universelle* in 1905, which was subsequently utilized as an information source by modern writers and biographical dictionaries. For example, the *Dictionnaire de biographie française* (vol. 6), published in 1954, called Bing Samuel.

 All official documents pertaining to Bing's life, his birth and death certificates, and various business documents either carry the name Siegfried Bing or its French version, "Siegefroi," and never utilize the name "Samuel." The author contributed to the confusion about Bing's first name in his earliest article in *The Connoisseur* (1969). However, in a 1971 article in *The Connoisseur*, the author noted that records for the Père Lachaise cemetery in Paris proved that S. Bing was rightfully called Siegfried. Documents pertaining to Bing's receipt of the Légion d'Honneur in 1890 reinforce this fact. In a critical article on Koch's republication of Bing's articles and his pamphlet *Artistic America*, D. J. Gordon, an Englishman linked to the Bing family in London, finally clarified the mystery concerning Bing's real first name ("Mistaken Identities," *The Studio International*, 1970).

 Until evidence is found that S. Bing was called Samuel by his friends and colleagues, or until a document or article written or published during his lifetime is located, we can safely eliminate the possibility that he was ever called Samuel in France. Another stumbling block to full understanding is that Bing had a brother, Samuel Otto Bing, who also died in September 1905. Announcements of their deaths could understandably be confused. Bing probably adopted the use of the initial "S" to avoid possible complication with a family relative during his lifetime. Scholars and writers who have incompletely researched the facts, or falsified information to preserve the myth of "Samuel" as the real name for "Siegfried," have only created more difficulties.

CHAPTER 1

1. See Familien-Register and Stammtafel, *Michael Isaac Bing und seine Nachkommen*, Frankfurt-am-Main, October, 1864, pp. 20–21. Information on Friedericke Renner and their twelve children is also taken from this source.

2. Letter of November 24, 1971, to the author from Mr. Kotzsch, curator of the Staatsarchiv in Hamburg, mentioning Protokoll no. 387, dated April 13, 1849. The address of the firm was Neuer Wall 58 before 1862 and Neuer Wandrahm 8 afterwards.

3. Letter of November 19, 1972, to the author from Mr. Kotzsch, curator of the Staatsarchiv in Hamburg, noting that an official document of December 31, 1846, stated, "The business partnership that had been in effect between Mr. Jacob Bing and Moses Bing in the firm of Bing Brothers and Company was dissolved as of January 1, 1847." In a document dated January 1, 1847, Joseph Samuel Renner was made a partner in the business. Moses Bing most likely received a pension with income from the firm when the new partner was added. The financial ties between Hamburg and Paris remained intact although it is unclear how all the money was divided among members of the family at given moments.

4. See Gabriel P. Weisberg, "A Note on S. Bing's Early Years in France, 1854–1876," *Arts Magazine*, 57.5 (January, 1983) pp. 84–85. For further reference to Siegfried, see Archives Nationales, *Demande de naturalisation*, dated August 1876 and granted by decree December 12, 1876. The 1876 document states that Siegfried came to Paris in 1854 "après avoir terminé ses études universitaires . . . pour y faire son éducation commerciale et retrouver ses parents; son père était établi alors à Paris, fabricant de porcelaines rue Martel, 12." Jacob Bing apparently never became a French citizen.

 Michael (Michel) Bing, Siegfried's brother, arrived in Paris in 1858. In 1865 he married Emma Augustine Bing (b. November 26, 1842 in Paris). Her father, Loeb (Lob) Salomon Bing, known as Leopold, appears in the 1856 *Didot-Bottin* (p. 547), the guide to Paris merchants, as a *commissionnaire en horlogerie et articles de Paris* located at Place Vendôme 20, the same address as his brother Alfred Daniel Bing (Bing jeune, Alfred). Both Loeb and Alfred Bing were brothers of Rosa Bing Baer, the mother of Johanna Baer, who eventually became Siegfried Bing's wife. Thus both Michael and Siegfried married third cousins, a rather common practice in Jewish families of the time. Information on Auguste Bing's first arrival date in Paris remains inconclusive.

5. For reference to the purchase of this manufactory, see Archives de Paris, D 31 U³ 18² (*Actes de Sociétés—Dissolutions de sociétés—Jugements arbitraux—Emancipations—Autorisations de faire commerce—Actes de voyage—Déclarations de vente de marchandises*, no. 184, January 25, 1854). This document, registered in Hamburg on January 18, 1854, by Jacob Bing of Paris and Joseph Renner of Paris, attests to the establishment of a corporation for production, sale, purchase, consignment, commissioning, and exportation of porcelain. The use of the word "fabrication" reflects the purchase of the porcelain manufactory at St. Genou in the same year. See B. de Gaulejac, "Les Manufactures de porcelaine de la Nièvre," *Mémoires de la Société Académique du Nivernais*, 53, (1965), pp. 24–25, 34, who suggests that the ceramic manufactory was purchased in late 1853, a date that supports the assumption that Jacob Bing was a *fabricant de porcelaines* before his son arrived in 1854.

 By 1855 Jacob Bing gave his occupation in France as a manufacturer of porcelain. See *Registre des personnes admises à visiter les ateliers et les collections de la Manufacture de Sèvres (1845 à 1857 inclus)*, June 12, 1855. Bing and Renner purchased the almost bankrupt factory, together with its depot at 12 rue Martel (see *Didot-Bottin*, 1853, p. 1498). In the 1854 *Didot-Bottin* (p. 114) Bing frères et Cie. appears twice, at Petites Ecuries 55 as *commissionaires en marchandises* and at 12 rue Martel as makers of porcelain. See also B. de Gaulejac, p. 25. When Bing and Renner bought the factory it was managed by Philippe Loth, but he almost immediately died of cholera. It was then run by J. B. Martin until 1861, when it was handed over by J. B. Pommier. None of these managers seems to have been an effective administrator, and costs of running the plant continued to rise.

6. The 1864 *Didot-Bottin* gives Martin, Pommier, and Radan as owners of St. Genou. Since the *Almanach du Commerce* usually appeared a year late, the sale probably took place in 1863. The former manag-

ers now appear to have a new partner in order to purchase the plant. A document dated March 9, 1863, establishes the creation of a new partnership for the commission and importation of goods to last for four years and ten months. Called Bing Frères et Cie., it listed Jacob Bing and his son Michael as partners. (See Archives de Paris, *Actes de Sociétés*...D 31 U³, 237, no. 489, March 9, 1863.) In this way Jacob Bing retained cordial relations with his former managers, gave himself something to do, and provided income for Michael.

7. See Archives Nationales, *Demande de naturalisation*, 1876. The document notes, "et s'est associé ensuite en 1863, avec M. Leullier, qui était également fabricant de porcelaines. Ils ont réuni leurs deux maisons en une seule à laquelle ils ont donné une grande extension par l'annexion de leur double clientèle." See Archives de Paris, *Actes de Sociétés*...D. 31 U³, 236, December 12, 1862–June 2, 1863, no. 404, "Leullier fils et Bing, enregistré à Paris, February 20, 1863." The document links Siegfried Bing and Jean Baptiste Ernest Leullier together in a "société en nom collectif pour l'achat et la vente des porcelaines."

8. *Didot-Bottin*, 1869, p. 1215.

9. In Archives Nationales, *Admission à Domicile*, June 16, 1866, no. 6946, no. 8, Michael Bing asked for permanent residence in France. He probably never became a citizen.

10. *Didot-Bottin*, 1865, p. 1018.

11. In Exposition Universelle de 1867 à Paris, *Catalogue général publié par la Commission Impériale*, Paris, 1867, p. 336, Leullier was listed as producing decorated and undecorated pieces. Awards at exhibitions were mentioned in their advertisements in the *Didot-Bottin* (p. 1192) beginning in 1868. See also *Le Monde illustré*, July 20, 1867, pp. 44–45.

12. Archives Nationales, *Demande de naturalisation*, 1876. According to this document, Bing was given the authorization to live in France on April 15, 1869. Bing noted that he kept French workers employed at two of the firm's manufactories even during the economic crisis that had hit French industries in the late 1860s, an important point for a citizen of Hamburg to make on the eve of the Franco-Prussian War. According to this same source, a second child was born to the Bing family while they lived in Brussels but did not survive infancy. Walter O. Michael identified the child as George Bing.

13. Document, Staatsarchiv Hamburg, June, 1868. See also Archives de Paris, *Actes de Sociétés*...D 31 U³, 286, July 9, 1869, no. 587, "Remplacement de liquidateur Ste. Bing-Renner/M. Michel Bing, 17 rue Martel." In this document Michael Bing was given all the rights and powers to liquidate the firm of Bing-Renner to satisfy its creditors and to

ensure that debtors paid their debts. Since the document was signed in Paris (June 27, 1868) and then forwarded to Germany, all legal ramifications with Germany were also covered.

14. Marriage License Application, July 22, 1868. This document was kindly shared with the author by Walter O. Michael. Johanna Baer's parents were Isaac Solomon Baer (July 12, 1812–December 14, 1856) from Cronberg and Rosa Bing (born August 18, 1810), daughter of Solomon Moses Bing, Siegfried's great uncle. As Siegfried's third cousin, Johanna Baer was the niece of Alfred Daniel Bing, an important manufacturer during the Second Empire, who also wrote several books on commerce and industry.

15. See Archives de Paris, V4E 1245, Naissances, September 4–November 10, 1869, vol. 71, no. 4,135, September 19, 1869. Jacques died at age 22 while in the army.

16. Mairie du 10e Arrondissement, Paris, "Décès." Michael Bing's death was announced on February 6, 1873. The child's death appeared November 7, 1873.

17. Information provided by Hisao Miyajima, 1983. The East Asian Society was founded in Tokyo in 1873 under the sponsorship of Max von Brandt. Its membership included Michael Martin Baer, Bing's brother-in-law (1873) and H. Ahrens, a leader in the industrial trade world at the time (1874). Bing joined on March 13, 1874.

18. See Geneviève Lacambre, "Les Milieux japonisants à Paris, 1860–1880," in *Japonisme in Art*, Tokyo, 1980, pp. 43–55, and Gabriel P. Weisberg, "Japonisme: Early Sources and the French Printmaker, 1854–1882," in *Japonisme: Japanese Influence on French Art, 1854–1910*, exhibition catalogue, The Cleveland Museum of Art, 1975, pp. 1–19.

19. Bing was first mentioned as a dealer of Oriental curios in *Didot-Bottin*, Paris, 1878, p. 148, where he is listed with a colleague, Proost Besce. By 1879, Bing was listed in a category of *chinoiseries and japonaiseries* established after the Universal Exposition of 1878, which meant he was a dealer in Oriental objects. Edmond de Goncourt, in his *Journals*, says that Bing was selling Japanese objects by 1875, however, and that he had visited Bing's establishment with the idea of obtaining pieces for his own collection.

20. See *Procès-verbal, Vente Bing*, Hôtel Drouot, March 19, 1876, Archives de Paris. Charles Pillet was listed as the *commissaire-priseur*; Bing signed the official documents.

21. Bing was last listed in the *Didot-Bottin* as associated with Leullier in 1881. Leullier fils et Bing was bought out by Alfred Haase, who continued as the successor to the earlier firm. Alfred Haase could have been related to René Haase, who eventually took over for Marcel Bing in the 1920s, further

suggesting that ties were quite interrelated in the Bing family history.

22. See Gabriel P. Weisberg, "Philippe Burty and a Critical Assessment of Early 'Japonisme' " in *Japonisme in Art*, Tokyo, 1980, pp. 109–125. Burty wrote in *L'Art* that Bing had "exhibited an entire vitrine where one's eye can rejoice in the variety and quality of the enamels." For further reference, see Philippe Burty, "L'Exposition Universelle de 1878, Le Japon ancien et le Japon moderne," *L'Art*, 1878, p. 251.

23. See *Ville de Paris—Cadastre de 1876*, Archives de Paris, 19 rue Chauchat. Bing was listed in the rent records as a "marchand d'objets de curiosité." Also see *Ville de Paris—Cadastre de 1876*, Archives de Paris, 19 rue Chauchat². By 1892 Bing is listed as the owner of the building with the original owner retaining title to the land.

24. For further reference, see Philippe Sichel, *Notes d'un Bibeloteur au Japon*, with a preface by Edmond de Goncourt (Paris: E. Dentu, 1883). Sichel says that Auguste Sichel had been living in Japan since 1867 and that a friend sent numerous objects back for sale in Europe. The Sichels visited a number of cities in the interior of the country but did not have access to private collections.

25. Letter of November 20, 1982, from Hisao Miyajima, curator of the Museum of Art, Osaka, to the author. Mr. Miyajima located in the Archives of Foreign Affairs, Tokyo, Michael Martin Baer's date of arrival and term of office in Japan.

26. Erwin Baelz, a surgeon stationed in Japan, wrote in his diary under the date of November 18, 1880, "Baer was with me this evening. He is negotiating with the Japanese (with those that count in this matter) for the foundation of a society to promote the development of the economic resources of the country, and above all for the improvement of agriculture and commerce. Baer is well-to-do." See *Awakening Japan: The Diary of a German Doctor: Erwin Baelz*, edited by his son, Toku Baelz, Bloomington: Indiana University Press, 1974.

27. "Hr. S. Bing og den Japansk Samling," *Kunst-bladet*, Copenhagen, 1888, pp. 119–121, translated by Sylvia Herschede and Walter O. Michael.

28. "Futsujin Bing Shibata Zeshin ni Shinsui," *Tokyo Daily News*, July 15, 1880, translated for the author by Hisao Miyajima.

29. See Hisao Miyajima, "S. Bing's Visit to Japan," in *The Bulletin of the Study of Japonisme*, no. 2, 1982, pp. 29–33, an article partially based on Weisberg, "L'Art Nouveau Bing," in *Arts in Virginia*, 1979, pp. 4–5. This information was corroborated by the lists of passengers published in *The Japan Weekly Mail*.

30. Information supplied by Walter O. Michael, who conducted an extensive search into the Bing family archives. In 1976 he interviewed surviving fam-

ily members, including the daughter of Auguste Henry Bing, who has since died. This interview provided the basis for the account of the Oriental interests of Auguste Bing and the details of his various trips to the Far East.

31. *Ville de Paris—Cadastre de 1876, Archives de Paris*, 23 rue de Provence. The rent was 4,000 francs for three months. He was listed as a "marchand de porcelaines de Chine en ½ gros."

32. Louis Gonse, *L'Art Japonais*, Paris, 1883.

33. See *Catalogue de l'exposition rétrospective de l'art japonais organisée par M. Louis Gonse*, Paris, 1883. The section "Collection de M. S. Bing," pp. 15–99, lists 659 works.

34. For an assessment of the painting sections of Gonse's book, see Ernest F. Fenollosa, *Review of the Chapter on Painting in Gonse's 'L'Art Japonais,'* Boston: James R. Osgood and Company, 1885.

35. See Lawrence C. Chisholm, *Fenollosa: The Far East and American Culture*, New Haven: Yale University Press, 1963. In 1882 Fenollosa delivered a paper at the Ryuchikai Club in which he criticized the Japanese craze for Western art.

36. See *Salon Annuel des Peintres Japonais*, deuxième année, introduction by S. Bing, Paris, 1884, 63 entries. In both 1883 and 1884, the show was held under the auspices of the Union Centrale des Arts Décoratifs at the Palais de l'Industrie in Paris.

37. Letter from S. Bing to Dr. Serrurier, Leiden, October 23, 1883, in the archives of the National Museum of Ethnology, Leiden. The author is indebted to Peter van Dam for originally calling this document to his attention.

38. See Rose Hempel, "Die Japan-Sammlungen des Museums für Kunst und Gewerbe, Hamburg," *Bonner Zeitschrift für Japonologie*, Bonn, 1981, pp. 159–166. The inventory books of the Oriental Department of the Kunst und Gewerbe Museum, Hamburg, record purchases from Bing's Paris shop beginning in 1885 (number 223). Brinckmann bought a number of Japanese objects from Bing over the years and helped translate Bing's *Artistic Japan* into German. Brinckmann's interest in Japan is also found in his *Kunst und Handwerk in Japan*, Berlin: Wagner, 1889.

39. Letter from Bing to the director of the Victoria and Albert Museum, London, February 1, 1883.

40. See *Ville de Paris—Cadastre de 1876*. According to the listing for 19 rue Chauchat[2], the 1883 renovation included a glass roof over the interior courtyard so that it could be used for storage. Listings for 19 rue de la Paix and for 13 rue Bleue are also found here. S. Bing is mentioned as renting a shop at the rue Bleue address beginning in 1881.

41. For further information, see Tribunal de Commerce, Paris, *Registres du Commerce après 1881, Dépôt de Statuts de la Société en commandite par actions S. Bing et Cie. avec Déclaration de souscription et de versement*, Paris,

June 14, 1884. Bing held 250 shares at a face value of 500,000 francs. Article VIII allowed Bing to continue his business at rue Chauchat and Auguste to manage it. It also permitted Bing to sell Japanese antiquities, those earlier than the nineteenth century, at other locations.

42. Letter from S. Bing to the director of the Victoria and Albert Museum, London, May 1, 1885.

43. S. Bing et Cie. had two offices: one on the bluff in Yokohama (at number 87), and another smaller one in Kobe (at number 20-B) noted by Hisao Miyajima as taking place in 1887. The next year S. Bing et Cie. moved to a new address in Kobe (number 104). Auguste Bing was in charge; T. Peny was listed as manager. Hisao Miyajima, a contemporary contact in Japan, kindly provided this information. See note 25 for a first reference to him.

44. See letter dated January 24, 1887, with the logo Agence Générale Française, S. Bing et Cie. Siège social, Paris, 13 rue Bleue. This lists groups for whom Bing was acting as an umbrella agent. Bing continued to sell commercial Japanese objects to collectors in Paris. For one of these cases, see Lucie Prost/Chantal Valluy, "Histoire d'une collection: le musée d'Ennery," *La Revue du Louvre*, 1977, no. 1, pp. 12–16. Madame d'Ennery purchased a number of contemporary Japanese objects from Bing.

45. For further reference to the Bing activity in Japan, see Correspondance Commerciale, Tokyo, vol. v, 1886–1888, Ministère des Affaires Etrangères. Specific contact is contained in letters number 315, 318, 428, and 429 from 1887 and 1888. The Bing firm was considered one of the five most important "houses" in contact with the Far East. This distinction allowed Bing to represent the "Syndicat Japon."

46. George Auriol, "Le Japon Artistique," *Le Chat Noir*, May 26, 1888.

47. "Art Notes and Reviews," *The Art Journal*, 1888, p. 256. Also see *Tidsskrift for Kunstindustri*, 1888, p. 128, and *Nordisk Tidsskrift*, 1888, p. 152.

48. *The Japan Weekly Mail*, March 30, 1889.

49. *The Japan Weekly Mail*, September 7, 1889.

50. *The Japan Weekly Mail*, June 8, 1889.

51. See *The Complete Letters of Vincent van Gogh*, vol. II, Boston: New York Graphic Society, pp. 600–601. The full extent of Bing's interaction with Van Gogh or how the dealer compensated the painter are not clear. Additional quotes from Van Gogh's letters are taken from this source.

52. See *Den Nordiske Industri-og Kunstudstilling, i Kjobenhavn*, Officiel Katalog, Copenhagen, 1888, "Japansk Kunst og Kunstindustri udstillet ved S. Bing, Rue Chauchat 19, Paris." Also see "Hr. S. Bing og den Japansk Samling," *Kunst-bladet*, Copenhagen, 1888, pp. 119–121.

53. Examples of early Bing and Gröndahl pieces in the

Japonisme style are housed in the manufactory museum in Copenhagen. Bing's ties with ceramic manufactories in Scandinavia also extended to the Royal Copenhagen Porcelain Manufactory. Bing assisted this organization in showing works at the 1889 Exposition Universelle in Paris. For further reference, see letter of Freddy Jensen, curator, The Royal Copenhagen Porcelain Manufactory, to the author on March 15, 1984.

54. "L'Exposition japonaise à Bruxelles," *Caprice Revue*, no. 65, 1888–1889. The brief review was signed with the initials J.D.T.A.

55. See Archives, Conservatoire National des Arts et Métiers, Don Bing, "Collection de pièces de porcelaines japonaises fournie au musée par Bing en 1888," inventory numbers 11353 to 11400. These pieces may be the first examples of Japanese work Bing gave to a museum for purely educational purposes.

56. *Exposition de la Gravure Japonaise ouverte à L'Ecole Nationale des Beaux-Arts*, du 25 avril au 22 mai 1890, catalogue. In his preface Bing placed the Japanese print movement in its historical context and traced its development. He noted that the *ukiyo-e* tradition had liberalized the artist's role in Japan. Their democratic position should thus serve as a model for artists in the Western tradition. Whether Bing actually knew how traditional Japanese artists' training really was or not, his choice of the theme of democracy may be an instance where he viewed the Far East through Western eyes.

57. See *Constatation de l'Etat Civil, d'un Membre de la Légion d'Honneur*, Bing, Sigefroy, no. 42.497, July 28, 1890.

58. A series of letters from S. Bing to M. Serrurier, now in the archives of the National Museum of Ethnology in Leiden, document his purchases for them. His letter of March 22, 1891, discusses the Burty sale. References to print volumes by Hokusai and Utamaro that Bing sold the museum appear in an October 1, 1892, letter. Transactions of an excellent print by Toyokuni and a superb album by Masonobu, which Bing later sold them, are found in a letter from April 1893.

59. Archives du Louvre, M8, December 23, 1893.

60. *De Portefeuille*, September 2, 1893. Bing tried to have a number of traveling shows touring at the same time. The impact of Japanese art on Dutch ceramicists is noted in *Zie Bouwkundig Weekblad*, xiii, 1893, p. 2254.

61. Bing arrived in the United States on February 12, 1894. For further reference, see National Archives, Washington, D.C., List of Passengers, New York, February 12–March 16, 1894, no. 172. Bing traveled aboard *La Champagne* from Le Havre.

62. See *The Collection of S. Bing of Paris, Chinese Porcelains, Jades, Bronzes, Japanese Pottery, Crystals, Lacquers, Metalwork, Ivories, etc.*, Moore's Art Galleries, 290 Fifth

Avenue, New York, 1887. The sale, which offered bronzes and antique Chinese and Japanese porcelains, was noted in *The Art Amateur* in June, 1887.

63. See *Catalogue of Bronzes and other Works of Art comprising Antique Chinese and Japanese Porcelains...to be sold by auction under the direction of the firm of S. Bing at their rooms, nos. 220 and 222 Fifth Avenue, November 21, 1888.* The exact date Bing established his own offices in New York remains unclear, although in 1887 a show was held at Bing's in New York.

64. See *Catalogue of Antique Chinese and Japanese Porcelains, Pottery, Enamels, and Bronzes, Cabinet Specimens in Jade, Agate and Crystal, Sword-Guards, Netsukes, Kakemonos, Old Fabrics, etc.,* to be sold at public sale by order of S. Bing, Paris, on Friday, February 23d and following days...at the American Art Galleries, Madison Square, South, The American Art Association, Managers, New York, 1894. Bing had previously been offered Durand-Ruel's galleries on Fifth Avenue for this auction, but he may have turned them down because the objects were not of excellent quality. For reference, see *Lettres de Durand-Ruel 1892 to 1894, no. 474,* February 8, 1894, in which Durand-Ruel gives Bing permission to use their showroom in New York. Bing's Paris company was bought by Dubuffet et Cie. on December 10, 1892. (See Archives du Tribunal de Commerce de Paris, August 24, 1892–June 7, 1893, no. 2402, Société Dubuffet et Cie.) S. Bing remained as a limited partner, holding on to 64,000 francs of the initial capital of 400,000 francs. His brother Auguste was no longer associated with the firm.

65. For this show, see *Japanese Engravings, Old Prints in Color, Collected by S. Bing, Paris,* The American Art Galleries, Madison Square, South, New York, 1894.

66. *Annual Report,* The Metropolitan Museum of Art, December, 1882, New York, 1883, Archives, Metropolitan Museum of Art, Correspondence Files, 1870–1950. S. Bing's letter to L. P. de Cesnola, October 2, 1882, noted his donation of a Chinese porcelain.

67. Archives, The Metropolitan Museum of Art, Correspondence Files, 1870–1950, letter of S. Bing to H. R. Bishop, December 27, 1889.

68. The Pennsylvania Academy of Fine Arts wanted objects from Bing's collection, but they could not be shipped in time. (See *Letterbook,* Pennsylvania Academy of Fine Arts, February–June, 1894, no. 170, March 30, 1894.) Ernest Fenollosa, at the Boston Museum of Fine Arts, tried to have the Pennsylvania Academy of Fine Arts exhibit as many of Bing's objects as possible. See *Letterbook,* Pennsylvania Academy of Fine Arts, October 11, 1893–February 24, 1894, especially letter of February 17, 1894. Also see Archives, The Metropolitan Museum of Art, Correspondence Files, 1870–

1950, Bing file, letter no. 7, written from Boston, April 3, 1894 (at St. Botolph Club).

69. Archives, The Metropolitan Museum of Art, Mr. and Mrs. H. O. Havemeyer File, H. 2983, contains the notice that in 1894 the collection was loaned to the museum by S. Bing. S. P. Avery asked for clarification as to what Bing had left on loan to see how the textiles related to objects already owned by the Havemeyers. See Frances Little, "Japanese Textiles from the Bing Collection," *Bulletin of the Metropolitan Museum of Art,* vol. 27, January, 1932, pp. 14–16. The Havemeyer Oriental art collection was shown at the Metropolitan in 1930. For further reference, see *The H. O. Havemeyer Collection, A Catalogue of the Temporary Exhibition,* March 10–November 2, 1930, The Metropolitan Museum of Art, 1930.

70. Lawrence W. Chisolm, *Ernest Fenollosa: The Far East and American Culture,* New Haven and London: Yale University Press, 1963, p. 93.

71. S. Bing, "The Art of Utamaro," *The Studio,* February, 1895, no. 23, vol. 4, pp. 137–141.

72. S. Bing, "La Vie et l'oeuvre de Hok'sai," *La Revue Blanche,* vol. 10, 1896, pp. 97–101.

73. See Edmond le Roy, "A propos d'Hokusai chez M. de Goncourt," *Gil Blas,* February 5, 1896. In this interview, Goncourt presented his version of the incident by saying, "If Hayashi had not given [the information] to me, I would have probably received it from someone else. I have always had, in fact, correspondents over there." He also pointed out that his work on Hokusai was far different from Bing's biography, stating, "I have not limited myself to narrate the life of the man, I have really wanted to make his work known. For that reason, I have, I repeat, studied the collections, the books...the illustrations...the albums supplied me with the documentation I might have lacked." Other articles on the rivalry between Bing and Goncourt appeared in the Parisian press, especially in *Le Figaro.*

Incidentally, during the Bing-Goncourt commotion, little attention was paid to Hayashi, whose translation caused the controversy. An independent dealer in Oriental art, Hayashi was in some respects Bing's major rival. By 1900 he had sold over 166,000 ukiyo-e prints to all types of collectors. Nor was his translating the Hanjuro text an altogether innocent act. He no doubt enjoyed watching his chief competition challenge a prominent public figure like Goncourt, although he never commented on it in public until his death in 1906. For more information on Hayashi, see S. Bing, "La Collection Hayashi," in *Objets d'Art du Japon et de la Chine, peintures, livres réunis par T. Hayashi,* January 27–February 1, 1902, Galeries Durand-Ruel, Paris, 1902.

74. S. Bing, "Les Arts de l'Extrême-Orient dans la Col-

lection des Goncourt," in *Objets d'art japonais et chinois, peintures, estampes composant la Collection des Goncourt,* dont la vente aura lieu Hôtel Drouot, March 8–13, 1897, Paris, 1897. Bing also wrote the catalogue's introduction.

75. In correspondence with the author, Dr. Waltraud Neuwirth notes that the Österreichisches Museum für angewandte Kunst in Vienna purchased a number of Tiffany pieces through Bing in 1898 and 1899. The museum later held exhibitions of Japanese art, which Bing had been instrumental in organizing for international tours.

76. Archives, Kaiser Wilhelm Museum, Krefeld, Germany, dossier Bing/Kaiser-Wilhelm Museum contains a detailed register of the correspondence between S. Bing and the museum from the date of the museum's opening in 1897. The letter from museum director Deneken asking for Japanese objects for the opening no longer exists. In his reply of October 13, 1897, Bing promises to put together a collection of Japanese objects rather than ukiyo-e prints for the opening.

77. Archives, Kaiser Wilhelm Museum, Krefeld, Germany, dossier Bing/Kaiser-Wilhelm Museum, letter November 24, 1900, sent by Deneken to Bing. The author is grateful for the assistance of Walter O. Michael in translating these handwritten documents.

78. According to *Bulletin, Société Franco-Japonaise de Paris,* Paris, 1902, a dinner in honor of Prince Komatsu was held on June 10, 1902, and Bing, Koechlin, Félix Régamey, Henri Rouart, and Henri Vever attended. The Society may have been an official group that developed out of the Japanese dinners often hosted by Hayashi, who had assumed considerable power in Paris by 1900. The Franco-Japanese Society published a bulletin, maintained a library filled with current publications on Japan, held discussions at its headquarters on the rue de Grenelle, and gave banquets for distinguished visitors.

79. See *Exposition Internationale Universelle de 1900, Catalogue Général Officiel,* vol. 17, groupe xv, industries diverses. Also see *Volume annexe du Catalogue Général Officiel,* especially "Notice concernant l'Empire du Japon à l'Exposition Universelle de 1900," n.d.

80. *Rapports du Jury International, Groupe XII, Décoration et mobilier des édifices et des habitations,* Paris, 1902, specifically "Céramique-Classe 72." Bing was nominated for the jury by Hayashi, one of the organizers of the Japanese pavilion's exhibitions.

81. *Ibid.,* pp. 52–53. Many Japanese ceramicists showed their works in this exhibition, thus further extending Western knowledge of contemporary tendencies in the Japanese decorative arts.

82. An invitation card for the opening of the Nihon-Gwakei exhibition is preserved in the Archives,

Bibliothèque d'Art et d'Archéologie, Paris. A catalogue for this particular show, held from March 27 to April 30, 1901, has not been located.

83. G. M., "Paris—Nihon Gwakei," *The Studio*, 1901, vol. 23, pp. 279–282. Some of the works in the exhibition are illustrated.

84. S. Bing, "Le Bois Japonais," in *Exposition de la Gravure sur bois à l'Ecole Nationale des Beaux-Arts, Mai, 1902. Catalogue avec notices historiques et critiques par MM. Henri Bouchot, G. Claudin, J. Masson, Henri Béraldi, et S. Bing*, Paris, 1902, pp. 61–66. The president of the exhibition committee was Auguste Lepère, an important, practicing printmaker, who advocated both wood engraving and the revival of woodblock printing techniques. In addition to Bing, vice-presidents included Henri Béraldi, G. Claudin, and Jean Masson. For further reference to Lepere, see *The Artistic Revival of the Woodcut in France 1850–1900*, exhibition catalogue, The University of Michigan Museum of Art, Ann Arbor, 1984.

85. See *Objets du Japon et de la Chine, peintures, livres réunis par T. Hayashi*, January 27–February 1, 1902, Galeries Durand-Ruel, Paris, 1902. Also see S. Bing, "La Gravure Japonaise," in *Collection Hayashi, dessins, estampes, livres illustrés du Japon, réunis par T. Hayashi . . . dont la vente aura lieu du lundi 2 juin au vendredi 6 juin 1902, à l'Hôtel Drouot*, Paris, 1902.

86. "La Collection Gillot," *Art et Décoration*, vol. 15, 1904, p. 1 (February Supplement). See also *Collection Ch. Gillot, Objets d'art et peintures d'Extrême Orient*, February 8–13, 1904, Galeries Durand-Ruel, Paris, 1904. The catalogue's preface was prepared by Gaston Migeon, who met Gillot at a dinner hosted by Bing. Migeon considered Gillot a member of the second generation of *japonistes*, along with Louis Gonse and Charles Haviland.

87. Freer Diaries, Freer Gallery of Art, Washington, D.C., June–July, 1901. Attributions were reported by Yoshiaki Shimizu, a curator at the Freer Gallery, June, 1983. Questions have been raised about the attributions of the works purchased from Bing (Freer Gallery 01.84, 01.192, 01.26). The so-called Kenzan (01.84) has been judged of poor quality and not by the artist, and the Korin (01.192) a forgery. Only the Sotatsu (01.26) is of good quality and fair attribution.

The question of forgeries and works of poor quality on the Oriental art market at the turn of the century is a particularly difficult problem to unravel since it is directly related to Western art market needs. Entrepreneurial interest in having art objects produced by contemporary Japanese artists in the style of earlier masters for sale and distribution in the West seems highly probable. Without detailed records of the many firms in the West and Far East, however, it is an extremely difficult assumption to substantiate accurately.

88. Helen Tomlinson, "Charles Lang Freer: Pioneer Collector of Oriental Art," Ph.D. dissertation, Case Western Reserve University, May, 1979, p. 408. Tomlinson traces Freer's remark to a letter he wrote to Fenollosa on February 11, 1902. According to Yoshiaki Shimizu's discussions with the author, a number of other pieces secured from the Hayashi sale have been judged of negligible quality (Freer Gallery 02.37, 03.52, 03.54). Mr. Shimizu also doubts the authenticity of several pieces from the Hayashi collection sold in the West.

89. S. Bing, "La Japonaise," *Revue Universelle*, February 1, 1905, pp. 66–72.

90. R. C., "The Passing of Siegfried Bing," *Brush and Pencil*, November, 1905, pp. 161–164. In its entirety, this was a particularly sensitive obituary.

91. *Collection S. Bing*, 6 fascicules grand in folio, réunis dans un carton, et contenant 54 planches hors texte en héliogravure ou en phototypie et un grand nombre d'illustrations dans le texte, Paris, chez M. Bing, 10 rue Saint-Georges. See also "Collection S. Bing (arts de l'Extrême Orient)," *Bulletin de l'Art ancien et moderne*, no. 300, May 5, 1906, pp. 140–141. The director of the Nordenfjeldske Kunstindustrimuseum in Trondheim, Norway, attended the Bing sale in 1906, purchased objects for his museum, and later prepared a detailed report on the sale. For further information, see Avskrift Nordenfjeldske Kunstindustrimuseums Forhandlings-protokol no. 2, 2/28/1900–2/10/1908 and specifically "Auktion Bing." Citation provided by Jan-L. Opstad, director, Nordenfjeldske Kunstindustrimuseum, in a letter dated April 5, 1983.

92. See *Extrait du registre des déclarations du bureau d'enregistrement des Commissaires Priseurs*, May 2, 1906, Monsieur Marcel Bing, expert, demeurant à Paris, rue Saint-Georges, number 1395.

93. Marcel Bing to Charles Freer, in Freer Gallery of Art Archives, Washington, D.C. Bing's correspondence is dated April 10, 1906. Other correspondence between Bing and Freer cited here is also found in the Freer archives.

94. See *Inventaire après le décès de M. Bing*, July 6, 1921.

95. Musée Guimet, Paravent, given in memory of S. Bing in 1906, no. 827 of the Musée Guimet inventory.

96. René Haase, *Vente à la requête du Commissaire Gérant des Biens Israélites, Art Antique—Art d'Extrême-Orient*, Hôtel Drouot, May 10–11, 1943. René Haase was related to the Haase family that purchased Bing's porcelain manufactory. This further documents the extremely close ties between various member families in the Jewish community in Paris. A search for Haase's descendants has yielded no trace of family members who remember this phase of their business life.

CHAPTER 2

1. *Archives Nationales*, F 21 4061, "Exposition Universelle de Chicago, Section des Arts Décoratifs, Séance du 15 décembre, 1892. Among the designers who supported the pro-decorative arts resolution were the leading ceramicist Auguste Delaherche, Frantz Jourdain, Jules Chéret, and Lucien Falize, an important jeweler. The impact of the French industrial designers was studied by Victor Champier, who also made an official trip to the United States in 1893, which he commented upon in articles published in *Le Figaro*. These articles demonstrated growing ties between European and American designers.

2. S. Bing, *Artistic America, Tiffany Glass and Art Nouveau*, originally *La Culture artistique en Amérique*, 1896, translated by Benita Eisler (Cambridge: The MIT Press, 1970). Bing's report to Henri Roujon was printed and published, although it remains unclear how widely it was circulated and discussed. Certain sections of the book appeared in Parisian journals, indicating that it was read to some extent. His trip was one of several undertaken by French leaders in the decorative arts to explain American achievements. For further reference, see S. Bing, "L'Architecture et les Arts Décoratifs en Amérique," *Revue Encyclopédique*, December 11, 1897, pp. 1029–1036. An American newspaper article, "Bing on American Art, The French Expert Praises American Architecture and Industrial Arts," is in the Archives Durand-Ruel, *Scrapbook*, ca. 1897, but the paper's name and date are clipped off.

3. Robert Koch, *Louis C. Tiffany, Rebel in Glass* (New York: Crown Publishers, 1964), p. 9. "Moore, who was a collector of Oriental art, was interested in ancient and Oriental glass and encouraged young Louis C. Tiffany to acquire objects of interest and to study the values of non-European cultures. Samuel Bing, who imported Oriental items, supplied them both with many unique articles."

4. S. Bing, *Artistic America*, p. 146.

5. Koch, *Tiffany*, p. 74. Bing probably chose Tiffany over other American glassmakers because of organizational acumen and his technical innovations in coloring glass, many of which he invented. He also considered John La Farge and made inquiries in his direction, but there is no record that anything came of it. Information shared with the author by Henry A. La Farge, a descendant of the artist, indicates that John La Farge sent a series of questions, dated January 1894, to John Getz, Bing's agent in New York. For further reference to La Farge's role in American glassmaking, see H. Barbara Weinberg, *The Decorative Work of John La Farge* (New York and London: Garland, 1977).

6. Letter from Edouard Vuillard to Maurice Denis, May 30, 1894, Archives familiales de Maurice

Denis, St. Germain-en-Laye.

7. Letter from S. Bing to Maurice Denis, October 30, 1984, Archives familiales de Maurice Denis, St. Germain-en-Laye.

8. Letter from M. Morot, an assistant who worked closely with Bing throughout this period, to Maurice Denis, April 18, 1895, Archives familiales de Maurice Denis, St. Germain-en-Laye.

9. *La Revue Franco-Américaine*, vol. 1, 1895, wrote, "enfin vient une série de vitraux superbes exécutés à New York, chez Tiffany, sous l'habile influence de Bing qui les fit dessiner à Paris par...Toulouse-Lautrec, Vuillard, Vallotton, Bonnard, Ibels, et Roussel, et nous sommes heureux de constater que l'Amérique, indépendante et sincère comme toujours, n'a pas hésité à négliger nos misérables peintres officiels pour s'adresser de suite aux artistes jeunes, vivants et pleins de talent."
Also see Alastair Duncan, *Tiffany Windows*. (New York: Simon and Schuster, 1980), pp. 106–112. Some of the preliminary cartoons for the windows are reproduced there. Duncan suggests that they, together with other pieces, were purchased by the art dealer Bernheim-Jeune from Marcel Bing in 1909. The location of these preliminary studies and how many still exist are not known.

10. Letter from S. Bing to Maurice Denis, April 30, 1895, Archives familiales dè Maurice Denis, St. Germain-en-Laye.

11. For further reference, see "A La Toison d'Or, une maison d'Art à Bruxelles," *L'Art Moderne, Revue Critique des Arts et de la Littérature*, December 16, 1894. The *Maison d'Art* also contained a theater and held symposia where artists could discuss their work. It did not sell works on the premises, however, so the marketplace could not influence the choice of artists exhibited. Bing's new galleries were to be a Paris version of this institution, although all the works on view would be for sale. He did plan to encourage young talent by holding either group or one-artist shows and in general creating an ambience that would inspire artistic innovation.

12. Kenworth Moffett, *Meier-Graefe as Art Critic*, (Munich: Prestel-Verlag, 1973), p. 28. Meier-Graefe made his reputation as a forceful and inventive editor interested in modern art.

13. *Documents sur l'art industriel au XXe siècle*, (Edition de la Maison Moderne), Paris, n.d.

14. For reference to what was planned, see Archives de Paris, letter from S. Bing to the Préfet de Paris, July 8, 1895, vol. 11 2351, 22 rue de Provence.

15. For further reference to this relationship, see Gabriel P. Weisberg, "Siegfried Bing, Louis Bonnier et la Maison de l'Art Nouveau en 1895," *Bulletin de la Société de l'Art Français*, Séance du 4 décembre 1982, 1985, pp. 241–249. Bonnier used a series of private commissions in the late 1890s to demonstrate the use of new materials in challenging ways.

16. Louis Bonnier's Japanese art collection is now dispersed, although it included prints of exceptional quality by Hiroshige and Hokusai. The author had a chance to study these objects, as well as sword guards and *netsuke*, when they were in the possession of Bernard K. Bonnier, the architect's late grandson.

17. See Martin Eidelberg and Suzanne Henrion-Giele, "Horta and Bing: An Unwritten Episode of L'Art Nouveau," *Burlington Magazine*, November 1977, pp. 747–752.

18. Archives de Paris, letter from S. Bing to the Préfet de Paris, July 8, 1895, vol. 11 2351, rue de Provence. Ceramic tile was originally thought to play an important role in the redecoration of the building's facade, most likely because it was then a popular decoration. Architects used ceramic tiles on the facades of many other buildings in Paris at the time. Alexandre Bigot, a major craftsman and ceramicist and an artist Bing exhibited, received several commissions to decorate Parisian buildings this way.

19. Eidelberg and Henrion-Giele, "Horta and Bing," p. 748. Unless otherwise stated, references to Brangwyn's plan and Horta's role in Bing's renovation are from this source. The letter from Bing to Horta is in the archives of the Horta Museum in Brussels. Many of the changes Bing proposed were obviously developed from conversations he had with those members of his staff who had also been trained in the decorative arts, including his assistants Marcel Morot and H. M. Jaeger.
Authors Eidelberg and Henrion-Giele have reconstructed these drawings by Horta, although these plans could be alternative schemes rather than preliminary sketches for Bing's building. Bing probably ignored Horta's suggestions because the architect disregarded most of his instructions. Horta's elaborate design in either carved stone or ironwork surely would have cost more, not less, than Brangwyn's ceramic facade and certainly would have taken far more time than they had to meet Bing's deadline of the end of the year (1895).

20. Rodney Brangwyn, *Brangwyn*, London, 1978, p. 72. The exterior friezes have not survived, although a stencil pattern for part of one design on the facade was in the collection of the late Bernard K. Bonnier.

21. The one extant interior panel, now at the William Morris Gallery, Walthamstow, London, reinforces the stylized allegorical design Brangwyn utilized in some of these images. Other images, including the external friezes, have disappeared, either worn away by exposure to the elements or destroyed when the building was demolished.

22. Weisberg, "Siegfried Bing," *Bulletin de la Société de l'Histoire de l'Art Français*, pp. 241–249.

23. Gabriel P. Weisberg, "Samuel Bing: Patron of Art Nouveau, Part II: The Salons of Art Nouveau," *The Connoisseur*, December 1969, pp. 294–299. The invitation card for the Salon cited the entrance on rue Chauchat for the Japanese galleries.

24. L. C. Boileau, fils, "La Maison de l'Art Nouveau," *L'Architecture*, January 11, 1896, p. 14. Boileau described the interior effect as an "aquarium rempli d'eau trouble." He gave a detailed analysis of what Bing and Bonnier attempted to do with the galleries at 22 rue de Provence. Probably an architect, Boileau understood Bonnier's problem of having to give the building a new, modern appearance.

25. For a reproduction of Isaac's installation, see "'L'Art Nouveau' at Paris," *Art Journal*, 1897, pp. 89–90. For reference to his work, also see *Salon de L'Art Nouveau*, Premier Catalogue, 1895, number 541.

26. S. Bing to Maurice Denis, January 13, 1896, Archives familiales de Maurice Denis, St. Germain-en-Laye. Bing wrote, "Maintenant que vos désirs ont été satisfaits, voulez-vous faire prendre votre lit? J'aimerais qu'on put venir le démonter demain, Mardi, de bonne heure, le matin." Unless otherwise stated, all correspondence between Bing and Denis is located in the Archives familiales de Maurice Denis, St. German-en-Laye.
As found in André Hallays, "Au jour le jour" in *Le Journal des Débats*, January 12, 1896, critical reaction to the furniture had been negative. The critic for L'Architecture described the bedroom furniture, "Hélas! le bois du lit a une apparence de palier de marteau-pilon."
Bing's letter to Denis about the Gallé furniture is dated August 27, 1895. One letter from Bing to Denis about selling the bedroom panels is undated, while another about the price of the panels, dated January 31, 1896, notes, "Merci de votre mot d'hier. C'est plutôt à vous de me dire quel prix je dois demander des panneaux en question et si une petite affaire peut venir alléger dans une petite mesure les frais dépensés je vous en aurai de l'obligation."
A February 3, 1896, letter from S. Bing to Denis added, "En restituant vos panneaux, je regretterais de ne pas consigner les faits qui ont accompagné leur passage dans mes galeries. Après avoir, pour me plier à vos désirs, dépensé près de 2000 francs de la façon que vous savez; après avoir réservé à vos peintures un emplacement où tout Paris a défilé, il s'est trouvé en ce public un amateur qui s'en est épris-là. Or, si, en l'absence de tout écrit entre nous, vous vous considérez comme dispensé de toute indemnité à mon égard, c'est votre affaire; mais il me plait de constater que telle est votre manière de voir."

27. Critical response to Van de Velde's rooms was

positive, as in Gustave Geffroy's "L'Art d'Aujour-d'hui, Ameublement," *Le Journal*, January 3, 1896, p. 1. The critic for *Le Temps* had mixed feelings toward the Salon, but even he commented favorably on Van de Velde's work. See "Au Jour le Jour," *Le Temps*, December 30, 1895, p. 3. Also see " 'L'Art Nouveau' at Paris," *Art Journal*, 1897, p. 90.

28. For more information on this chair, see Musée des Arts Décoratifs, *Album Bing*, Bibliothèque du Musée des Arts Décoratifs. Not everyone liked the chairs. (See " 'L'Art Nouveau' at Paris," *Art Journal*, 1897, p. 90.) The critic commented, "The chairs want comfort, and their tinsel decoration recalls with their arabesques the operatic 'Orient.' "

A record of Bing selling other objects by Van de Velde after the opening Salon suggests that both men continued to work together for a longer period than first believed. A Van de Velde door handle was sold through Bing's shop, for 60 francs, in 1901. (See Archives, Nordenfjeldske Kunstindustrimuseum, Trondheim, Norway, NK 10-1901, and Bill of Sale from *L'Art Nouveau*, object number 8730.) Others of his pieces passed through Bing's shop after 1899.

Bing's relationship with Van de Velde is also linked with H. M. Jaeger, Bing's first deputy in decorative design. Eidelberg and Henrion-Giele (p. 748) assumed that Jaeger died because Bing suddenly took over so much of the work himself. A December 27, 1896, letter from Jaeger to M. Thiis, director of the Nordenfjeldske Kunstindustrimuseum, Trondheim, Norway, refers to Jaeger having left Bing's firm on August 15 to work for Van de Velde. Eidelberg also assumed that Bing turned the handling of foreign artists over to Julius Meier-Graefe, but a number of designers he represented, Colonna and de Feure for example, were not French.

29. " 'L'Art Nouveau' at Paris," *Art Journal*, 1897, p. 90.

30. Rodney Brangwyn, *Brangwyn*, p. 73. Bing installed pieces of furniture on a rotating basis to emphasize the availability of new stock for sale.

31. A good example of Bing's innovative way to exhibit pieces was the ceramic service by Edouard Vuillard. Although it is not listed in the catalogue of the first Salon, this ceramic service is visible in a photograph of the Van de Velde dining room. It is also not mentioned in the catalogue of the second Salon, but Gustave Geffroy, in his review of the first Salon, mentions the plates. (See Gustave Geffroy, "L'Art d'aujourd'hui, ameublement," *Le Journal*, January 3, 1896, pp. 1–2.)

32. *Salon de L'Art Nouveau*, Premier Catalogue, numbers 445–502.

33. *Salon de L'Art Nouveau*, Premier Catalogue, number 541, "Tenture d'un salon en rotonde, onze panneaux et une frise, peluche décorée."

34. For Rippl-Ronai in 1895, see *Salon de L'Art Nouveau*, Premier Catalogue, number 167–169, number 633 (*Les Vierges*) lithographs for an illustrated book commissioned by Bing. Also see *Oeuvres de Rippl-Ronai exposées à l'Art Nouveau*, June, 1897.

35. *Catalogue des publications contemporaines figurant à l'exposition internationale du livre moderne organisée à l'art nouveau*, Paris, 1896.

36. "British Decorative Arts of the late Nineteenth Century in the Nordenfjeldske Kunstindustrimuseum," *Arbok, 1961–1962*, Nordenfjeldske Kunstindustrimuseum, Trondheim, 1963, pp. 37–106. *The Studio*, April 1896, p. 179, mentions a Benson fireplace fender, fire-dogs, and fire-irons later acquired by the museum in Trondheim. Benson also exhibited a number of light fixtures and furniture, but he dealt mainly in metalwork.

37. Letter from S. Bing to Auguste Rodin, December 13, 1895, in Rodin Archives, Musée Rodin, Paris. Also see S. Bing's letter to Rodin, May 16, 1896, in Rodin Archives, Musée Rodin.

38. Gabriel Lefeuve, "Choses d'Art, L'Exposition Bing," *Le Siècle*, January 5, 1896.

39. Alfred Pallier, "Chronique d'art," *La Liberté*, January 8, 1896, p. 3.

40. "L'Art Nouveau," *La Chronique des Arts*, January 11, 1896, noted, "L'exposition ouverte sous ce nom, dans les salles de la rue de Provence—si libéralement prêtées par M. Bing à des artistes parfois jeunes—n'est pas concluante. Il est vrai qu'aucune exposition ne saurait suffire au fardeau de justifier deux pareils vocables. Le mot 'nouveau' à lui seul, est un de ces mots terribles, dont les organisateurs doivent se défier et que les apôtres des meilleurs causes n'ont jamais employé; il est plein de promesses irréalisables et, dans le cas présent, s'applique mal au groupement improvisé qu'abrite l'hôtel polychrome de M. Bing. Il n'y a là, à proprement parler, rien d'original. Il y a de jolies choses en désordre: mais rien ne peut y faire craindre ou espérer la plus petite Révolution artistique."

41. André Hallays, "Au jour le jour," *Le Journal des Débats*, January 12, 1896, p. 1.

42. Arsène Alexandre, "L'Art Nouveau," *Le Figaro*, December 28, 1895. All of Alexandre's remarks cited here are from this source. This was the time of the Dreyfus affair, and anti-Semitism was again fashionable. So far, Bing had not been bothered by it—although the issue had emerged in his debate with Edmond de Goncourt—possibly because he had kept a respectable Oriental dealership and was known only among the cognoscenti. The Salon de l'Art Nouveau was, in contrast, ostentatious and avant-garde.

43. André Hallays, "Au Jour le jour," *Le Journal des Débats*, January 12, 1896.

44. " 'L'Art Nouveau' at Paris," *Art Journal*, 1897, p. 90.

45. Gustave Geffroy, "L'Art d'Aujourd'hui, Ameublement," *Le Journal*, January 3, 1896, p. 1.

46. L. C. Boileau, fils, "La Maison de l'Art Nouveau," *L'Architecture*, January 11, 1896, p. 14.

47. Jules Chancel, "Notes parisiennes, L'Art Nouveau," *L'Evénement*, December 28, 1895, p. 1.

48. Geffroy, *Le Journal*, pp. 1–2. Geffroy concentrated on the room interiors, especially the furniture, as Bing's major contribution to French design reform. He made these comments on Denis' work: "Maurice Denis, among the newcomers, is also one of those who know how to extract a certain meaning from contemplated spectacles. He has composed a frieze for the decoration of a bedroom, which admirably denotes the quality of his inspiration. I believe that he was mistaken when he imagined the wardrobe as heavy as a strongbox and the bed and chairs equally as heavy. However, as regards the frieze, he follows the logic of his style and the evolution of his taste for ornamentation. Since he has painted all the sweet figures of young girls, women, mothers as represented in scenes of betrothals, marriages, visits to a new mother in supple lines and attenuated colors, they match the walls with a soft light."

49. Edmond Cousturier, "Galeries S. Bing, Le Mobilier," *La Revue Blanche*, 1896, p. 94.

50. *Tidsskrift for Kunstindustri*, 1896, p. 174. This source gave special attention to the exhibition of "Livre Moderne."

51. *L'Art Moderne*, January 5, 1896, p. 7.

52. " 'L'Art Nouveau' at Paris," *Art Journal*, 1897, pp. 89–90.

53. Julius Meier-Graefe, "L'Art Nouveau, Das Prinzip," *Das Atelier*, 1896, Jg. 6, vol. 5, pp. 2–4.

54. Julius Meier-Graefe, "L'Art Nouveau, Die Salons," *Das Atelier*, 1896, Jg. 6, vol. 6, pp. 2–4.

55. Although he was fully aware of what the rooms were supposed to accomplish, Meier-Graefe had some reservations about the final effect. He found the furniture too heavy for the small space and criticized this room (the only one he was not fully satisfied with by the Belgians) for missing a "natural harmony." He was, however, supportive of the collection cabinet, calling it the "happiest room," and adding, "The wallpaper is done by Van de Velde, a pattern of distinguished taste, on a faintly yellow background where there is a very discreet flower design in the same color. . . . It all fits in perfect harmony."

56. Julius Meier-Graefe, "L'Art Nouveau, Die übrigen Kunst und kunstgewerblichen Zweige," *Das Atelier*, 1896, Jg. 6, vol. 8, pp. 2–4.

57. Victor Champier, "Les Expositions de l'Art Nouveau," *Revue des Arts Décoratifs*, December 16, 1896, pp. 1–6. Champier, a key figure in the design reform movement, compared French decorative de-

sign with American achievements. Like Bing, Champier had visited the United States and prepared a detailed report on his observations.

58. "'L'Art Nouveau' at Paris," *Art Journal*, 1897, pp. 89–90.

CHAPTER 3

1. The room appears in "Französisches Mobiliar," *Dekorative Kunst*, September, 1898, pp. 104–108.
2. Linda S. Smith, "S. Bing and *L'Art Nouveau*," unpublished M.A. thesis, The Pennsylvania State University, March 1971. In an essay on Bing and his exhibitions, Smith noted that the Tiffany show took place in June 1897. *Art et Décoration* listed it in November.
3. S. Bing, "Wohin Treiben Wir?," *Dekorative Kunst*, 1897, vol. 1, pp. 1–3, 68–71, and 173–177.
4. Letter from Jens Thiis to his Consul, August 11, 1896, Archives, Nordenfjeldske Kunstindustrimuseum, Trondheim.
5. Report by Jens Thiis, *Arbok, 1961–1962*, Nordenfjeldske Kunstindustrimuseum, Trondheim, 1963, pp. 37–106.
6. For further reference to the English pieces in Trondheim, see Hugh Wakefield, Elizabeth Aslin, Barbara Morris, and Shirley Bury, "British Decorative Arts of the late Nineteenth Century in the Nordenfjeldske Kunstindustrimuseum," *Arbok, 1961–1962*, Nordenfjeldske Kunstindustrimuseum, pp. 37–106. The Österreichisches Museum für angewandte Kunst purchased a similar group of Morris designs in 1898 (inventory number 4934). This example, similar to a piece by Arthur Silver, was purchased from *L'Art Nouveau* on August 28, 1898, for just under thirty francs. The same pattern is found on other fabrics in the museum (inventory numbers T. 5011, 5012, and 5013).
7. For reference to Brangwyn's late commissions, see "Stained Glass Designs by Frank Brangwyn," *The Studio*, 1899, vol. 16, pp. 252–259. Also see Alastair Duncan, *Tiffany Windows*, New York, 1980, p. 130. An article by Georges Lemmen ("Moderne Teppiche," *Dekorative Kunst*, 1897, vol. 1–2, pp. 97–105) gives examples of Brangwyn's carpets, with one reproduction in color.
8. *L'Art Nouveau*, Deuxième Catalogue, février, 1896, numbers 663–849. Delâtre exhibited numbers 704–716, while Kaehler displayed eight ceramics, numbers 796–803. Manuel Orazi showed a most curious work called *Calendrier magique*, which both mocked Bing's interest in printmakers and could be viewed as self-satire. An example of this work is found in the Cabinet des Estampes, Bibliothèque Nationale, Paris.
9. Maxime Vallotton and Charles Georg, *Félix Vallotton, catalogue raisonné de l'oeuvre gravé et lithographié*, Geneva, 1972, number 237. Vallotton's poster was available for sale at 200 francs. The business card is reproduced in *Japonismus und Art Nouveau*, Europäische Graphik aus den Sammlungen des Museums für Kunst und Gewerbe, Hamburg, Kobe, Kitakyushu, und Tokyo, 1981, number 156.
10. Camille Mauclair, "Choses d'Art," *Mercure de France*, February, 1896, pp. 265–269. Surprised by Arsène Alexandre's attack, Mauclair wrote, "On a été pour lui d'une injustice intolérable. J'ai dit ailleurs, et je n'y reviens pas, ce qu'il fallait penser de la piêtre incartade de M. Arsène Alexandre dans le *Figaro*: on eut attendu de ce soi-disant critique d'avant-garde autre chose qu'un éreintement."
11. *L'Art Nouveau, Exposition Constantin Meunier, du 16 février au 15 mars 1896*, Salon de l'Art Nouveau (introduction by Georges Lecomte). The retrospective of seventy objects opened on February 16, 1896.
12. *Catalogue de la Société Nationale des Beaux-Arts*, Paris, 1893, pp. 201–202.
13. Clément Janin, "Notes d'Art," *Le National*, February 26, 1896. Janin found the comparison off the mark, stating, "Michel Ange exagère....M. Constantin Meunier est plutôt en deçà. Il n'est pas exubérant, il se contente d'être juste."
14. Gustave Geffroy, "L'Art d'aujourd'hui, Constantin Meunier," *Le Journal*, February 17, 1896.
15. Cabinet des Estampes, Bibliothèque Nationale, DC 375, vol. 7, records the invitation. The catalogue has disappeared; the exhibition was held April 2–15, 1896.
16. "Louis Legrand," *Le National*, April 15, 1896. Other reviews of the Legrand exhibition appeared in *La Revue des Beaux-Arts et des Lettres*, written by Léon de Saint-Valéry ("Exposition de M. Louis Legrand, à 'l'Art Nouveau,'" April 15, 1896, pp. 109–110) and in *Mercure de France* (May, 1896, pp. 317–318), which drew the parallel with Degas. Also see Ernest Jaubert, "L'Exposition de Louis Legrand," *L'Artiste*, 1896, vol. 66, pp. 354–356.
17. Camille Mauclair, *Mercure de France*, June, 1896, p. 466. A second brief notice is found in *Le National* (Clément-Janin, "Notes d'art Eugène Carrière," April 23, 1896).
18. *The Prints of Edvard Munch, Mirror of His Life*, an exhibition of prints from the collection of Sarah G. and Lionel C. Epstein, exhibition catalogue, Allen Memorial Art Museum, Oberlin College, March, 1983, p. 58. This source also mentions Meier-Graefe's involvement with Munch's printmaking. Also see A. J. Meier-Graefe, Edvard Munch, *Acht Radierungen*, Berlin, June, 1895.
19. The usual date given is June; see *The Prints of Edvard Munch ...*, p. 59. For the correct date, see *Catalogue Edvard Munch, L'Art Nouveau*, May, 1896. This small pamphlet lists the sixty objects, some with owners, that were displayed in Bing's show.
20. Camille Mauclair, "Revue du mois," *Mercure de France*, July, 1896, pp. 186–189.
21. *Catalogue Edvard Munch, L'Art Nouveau*, May, 1896.
22. *Catalogue des publications contemporaines figurant à l'exposition internationale du livre moderne organisée à l'art nouveau*, Paris, 1896.
23. A copy of the poster is in the Museum für Kunst und Gewerbe, Hamburg, number 1897.805.
24. "L'Art du Livre," *Le Figaro*, June 8, 1896.
25. "Notes d'Art Parisiennes, ... *Le Livre moderne*," *L'Art Moderne*, June 28, 1896, p. 203.
26. *The Studio*, vol. 7, 1896, pp. 115–117. This critic also made the later comment on Belgian advancements in book design.
27. Edmond Cousturier, "Exposition internationale du livre moderne à l'art nouveau," *La Revue Blanche*, vol. 11, 1896, pp. 42–44.
28. *Catalogue des publications contemporaines ...*, numbers 1–28. Bindings by Claessen, Michel, Prouvé, Van de Velde, Sparre, and Vallgren are listed as numbers 1112, 1113, 1118, 1119, 1120, and 1121.
29. No catalogue remains for examples of his work in this exhibition. See *Catalogus Tentoonstelling Grapfisch Werk S. Moulijn*, Boymans Museum, Rotterdam, for an exhibition held October 27 to December 2, 1951.
30. *Salon de l'Art Nouveau*, Premier Catalogue, numbers 49–58.
31. See *Collection Bing*, Catalogue de Tableaux Modernes, Hôtel Drouot, May 15–16, 1900, pp. 33–59. A *Triptych* sold for 12,000 francs and the *Port de Douarnenez* for 3,500 francs.
32. *Tableaux de Charles Cottet*, November, 1896, L'Art Nouveau, 22 rue de Provence.
33. *The Studio*, 1896, vol. 9, p. 291.
34. Henry Ron, "M. Charles Cottet," *La Plume*, December 1, 1896, p. 776. Other reviews by E. Durand-Greville ("L'Exposition de Ch. Cottet," *L'Artiste*, 1896, vol. 66, pp. 336–338) and Henri Frantz ("Notes sur L'Art, Exposition d'oeuvre de Charles Cottet à l'Art Nouveau," located in Archives Nationales, Cottet F21 4301) were generally favorable.
35. Gabriel Mourey ("The Decorative Art Movement in Paris," *The Studio*, 1897, vol. 10, pp. 123–124) exclaimed, "The stoneware, the tiles for walls and hearths—everything, in fact, coming from the workshop of the well-known ceramic artist, bears the imprint of originality." Mourey went on to describe Bing's commissions for the Dresden show, which included designs for cretonnes by Henry van de Velde, models for velvets and cretonnes by Paul Ranson, and cartoons for carpets by Frank Brangwyn. Ranson's designs were found in a num-

ber of pieces of furniture Bing exhibited in Paris.

36. Kenworth Moffett, *Meier-Graefe as Art Critic*, (Munich: Prestel-Verlag, 1973), pp. 28–29. Based on the English journal *The Studio*, Meier-Graefe's *Dekorative Kunst* (which he began under an assumed name) soon became the organ of international *art nouveau* and the critical conscience of the new movement through articles on exhibitions and major design innovators. Incidentally, Meier-Graefe's offices on the rue Pergolese in Paris were entirely decorated by Van de Velde.

37. While the salon rooms were in Dresden, English-style rooms were installed at Bing's gallery. The original rooms disappeared, leaving behind little trace of Bing's early *art nouveau* style. It is not known what happened to them when the Dresden exhibition ended because information on the location of pieces after its close has been difficult to obtain. The room ensembles may have been returned to Bing in Paris (or at another location) or they may have been purchased from the Dresden display by private collectors or museums.

38. *Führer durch die Internationale Kunst-Ausstellung Dresden 1897, Eine Auswahl aus den darüber erschienenen Besprechungen*, Dresden, 1897, pp. 9–14.

39. Henry F. Lenning, *The Art Nouveau*, The Hague, 1951, p. 33.

40. For further reference, see *Oeuvres de Rippl-Ronai exposées à L'Art Nouveau*, June, 1897. There were no illustrations in this catalogue. Also see *Bing Collection . . .*, 1900, numbers 109–110; *La Revue Blanche*, 1897, vol. 12, pp. 802–803; and André Fontainas, *Mercure de France*, July, 1897, vol. 23, p. 182.

41. Inventory, *Staatliche Museen Preussischer Kulturbesitz, Kunstgewerbemuseum*, numbers 69 and 70 (1895) and number 163 (1895). The present location of these pieces is unknown. Tiffany is also well represented in the *Offizieller Katalog der Internationalen Kunst-Ausstellung*, Dresden, 1897, section VI, p. 86.

42. Letter from S. Bing to M. de Scala, director, Österreichisches Museum für angewandte Kunst, August 4, 1897, in the museum's archives. Also see Herwin Schaefer, "Tiffany's Fame in Europe," *The Art Bulletin*, December, 1962, vol. 44, pp. 309–328. Museums that purchased works by Tiffany included Arts et Métiers (Paris), Sèvres, the Luxemburg, Limoges, Musée Galliera, and the Musée des arts décoratifs (Paris). Major museums in Brussels and St. Petersburg also purchased Tiffany objects at this same time.

43. Letter from S. Bing to M. de Scala, January 31, 1898, Archives, Österreichisches Museum, Vienna.

44. "Die Kunstgläser von Louis C. Tiffany," *Kunst und Kunsthandwerk*, vol. 1, 1898, pp. 105–111. De Scala was the publication's editor. The article on Tiffany was later translated into English and used as the catalogue introduction for the Grafton Galleries show in London (1899). The translation is reprinted in *Artistic America, Tiffany Glass and Art Nouveau* by Samuel Bing, with an introduction by Robert Koch (Cambridge: The MIT Press, 1970), pp. 195–212. The original article was illustrated with pieces purchased by museums that had shown the traveling exhibition.

45. See inventory numbers 1982 and 1984–89 (works purchased in Paris in 1898) and numbers 2019–24 (works purchased from Bing in London in 1899). Information provided by Dr. Waltraud Neuwirth, curator of the Österreichisches Museum, in a letter to the author dated October 9, 1969.

46. Letter from S. Bing to M. de Scala, January 15, 1898, Archives, Österreichisches Museum, Vienna.

47. Letter from S. Bing to Friedrich Deneken, October 13, 1897, Archives, Kaiser Wilhelm Museum, Krefeld.

48. Letters from S. Bing to Friedrich Deneken, dated February 2 and July 8, 1899, Archives, Kaiser Wilhelm Museum, Krefeld.

49. Bing continued to sponsor rotating exhibitions at his gallery, but they were largely dedicated to printmakers and draftsmen. Thirty works were mentioned in a show of Charles Pepper's watercolors, and the exhibition was noted in *The Studio* (1898, vol. 13, p. 116). For further reference, see *Aquarelles de Charles H. Pepper*, L'Art Nouveau, December, 1897. Bing then held an exhibition of Alphonse Legros' work. For further reference, see *Alphonse Legros, Exposition de son oeuvre à L'Art Nouveau*, March, 1898. Another printmaker who received attention was Daniel Vierge. For further reference, see *Daniel Vierge, Exposition de son oeuvre à L'Art Nouveau*, April, 1898. The catalogue included an introduction by Roger Marx and referred to 331 different works.

Two other exhibitions of note were the works of Ernest Baillet (June, 1898) and the prints of J. F. Raffaelli. For further reference, see *Exposition J. F. Raffaelli, Pointes-sèches et eaux-fortes en couleurs à L'Art Nouveau*, Novembre-Decembre, 1898. Bing received modest press coverage on this exhibition, including a small notice in *La Revue des Beaux-Arts et des Lettres* (January 15, 1899); Jean Priscal, "M. J. F. Raffaelli, Exposition de ses oeuvres à L'Art Nouveau," *Revue Internationale des Expositions*, January 1, 1899 and February, 1899; and Roger Marx, "Les Petites Expositions, Exposition Raffaelli," *Revue Populaire des Beaux-Arts*, December 3, 1898.

CHAPTER 4

1. Gabriel P. Weisberg, "S. Bing's Craftsmen Workshops: A Location and Importance Revealed," *Source*, Fall, 1983, pp. 42–48.

2. Archives de Paris, Cadastre de 1876, 19 rue Chauchat². Also see Viviane, "L'Art Nouveau, Les Bijoux," *Revue Illustrée*, vol. 28, no. 24, December 1, 1899.

3. Letter from S. Bing to Friedrich Deneken, April 2, 1898, Archives, Kaiser Wilhelm Museum, Krefeld.

4. *Art et Décoration*, July, 1898, has a photograph of the room for the villa in Deauville. This buffet, numbered 75, sold for 800 to 900 francs.

5. See S. Bing, "Wohin Treiben Wir?," *Dekorative Kunst*, 1897, vol. 1, pp. 1–3. Bing's ideas on Ruskin and Morris are also found in this article. His discussion of Japanese decorative arts appears on pp. 68–71.

6. L. Jouvance, "Les bijoux de l'Art Nouveau Bing," *Revue de la bijouterie, joaillerie, orfèvrerie*, I, 1901, pp. 214–215. Also see Martin Eidelberg, "The Life and Work of E. Colonna, Part 2: Paris and L'Art Nouveau," *The Decorative Arts Society Newsletter*, vol. 7, no. 2, p. 1.

7. "Modern Tendencies in Applied Art," *Encyclopedia Britannica* (14th edition), 1929, vol. xv, p. 639. Richards asked Colonna to write a memorandum on artistic activities in Paris between 1890 and 1910.

8. Eidelberg, "Colonna, Part 2," p. 1. Also see *Art et Décoration*, III, 1898, pp. 68, 70, 71.

9. Gabriel Mourey, "L'Art Nouveau de M. Bing à l'Exposition Universelle," *Revue des Arts Décoratifs*, XX, 1900, p. 261.

10. Many of Bing's atelier works were united by this central theme of lines in action or the suggestion of a flowering bud, but pieces were infrequently duplicated. Eidelberg ("Colonna, Part 2," p. 3) asserts that when a copy or variation was made, it was usually completed in a different metal. For example, a Colonna buckle in gold, illustrated in *The Studio* (1899, XVII, p. 44), was duplicated in silver and sold at the American Art Galleries in New York (March 9–13, 1908; number 950), but this situation was apparently rare.

Uninterested in mass production, Bing monitored pieces as they were made to ensure that they met the highest standards of quality. Yet such works did not sell for extremely high prices, as Bing tried to keep his word about making utilitarian objects affordable for the public. In his article "Wohin Treiben Wir?" (*Dekorative Kunst*, 1897, vol. 1, pp. 173–177), Bing advocated these low-cost items, but according to René Chapoulée (*Exposition des rénovateurs de l'art appliqué de 1890 à 1910*, Paris, 1925, pp. vi–vii), this was little more than "lip ser-

vice" in regards to the furniture designed for *L'Art Nouveau*.

11. Eidelberg, "Colonna, Part 2," p. 3. In a letter from S. Bing to Friedrich Deneken dated April 2, 1898, Bing noted that "copper decorations [and] writing desk sets" were available for exhibition in Krefeld.

12. See *Grafton Galleries, Exhibition of L'Art Nouveau*, S. Bing, Paris, May-July, 1899.

13. See catalogue, *Société Nationale des Beaux-Arts*, Paris, 1894, p. 174 and p. 262. De Feure's works included furniture, ceramics, and three interior panels. Ian Millman is currently completing a monograph outlining de Feure's contribution to the Symbolist/ Art Nouveau aesthetic. For further reference, see Gabriel P. Weisberg, "Georges de Feure's Mysterious Women, a Study of Symbolist Sources in the Writings of Charles Baudelaire and Georges Rodenbach," *Gazette des Beaux-Arts*, October, 1974, pp. 223–230, and Ian Millman, "Georges de Feure, The Forgotten Dutch Master of Symbolism and Art Nouveau," *Arts Magazine* (Europe), September/ October, 1983, vol. 6, no. 1, pp. 41–47.

14. Letter from S. Bing to Friedrich Deneken, April 5, 1901, Archives, Kaiser Wilhelm Museum, Krefeld. Ian Millman ("Georges de Feure," *Arts Magazine*, p. 46) confirmed that de Feure developed his own clientele while working for Bing.

15. See Eugène Gaillard, *A-Propos du mobilier. Opinions d'avant-garde. Technique fondamentale l'Evolution*, Paris, 1906.

16. Letter from S. Bing to Messieurs Durand-Ruel, sent from London on June 1, 1899. The letter is now found in the publication *Brouillard (Août 1898 à 1902)* in the Archives Durand-Ruel, Paris.

17. Letter from S. Bing to Messieurs Durand-Ruel, September 9, 1899, in *Brouillard (Août 1898 à 1902)* in the Archives Durand-Ruel, Paris.

18. "Art Notes, L'Art Nouveau in Grafton Street," July 6, 1899. Charles Carpenter found the review pasted inside a copy of the Grafton Galleries exhibition catalogue and shared it with the author. The article's author and the periodical in which it appeared have not been identified.

19. See Horace Townsend, "American and French Applied Art at the Grafton Galleries," *The Studio*, 1899, vol. 17, pp. 39–44, for all of these quotes.

20. Letter from S. Bing to Friedrich Deneken, November 16, 1899, Archives, Kaiser Wilhelm Museum, Krefeld.

21. Letter from Friedrich Deneken to S. Bing, November 14, 1899, Archives, Kaiser Wilhelm Museum, Krefeld.

CHAPTER 5

1. See Philippe Jullian, *The Triumph of Art Nouveau, Paris Exhibition 1900* (New York: Larousse and Company, 1974) for a general description of the fair. A more detailed account can be found in Alfred Picard's *Exposition Universelle Internationale de 1900 à Paris, Rapport Général Administratif et Technique*, Paris, 1902, which lists each area and installation, and in the *Catalogue Général Officiel*, Exposition Internationale Universelle de 1900, (Paris, 1900).

2. Jullian, *The Triumph of Art Nouveau*, pp. 99–100. The idea of blaming the Belgians is found in some writings by the art critic André Hallays.

3. Picard, *Rapport Général Administratif et Technique*, vol. 1, p. 273. Bing's invitation to participate in the 1900 Exposition should have been among the documents housed in the Archives Nationales under F 12 6356, *Exposition Universelle de 1900 Rapports French Section, 1898–1902* (ordonnances, décrets, et arrêtés sociétés anonymes). It is, however, among the Grands Magasins (Le Louvre, Printemps, Bon Marché, the Pavillon de l'Union Centrale des Arts Décoratifs) under the section title *Expositions particulières*. Documents about the private installations were probably destroyed.

4. See "Nécrologie, André Arfvidson," *L'Architecture*, July 15, 1935, p. 97. Arfvidson studied at the Ecole des Beaux-Arts and by 1900 was listed in the Parisian voting records as a practicing architect (Listes électorales, 1899, 1900, 1901, *Archives de Paris*). He won some reputation at the Exposition Universelle, which helped to establish his reputation as an architect, and by 1901 he had moved to 103 Faubourg St. Honoré, a fashionable and expensive address.

5. Picard, *Rapport Général Administratif et Technique*, vol. 4, p. 293. Picard established a separate category for installations like Bing's, calling them "Palais et Pavillons élévés par les exposants."

6. These photographs, given to the author, entered the collection of a Parisian art dealer who had been in contact with the Jallot family. They gave him the contents of the atelier, including a complete set of preliminary drawings, after Jallot died, but there were few tangible references to the short time Jallot worked for Bing.

Among those working in wood were Niederkorn (a master *ébéniste*) and Coferet (a master sculptor).

7. See letter from S. Bing to Tadamasa Hayashi, May 9, 1900, in the Tokyo National Research Institute of Cultural Properties, Tokyo.

8. Viviane, "L'Art Nouveau au Pavillon de 'l'Art Nouveau' S. Bing à l'Exposition," *Revue Illustrée*, July 1 and August 1, 1900. This reviewer compared Sert's wall panels with works by Goya. Sert executed his canvases of charcoal images on a blue ground in

less than six weeks. They were the work of a draftsman and not, properly speaking, of a painter. The effect, however, must have been quite novel since the themes of Bacchus, Pan, and Pamona emphasized the sensuality of the bulbous shapes Gaillard used in his furniture. Other descriptions of Gaillard's furniture are from this source. For a further discussion of José María Sert, see Alberto del Castillo, *José María Sert. Su vida y su obra*, Barcelona-Buenos Aires, 1947.

9. See *Arbog, 1898–1901*, Nordenfjeldske Kunstindustrimuseum, Trondheim, report by Jens Thiis, pp. 103–109. This report also contains Thiis' thoughts on Colonna's salon and de Feure's boudoir.

10. Gabriel P. Weisberg, "Samuel Bing: International Dealer of Art Nouveau, Part 4: Contacts with The Museum of Decorative Art, Copenhagen," *The Connoisseur*, July 1971, vol. 177, pp. 211–219.

11. See Viviane, "L'Art Nouveau, meubles et toilettes," *Revue Illustrée*, January 15, 1901. The "Princesse de T…" identified in this article as the purchaser of the de Feure ensemble may have been Princess Tenicheff of Russia. For further reference to Bing's ties with Russia, see his letter to Friedrich Deneken (October 3, 1900) on official stationery of the Exposition Internationale Artistique et Industrielle de Céramique de Saint-Petersbourg, in the Archives of the Kaiser Wilhelm Museum, Krefeld.

12. Exposition Internationale Universelle de 1900, *Catalogue Général Officiel*, vol. 17, Groupe XV, Classes 92 à 100, Paris, 1900, p. 10. It is uncertain whether these pieces were on display in Bing's pavilion or at another location. Bing's jewelry was apparently not shown in the private installation.

13. S. de Pierrelée in "L'Art Nouveau, Etains et cuivres," (*Revue Illustrée*, March 15, 1901) states, "on trouvera un choix infini de toutes les applications de cuivre et de l'étain." For further reference, see L. Jouvance, "Les Bijoux de l'Art Nouveau Bing," *Revue de Bijouterie—Joaillerie—Orfèvrerie*, vol. I, 1900– 1901, (March, 1901), pp. 211–217.

14. A group of unknown objects were recently found and attributed to Bing's workshop. Although the atelier did not use machines, these pieces could have been samples of more modest objects being standardized for mass production. Until more is known about how many of these pieces were made, little can be said about this aspect of Bing's operations. The candlestick, however, was purchased around 1900 (see *Jahresbericht des Kantonalen Gewerbesmuseum Bern für das Jahr 1900*, p. 4). This suggests that Bing was at least turning out some lower-priced pieces along with the elaborate jewelry and objects destined for his wealthier clientele.

15. Letter from S. Bing to Friedrich Deneken, October 3, 1900, Archives, Kaiser Wilhelm Museum, Krefeld. This letter is written on stationery of the

St. Petersburg exhibition.

16. Gabriel P. Weisberg, "Gérard, Dufraisseix and Abbot: The Manufactory of Art Nouveau Bing Porcelains in Limoges, France," *The Connoisseur*, February, 1978, vol. 197, pp. 125–129.

17. Gabriel P. Weisberg, "Bing Porcelain in America," *The Connoisseur*, November, 1971, vol. 178, pp. 200–203. Stickley's daughter in Syracuse, New York, confirmed in the early 1970s that the table service was used in the restaurants. She owned a complete service with a light-green border.

18. Weisberg, "Gérard, Dufraisseix and Abbot," *The Connoisseur*, p. 128.

19. A photograph of de Feure's porcelain appears in "L'Ameublement aux Salons," *Art et Décoration*, June, 1901, p. 199. Beneath the marks of de Feure and/or *Art Nouveau Bing* is found the word "Leuconoë," a strange term that might have something to do with Bing's beginnings as a manufacturer of porcelains at Leullier et Cie.

20. Gustave Kahn, "Les Objets d'art aux Salons," *Art et Décoration*, July 1902, p. 26.

21. The records of the Scheurer and Lauth manufactory in Thann were consumed in a fire several years ago that destroyed the entire archival/library building. For an analysis of Bing's association with the firm, see Gabriel P. Weisberg, "Preservation News," *College Art Association Newsletter*, winter 81/82, vol. 6, p. 11. Some of de Feure's stained glass windows may have been made by the firm of Müller-Hickler in Darmstadt. See *Arts Décoratifs Styles 1900 et 1925*, number 93, Stained Glass Window by Georges de Feure, sale at Sotheby's in Monte Carlo, Monaco, March 6, 1983.

22. Two of Arsène Alexandre's reviews of the Exposition Universelle are in *Le Figaro*, April 6 and April 14, 1900. The second one is entitled "Les Beaux-Arts à l'Exposition," but neither mentions Bing. "Le Pavillon des Arts Décoratifs," August 13, 1900, does not address Bing either.

23. Jules Rais, "Les Beaux-Arts à l'Exposition, Postscripta: Notes sur l'Exposition Décennale, l'art décoratif et l'architecture," *Le Siècle*, November 13, 1900.

24. O. M. [Octave Maus], "Le Pavillon de L'Art Nouveau à l'Exposition Universelle," *L'Art Moderne*, July 1, 1900, pp. 209–210.

25. G. M. Jacques, "Exposition Universelle, L'Art Nouveau Bing," *L'Art Décoratif*, June 1900, pp. 88–97. Works seen in the article's reproductions suggest that the objects Bing gave to other firms to produce—the stained glass and textiles—were finished before those being made in his own atelier.

26. Léon Riotor, "Les Bijoutiers modernes à l'Exposition, Lalique, Colonna, Marcel Bing," *L'Art Décoratif*, August, 1900, p. 177.

27. Gabriel Mourey, "L'Art Nouveau de M. Bing à l'Exposition Universelle," *Revue des Arts Décoratifs*, 1900, vol. 20, pp. 257–268 and 278–284. The article was illustrated with photographs of the major pieces Bing had produced, almost all of which ended up in public collections.

28. Gabriel Mourey, "Round the Exhibition—I. The House of the 'Art Nouveau Bing,'" *The Studio*, 1900, vol. 20, p. 180.

29. See R. Davis Benn, "The Review of the Paris Exhibition, 1900," *The Cabinet Maker and Art Furnisher*, 1900–1901, pp. 197–214.

30. See Dr. Max Osborn, "S. Bing's 'Art Nouveau' auf der Weltausstellung," *Deutsche Kunst und Dekoration*, 1900, vol. 6, pp. 250–269. The photographs seem to have been made specifically for this publication.

31. "Der Bing'sche Pavillon L'Art Nouveau auf der Weltausstellung," *Die Kunst*, 1899–1900, vol. 2, pp. 488–493.

32. Gustave Geffroy, *Les Industries artistiques, francaises et étrangères à l'Exposition Universelle de 1900*, Paris, n.d., p. 11. This article features numerous illustrations of furniture from Bing's pavilion.

33. René Puaux, "L'Art Nouveau Bing," *Art et Décoration*, n.d., unpaginated.

34. See "The Arts and Crafts Movement at Home and Abroad," *Brush and Pencil*, June, 1900, vol. 6, pp. 110–121.

35. See *Arbog, 1898–1901*, Nordenfjeldske Kunstindustrimuseum, Trondheim, report by Jens Thiis, pp. 100–101.

36. S. Tschudi Madsen, *Sources of Art Nouveau* (New York: George Wittenborn, 1955), pp. 1–31. Madsen identified the other center as Nancy, where Louis Majorelle and Emile Gallé produced furniture. Bing only occasionally handled the latter because he favored a less florid and exaggerated style. Madsen considers French Art Nouveau a decorative style with little architectural impact.

37. See *Catalogue Illustré de la Société Nationale des Beaux-Arts*, Paris, 1901. De Feure exhibited ceramics in a vitrine of sculpted wood similar to his gilded furniture shown in 1900. The examples, all produced at G.D.A., Limoges, included dessert plates and a carry tray (numbers 217–223). Marcel Bing filled another vitrine with jewelry, a mirror, and a gold brush, all exhibited under the number 157. These pieces and the work of Colonna are discussed in Em. Sedeyn, "La Céramique de Table," *L'Art Décoratif*, 1900–1901, pp. 7–17. Octave Uzanne offered a similar discussion on de Feure ("G. de Feure," *Art et Décoration*, March 1901, pp. 77–88). De Feure's ceramics were positively reviewed in *The Studio* (G. M., "Studio-Talk," 1901, vol. 23, pp. 64–69): "De Feure and his collaborators have succeeded in producing much more delicate effects, the subtle tones obtained being quite uncommon, at least in Europe, in fired porcelain."

38. *La Joaillerie française en 1900*, Paris, 1901, Plates 17 and 19. Published in 1901, the volume refers to examples shown in 1900 and documents the wide array of Colonna pieces that had been shown at the Exposition. For reference to jewelry in 1901, see J. L. Bertrand, "Les Bijoux aux Salons de 1901," *Revue de Bijouterie—Joaillerie—Orfèvrerie, 1901–1902* (June, 1901), pp. 40–53. For reference to Colonna and de Feure at the 1902 Salon, see Société Nationale des Beaux-Arts, *Catalogue Illustré du Salon de 1902* (Paris, 1902), p. LIV, number 51, and p. LV, numbers 86–89. The latter included a large group of pieces exhibited in this catalogue area; it was the major Salon for the ceramics of Colonna and de Feure.

39. Dr. Henri Cazalis, (pseudonym, Jean Lahor), *L'Art Nouveau, son histoire à l'exposition. L'Art nouveau au point de vue social* (Paris, 1901), pp. 16, 25.

CHAPTER 6

1. See *Art et Décoration* (supplement), January, 1902, n.p. The advertisement, designed by Georges de Feure, also appeared in *L'Art Décoratif* in 1901.

2. Gabriel P. Weisberg, "Samuel Bing: International Dealer of Art Nouveau, Part 4: Contacts with the Museum of Decorative Art, Copenhagen," *The Connoisseur*, July, 1971, vol. 177, pp. 211–217. Unless otherwise cited, all references to Bing's dealings with the Copenhagen museum are from this source. Also see Den Nordiske Industri—Landbrugs—og Kunstudstilling i Kjobenhavn 1888, *Officiel Katalog*, Copenhagen, 1888.

3. Krohn's most impressive work for Bing and Gröndahl was the "héron" service, which was shown at the Paris Exposition of 1889 (Exposition Universelle de 1889 à Paris, *Le Danemark Catalogue Illustré*, Copenhagen, 1889, pp. 36–38). Also see Harold Bing, "Pietro Krohn," *Det Danske Kunstindustrimuseums Virksomled*, 1901–1910, pp. 3–5. Krohn also shared Bing's enthusiasm for Oriental art.

4. See *Photo Album, Musée des Arts Décoratifs*, Paris number 343, "Etagère Copenhague." Krohn bought it in November 1900 for 1,500 francs. It is so similar in style to the other boudoir pieces that it was clearly intended to be shown with Krohn's other purchases. Today it is used to display ceramics in the Copenhagen museum. Krohn was obviously pleased with his purchases, for in an article entitled "S. Bings Pavillon: 'L'Art Nouveau' paa Verdensudstillingen i Paris 1900" in *Tidsskrift for Industri* (1900), he echoed the laudatory sentiments of critics Gabriel Mourey and Max Osborn for Bing's achievements. He also provided many new photographs of the smaller pieces Bing produced.

5. These two chairs remain the only examples of Bing's *art nouveau* style in the applied arts museum in Helsinki. Information provided by the Museum of Decorative Arts, Helsinki, September, 1982. See also Konstflitsföreningen i Finland, *Redogörelse för år 1900*, Helsinki, 1901, pp. 10–11. Other pieces bearing the marks of *L'Art Nouveau* or designed by craftsmen who worked for Bing are in the collection of the Finnish Decorative Arts Society.

See also Gabriel P. Weisberg, "Samuel Bing: International Dealer of Art Nouveau, Part 3: Contacts with the Kaiser Wilhelm Museum, Krefeld, Germany and the Finnish Society of Crafts and Design, Helsinki, Finland," *The Connoisseur*, May, 1971, vol. 177, pp. 49–55. This article incorrectly states that other pieces were purchased at the Exposition.

6. Minutes of the Board of Trustees, Fine Arts Society, Helsinki, Finland, May 30, 1901, in the Archives, Ateneum, Helsinki. The show was intended to demonstrate the role the Parisian Société Nationale des Beaux-Arts could play in shaping French exhibitions in foreign countries. The *Catalogue de l'Exposition Française des Beaux-Arts à Helsingfors* (Helsinki, 1901) credits André Saglio of the Grand Palais in Paris for organizing the show of 69 paintings and even more decorative art objects.

7. According to the number of works listed in the catalogue, this may have been the largest number of objects Marcel Bing ever exhibited in one place. Some may have been purchased by private collectors but apparently none were by museums. Several of de Feure's pieces were acquired by the Andell Foundation and are now in the collection of the Decorative Arts Museum in Helsinki.

8. "Konstindustriföremål Från de Franska Konstnärernas Utställning i Helsingfors," *Ateneum*, 1901. H. O. Gummerus, director of the Finnish Society, reported that the de Feure vase had been acquired for 70 francs, but his information may not be correct. The catalogue of the 1901 Helsinki exhibition describes a vase of similar dimensions with a price of 150 francs, which Andell Collection documents confirm. See also *Catalogue de l'Exposition . . .*, Helsinki, 1901, number 183, p. 28. The vase has no *Art Nouveau Bing* trademark on its base but was made by G.D.A., Limoges. The other de Feure ceramic, a cup and saucer, is marked *L'Art Nouveau, Paris* on the base.

9. Information from author's interview with Dr. Dag Knutson, September 18, 1982, in Sweden.

10. See *Record Books*, Oriental Department, Museum für Kunst und Gewerbe, Hamburg, beginning in 1885. Bing and Brinckmann's friendship began in the 1880s when Bing sold Japanese art to the Hamburg museum. Brinckmann also translated Bing's *Artistic Japan* into German.

11. For further information on Brinckmann's purchases at the Exposition, see *Das Hamburgische Museum für Kunst und Gewerbe, Dargestellt zur Feier des 25 Jährigen Bestehens von Freunden und Schülern Justus Brinckmanns*, Hamburg, 1902.

12. See catalogue, *Kunstausstellung 1897*, Kaiser Wilhelm Museum, Krefeld. Bigot's works were numbers 393–403; Dalpayrat's, numbers 427–435; Dammouse's, numbers 436–437; and the firm of Bing and Gröndahl, numbers 404–426. Some of these exhibition objects may have come from Bing's shop in Paris due to their eventual purchase from *L'Art Nouveau*. See Inventory Books, Kaiser Wilhelm Museum, 1897–1901, number 50 (Dalpayrat), number 51 (Dalpayrat), and number 53 (A. Bigot).

13. Letter from Friedrich Deneken to S. Bing, November 24, 1900, Archives, Kaiser Wilhelm Museum, Krefeld. There Bing states, "the flood of visitors since your departure increased daily. However, I am certain that this week I shall be able to get these things on the road." The "hinge straps" could have been for Deneken's curtains instead of for the museum's collections. See also Deneken's letter to the tax office, Krefeld, November 29, 1900.

14. The Krefeld museum first purchased Tiffany pieces in 1899. See Inventory Books, Kaiser Wilhelm Museum, 1897–1901, number 21 (Vase, Tiffany and Company, purchased for 122.70 francs), number 22 (Champagne Glass, Tiffany and Company), and number 36 (Lampshade, Tiffany and Company). Almost all of the Tiffany pieces have disappeared. All of Colonna's metal pieces, originally purchased for modest prices, are no longer in the museum collection. See Inventory Books, Kaiser Wilhelm Museum, 1897–1901, 1900, numbers 6, 7a/b, and 8a/b/c. Through his discussions with Deneken, Justus Brinckmann could have influenced the Krefeld museum's selection of Colonna objects.

15. Letter from S. Bing to Friedrich Deneken, January 29, 1901, Archives, Kaiser Wilhelm Museum, Krefeld. Also see letter from Deneken to S. Bing, February 1, 1901, Archives, Kaiser Wilhelm Museum, Krefeld. Deneken did not mention press coverage in his letters to Bing. In late February (letter from Deneken to S. Bing, February 20, 1901), Leipzig and Darmstadt were being considered as sites for the show. No further documentation of the exhibition remains today.

16. Letter from S. Bing to Deneken, April 5, 1901, Archives, Kaiser Wilhelm Museum, Krefeld. See also *Führer durch das Städtische Kunstgewerbe Museum zu Leipzig*, Leipzig, 1931, pp. 55–56, for further reference to objects that may have been purchased from Bing.

17. In 1901 Bing contributed a piece to the Internationale Kunstausstellung in Dresden that began on May 8, 1901 (catalogue, *Internationale Kunstausstellung*, Dresden, 1901, number 1950a, Art Nouveau Bing, "Schmuck").

18. Letter from Dr. Margrit Bauer, Museum für Kunsthandwerk, Stadt Frankfurt-am-Main, to the author, January 24, 1983. This letter also confirms the Museum für Kunsthandwerk's purchase of a Gaillard chair. The price paid for these and other objects is no longer in the museum's records. Confirmation of the sale of a Gaillard chair to the applied arts museum in Graz appears in Dr. Inge Woisetschlager's letter to the author on September 1, 1982.

19. The author is indebted to Mr. Fritz Fischer and Dr. F. A. Dreier for searching the remaining archival records in the Kunstgewerbemuseum, Berlin, for references to museum transactions with Bing. None after 1898 could be found as many records were destroyed in the war. See Inventory Books, Kunstgewerbemuseum, Berlin, for 1895 (numbers 69, 70, and 163); 1897 (number 83); and 1898 (number 481) for the appropriate references to these artists.

20. For further reference to these items, see Museum Inventory (old) Book, Gewerbemuseum, Nuremberg, November 5, 1900, number 8528, *Tapis de Feure*; January 17, 1901, number 8529, *Vase* (Rookwood); January 19, 1901, number 8530, *Vase* (Rookwood); January 17, 1901, number 8531, *Vase* (Rookwood); January 17, 1901, number 8532, *Vase* (Rookwood); and January 17, 1901, number 8533, *Couvert argent von Lilber* (by de Feure). The furniture is no longer found in Nuremberg.

21. *Jahresbericht der gewerblichen Unterrichtsanstalt des Kantonalen Gewerbemuseums in Aarau*, April, 1897. The original collection has been dispersed and is only now being reassembled in a new museum in the Lenzburg Castle near Aarau. According to Dr. Durst, the current curator, many of the original pieces were lost in the interim. Further reference to the museum's purchases appeared in Bing's 1902 advertisement in *Art et Décoration*.

22. See *Jahresbericht des Kantonalen Gewerbemuseums Bern für das Jahr 1900*, "Bericht über die Weltausstellung Paris 1900," Bern, 1900, pp. 27–38.

23. For further reference, see *Photo Album, Musée des Arts Décoratifs*, Paris, and specifically the installation photographs of de Feure's *cabinet de toilette*. The piece is situated on the small dresser to the right in the photograph. The craftsman of the candle holder is not known, but it is doubtful that it came from a drawing by de Feure. The piece seems to have been cast, which would have prevented an exquisite finish.

Founded in 1894, the Kantonales Gewerbemuseum in Bern was dedicated to showing relationships between the machine-made and the handcrafted piece. It developed an impressive

technological collection that demonstrated how pieces currently on the market were made by machines. At the same time, the museum exhibited handicrafts to prove to local artisans that not everything had to be made by machine. If it illustrated how a piece could be mass-produced in lighter metal and made available at a lower price, this may explain the candle holder's presence there.

24. See the collection of the Kantonales Gewerbemuseum, Bern, for this tea service with platter. Marked AD, the piece is probably the work of Alfred Daguet from around 1900.

25. Paul Pierre Jouve began his career as an *animalier* for the Bing workshops, producing porcelain designs for G.D.A., Limoges. He later became a leading Art Deco painter and designer, who depicted animals in a flat, two-dimensional style. A friend of Marcel Bing, Jouve was listed as a beneficiary in Marcel's will.

26. See Inventory Books, Österreichisches Museum für angewandte Kunst, numbers 5177 and 5178. The pieces were inventoried under *Art Nouveau Bing*. These rugs were displayed in *Art Nouveau Bing*'s model rooms, so they were either delivered after the Exposition closed or more than one set of rugs was produced. For further reference, see E. Colonna, exhibition catalogue, The Dayton Art Institute, 1984, p. 54.

27. See Inventory Books, Österreichisches Museum, number 5254. Although the artist is not named, it could quite possibly be the work of Isaac. It may have been the first Isaac velours exhibited outside France. The museum bought it for 55 francs.

28. Letter from S. Bing to Musée de Graz, December 19, 1900, Archives, Landesmuseum, Joanneum, Graz.

29. Information provided by Karel Holešovsky, Department of Applied Art, Moravian Gallery, Brno, June 16, 1983. The author is indebted to Paul Perrot, Director, Virginia Museum of Fine Arts, for information on sources in eastern Europe.

30. Information supplied by Dr. Pál Miklós, Directeur Général, Musée des Arts Décoratifs, Budapest, August 24, 1982. See also Ferenc Batari, "Art Nouveau 1900, Présentation des objets d'art acquis à l'occasion de l'Exposition Universelle de Paris," *Arts Decorativa 5*, Budapest, 1977, pp. 175–200. The Gaillard hat rack purchased by the museum in Budapest was similar to that reproduced in *Brush and Pencil*, except it had another rung. (See *Brush and Pencil*, April–September, 1900.) See also *Az 1900. Evi Nemzetkozi, Parisi Vilagkiallitason vasarolt Iparmuveszeti Gyujtemeny*, Budapest, 1901, pp. 29–30, 32.

31. The furniture sold to the Tokyo museum and noted in the 1902 *Art et Décoration* advertisement has not been traced.

32. See Asai Chu, "Paris shosoku," *Hototogisu*, vol. 4, January, 1901. Information supplied by Mr. Shigemi Inaga, a graduate student in Paris.

33. For a more detailed analysis, see Gabriel. P. Weisberg, "Samuel Bing: International Dealer of Art Nouveau, Part 2: Contacts with the Victoria and Albert Museum, London," *The Connoisseur*, April, 1971, vol. 176, pp. 275–276.

34. See Inventory Books, Musée des Arts Décoratifs, Paris, numbers 9079, 9015, 9616, 9617. For others pieces added in 1902, see Gabriel P. Weisberg, "Samuel Bing: International Dealer of Art Nouveau, Part 1: Contacts with the Musée des Arts Décoratifs, Paris," *The Connoisseur*, March, 1971, vol. 176, pp. 200–205. All of the furniture from *Art Nouveau Bing* was donated.

35. *La Revue Blanche*, 1902, vol. 27, pp. 544–545. The exhibition catalogue is listed as March, 1902, *Oeuvres de Mlle. Marie Bermond*, Galeries de l'Art Nouveau Bing. The show opened on March 12.

36. *Oeuvres de F. Borchardt exposées à L'Art Nouveau Bing*, 22 rue de Provence, Paris, April 1902. The catalogue lists 52 items; its essay was written by Gabriel Mourey.

37. "Studio-Talk," *The Studio*, 1902, vol. 26, pp. 296–299. See also Charles Saunier, "Félix Borchardt," *La Revue Blanche*, 1902, vol. 27, pp. 622–623.

38. Fagus, "Arbres nains du Japon," *La Revue Blanche*, 1902, vol. 28, p. 462.

39. Edmond Cousturier, "Exposition d'Oeuvres de Paul Signac," *La Revue Blanche*, 1902, vol. 28, pp. 213–214. See also Galerie de l'Art Nouveau Bing, *Exposition d'Oeuvres de Paul Signac, à partir du 2 juin 1902* (Paris, 1902). The relationship between Bing and Signac is mentioned in the artist's journal, to be published by Françoise Cachin.

40. William Francis O'Donnell, "Meta Vaux Warrick, Sculptor of Horrors," *World Today*, November, 1907, pp. 1138–1145. See also Florence Lewis Bentley, "Meta Warrick a Promising Sculptor," *The Voice of the Negro*, March, 1907, pp. 116–118. The objects were shown in Bing's gallery: *Oeuvres de Mlle Meta Warrick—Sculpteur, exposées à l'Art Nouveau Bing, 22 rue de Provence, juin, 1902*.

41. See *William Degouve de Nuncques et J. Massin feront une exposition de leurs oeuvres à l'Art Nouveau, rue de Provence, 22, et vous prient de leur faire l'honneur de la visiter, ouverture le samedi 15 Novembre, 1902*. See also "Gazette d'Art, Expositions William Degouve de Nuncques et J. Massin," *La Revue Blanche*, 1903, vol. 29, pp. 541–542.

42. *Galerie de l'Art Nouveau, Chez Bing, 22 rue de Provence, à partir du 10 janvier, 1903, Cinquante Aquarelles d'Adolphe Dervaux*.

43. Invitation, "Les Amis et les Admirateurs de Georges de Feure," December 3, 1901, Fichier Moreau-Nélaton, documentation in the Musée du Louvre.

44. "De Feure bij Bing," *Nieu Nast*, April 5, 1903. Petra Chu translated the review.

45. Gabriel P. Weisberg, "Georges de Feure's Mysterious Women: A Study of Symbolist Sources in the Writings of Charles Baudelaire and Georges Rodenbach," *Gazette des Beaux-Arts*, October, 1974, pp. 220–230.

46. Ian Millman has discovered that de Feure did numerous backdrops and theatrical costumes for popular performances in London.

47. *Het Nieuws van de Dag*, April 30, 1903. Petra Chu translated the review.

48. Letter from S. Bing to Friedrich Deneken, April 23, 1902, Archives, Kaiser Wilhelm Museum, Krefeld.

49. Letter from Friedrich Deneken to S. Bing, April 24, 1903, Archives, Kaiser Wilhelm Museum, Krefeld.

50. G. Mourey, "L'Exposition Georges de Feure," *Art et Décoration*, May, 1903, pp. 162–164. See also Marcel Batilliat, "Georges de Feure," *L'Art Décoratif*, June, 1903.

51. See *Deutsche Kunst und Dekoration*, October 1902–March 1903, vol. 11. This volume contains a German version of René Puaux's article on de Feure that was published in Darmstadt, where much of his stained glass was manufactured. Alexander Koch, the journal's editor, was an admirer of de Feure and *art nouveau*.

52. "Bing on American Art," *The Sun* (New York), Sunday, February 23, 1896, p. 7.

53. For a further discussion of this topic, see Nancy Troy, "Toward a Redefinition of Tradition in French Design, 1895 to 1914," *Design Issues*, Fall, 1984, vol. 1, pp. 53–69.

54. Ch. L., "L'Art Nouveau et l'école normale d'enseignement du dessin," *La Construction Moderne*, November, 1897, vol. 13 (1897–98), n.p.

55. Charles Lucas, "L'Art Nouveau au Faubourg Saint-Antoine," *La Construction Moderne*, vol. 15 (1899–1900), n.p.

56. Albert Mallié voiced these concerns in a lecture on *art nouveau* that he presented to a select audience in Besançon in 1901, published by Imprimerie de Paul Jacquin, Besançon.

57. S. Bing, "L'Art Nouveau," *The Architectural Record*, August, 1902, vol. 12, p. 279.

58. *Ibid.* and Nikolaus Pevsner, *Pioneers of Modern Design from William Morris to Walter Gropius* (New York: The Museum of Modern Art), 1949. Bing's workshop concept remained very much alive and reappeared in the German Bauhaus, among other places. If all designers and artisans could work together and if their work could be successfully marketed, it was possible for a new style to have an impact. In this sense, Bing was a true pioneer of modern design.

59. A. D. F. Hamlin, "L'Art Nouveau: Its Origins and Development," *The Craftsman*, December, 1902,

vol. 3, pp. 129–143. See also Jean Schopfer, "L'Art Nouveau: An Argument and Defence," *The Craftsman*, July, 1903, vol. 4, pp. 229–238.
60. S. Bing, "L'Art Nouveau," *The Craftsman*, October, 1903, vol. 5, pp. 1–15. All remaining quotes are from this article.

CHAPTER 7

1. These rules were listed in the catalogue accompanying the exhibition. See *Prima Esposizione Internazionale d'Arte Decorativa Moderna, sotto l'Alto Patronato de S. M. il Re d'Italia, Relazione della Giura Internazionale*, Torino, 1902. See also Enrico Thovez, "The First International Exhibition of Modern Decorative Art at Turin," *International Studio*, July, 1902, pp. 45–46.
2. *Prima Esposizione Internazionale*, pp. 135–139. A review of the Belgian section appeared on pp. 279–281. For the contributions of Herbert McNair and his wife Frances, see "The First International Exhibition of Modern Decorative Art at Turin—The Scottish Section," *International Studio*, July 1902, pp. 91–103.
3. S. Tschuldi Madsen, *Sources of Art Nouveau*, 1955, p. 384. "In France no attempt had been made in 1902 to compose furniture as part of a room." Madsen accuses the Nancy school in particular of placing too great a value on luxury objects and remaining enslaved to traditional techniques of making furniture.
4. Alfredo Melani, "L'Art Nouveau at Turin, a Description of the Exhibition by A. Melani, a Member of the International Jury," *The Architectural Record*, December, 1902, pp. 739–743. In this article, he described the dining room by Behrens as well as the works contributed by the Mackintoshes.
5. *Prima Esposizione Internazionale*, p. 47. Besnard seems to have been the jury member who did most of the selecting of objects.
6. A. Melani, "L'Art Nouveau at Turin," p. 743.
7. *Prima Esposizione Internazionale*, pp. 48, 50–51. The citation for S. Bing read, "Richiamiamo per questo importante espositore le considerazioni fatte sul concorso dei commercianti in generale e sui padiglioni di vendita in particolare alla Mostra de Torino."
8. See *Art et Décoration*, February, 1902, and *Revue de Bijouterie-Joaillerie*, 1902 (supplément).
9. *Internationale Kunstausstellung Düsseldorf 1904 im Städtischen Kunstpalast, veranstaltet von dem Verein zur Veranstaltung von Kunstausstellungen, 1 Mai bis 23 Oktober*, Düsseldorf, 1904, numbers 164–242, p. 151. The catalogue does not list the pieces Bing finally sent.

It is also unknown whether or not Deneken acted on Bing's suggestion to decorate the show with Japanese dwarf trees.
10. Letter from S. Bing to Friedrich Deneken, August 3, 1903, Archives, Kaiser Wilhelm Museum, Krefeld.
11. Letter from S. Bing to Friedrich Deneken, March 12, 1904, Archives, Kaiser Wilhelm Museum, Krefeld.
12. Form letter from *La Maison Moderne* at 82 rue des Petits Champs, April 1, 1904, Archives, Kaiser Wilhelm Museum, Krefeld, file number 35. This form letter announced that Meier-Graefe had sold his shop to a new collective organization named Delrue et Cie, which would continue to sell "les productions les plus artistiques et les plus nouvelles de l'Art Moderne." In another letter in the same file, Meier-Graefe says he is tired of practical affairs and wants to devote himself to writing.
13. Letter from Georges de Feure to Tadamasa Hayashi, June 14, 1904, now in the possession of the Tokyo National Research Institute of Cultural Properties, Tokyo. De Feure asked Hayashi to buy some of his work as he was in need of money, which may have been due to his spendthrift ways as much as from having suddenly been cast adrift by Bing. He noted in his letter that Bing had always sold his watercolors at either 600 or 800 francs each. He wanted Hayashi to give him 800 francs for two works, which he apparently did. In the catalogue of Hayashi's collection sold in the United States (*Collection of the Late Tadamasa Hayashi*, January 8–9, 1913, American Art Galleries, New York), the works listed by de Feure included two watercolors of women (numbers 41 and 42).
14. Martin Eidelberg, "The Life and Work of E. Colonna, Part 3: The Last Decades," *The Decorative Arts Society Newsletter*, vol. 7 (September, 1981), pp. 1–8. When he moved to Canada, Colonna was commissioned to decorate the new King Edward Hotel in Toronto.
15. *Art et Décoration* (supplément), June 1904.
16. Letter from Friedrich Deneken to Galerie Majorelle, July 14, 1905, Archives, Kaiser Wilhelm Museum, Krefeld.
17. Art Nouveau Bing, *Catalogue des meubles artistiques, tapis, bronzes, céramiques, appareils d'éclairage, bijoux en or, enrichis de pierreries et d'émaux, par suite de cessation de commerce, Hôtel Drouot, 19 et 20 decembre, 1904.* The catalogue was simply printed, without illustrations, in marked contrast to the one for the sale of his Japanese art collection in 1906.
18. Bing, however, did receive official authorization for the sale, which noted that it was for a "vente de marchandises venue après cessation d'une branche de commerce." See *Jugements au plumitifs d'audience*, 3030–4030, janvier 1891 à decembre 1911, no. 106, Siegfried Bing, 10 rue St. Georges à Paris,

Archives de Paris.
19. See *Journal des Arts*, December 17 and 18, 1904.
20. *1904, du 17 decembre, Réquisition afin de vente de meubles et objets d'art (art nouveau) appart. à M. Bing; du 19 décembre, Vente des dits objets; du 28 decembre, décharge du produit de la dite vente, M. F. Lair-Dubreuil, commissaire-priseur, Paris.*
21. *Inventaire après le décès de M(arcel) Bing*, 6 juillet, 1921, Paris, 1921.
22. "Passing Events," *Art Journal*, 1905, p. 349.
23. See *Bulletin de l'Art Ancien et Moderne*, September 16, 1905, p. 243. The same attitude is found in "Nécrologie, S. Bing," *L'Art Moderne*, September 17, 1905, p. 306.
24. "Nécrologie," *Revue Universelle*, October 15, 1905, under the name Samuel Bing. Although brief, a more rounded appreciation of Bing appeared in "Nécrologie, S. Bing," *Journal des Arts*, September 9, 1905.
25. A concerted effort to rediscover the objects that the collections at Krefeld, Trondheim, the Museum für Kunst und Gewerbe in Hamburg, and the Musée des Arts Décoratifs in Paris bought from Bing might provide basis for a proper assessment, but that work has yet to be done. An evaluation of his contribution to the greatest private collections of his time—those of Philippe Burty and Edmond de Goncourt, for example—could easily be reconstructed from sales and auction catalogues, and other records of purchase would help fill out the picture. An evaluation of Bing's own private Japanese collection kept at the rue Vézelay would also help. Until this material has been properly studied, exactly who was the first to utilize and promote Japanese art in France will continue to be debated. It is at least safe to say that Bing had his own original way of attracting the public to *japonisme*.

BiBLiOGRAPHY

This bibliography is divided into six sections: 1) writings by S. Bing and his son Marcel Bing; 2) S. Bing's sales catalogues; 3) reviews and catalogues pertinent to the first Salon of Art Nouveau in December, 1895; 4) catalogues and reviews of other exhibitions held at L'Art Nouveau, 1896–1905; 5) reviews of the pavillion Art Nouveau Bing at the Paris World's Fair of 1900; 6) general writings on Japan, art nouveau, and nineteenth-century decorative art. This bibliography is a selective list as the period under study saw many publications, some of which have not been fully catalogued. Sections 1–5 are in chronological order, section 6 is in alphabetical order.

1. WRITINGS BY S. BING AND HIS SON MARCEL BING

Bing, S., "La Céramique," in Louis Gonse, L'Art japonais, Paris, 1883, pp. 246–334.

Salon annuel des peintres japonais, Première année, (Introduction by S. Bing), Paris, 1883.

Salon annuel des peintres japonais, Deuxième année, (Introduction by S. Bing), Paris, 1884.

Bing, S., "Programme," Artistic Japan, May, 1888, vol. 1, no. 1, pp. 1–7.

———, "The Origin of Painting Gathered from History: I—Religious Painting," Artistic Japan, May, 1889, vol. 3, no. 13, pp. 151–162.

———, "The Origin of Painting Gathered from History: II—The Tosa School; III—The School of Kano," Artistic Japan, June, 1889, vol. 3, no. 14, pp. 167–179.

Exposition de la gravure japonaise à l'Ecole Nationale des Beaux-Arts, (Introduction by S. Bing), Paris, April–May, 1890, pp. xi–xxiv.

Collection Ph. Burty. Objets d'art japonais et chinois, (Introduction by S. Bing), Paris: Galerie Durand-Ruel, 1891, pp. v–x.

Japanese Engravings. Old Prints in Color Collected by S. Bing, Paris, (Introduction by S. Bing), New York: American Art Galleries, 1894.

Bing, S., "The Art of Utamaro," The Studio, February, 1895, vol. 4, no. 23, pp. 137–141.

———, La Culture artistique en Amérique, Paris, 1896.

———, "La Vie et l'oeuvre d'Hok'sai," La Revue Blanche, February 1, 1896, pp. 97–101.

———, "L'Art Japonais avant Hok'sai," La Revue Blanche, February 15, 1896, pp. 162–172.

———, "La Jeunesse de Hok'sai," La Revue Blanche, April 1, 1896, pp. 311–315.

———, "La Gravure japonaise," L'Estampe et l'Affiche, April, 1897, vol. 1, pp. 38–44.

———, "L'Architecture et les arts décoratifs en Amérique," Revue Encyclopédique, December 11, 1897, pp. 1029–1036.

———, "Les Arts de l'Extrême-Orient dans la collection des Goncourt," in Objets d'art japonais et chinois, peintures, estampes composant la collection des Goncourt, Paris, 1897, pp. 1–v.

———, "Wohin Treiben Wir," Dekorative Kunst, October, 1897, vol. 1, pp. 1–3, 68–71, and 173–177.

———, "Die Kunstgläser von Louis C. Tiffany," Kunst und Kunsthandwerk, 1898, pp. 105–111.

———, "La Collection Hayashi," in Objets d'art du Japon et de la Chine, peintures, livres réunis par T. Hayashi, Paris, 1902, pp. i–iv.

———, "La Gravure japonaise," in Collection Hayashi, dessins, estampes, livres illustrés du Japon, réunis par T. Hayashi...dont la vente aura lieu du lundi 2 juin au vendredi 6 juin, 1902, à l'Hôtel Drouot, Paris, 1902.

———, "L'Art Nouveau," The Architectural Record, August, 1902, vol. 12, pp. 279–285.

———, "Le Bois japonais," in Exposition de la gravure sur bois à l'Ecole Nationale des Beaux-Arts, May 1902. Catalogue avec notices historiques et critiques par M.M. Henri Bouchot, G. Claudin, J. Masson, Henri Béraldi, et S. Bing, Paris, 1902, pp. 61–66.

———, "L'Art Nouveau," The Craftsman, (translated from the French by Irene Sargent), October, 1903, vol. 5, pp. 1–15.

———, "La Japonaise," Revue Universelle, February 1, 1905, no. 127, pp. 66–72.

Bing, Marcel, "Japan," in Die Krisis im Kunstgewerbe: Studien über die Wege und Ziele der modernen Richtung, Leipzig, 1901, pp. 78–87.

Bing, S., Artistic America, Tiffany Glass and Art Nouveau, (edited by Robert Koch and translated by Benita Eisler), Cambridge: M.I.T. Press, 1970.

2. S. BING'S SALES CATALOGUES

Catalogue de belles porcelaines de la Chine et du Japon ...Paris: Hôtel Drouot, March, 1876.

Catalogue of the Collection of Mr. S. Bing of Paris and 220 Fifth Avenue. Rare and Antique Oriental Porcelains, Superb Bronzes...to be sold by auction in Moore's Auction Galleries, New York, April, 1887.

Catalogue of Rare and Valuable Art Objects comprising Chinese and Japanese Porcelains, Faiences...to be sold...under the Direction of the Firm of S. Bing, 220 Fifth Avenue, New York...Philadelphia, Davis and Harvey's Art Galleries, April, 1888.

Catalogue of Bronzes and other Works of Art comprising Antique Chinese and Japanese Porcelains...to be sold under the Direction of the Firm of S. Bing at their rooms, 220 and 222 Fifth Avenue, New York, November, 1888.

Catalogue of Antique Chinese and Japanese Porcelain, Pottery, Enamels and Bronzes...to be sold at Public Sale by order of S. Bing, Paris, at the American Art Galleries, New York, February, 1894.

Catalogue of a Valuable Collection of Old Chinese Porcelain and Objects of Art, the Property of a Well-known Collector, London: Messrs. Christie, Manson and Woods, Thursday, January 24, 1895.

Anciennes porcelaines de Chine, porcelaines du Japon ...Paris: Hôtel Drouot, February, 1896.

Collection Bing. Catalogue de tableaux modernes, oeuvres de Besnard, Cottet, Thaulow, etc., Paris: Hôtel Drouot, May, 1900.

Art Nouveau Bing. Catalogue des meubles artistiques, tapis, bronzes, céramiques, appareils d'éclairage, bijoux en or enrichis de pierreries et d'émaux, par suite de cessation de commerce, Paris: Hôtel Drouot, December, 1904.

Collection S. Bing. Objets d'art et peintures du Japon et de la Chine, Paris, Galerie Durand-Ruel, May, 1906.

Estampes japonaises, peintures chinoises et japonaises ...appartenant à M. René Haase et provenant pour la plupart des successions S. et M. Bing, Paris: Hôtel Drouot, February, 1927.

3. THE FIRST SALON OF ART NOUVEAU: CATALOGUES AND REVIEWS

Salon de l'Art Nouveau, Premier catalogue, Paris, 1895.

Salon de l'Art Nouveau, Deuxième catalogue, February, 1896.

La Revue Franco-Américaine, "Le Home échos," July, 1895, p. 95, and "L'Art échos," July, 1895, p. 99.

Alexandre, Arsène, "L'Art Nouveau," Le Figaro, December 28, 1895.

Chancel, Jules, "Notes parisiennes, l'Art Nouveau," L'Evénement, December 28, 1895.

Chronique des Arts, "L'Art Nouveau," December 28, 1895.

Thiébault-Sisson, "Au jour le jour, L'Art Nouveau," Le Temps, December 30, 1895.

Geffroy, Gustave, "L'Art d'aujourd'hui, ameublement," Le Journal, January 3, 1896.

L'Art Français, January 4, 1896, no. 454.

Lefeuve, Gabriel, "Choses d'art, l'exposition Bing," Le Siècle, January 5, 1896.

Pallier, Alfred, "Chronique d'art," La Liberté, January 8, 1896, p. 3.

Boileau, L. C., "La Maison de l'Art Nouveau," L'Architecture, January 11, 1896, pp. 14–15.

Chronique des Arts, "L'Art Nouveau," January 11, 1896.

Hallays, André, "Au jour le jour," Le Journal des Débats, January 12, 1896.

L'Art Moderne, "La Maison d'Art 'Bing' à Paris," January 19, 1896, no. 3, p. 22.

Geffroy, Gustave, "L'Art d'aujourd'hui. Constantin Meunier," *Le Journal*, February 17, 1896.

Mauclair, Camille, "Choses d'art," *Mercure de France*, February, 1896, pp. 265–269.

Feld, Otto, " 'Bing's L'Art Nouveau," *Zeitschrift für Bildende Kunst*, June 4, 1896, no. 28, pp. 441–447.

Champier, Victor, "Les Expositions de l'Art Nouveau," *Revue des Arts Décoratifs*, December 16, 1896, vol. 16, pp. 1–6.

Cousturier, Edmond, "Galeries S. Bing. Le mobilier," *La Revue Blanche*, 1896, vol. 10, pp. 92–95.

Meier-Graefe, Julius, "l'Art Nouveau, Das Prinzip," *Das Atelier*, 1896, Jg. 6, vol. 5, pp. 2–4.

————, "l'Art Nouveau, Die Salons," *Das Atelier*, 1896, Jg. 6, vol. 6, pp. 2–4.

————, "l'Art Nouveau, Die übrigen Kunst und kunstgewerblichen Zweige," *Das Atelier*, 1896, Jg. 6, vol. 8, pp. 2–4.

G. M. (Gabriel Mourey), "Studio Talk," *The Studio*, 1896, vol. 7, p. 180.

Natanson, Thadée, "Art Nouveau," *La Revue Blanche*, 1896, vol. 10, pp. 115–117.

Magazine of Art, "The Art Movement (Paris), I Door Furniture. II Stained Glass," March, 1897, pp. 268–271.

Art Journal, " 'L'Art Nouveau' at Paris," 1897, pp. 89–90.

Dekorative Kunst, "Moderne kunstgewerbliche Ausstellung," 1897, vol. 1–2, pp. 28–33.

Mourey, Gabriel, " 'L'Art Nouveau' at Paris," *Art Journal*, 1897, vol. 59, pp. 89–90.

————, "The Decorative Art Movement in Paris," *The Studio*, 1897, vol. 10, pp. 119–124.

Rivoalen, E., "L'Art Nouveau," *La Construction Moderne*, 1897–1898, vol. 14.

Soulié, Gustave, "Le Mobilier," *Art et Décoration*, 1898, vol. 3, pp. 65–72.

4. OTHER EXHIBITIONS HELD AT 'L'ART NOUVEAU' FROM 1896 TO 1905: CATALOGUES AND REVIEWS

L'Art Nouveau, Exposition Constantin Meunier, (Introduction by Georges Lecomte), February 16–March 15, 1896.

La Presse, "Petits Salons. Notes d'art" (Review of the Constantin Meunier exhibition at l'Art Nouveau), February 19, 1896.

Frémine, Charles, "Constantin Meunier," *Le XIXe Siècle*, February 19, 1896.

L'Art Moderne, "Constantin Meunier à Paris," February 23, 1896, no. 8, pp. 61–62.

Clémenceau, Georges, "Constantin Meunier," *Le Journal*, February 26, 1896.

Clément-Janin, Noël, "Notes d'art. Constantin Meunier," *Le National*, February 26, 1896.

Mauclair, Camille, "Constantin Meunier," *Mercure de France*, April, 1896, vol. 18, p. 157.

Exposition Louis Legrand à l'Art Nouveau, Paris, April 2–15, 1896.

Le National, "Louis Legrand," April 15, 1896.

Saint-Valéry, Léon de, "Beaux-Arts. Exposition de M. Louis Legrand, à l'Art Nouveau," *La Revue des Beaux-Arts et des Lettres*, April 15, 1896, pp. 109–110.

Mauclair, Camille, (Review of the Louis Legrand exhibition at l'Art Nouveau), *Mercure de France*, May, 1896, vol. 18, pp. 317–318.

Jaubert, Ernest, "L'Exposition de Louis Legrand," *L'Artiste*, 1896, vol. 66, pp. 354–356.

Salon de l'Art Nouveau. Exposition Eugène Carrière, (Introduction by Eugène Carrière), Paris, April 18–May 13, 1896.

Clément-Janin, Noël, "Notes d'art Eugène Carrière," *Le National*, April 23, 1896.

Mauclair, Camille, (Review of the Eugène Carrière exhibition at l'Art Nouveau), *Mercure de France*, June, 1896, vol. 18, p. 466.

Catalogue Edouard Munch, *L'Art Nouveau*, Paris, May, 1896.

Le Soir, (Review of the Edvard Munch exhibition at l'Art Nouveau), May 20, 1896.

Pellier, Henri, "Les Petits Salons. Edouard Munch," *Le Petit Républicain*, May 21, 1896.

Jourdain, Frantz, (Review of the Edvard Munch exhibition at l'Art Nouveau), *La Patrie*, May 30, 1896.

Strindberg, August, "L'Exposition Edvard Munch," *La Revue Blanche*, June 1, 1896, pp. 525–526.

L. R., "Exposition de Munch," *L'Aube*, June, 1896, p. 47.

Mauclair, Camille, "Art. Revue du mois," *Mercure de France*, July, 1896, vol. 19, pp. 186–189.

Catalogue des publications contemporaines figurant à l'exposition internationale du livre moderne organisée à l'Art Nouveau, Paris, June, 1896.

L'Art Moderne, "Notes d'art parisiennes. Exposition Renoir, chez M. Vollard, Le 'Livre moderne'," June 28, 1896, no. 20, p. 203.

Cousturier, Edmond, "Exposition internationale du livre moderne à l'Art Nouveau," *La Revue Blanche*, 1896, vol. 11, pp. 43–44.

The Studio, "Studio-Talk," 1896, vol. 8, pp. 115–116.

Tableaux de Charles Cottet, *L'Art Nouveau*, Paris, November, 1896.

Frantz, Henri, "Notes sur l'art. Exposition d'oeuvres de Charles Cottet à l'Art Nouveau," *Paris*, November 13, 1896.

Eon, Henry, "M. Charles Cottet," *La Plume*, December 1, 1896, p. 776.

Mercure de France, (Review of the Charles Cottet exhibition at l'Art Nouveau), December, 1896, vol. 20, pp. 612–613.

Durand-Gréville, E., "L'Exposition de Charles Cottet," *L'Artiste*, 1896, vol. 66, pp. 336–338.

G. M., (Gabriel Mourey), "Studio-Talk," *The Studio*, 1896, vol. 9, p. 291.

Oeuvres de Rippl-Ronai exposées à l'Art Nouveau, Paris, June, 1897.

Fontainas, André, (Review of the Rippl-Ronai exhibition at l'Art Nouveau), *Mercure de France*, July, 1897, vol. 23, p. 182.

Natanson, Thadée, "Petite Gazette d'Art," *La Revue Blanche*, 1897, vol. 12, pp. 802–803.

Aquarelles de Charles H. Pepper. L'Art Nouveau, Paris, December, 1897.

The Studio, "Studio-Talk," 1898, vol. 13, p. 116.

Daniel Vierge. Exposition de son oeuvre à l'Art Nouveau, (Introduction by Roger Marx), Paris, April, 1898.

Natanson, Thadée, "Petite Gazette d'art," *La Revue Blanche*, 1898, vol. 15, p. 615.

Alphonse Legros. L'Art Nouveau, Paris, March, 1898.

Fontainas, André, "Revue du mois. Art Moderne," (Review of the exhibition of Alphonse Legros at l'Art Nouveau), *Mercure de France*, 1898, vol. 26, pp. 295–296.

Lecomte, Georges, "Alphonse Legros," *Revue Populaire des Beaux-Arts*, October 1897–June, 1898, vol. 1, pp. 326–330.

Natanson, Thadée, "Petite Gazette d'art," *La Revue Blanche*, 1898, vol. 15, pp. 614–615.

Exposition J. F. Raffaelli, pointes-sèches et eaux-fortes en couleur à l'Art Nouveau, November–December, 1898.

Marx, Roger, "Les Petites expositions. I. Exposition Raffaelli," *Revue Populaire des Beaux-Arts*, December 3, 1898, vol. 2, pp. 417–418.

La Revue des Beaux-Arts et des Lettres, "Petits Salons. Exposition de M. J. F. Raffaelli," January 15, 1899, p. 40.

Priscal, Jean, "M. J. F. Raffaelli. Exposition de ses oeuvres à l'Art Nouveau," *Revue Internationale des Expositions*, January, 1899, pp. 1–2; February, 1899, p. 20.

G. Ch., "Petits Salons," *La Revue des Beaux-Arts et des Lettres*, June 15, 1898, p. 364.

Fontainas, André, "Revue du mois. Art moderne," *Mercure de France*, 1898, vol. 27, p. 283.

Grafton Galleries, Exhibition of l'Art Nouveau, S. Bing, Paris, May–July, 1899.

Townsend, Horace, "American and French Applied Art at the Grafton Galleries," *The Studio*, 1899, vol. 17, pp. 39–44.

J. "Chronique," (Review of the Santiago Rusinol exhibition at l'Art Nouveau), *L'Art Décoratif*, November, 1899, p. 137.

Saunier, Charles, "Petite Gazette d'Art. Santiago Rusinol," *La Revue Blanche*, 1899, vol. 20, p. 462.

Exposition d'aquarelles de Gaston Prunier à l'Art

Nouveau, Paris, April, 1899.

Denoinville, Georges, "Petits Salons," *La Revue des Beaux-Arts et des Lettres*, May 1, 1899, p. 236.

Fagus, Félicien, "Petite Gazette d'Art. Les Aquarelles de Gaston Prunier," *La Revue Blanche*, 1899, vol. 19, pp. 60–61.

Fontainas, André, "Revue du mois," *Mercure de France*, April, 1900, pp. 247–249.

A. T., "Chronique," *L'Art Décoratif*, 1900, vol. 5–6, pp. 270–271.

Exposition de la société de peintres japonais Nihon-Gwakai de Tokyo, Galeries de l'Art Nouveau Bing, March–April, 1901.

E. R., "L'Exposition des peintres de la Société Nihon Gwakai de Tokyo," *Art et Décoration*, September, 1901, pp. 92–96.

G. M., (Gabriel Mourey), "Studio-Talk," *The Studio*, 1901, vol. 23, pp. 279–282.

Oeuvres de F. Borchardt exposées à l'Art Nouveau Bing, Paris, April, 1902.

Saunier, Charles, "Gazette d'Art. Félix Borchardt," *La Revue Blanche*, 1902, vol. 22, pp. 622–623.

The Studio, "Studio-Talk," 1902, vol. 26, p. 296.

Oeuvres de Mlle. Marie Bermond, Galeries de l'Art Nouveau, Paris, March, 1902.

Saunier, Charles, "Gazette d'art. Marie Bermond," *La Revue Blanche*, 1902, vol. 27, pp. 544–545.

Oeuvres de Mlle. Meta Warrick. Sculpteur. Exposées à l'Art Nouveau Bing, (Introduction by Edouard Gérard), Paris, June, 1902.

Bentley, Florence Lewis, "Meta Warrick a Promising Sculptor," *The Voice of the Negro*, March, 1902, vol. 4, pp. 116–118.

Galerie de l'Art Nouveau Bing. Exposition d'oeuvres de Paul Signac, (Introduction by Arsène Alexandre), Paris, June, 1902.

Exposition Degouve de Nuncques et F. Massin. L'Art Nouveau, Paris, November 15, 1902.

Fagus, Félicien, "Gazette d'art. Expositions William Degouve de Nunques et J. Massin," *La Revue Blanche*, 1902, vol. 29, pp. 541–542.

Cousturier, Edmond, "Gazette d'art. Exposition d'oeuvres de Paul Signac," *La Revue Blanche*, 1902, vol. 28, pp. 213–214.

Fagus, Félicien, "Gazette d'art. Arbres nains du Japon," *La Revue Blanche*, 1902, vol. 28, p. 462.

Trois maitres japonais. Hiroshige, Hok'sai, Kouniyoshi. L'Art Nouveau Bing, Paris, May, 1903.

Exposition des oeuvres de George de Feure à l'Art Nouveau Bing, Paris, March, 1903.

Mourey, Gabriel, "L'Exposition Georges de Feure," *Art et Décoration*, May, 1903, pp. 162–164.

Puaux, René, " 'L'Art Nouveau Bing' introduction to *Oeuvres de Georges de Feure*," Paris, 1903.

———, "Georges de Feure," *Deutsche Kunst und Dekoration*, October, 1902–March, 1903, vol. 12, pp. 313–348.

Ruffe, Léon, "Georges de Feure," *L'Art Décoratif pour Tous*, June, 1903, no. 42, n.p.

Adolphe Dervaux. Galerie de l'Art Nouveau, Paris, January, 1903.

Fagus, Félicien, "Gazette d'art. Aquarelles d'Adolphe Dervaux," *La Revue Blanche*, 1903, vol. 30, pp. 235–236.

Exposition de tableaux par Ernest Baillet. L'Art Nouveau, Paris, March, 1903.

Exposition Paul Jouve, Galerie Bing, 10 rue St. Georges, Paris, March, 1905.

5. ART NOUVEAU BING: PARIS 1900—REVIEWS

Bussières, A. de, "L'Art Nouveau Bing—Paris," *Revue Internationale des Expositions Moniteur Général*, January, 1899, no. 2, p. 8.

E, "Der Bing'sche Pavillon L'Art Nouveau auf der Weltausstellung," *Die Kunst*, 1899–1900, vol. 2, pp. 488–493.

Jacques, G. M., "Exposition Universelle, l'Art Nouveau Bing," *L'Art Décoratif*, June, 1900, vol. 2, pp. 88–97.

O. M., "Le Pavillon de l'Art Nouveau à l'Exposition Universelle," *L'Art Moderne*, July 1, 1900, pp. 209–210.

Viviane, "L'Art Nouveau," *Revue Illustrée*, July 1, 1900, vol. 30, no. 14, p.n.

Becker, Marie Luise, "Das Kunstgewerbe in der Rue des Nations," *Innen-Dekoration*, August, 1900, vol. 11, pp. 129–134.

Viviane, "L'Art Nouveau au pavillon de 'L'Art Nouveau' S. Bing à l'Exposition," *Revue Illustrée*, August 1, 1900, vol. 30, no. 17, n.p.

Riotor, Léon, "Les Bijoutiers modernes à l'Exposition, Lalique, Colonna, Marcel Bing," *L'Art Décoratif*, August, 1900, vol. 2, pp. 173–179.

Soulié, Gustave, "L'Ameublement à l'Exposition," *Art et Décoration*, August, 1900, pp. 34–35.

Jacques, G. M., "L'Art décoratif. L'Intérieur rénové," *L'Art Décoratif*, September, 1900, vol. 2, pp. 217–228.

Rais, Jules, "Les Beaux-Arts à l'Exposition, Postscripta: Notes sur l'exposition décennale, l'art décoratif et l'architecture," *Le Siècle*, November 3, 1900.

Viviane, "L'Art Nouveau," *Revue Illustrée*, December 1, 1900, vol. 30, no. 24, n.p.

Bénédite, Léonce, "Le Bijou à l'exposition universelle," *Art et Décoration*, 1900, vol. 8, pp. 65–82.

Fred, W., "Interieurs und Möbel auf der Pariser Weltausstellung," *Kunst und Kunsthandwerk*, 1900, vol. 3, pp. 331–352.

Krohn, Pietro, "S. Bings Pavillon: 'L'Art nouveau' paa Verdensudstillingen i Paris 1900," *Tidskrift for Industri*, 1900, pp. 305–323.

Die Kunst, "Der Bing'sche Pavillon L'Art Nouveau auf der Weltausstellung," 1899–1900, vol. 2, pp. 488–493.

Minkus, Fritz, "Die Juwellierkunst auf der Pariser Weltausstellung," *Kunst und Kunsthandwerk*, 1900, vol. 3, pp. 485–503.

Mourey, Gabriel, "L'Art Nouveau de M. Bing à l'Exposition Universelle," *Revue des Arts Décoratifs*, 1900, vol. 20, pp. 257–268 and 278–284.

———, "Round the Exhibition—I. The House of 'Art Nouveau Bing'," *The Studio*, 1900, vol. 20, pp. 164–180.

Osborn, Max, "Bing's 'Art Nouveau' auf der Weltausstellung," *Deutsche Kunst und Dekoration*, 1900, vol. 6, pp. 550–569.

Weisbach, Werner, "Von der Pariser Weltausstellung," *Zeitschrift für Bildende Kunst*, July 20, 1900, no. 31, pp. 482–490.

Osborn, Max, "Das Testament der Pariser Weltausstellung 1900," *Deutsche Kunst und Dekoration*, October, 1900–March, 1901, vol. 7, pp. 169–176.

Benn, Davis, R., "The Review of the Paris Exhibition, 1900," *The Cabinet Maker and Art Furnisher*, 1900–1901, vol. 21, pp. 197–214.

Chu, Aasai, "Paris shosoku," *Hototogisu*, January, 1901, vol. 4.

Gerdeil, O., "Le Meuble," *L'Art Décoratif*, January, 1901, vol. 3, pp. 170–175.

Viviane, "L'Art Nouveau—Bijoux et bibelots," *Revue Illustrée*, January 1, 1901, vol. 31, no. 2, n.p.

———, "L'Art Nouveau, meubles et toilettes," *Revue Illustrée*, January 15, 1901, vol. 31, no. 3, n.p.

Thiébault-Sisson, "Choses d'art. L'Art Nouveau dans le meuble et dans la décoration intérieure," *Le Temps*, March 1, 1901.

Piérrelée, S. de, "L'Art Nouveau, étains et cuivres," *Revue Illustrée*, March 15, 1901, vol. 31, no. 7, n.p.

Blanc, Armand, "L'Art Nouveau Bing," *Revue Illustrée*, June 1, 1901, vol. 31, no. 12, n.p.

Brinkmann, Justus, "Die Ankäufe auf der Weltausstellung Paris 1900," *Hamburgisches Museum für Kunst und Gewerbe*, Hamburg, 1901.

Jouvance, L., "Les Bijoux de l'Art Nouveau Bing," *Revue de la bijouterie, joaillerie, orfèvrerie*, 1901, vol. 1, pp. 211–217.

Thiis, Jens, "Om verdensudstillingen i Paris. Spredte tanker og indtryk om Kunsthaandvoerk," *Nordenfjeldske Kunstindustrimuseums Aarbog 1898–1901*, Trondheim, 1902.

Puaux, René, "L'Art Nouveau Bing," *Deutsche Kunst und Dekoration*, October, 1902–March, 1903, vol. 12, pp. 308–312.

6. GENERAL WRITINGS ON JAPAN, ART NOUVEAU, AND NINETEENTH-CENTURY DECORATIVE ART

BOOKS

Aslin, Elizabeth, *The Aesthetic Movement: Prelude to Art Nouveau*, London, 1969.

Awakening Japan: The Diary of a German Doctor: Erwin Bäelz, edited by his son, Toku Baelz, Bloomington, 1974.

Bouillon, Jean Paul, *Art Nouveau, 1870–1914*, Geneva, 1985.

Frank Brangwyn Centenary, National Museum of Wales, Welsh Arts Council, Cardiff, 1967.

Brangwyn, Rodney, *Brangwyn*, London, 1978.

Brinkmann, Justus, *Kunst und Kunsthandwerk in Japan*, Berlin, 1889.

Brunhammer, Yvonne, *Art Nouveau*, Catalogue of an exhibition, Rice University and Art Institute of Chicago, Houston 1976.

Catalogue de l'Exposition rétrospective de l'art japonais organisée par M. Louis Gonse, Paris, 1883.

Cazalis, Henri (pseudonym for Jean Lahor), *L'Art Nouveau, son histoire à l'Exposition. L'Art Nouveau au point de vue social*, Paris, 1901.

Champier, Victor, *Les Industries d'art à l'exposition universelle de 1900*, Paris, 1902.

Chisholm, Lawrence C., *Fenollosa: The Far East and American Culture*, New Haven, 1963.

Clément-Janin, Noël, *Le Déclin et la renaissance des industries d'art décoratif en France*, Paris, 1911.

Duncan, Alastair, *Tiffany Windows*, New York, 1980.

Eidelberg, Martin, *E. Colonna*. Dayton, 1984.

Fontaine, André, *Art et esthétique. Constantin Meunier*, Paris, 1923.

Furst, Herbert, *The Decorative Art of Frank Brangwyn*, London, 1924.

Gaillard, Eugène, *A Propos du Mobilier. Opinions d'avant-garde. Technique fondamentale. l'Evolution*, Paris, 1906.

Geffroy, Gustave, *Les Industries artistiques françaises et étrangères à l'exposition universelle de 1900*, Paris, 1900.

Gonse, Louis, *L'Art japonais*, Paris, 1883.

Grasset, Eugène, *L'Art Nouveau. Conférence faite à l'Union Centrale des Arts Décoratifs le 11 avril 1897*, Paris, 1897.

Guérinet, Edouard, *La Décoration et l'ameublement à l'exposition de 1900*, Paris, 1901.

Guerrand, Roger H., *L'Art Nouveau en Europe*, Paris, 1965.

Das Hamburgische Museum für Kunst und Gewerbe, dargestellt zur Feier des 25 Jährigen Bestehens von Freunden und Schülern Justus Brinckmanns, Hamburg, 1902.

Hammacher, A. M., *Le Monde de Henry van de Velde*, Antwerp-Paris, 1967.

Johnson, Diane Chalmers, *American Art Nouveau*, New York, 1979.

Julian Philippe, *The Triumph of Art Nouveau, Paris Exhibition 1900*, New York, 1974.

Koch, Robert, *Louis C. Tiffany, Rebel in Glass*, New York, 1964.

Koechlin, Raymond, *Le Pavillon de l'Union Centrale des arts décoratifs à l'exposition de 1900*, Paris, 1900.

———, *Souvenirs d'un vieil amateur d'art de l'Extrême-Orient*, Chalon-sur-Saone, 1930.

Lahor, Jean, *L'Art pour le peuple à défaut de l'art par le peuple*, Paris, c. 1902.

Lambert, Théodore, *L'Art décoratif moderne. L'Exposition universelle de 1900*, Paris, n.d.

———, *Meubles de style moderne. Exposition universelle 1900*, Paris, n.d.

———, *Meubles et ameublement de style moderne*, Paris, n.d.

Lenning, Henry F., *The Art Nouveau*, The Hague, 1951.

Levin, Miriam R., *Republican Art and Ideology in Late Nineteenth Century France*, UMI Research Press, 1986.

Madsen, Stephan Tschudi, *Sources of Art Nouveau*, New York, 1955.

———, *L'Art Nouveau*, Paris, 1967.

Mallié, Albert, *L'Art Nouveau*, Besançon, 1901.

Mandell, Richard D., *Paris 1900. The Great World's Fair*, Toronto, 1967.

Marx, Roger, *La Décoration et les industries d'art à l'exposition universelle de 1900*, Paris, 1900.

Meusnier, Georges, *La Joaillerie française en 1900*, Paris, 1901.

Moffett, Kenworth, *Meier-Graefe as Art Critic*, Munich, 1973.

Mourey, Gabriel, *Essai sur l'art décoratif français moderne*, Paris, 1921.

Nocq, Henri, *Tendance Nouvelle. Enquête sur l'évolution des industries d'art*, Paris, 1896.

Olmer, Pierre, *La Renaissance du mobilier français 1890–1910*, Paris, 1927.

Orazi, Manuel, *Calendrier magique*, Paris, 1896.

Pevsner, Nikolaus, *Pioneers of Modern Design from William Morris to Walter Gropius*, New York, 1949.

Picard, Alfred, *Exposition universelle internationale de 1900 à Paris, rapport général administratif et technique*, Paris, 1902.

Remon, Georges, *Intérieurs modernes*, Paris, 1903.

Rheims, Maurice, *L'Objet 1900*, Paris, 1964.

———, *L'Art 1900 ou le style Jules Verne*, Paris, 1965.

Saunier, Charles, *Les Industries d'art à l'exposition universelle de 1900*, Paris, 1902.

Schmutzler, Robert, *Art Nouveau*, New York, 1964.

Sichel Philippe, *Notes d'un bibeloteur au Japon*, Paris, 1883.

Smith, Linda S., "S. Bing and l'Art Nouveau," unpublished M.A. thesis, The Pennsylvania State University, 1971.

Tomlinson, Helen, "Charles Lang Freer: Pioneer Collector of Oriental Art," unpublished Ph.D. dissertation, Case Western Reserve University, May, 1979.

Vachon, Marius, *Nos industries d'art en péril*, Paris, 1882.

———, *Pour la défence de nos industries d'art*, Paris, 1899.

Velde, Henry van de, *Déblaiement d'art*, Brussels, 1894.

———, *Die Renaissance im modernen Kunstgewerbe*, Berlin, 1901.

———, *Geschichte meines Lebens*, Munich, 1962.

Weinberg, Barbara H., *The Decorative Work of John La Farge*, New York and London, 1977.

ARTICLES

d'Albis, Jean, "Limoges, Bing et l'Art Nouveau," *Connaissance des Arts*, October, 1978, pp. 5–9.

Bailly-Herzberg, Jeanine, "Essai de reconstitution grâce à une correspondance inédite du peintre Pissarro du magasin que le fameux marchand Samuel Bing ouvrit en 1895 à Paris pour lancer l'Art Nouveau," *Connaissance des Arts*, September, 1975, no. 283, pp. 72–81.

Batari, Ferenc, "Art Nouveau 1900, présentation des objets d'art acquis à l'occasion de l'exposition universelle de Paris," *Ars Decorativa 5*, Budapest, 1977, pp. 175–200.

Boime, Albert, "Entrepreneurial Patronage in Nineteenth Century France," in *Enterprise and Entrepreneurs in Nineteenth and Twentieth Century France*, edited with an Introduction by Edward C. Carter II, Robert Forster and Joseph N. Moody, Baltimore and London, 1976.

Brush and Pencil, "The Arts and Crafts Movement at Home and Abroad," April–September, 1900, vol. 6, pp. 110–121.

Dam, Peter van, "Siegfried Bing 1838–1905. An Overview of his Activities in the Field of Oriental Art," *Andon*, Summer, 1983, no. 10, pp. 10–14.

———, "Wakai Kenzaburo, The Connoisseur," *Andon*, 1985, vol. 5, no. 10, pp. 36–41.

Deutsche Kunst und Dekoration, "Die Französische Gewerbekunst auf der Turiner Ausstellung," 1902, vol. 11, pp. 169–171.

Eidelberg, Martin, "Edward Colonna's 'Essay on Broom-Corn': a forgotten book of early art nouveau," *The Connoisseur*, February, 1971, pp. 123–130.

———, and Henrion-Giele, Suzanne, "Horta and Bing: An Unwritten Episode of l'Art Nouveau," *Burlington Magazine*, November, 1977, pp. 747–752.

————, "The Life and Work of E. Colonna, Part 1: The Early Years," *The Decorative Arts Society Newsletter*, March, 1981, vol. 7, pp. 1–7; "Part 2: Paris and l'Art Nouveau," June, 1981, vol. 7, pp. 1–10; "Part 3: The Last Decades," September, 1981, vol. 7, pp. 1–8.

Fred, W., "Die Turiner Ausstellung. Die Sektion Frankreich," *Die Kunst*, 1902, vol. 6, pp. 458–462.

Gardelle, Camille, "Moderne Kunst in der französischen Architektur: II Der Architekt Louis Bonnier," *Dekorative Kunst*, 1897, vol. 1, pp. 215–221.

Gerdeil, O., "Un Atelier d'artiste," *L'Art Décoratif*, January 1902, vol. 9–10, pp. 144–150.

Gordon, D. J., "Mistaken Identities," *The Studio International*, November, 1970, pp. 216–218.

Grady, James, "Nature and the Art Nouveau," *The Art Bulletin*, September, 1955, vol. 37, pp. 187–192.

Hamlin, A. D. F., "L'Art Nouveau: Its Origins and Development," *The Craftsman*, December, 1902, vol. 3, pp. 129–143.

Hempel, Rose, "Die Japan-Sammlungen des Museums für Kunst und Gewerbe Hamburg," *Bonner Zeitschrift für Japanologie*, vol. 3, 1981.

Japonismus und Art Nouveau. Europäische Graphik aus den Sammlungen des Museums für Kunst und Gewerbe Hamburg, Hamburg, 1981.

Kahn, Gustave, "Dessins de bijoux MM. Mucha, de Feure, Dufrêne, Marcel Bing," *Art et Décoration*, 1902, vol. 11–12, pp. 13–17.

Koch, Robert, "Art Nouveau Bing," *Gazette des Beaux-Arts*, 1959, vol. 53, pp. 179–190.

Lancaster, Clay, "Oriental Contribution to Art Nouveau," *The Art Bulletin*, 1952, vol. 34, pp. 297–310.

Lemmen, Georges, "Moderne Teppiche," *Dekorative Kunst*, 1897, vol. 1–2, pp. 97–105.

Little, Frances, "Japanese Textiles from the Bing Collection," *Bulletin of the Metropolitan Museum of Art*, January, 1932, vol. 27, pp. 14–16.

Melani, Alfredo, "L'Art Nouveau à Turin. A Description of the Exhibition by A. Melani, a Member of the International Jury, II," *The Architectural Record*, December, 1902, vol. 12, no. 7, pp. 735–750.

Y, (Meier-Graefe, Julius), "Belgische Innendekoration," *Dekorative Kunst*, October, 1897, pp. 201–206.

Meier-Graefe, Julius, "Französisches Mobiliar," *Dekorative Kunst*, 1898, vol. 2, pp. 104–108.

Millman, Ian, "Georges de Feure, the Forgotten Dutch Master of Symbolism and Art Nouveau," *Arts Magazine* (Europe), September/October, 1983, vol. 6, no. 1, pp. 41–47.

————, "Ein bijzondere Nederlandse luchtvaartpionier: Georges de Feure," *Luchtvaartwereld*, October, 1985, vol. 2, no. 10, pp. 285–288.

Miyajima, Hisao, "S. Bing's Visit to Japan," *Bulletin of the Study of Japonism*, 1982, no. 2, pp. 29–33.

Mourel, Gabriel, "An Interview on 'Art Nouveau' with Alexandre Charpentier," *The Architectural Record*, 1902, vol. 12, pp. 121–125.

————, "Georges de Feure–Paris," *Innen-Dekoration*, 1902, pp. 7–15.

Prost, Lucie and Valléry, Chantal, "Histoire d'une collection: le Musée d'Ennery," *Revue du Louvre*, 1977, no. 1, pp. 12–16.

Rudder, Jean-Luc de, "Il y a cent ans Bing inventait l'Art Nouveau," *l'Estampille*, January, 1971, no. 17, pp. 32–37.

Sargent, Irène, "The Wavy Line," *The Craftsman*, June, 1902, vol. 2, pp. 131–142.

Schaefer, Herwin, "Tiffany's Fame in Europe," *The Art Bulletin*, December, 1962, vol. 44, pp. 309–328.

Schmutzler, Robert, "The English Origins of Art Nouveau," *The Architectural Review*, February, 1955, pp. 108–116.

Schopfer, Jean, "Modern Decoration," *The Architectural Record*, 1897, vol. 6, pp. 243–255.

Sedeyn, Emile, "La Céramique de table," *L'Art Décoratif*, 1900–1901, vol. 3, pp. 7–17.

Troy, Nancy, "Toward a Redefinition of Tradition in French Design, 1895 to 1914," *Design Issues*, Fall, 1984, vol. 1, pp. 53–69.

Uzanne, Octave, "G. de Feure," *Art et Décoration*, March, 1901, vol. 9, pp. 77–88.

Wakefield, Hugh, Aslin, Elizabeth, Morris, Barbara and Bury, Shirley, "British Decorative Arts of the Late Nineteenth Century in the Nordenfjeldske Kunstindustrimuseum," *Nordenfjeldske Kunstindustrimuseum, Arbok, 1961–1962*, Trondheim, 1963, pp. 37–106.

Weisberg, Gabriel P., "Samuel Bing: Patron of Art Nouveau, the Appreciation of Japanese Art," *The Connoisseur*, October, 1969, pp. 119–125; "Bing's Salons of Art Nouveau," *The Connoisseur*, December, 1969, pp. 294–299; "The House of Art Nouveau Bing," *The Connoisseur*, January, 1970, pp. 61–68.

————, "Samuel Bing: International Dealer of Art Nouveau, Part 1: Contacts with the Musée des Arts Décoratifs, Paris," *The Connoisseur*, March, 1971, vol. 176, pp. 200–205; "Part 2: Contacts with the Victoria and Albert Museum, London," *The Connoisseur*, April, 1971, vol. 176, pp. 275–283; "Part 3: Contacts with the Kaiser Wilhelm Museum, Krefeld, Germany, and the Finnish Society of Crafts and Design, Helsinki, Finland," *The Connoisseur*, May, 1971, vol. 177, pp. 49–55; "Part 4: Contacts with the Museum of Decorative Art, Copenhagen," *The Connoisseur*, July, 1971, vol. 177, pp. 211–219.

————, "Bing Porcelain in America," *The Connoisseur*, November, 1971, vol. 178, pp. 200–203.

————, "Georges de Feure's Mysterious Women: A Study of Symbolist Sources in the Writings of Charles Baudelaire and Georges Rodenbach," *Gazette des Beaux-Arts*, October, 1974, pp. 223–230.

————, "Gérard, Dufraissex and Abbot: The Manufactory of Art Nouveau Bing Porcelains in Limoges, France," *The Connoisseur*, February, 1978, vol. 197, pp. 125–129.

————, "L'Art Nouveau Bing," *Arts in Virginia*, Fall, 1979, vol. 20, no. 1, pp. 3–15.

————, "A Note on S. Bing's Early Years in France, 1854–1876," *Arts Magazine*, January, 1983, vol. 57, no. 5, pp. 84–85.

————, "S. Bing's Craftsmen Workshops: A Location and Importance Revealed," *Source*, Fall, 1983, vol. 3, no. 1, pp. 42–48.

————, "Siegfried Bing, Louis Bonnier et la maison de l'Art Nouveau en 1895," *Bulletin de la Société de l'Histoire de l'Art Français*, séance du 4 décembre, 1982, 1985, pp. 241–249.

Wilkins, David, "Ker-Xavier Roussel's 'The Window'," *Carnegie Magazine*, December, 1978, vol. 52, no. 10, pp. 17–19.

ACKNOWLEDGMENTS

Although my work on Siegfried Bing began almost twenty years ago as an outgrowth of my doctoral dissertation on Philippe Burty and the world of the *Japonistes*, the idea for *The Paris Style 1900: Art Nouveau Bing* came from Yvonne Brunhammer, Conservateur en Chef at the Musée des Arts Décoratifs in Paris. We originally hoped that an exhibition on Bing and *art nouveau* would be presented in Paris and Brussels before it travelled to the United States, but it ultimately emerged as a purely American endeavor under the auspices of SITES. The Musée des Arts Décoratifs, the world's most important repository of *Art Nouveau Bing* pieces, remains a major force in the creation of this exhibition through its willingness to lend its magnificent objects. Without their generous loans, this exhibition could not have been organized.

I wish to thank, first and foremost, Yvonne Brunhammer for her continued support and wise counsel, and for her pioneering work on *art nouveau*. I also thank the museum's director, François Matthey, and members of his staff, especially Marie-Noëlle de Gary and Nadine Gasc, Conservateurs, Evelyne Possémé and Jean-Luc Olivier, Yvonne Brunhammer's assistants, and Sonia Edard, Chargé du Service Photographique, for their generous help during my numerous years of research. The assistance of Geneviève Bonté and her colleagues at the Bibliothèque du Musée des Arts Décoratifs made conducting research a most pleasurable and fruitful experience.

I wish to further acknowledge the following people who helped in the completion of this project:

In France
Jean Adhémar, Editeur en Chef, Gazette des Beaux-Arts, Paris; Jean d'Albis, Limoges; Marie Amélie Anquetil, Conservateur en Chef, Musée Départemental du Prieuré, St. Germain-en-Laye; Juliet Wilson Bareau, Paris; Marc Bascou, Conservateur, Musée d'Orsay, Paris; Alain Beausire, Documentaliste, Musée Rodin, Paris; Annemarie Bergmans, Beaufort-en-Vallée; Jaap W. Brouwer, Beaufort-en-Vallée; the late Fernande Bing; the late Bernard Bonnier; Jean-Paul Bouillon, Professor, Paris; Alain and Annette Bourrut-Lacouture, Rambouillet; Françoise Cachin, Conservateur, Musée d'Orsay, Paris; Mrs. M. Cappiello, Paris; Jean-Loup Charmet, Photographer, Paris; Raymond Clappier, G.D.A., Limoges; Ivan Christ, Paris; Claire Denis, St. Germain-en-Laye; Dominique Denis, St. Germain-en-Laye; Jean-Francois Dreyfus, Paris; the late Andrée G. Duizend; Henri Duizend, Paris; Michel Duizend, Paris; the late Charles Durand-Ruel; Georges Encil, Paris; Isabel Fonseca, Paris; Elizabeth Foucart-Walter, Conservateur, Musée du Louvre, Paris; the late Renée Genay; Geneviève Gille, Directeur des Services d'Archives de Paris; Renée Haase, Paris; Barlach Heuer, Paris; Shigemi Inaga, Paris; J. Jaqué, Conservateur, Musée de l'Impression sur Etoffes, Mulhouse; Mme Paul Pierre Jouve, Paris; Bernard Koechlin, Paris; Pierre Koechlin, Meudon; Dorothée Koechlin de Bizemont, Paris; Geneviève Lacambre, Conservateur en Chef, Musée d'Orsay, Paris; Jacqueline Lordonnois, Paris; R. Manukian, Paris; Félix Marcilhac, Paris; Bernard Marey, Paris; Mr. and Mrs. Maritch-Haviland, Paris; Michel Melot, Centre Georges Pompidou, Paris; Ian Millman, Paris; Yolande Osbert, Paris; Hervé Poulain, Paris; Tamara Préaud, Archiviste, Archives du Musée National de Céramique, Sèvres; Anne Roquebert, Chef du Service de Documentation, Musée d'Orsay, Paris; Pierre Rosenberg, Conservateur en Chef, Musée du Louvre, Paris; Lynne Thornton, Paris; Mme Sevain, Bibliothèque d'Art et d'Archéologie, Paris; Mlle J. Villa, Conservateur en Chef, Archives du Louvre.

In Austria
Dr. Hanna Egger, Curator, Österreichisches Museum für angewandte Kunst, Vienna; Dr. Ursula Mayerhofer, Curator, Österreichisches Museum für angewandte Kunst, Vienna; Dr. Waltraud Neuwirth, Curator, Österreichisches Museum für angewandte Kunst, Vienna; Dr. Angela Volker, Curator, Österreichisches Museum für angewandte Kunst, Vienna; Dr. Christian Witt-Dörring, Curator, Österreichisches Museum für angewandte Kunst, Vienna; Dr. Inge Woisetschlager, Curator, Landesmuseum Joanneum, Graz.

In Belgium
Françoise Dierken, Conservateur, Musée Horta, Brussels; Jean Warmoes, Bibliothèque Royale Albert 1er, Brussels.

In Czechoslovakia
Dr. Karel Holesovsky, Curator, Moravian Gallery, Brno.

In Denmark
A. Ertberg, Curator, Museum of Decorative Art, Copenhagen; Kristian Jakobsen, Director, Museum of Decorative Art, Copenhagen; Freddy Jensen, Curator, The Royal Copenhagen Porcelain Manufactory Ltd., Copenhagen; Erik Lassen, former Director, Museum of Decorative Art, Copenhagen; Jorgen Schou-Christensen, Curator, Museum of Decorative Art, Copenhagen.

In England
Jane Abdy, London; Elizabeth Aslin, London; Peter D. Cormack, Deputy Keeper, William Morris Gallery, Walthamstow; Norah C. Gillow, Keeper, William Morris Gallery, Walthamstow; Kenneth McConkey, Professor, Newcastle upon Tyne Polytechnic, Newcastle upon Tyne; Robin Spencer, Professor, St. Andrews, Scotland; Lynne Walker, Newcastle upon Tyne Polytechnic, Newcastle upon Tyne; Robert Walker, London.

In Finland
H. O. Gummerus, former Director of the Finnish Society of Crafts and Design, Helsinki; Marjatta Levanto, Education Officer, the Art Museum of the Ateneum, Helsinki; Marja Supinen, Curator, Sinebrychoff Art Museum, Helsinki; Marketa Tamminen, Director, Porvoo Museum, Porvoo.

In Germany
Dr. Margrit Bauer, Curator, Museum für Kunsthandwerk, Frankfurt-am-Main; Mrs. E. Bornfleth, Director, Gewerbemuseum, Nürnberg; Dr. F. A. Dreier, Director, Staatliche Museen Preussischer Kulturbesitz, Berlin; Dr. Gisela Fiedler, Krefeld; Fritz Fischer, Staatliche Museen Preussischer Kulturbesitz, Berlin; Dr. Rose Hempel, Curator, Museum für Kunst und Gewerbe, Hamburg; Dr. Klaus Herding, Professor, Hamburg; Dr. Julian Heynen, Deputy Director, Kaiser Wilhelm Museum, Krefeld; Dr. Kötzsch, Archivist, Staatsarchiv, Hamburg; Vera Leuschner, Göttingen; Dr. Ruth Malhotra, Curator, Museum für Kunst und Gewerbe, Hamburg; Dr. Axel von Saldern, Director, Museum für Kunst und Gewerbe, Hamburg; Dr. Heinz Spielman, Curator, Museum für Kunst und Gewerbe, Hamburg.

In Holland
Peter van Dam, The Hague.

In Hungary
Dr. Miklós Pál, General Director, Iparmüvészeti Múzeum, Budapest.

In Japan
Akiko Mabuchi, University of Tokyo, Tokyo; Hisao Myajima, formerly at the National Museum of Art, Osaka.

In Norway
Jan L. Opstad, Director, Nordenfjeldske Kunstindustrimuseum, Trondheim.

In Sweden
Dr. and Mrs. Dag Knutson, Granna; Dr. Helena Dahlback Lutteman, Nationalmuseum, Stockholm.

In Switzerland

Marina Ducrey, Galerie Paul Vallotton, Lausanne; Dr. Durst, Curator, Lenzburg Castle, Aarau; Samuel Josefowitz, Lausanne; Dr. Hans Lüthy, Director, The Swiss Institute for Art Research, Zürich; Claude, Donald, and Philippe Vallotton, Galerie Paul Vallotton, Lausanne; Dr. Heiny Widmer, Director, Aargauer Kunsthaus, Aarau; Dr. Max Werren, Director, Kantonales Gewerbemuseum, Bern.

In the United States

Patricia Boyer, Curator, The Jane Voorhees Zimmerli Art Museum, Rutgers University, New Brunswick; Dr. Doreen Burke, Curator, The Metropolitan Museum of Art, New York; Sue Brunsman, Cincinnati; Eileen Carew, Exhibitions Coordinator, Danforth Museum, Framingham; Dennis Cate, Director, The Jane Voorhees Zimmerli Art Museum, Rutgers University, New Brunswick; Dr. Petra Chu, Seton Hall University, South Orange; Dr. Helen Conant, New York; Louise Cort, Curator, The Freer Gallery of Art, Washington, DC; Dr. Henri Dorra, Professor, Santa Barbara University, Santa Barbara; Alastair Duncan, Sotheby and Co.; Diana Duncan, SITES, Washington, DC; Dr. Martin Eidelberg, Professor, Rutgers University, New Brunswick; Nancy Eickel, SITES, Washington, DC; Sarah G. Epstein, Washington, DC; Lionel C. Epstein, Washington, DC; Bruce Evans, Director, The Dayton Art Institute, Dayton; David McFadden, Curator, Cooper Hewitt Museum, New York; Dr. Clive Getty, Professor, Miami University, Oxford, Ohio; Dr. Alden Gordon, Professor, Trinity College, Hartford; Anne Gossett, SITES, Washington, DC; Dr. June Hargrove, Professor, University of Maryland, College Park, Maryland; Sylvia Herschede; Kathryn B. Hiesinger, Curator, Philadelphia Museum of Art, Philadelphia; Elizabeth Holt, Washington, DC; Harold Jaffe, New York; Anthony Janson, Chief Curator, The Ringling Museum of Art, Sarasota; Dora Jane Janson, New York; the late H. W. Janson; William R. Johnston, Assistant Director, The Walters Art Gallery, Baltimore; Robert Koch; Rebecca Lawton, Professor, Syracuse University, Syracuse; Thomas Lawton, Director, The Freer Gallery of Art, Washington, DC; Martin Linsey, Scottsdale, Arizona; Peggy Loar, Director, SITES, Washington, DC; Mr. and Mrs. Lloyd Macklowe, New York; Jean Mailey, Curator, The Metropolitan Museum of Art, New York; Craig Miller, Curator, The Metropolitan Museum of Art, New York; Dr. Henry Millon, Dean, Center for Advanced Study in the Visual Arts, National Gallery, Washington, DC; Philippe de Montebello, Director, The Metropolitan Museum of Art, New York; Lilian Nassau, New York; Jane van Nimmen, Curator, The Sarah G. and Lionel C. Epstein Collection, Washington, DC; Anne Percy, Curator, The Philadelphia Museum of Art, Philadelphia; Paul N. Perrot, Director, Virginia Museum of Fine Arts, Richmond; Janet Rabinovitch, Senior Editor, Indiana University Press, Bloomington; Emily Rafferty, Vice President for Development, The Metropolitan Museum of Art, New York; Gordon Ray, formerly President, The S. Guggenheim Foundation, New York; Dr. Cleota Reed, Syracuse; Joseph Rishel, Curator, Philadelphia Museum of Art, Philadelphia; Henry Flood Robert Jr., Director, Joslyn Art Museum, Omaha; Margaret Sevçenko, Cambridge, Mass; Mr. and Mrs. Herbert Schimmel, New York; Hisao Shimitzu, Professor, Princeton University, Princeton; Marianna S. Simpson, Assistant Dean, Center for Advanced Study in the Visual Arts, National Gallery, Washington, DC; Linda S. Smith; Andrea Stevens, SITES, Washington, DC; Catherine Stover, formerly Archivist at the Pennsylvania Academy of Fine Arts, Philadelphia; Kenneth Trapp, Curator, The Oakland Museum, Oakland; Sue Walsh, Curator, The Dayton Art Institute, Dayton.

Several other individuals and institutions played extremely significant roles in the realization of this project. Professor Christopher Gray, my mentor at Johns Hopkins University and the first to note Bing's importance to nineteenth-century art, led me to Bing and his shops through a paper I did for one of his art history seminars in 1966. The late professor H. W. Janson saw the value of this project and did his best to cause its fruition. A special word of thanks is due to Walter O. Michael and his wife, Corolla. Without their help, it would have been almost impossible to clarify Bing's many family relationships, much less decipher the voluminous correspondence between Bing and German and Scandinavian museums. Mr. Michael spent many long hours translating handwritten documents that became crucial to the ultimate understanding of Bing's business relationships. I remember with great fondness the time we spent discussing Bing and am grateful for the friendship of the Michael family. My friends, Muriel and the late Stanley Rakusin of Washington, DC, also greatly helped in the completion of this manuscript.

In addition, I wish to recognize two institutions whose financial assistance were crucial to the completion of this project. The Guggenheim Foundation's grant, awarded to me for the year 1982–83, helped support my final research and work on the manuscript. The Center for Advanced Study in the Visual Arts at the National Gallery of Art in Washington, DC, also gave me free time to finish this text and proceed with the project. My appreciation extends to the University of Minnesota for their understanding and for allowing me to start my tenure in the department of art history with a sabbatical so I could finalize the many important details associated with publishing this book and organizing *The Paris Style 1900: Art Nouveau Bing*.

Most importantly, this monumental project could not have been completed without the support and dedication of my wife, Yvonne. And to Peggy Loar and her able staff at SITES, I offer my heartfelt thanks and admiration.

PHOTOGRAPH CREDITS

The author and publisher wish to thank the museums, galleries, and private collectors for permitting the reproduction of works in their collections. Photographs have been supplied by the owners or custodians of the works except for the following illustrations:

Bernheim, Jeune, Paris, figs. 31, 32
Brouwer, Jaap W., Beaufort-en-Vallée, France, fig. 5
Charmet, Jean-Loup, Paris, figs. 26, 34, 35, 37, 41, 42, 50–52, 55, 59, 76, 90, 149, 150, 164, 168, 170, 172, 175
Colomb-Gérard, J., Paris, figs. 27, 28, 43–45
Eidelberg, Martin, New York, figs. 48, 49
Finnish Society of Crafts & Design, Helsinki, figs. 177, 218
L'Image, Limoges, plates 42, 45, 47, 48, 72, 73
Josefowitz, Samuel, Lausanne, plates 15–17
Kiemer und Kiemer, Hamburg, figs. 33, 87, 88, 115, 116, 119, 128; plates 4, 11, 25, 57–61
Lian, Svein, Trondheim, figs. 18, 29, 30, 70, 73, 77, 96–105, 209–217; plates 19–23, 38
Michael, Walter O., New York, fig. 1
Millman, Ian, Paris, figs. 36, 38–40
Victor's Photography, Piscataway, New Jersey, figs. 74, 75, 78–82, 106, 107, 120, 132–134; plates 13, 14, 24
Weisberg, Yvonne, Minneapolis, figs. 2–4, 6–8, 17, 25, 46, 57, 58, 60–62, 72, 73, 85, 86, 95, 117, 118, 121, 127, 129, 137–148, 150–154, 159, 160, 169–171, 174, 175, 181, 184, 188, 189, 193, 194, 200, 201, 203, 206, 208, 219–221, 223, 224, 244–246; plates 1–3, 70
Woldbye, Ole, Copenhagen, figs. 9–13, 194, 195, 199, 202, 204, 207; plates 29, 33, 34, 36, 51–56
Xystus Studio, Springfield, Virginia, figs. 122–125, 126; plate 26

LENDERS TO THE EXHIBITION

The Dayton Art Institute, Dayton, Ohio
Sarah G. Epstein Collection, Washington, D.C.
Galerie P. Vallotton, S.A., Lausanne, Switzerland
Gewerbemuseum, Nurnberg, West Germany
Samuel Josefowitz, Lausanne, Switzerland
The Metropolitan Museum of Art, New York, New York
Musée des Arts Décoratifs, Paris, France
Museum für Kunst und Gewerbe, Hamburg, West Germany
Museum of Decorative Art, Copenhagen, Denmark
Nordenfjeldske Kunstindustrimuseum, Trondheim, Norway
Philadelphia Museum of Art, Philadelphia, Pennsylvania
Porcelaines GDA, Limoges, France
Mr. and Mrs. Edward J. Quinn, Clifton, New Jersey
Jane Vorhees Zimmerli Art Museum, Rutgers-The State University of New Jersey,
New Brunswick, New Jersey

INDEX